Images of God

BY THE SAME AUTHOR

The Champions
Art and Psychoanalysis
Beyond the Crisis in Art
Seeing Berger
Robert Natkin
The Naked Artist
Aesthetics After Modernism
Theoria: Art and the Absence of Grace

(with Jon Halliday)
The Psychology of Gambling

Images of God

The Consolations of Lost Illusions

PETER FULLER

The Hogarth Press
LONDON

Published in 1990 by
The Hogarth Press
an imprint of Chatto & Windus
20 Vauxhall Bridge Road
London SW1V 2SA

First published in Great Britain by Chatto & Windus 1985

A CIP catalogue record for this book is available from the
British Library.

ISBN 0 7012 0871 6

Printed in Great Britain by
Mackays of Chatham plc, Chatham, Kent

To Harold and Marjorie Fuller,
my parents
With love and thanks

Contents

Illustrations

Acknowledgements

'*Plus Ça Change*'; 'Auerbach versus Clemente'; 'Schnabel'; 'Neo-Romanticism: a Defence of English Pastoralism'; 'The Hard-Won Image'; 'Academic Choices'; 'Peter Blake: *Un Certain Art Anglais*'; 'Cecil Collins: Fallen Angels'; and 'A Black Cloud over the Hayward' first appeared in *Art Monthly*. 'Goodbye MOMA and All That' first appeared in *Village Voice*. 'Questions of Taste' and 'Art and Industry' first appeared in *Design*. 'Roger Scruton and Right Thinking'; 'Rouault: In the Image of God'; 'Soutine'; 'Raw Bacon'; 'Mother Nature'; 'Pleasing Decay: John Piper'; 'Epstein'; 'Gaudier-Brzeska'; 'The Success and Failure of Henry Moore'; 'Glynn Williams: Carving a Niche for Sculpture'; 'Aboriginal Arts'; 'Fred Williams'; 'Art in Education'; 'Black Arts: Coal and Aesthetics'; 'The Arts of War'; 'The Merchants of Venice'; 'John Ruskin: a Radical Conservative'; and 'Eric Gill: a Man of Many Parts' first appeared in *New Society*. 'Prophecy and Vision'; 'Carpet Magic'; 'William Morris Textiles'; 'Fabric and Form'; 'Dressing Down: Fashion History'; and 'Modern Jewellery' first appeared in *Crafts*. 'The Christs of Faith and the Jesus of History' first appeared in *The Monthly Review* of *The Melbourne Age* and subsequently in *New Left Review*. 'The Proper Work of the Potter' was a contribution to *Fifty Five Pots*, the catalogue for an exhibition held at the Orchard Gallery in Londonderry in 1983; and 'William Morris: a Conservationist Radical' was first published in *William Morris Today*, the catalogue for an exhibition held at the Institute of Contemporary Arts in London in 1984.

I am grateful to the editors of the publications in which these articles appeared both for publishing them in the first place and for allowing me to reprint them here. In some cases I have restored cuts originally made for space reasons; and in others I have made cuts to avoid, as far as possible, repetitions within this volume. I have also frequently replaced sub-editors' titles with my own. I would also like to thank Anthony Barnett of Tigerstripe and Carmen Callil of Chatto & Windus for their sustaining enthusiasm for this volume; and Mike Petty for his work on the text. Finally, I would like to thank Stephanie, who will be my wife by the time this book appears, for all her help and encouragement during the difficult time when this volume was being edged towards the press.

September 1984

New Foreword

Six years ago, when I first collected the essays and articles in *Images of God*, I thought I was being daring – if not perverse – in reviving the idea that aesthetic experience was greatly diminished if it became divorced from the idea of the spiritual. 'Serious' critics, after all, then seemed to pride themselves on their pre-occupation with other things: formalists, Marxists, structuralists and post-structuralists, alike, asked the mirror on the wall, 'Who is the most materialist of all?'

This was not my preferred brand of narcissism. Sociology, biology and psychology had taken me so far in my attempts to get to grips with the nature of aesthetic experience; but, in the end, not *that* far. I could not evade the fact that there was always a qualitative aspect to the encounter with art. Without evaluation, there can be no appreciation, let alone criticism: every aesthetic response is an act of discrimination which implies a hierarchy of taste. The attempts of the academic critics to evade this – to anaesthetise their 'methodologies' – seemed quite futile.

Almost everyone now seems to acknowledge the intellectual, ethical and aesthetic bankruptcy of Marxism: but it was not ever thus. I think it is true to say that, of the generation of critics who became deeply immersed in Marxism in the late 1960s, I was among the first to realise that we had entered a cul-de-sac. Marxism, per se, had nothing to contribute to the understanding of art, which, by its very nature, appeals to those dimensions of human experience which do not change greatly from one moment of history to the next. Although some socialists have written well about art, this is the reason why socialism has always been an impediment, rather than a stimulus, to critical perception.

Among critics who have called themselves socialists, Clement Greenberg is unique in having placed uncompromising emphasis upon the evaluative dimension in his response to art; he is also, without doubt, the greatest art critic America has yet produced –

or, in my view, is ever likely to produce. (This is not, of course, to say that I agree with all, or even many, of the evaluations he has made.) But I part company from Greenberg because of what seems to me to be his attempt to confine such evaluation to 'positivist' phenomena, to questions of sensation alone. He, too, trips up through a longing to present his criticism as being more materialist than the next man's.

For myself, I remain an incorrigible atheist; that is my proclamation of faith. Yet there is something about the experience of art, itself, which compels me to re-introduce the category of the 'spiritual'. More than that, I believe that, given the ever-present absence of God, art, and the gamut of aesthetic experience, provides the sole remaining glimmer of transcendence. The best we can hope for is that aesthetic surrogate for salvation: redemption through form.

One consequence of this change in my thinking about art has been a sharpening of my taste. Sometime in the 1980s, I found myself in agreement with Charles Baudelaire, who had praised British artists as 'enthusiastic representatives of the imagination and of the most precious faculties of the soul'; and that seemed to me to be just as true of the twentieth as of the nineteenth century. Certainly, I found myself in little sympathy with much recent American and European art which seemed merely to mimic the mass media and to reflect the tacky surfaces of contemporary commercial reality. The enthusiasms of Marxist critics for such things confirmed to me that, as far as art, at least, was concerned, Marxism was just another brand of vulgar materialism.

And so, in the late 1980s, I came to write *Theoria: Art and the Absence of Grace*, a book in which I tried to describe the changes that had occurred in my taste. I came to re-affirm John Ruskin's longing for an art which made great claims upon us, which did not just tickle the senses but demanded a response from our whole moral and spiritual beings.

All this can be seen, in retrospect, as part of an argument with the Left – though *Theoria* was, perhaps, the first of my books which was not addressed specifically in that direction and which therefore produced the most petulant response from it. For example, Terry Eagleton had engaged in cosy dialogue with me

about value in art at the Institute of Contemporary Arts and in the pages of *New Left Review*; then, as I recall, he liked to prick what he presumed to be my radical humanism with the cold stream of his neo-structuralist relativism. But the publication of *Theoria* put an end to such fun and games. I passed beyond the pale.

In a long review entitled 'Anger and After' published in *Artscribe*, Eagleton pronounced an anathema on me and all my works, of which his Jesuit teachers might have been proud. Intriguingly, however, in order to do so he had first to denounce that cultural relativism in which he had once played so prominent a part. Did I not realise that I could jettison all that and still remain a good Marxist? My fault was that I was ignorant of the 'breath-taking wager' of Marx's early work, namely that 'it might just be possible to . . . reconstruct everything – ethics, history, politics rationality – from a bodily basis'. If I had done the reading I ought to have done, I would have realised this, and would not have found it necessary to abandon the true faith of Marxism for the heresies of secular spirituality.

Poor Terry! Ever since his unconversion from Christianity, his apparently shifting beliefs have been underpinned by a craving for certainties of which Cardinal Manning would have been proud – although he would hardly have approved of the Marxist dogmas in which Eagleton invests his credulity. He failed to point out to the readers of *Artscribe* that in the 1970s and early 1980s, he was putting his faith in precisely that sort of Marxist relativism which he now believes belongs to the husk rather than the kernel of the true dogma. And, for my sins, I was then advocating exactly those positions which he today hurls against me.

For example, Eagleton drones on about the later work of Raymond Williams which he takes to be some sort of 'proof' that one can still remain a Marxist and believe in the relative constants of the human condition. He forgets that I, myself, had made the same point in *Beyond the Crisis in Art* and *Art and Psychoanalysis*, both published in 1980. This, no doubt, is what led Williams to take an interest in my work in the early 1980s, and to defend it against extreme cultural relativists. At that time, as I recall, Eagleton was still intent upon the intellectual humiliation of his erstwhile guru. Since Eagleton accuses me, among other things, of

intellectual treachery towards former comrades, it is perhaps
worth recording here that in 1980 Williams was kind enough to
praise the way in which I had handled my own differences with
John Berger. He told me how he wished that some of those whom
he had taught had shown a similar generosity towards him.

Similarly, there is something comic in Eagleton supposing that I
am ignorant of Norman Geras's book, *Marx and Human Nature*,
'which argues persuasively that Marx does indeed hold to a
concept of human nature in his work, and is quite right to do so'.
The truth of the matter is that when I read Geras's book in 1983, I
felt that he had reached many of the conclusions set out in my own
books three years previously. When *Marxism Today* asked me to
pick my book of the year for their Christmas issue that year, I
chose Geras's slim volume – and defended it on precisely those
grounds of which Eagleton presumes me to be ignorant. 'Whether
an idea is "Marxist",' I concluded, 'has always interested me less
than whether or not it is true: but since Geras shows the idea of
human nature is both of these things, perhaps we can now get on
with the business of building in theory and practice a socialism
which takes account of man's enduring ethical, aesthetic, and
ecological needs'.

I am, of course, delighted to learn that comrade Eagleton and
others have advanced towards the view which I held a decade ago;
but he is quite right in his belief that I have long since vacated the
positions which he now finds so congenial. Today any one who
fails to see the hollowness of even those forms of Marxism which
present a human face to the world, is either a bigot or a fool. For
myself, I regret that it took me so long to realise that such ideas
were impeding rather than advancing my quest for truth.

No one who is now shaking off, or pulling out, the weeds of
Marxism can claim any originality. I retain enough of what I am
leaving behind to recognise that the direction in which I am being
propelled is not unrelated to the impact upon my consciousness of
'historical forces'. But I would argue that the world of the 1990s is
a better place in which to live than the world of the 1960s (which
shaped both Eagleton and I) in part, indeed in large part, because
of the collapse of Marxism. This is not only a matter of what is
happening in Eastern Europe and the Soviet Union: it is also

because Marxism is losing all the claims which it once seemed to have over intellectual, aesthetic and cultural life in the west. This is a liberation indeed!

One of the most extraordinary features of cultural life in the late 1980s in England was the resurgence of interest in those romantic artists – including Henry Moore, Paul Nash, Stanley Spencer and Cecil Collins – whose contributions simply defy any of the usual 'materialist' analyses. I welcome the way in which Nicholas Serota has reorganised the Tate Gallery to celebrate their contribution; and feel a certain pride in the fact that this was a shift of taste which I was able to anticipate. Certainly, the article I wrote in 1983 on Cecil Collins had, for me, something of the character of a home-coming. I feel privileged to have known Collins in the last years of his life. Needless to say, I was delighted by the way in which his work seemed to be vindicated before he died in 1989. That could never have happened while 'materialist' critical theories exerted their stultifying hegemony. (Words like that still come so easily to mind!) I have also been very pleased to see over the last few years the emergence of a vigorous new criticism among those who have unequivocal belief in God. I cannot share her faith – or, for that matter, her taste – but I know that, say, Sister Wendy Beckett's insights into painting are far more challenging and rewarding than Eagleton's.

There is no doubt that the critical climate is changing. For me, one of the most important books of the last few years has been George Steiner's *Real Presences*, a bold essay in which he argues that the chatter of secondary discourse – academic or journalistic – is just a defence against an encounter with that real presence which great art has to offer. Such art, Steiner says, is 'touched by the fear and ice of God'. He affirms that even, or perhaps especially, in an era of unbelief and secularisation the artist must make 'a wager on transcendence'. Surely this is a far more creative, courageous and 'breathtaking' wager than that which Eagleton would have us make on the early Marx.

But in the end, I must admit that I have no great optimism that we are really emerging from the dark night of the critical soul into which certain critics plunged us in the 1970s. Chatter about transcendence is not necessarily qualitatively different from

chatter about the framing edge, 'proletarianisation', signifying practices, or post-modernist radical eclecticism. One worrying feature of recent years has been the fashionable appropriation of the language of the 'spiritual' to defend work of a numbing vacuity.

In 1989, I contributed to a conference about art and the church in Winchester Cathedral at which a member of the staff of the Tate Gallery encouraged the assembled clerics to believe that Gilbert and George and Andy Warhol were among the greatest spiritual artists of our time. Suddenly, I saw the catastrophe that might follow in the wake of the rhetoric of spiritual revival in aesthetic life. In my mind's eye, I had visions of lurid stained-glass windows with titles like *Marilyn* and *Dick Seed* rising above the altars of parish churches, the length and breadth of the land. Claims about the 'spirituality' of such works are, of course, preposterous; but they should not surprise us. 'What I affirm,' writes Steiner, 'is the intuition that where God's presence is no longer a tenable supposition and where His absence is no longer a felt, indeed overwhelming weight, certain dimensions of thought and creativity are no longer attainable'. Quite so. And under these circumstances, all that we can fall back on are, perhaps, the consolations of lost illusions.

Peter Fuller
Bath, March 1990

Introduction

Images of God is my third collection of articles, essays, reviews and polemical writings on art and aesthetics. In effect, it is a selection of my work in these areas from 1982 and 1983. My first such book was *Beyond the Crisis in Art*, published in 1980; although much of the material collected there was critical of then fashionable ways of writing about art and culture 'on the left', I still tried to maintain a position compatible with 'Marxism' – as I understood it.

I found there were many difficulties in doing so. One was my acute awareness of the importance to worthwhile cultural production of the imaginative activity of the individual human subject. My book *Art and Psychoanalysis* (1980) was, among other things, an exploration of this. But I also became increasingly conscious of the importance of certain 'relatively constant' elements in our human being to the making of good art. One result of this was that I began to give more weight to the role of tradition in each of the several arts and crafts. These themes – imagination, biology, and tradition – are all strongly reflected in the collection of critical writings I published in 1983, *The Naked Artist*.

Images of God manifests a continuation of this change, or shift of emphasis, in my thinking. This is only partially a matter of my personal evolution; the cultural developments of recent years have rendered it impossible for any serious seeker-after-truth to hold 'in good faith' many of the assumptions which were commonplace on the left only fifteen years or so ago.

Although I always regarded the idea of a Modernist-Leftist alliance with extreme scepticism – it seemed to depend on a false analogy of political and cultural avant-gardes – this was once part of the familiar rhetoric of the Left. It was assumed there could be no cultural progress without such an alliance. Today, however, the very idea is a dead duck – except, perhaps, among various pockets of special interest.

Images of God both chronicles some of these cultural shifts and shows how my own thinking has developed in response to them. The texts in the first section, 'Changing', discuss such issues and phenomena as the rise of a new, 'post-modernist', expressionistic painting and the decline of 'traditional' American, Late Modernist, 'historicist' assumptions in the practice and criticism of the visual arts. 'Changing' also contains reflections on the concept of 'Taste', which has become central and problematic again with the waning of Modernist orthodoxy. In *Seeing Berger* (1980), I expressed the view that we, on the left, might still have much to learn from traditional discussions of aesthetics; while I cannot share the *political* views of Roger Scruton, one of the younger ideologues of the 'New Right', I find myself in very considerable agreement with him when he writes on art, architecture, and aesthetics. In 'Roger Scruton and Right Thinking', I try to elaborate this position.

The single, dominant theme of this book is one which has also concerned Scruton: that is the plight of good art in a society, like ours, which is characterised by the absence of a shared symbolic order of the kind that a religion provides. The disappearance of a 'historicist', Modernist aesthetic, and the rise of loose, expressionistic art, are associated with a collapse into subjectivism and solipsism. In this century, of course, we have had examples of the false and degrading 'styles' of Soviet Russia, Nazi Germany – or Western Capitalism in the form of advertising. But none of these has remotely given rise to work of the calibre of the great Gothic cathedrals.

For me, these cathedrals are a continuing exemplar: though I am an atheist, they stand as perpetual monuments to that which we have lost culturally, along with the decline of Christendom. Even for a believer, like Rouault, there could be no returning to the era of the cathedrals: and yet, as I try to show in my chapter on him, his expressionism differed profoundly from that pursued by today's younger artists precisely because his was tempered by the grand illusions of faith and tradition. In the sections on Soutine, Auerbach and Bacon, I indicate how those of us who do not believe are compelled to fall back on a kind of cultural conservationism which draws on the achievements of those who *were*

believers; and also on the possibilities of an imaginative, yet secular, response to nature herself. This position can, I think be vividly demonstrated through consideration of the English landscape painting tradition, and the vicissitudes of our national sculpture in the twentieth century: 'Ars Britannica' and 'Marble Britannia' respectively endeavour to do this.

But this absence of a shared symbolic order is not simply a problem which affects the Fine Arts: good criticism today can no more evade the broader problem of imaginative and creative *work* than it could in the nineteenth century. The essays in the sections on 'Art in the World' and 'Arts and Crafts' are all explorations of these themes. In effect, they are developments of ideas first suggested in *Aesthetics after Modernism* (1982). They explore the fate of the aesthetic dimension in industrial production; and within the surviving crafts, like studio pottery, textile and jewellery design, carpets and so on.

The final section, 'Writings', contains essays on authors and texts which have been influencing me recently. Those with any knowledge of my writing will not be surprised to find John Ruskin and William Morris here. My reflections on these two great thinkers will be expanded and elaborated in a forthcoming book, *Theoria*. Ruskin, in particular, seems to me to raise questions of increasing importance at this time of 'post-modernism' and 'post-industrialism'. I have also found myself becoming intrigued by some of the arguments put forward by frankly 'eccentric' thinkers, like Eric Gill. In a crude, provocative and often infuriating way, Gill constantly drew attention to issues which had too easily been swept to one side in the development of the 'mainstream' socialist movement, and its thinking about art, work and production in general.

We may not be able to share Gill's passionate belief in the necessity of a 're-sacralisation' of work, through a return to Catholic Christianity. But as a result of reading him, we can, perhaps, better perceive the extent of all that we have lost together with the illusions of faith. Part of what we have lost, of course, is the redeeming myth of 'The Christ' himself. As the concluding essay on 'The Christs of Faith and the Jesus of History' explains, those of us who are historical materialists need to admit just how

far we are from understanding the *positive* role which the great and consoling illusions of religion have played in man's ethical, cultural, and indeed his spiritual life.

PETER FULLER
January 1984

I have taken advantage of an unavoidable delay in the publication of this book to include some essays written later in 1984.

P.F.
January 1985

I
CHANGING

I

Plus ça change . . .

Times change. And so do values: at least in the international 'art world'. Let's go back ten years to 'The New Art' at the Hayward Gallery in 1972. Remember? Art Language, Victor Burgin, Hamish Fulton, Gilbert and George, John Stezaker and the rest of them, all ticker-taping down from the walls and ceilings. Words, numbers, diagrams, photo-texts, and flickering electronic equipment. The Hayward bristled with surveillance, documentation and research. A visit to 'The New Art' exhibition was rather like getting your fingerprints taken at a large police station, or applying for a visa, in person, at the American Embassy.

Not a smear or whiff of paint in sight, of course. Not even a daub of it on the sole of a trendy shoe. 'We' knew so much better than that. As Donald Karshan wrote introducing a major exhibition of conceptual art in New York, 'We begin to understand that painting and sculpture are simply unreal in the coming age of computers and instant travel.' Quite so! Those were the days when Tate officials were openly explaining that art had become a sub-cultural game for a specific in-group, and the gallery was avidly acquiring twigs, blankets, maps, bricks and videotapes of effete young men getting drunk on Gordon's Gin and Arts Council grants: almost anything, in fact, so long as it wasn't actually *painted*.

Victor Burgin, a ubiquitous Bouguereau and salon semioticist of those far-off days, called painting 'the anachronistic daubing of woven fabrics with coloured mud'. And Anne Seymour, herself then on the Tate staff, introduced the catalogue to 'The New Art' with jibes at all those silly-billies who thought 'reality' could be summed up in a picture of 'a nude lady of uncertain age sitting on a kitchen chair'. Art, she said, could just as well be 'a Balinese "monkey dance", a piano tuner, running seven miles a day for seven days, or seeing your feet at eye level'. Through conceptual-

ism, and so forth, the artist was free to work in 'philosophy,
photography, landscape, etc.' – anything, in fact, that took his
fancy, so long as he didn't sully his hands with that nasty,
foul-smelling, pigmented stuff which certain consenting cultural
renegades squeezed out of little tubes in private. All this Miss
Seymour thought quite wonderful: the artist was no longer 'tied to
a host of aesthetic discomforts which he personally does not
appreciate'. (In those days, you didn't even have to watch your
'he's' and 'she's'.)

All that is *terribly* old hat now. Ms Seymour has long since left
the Tate, and is now firmly installed at Anthony D'Offay's in
Dering Street, from where she is delivering little homilies about
the unique existential and metaphysical value of painting. 'Paint-
ing', she writes in a recent introduction to the work of an Italian
called Chia, 'is an attempt to make a physical thing which both
questions and affirms its existence. The metaphysical problem in
painting is to paint something as normal as possible, but to
perceive it in a special way, which shows it as it is, and imbues it
with a sense of the existential complications that reality involves.'
Aesthetic discomforts, it would seem, are back in fashion. Nor, I
am sure, would it be fair to suggest that Seymour's conversion had
anything to do with the fact that, with artists like William
Coldstream on his books, Mr D'Offay knew a good deal about
what was still to be gained from pictures of nude ladies of
uncertain age seated on kitchen chairs. As Helena Kontova, editor
of *Flash Art*, who makes it her business to *know* about such
things, has written, there is a 'great wave of painting', which is
flowing simply *everywhere*, even 'into areas that, until very
recently, were considered improbable and even totally antagonis-
tic'.

I first picked up whiffs of the tidal slick that was heading in our
direction from certain puzzling exhibitions at the Lisson and
Whitechapel Galleries. The Nicholases Serota and Logsdail had
once run establishments so clinical that you could have carried out
a surgical operation on the floors: and then, quite suddenly, it
began to look as if surgical operations *had been* carried out there.
Slurpily lugubrious Lüpertzs and suchlike, squelching their en-
trails at you from every side. But I only became aware of the scale

of what was afoot when I saw 'The New Spirit in Painting' exhibition at the Royal Academy, early in 1981. The object of this show, or so the organisers said, was to demonstrate that 'Great Painting' was still being made today: every one of the 150 large pictures had been made within the previous decade.

In the catalogue, Hugh Casson, PRA, who should have known better, likened 'The New Spirit' to Roger Fry's famous exhibitions at the Grafton Gallery at the beginning of the century. These introduced Post-Impressionist painting to Britain and changed the course of taste, and subsequent history of art, in this country. The paintings of Cézanne, Gauguin and Van Gogh, however, met with resistance here; but the 'New Spirit' was immediately endorsed not just by the Royal Academy but by every modern art museum in the Western world. It is worth reminding ourselves of exactly what was on offer in that show.

First, there were works by the Grand Old Men of classical modernism, and assorted neo-legendary dinosaurs who had hung on into the 1970s but who 'belonged' to earlier decades: Bacon, Balthus, De Kooning, Helion, Matta, Picasso. Then there were pictures by a number of 'eccentrics' (mostly British) who, though well-established, had not previously held more than fringe positions in *The Story of Modern Art*: Auerbach, Freud, Kitaj, Hockney, Hodgkin. Next came a string of artists (mostly American) who exemplified the old reductionist spirit of Late Modernism, with its coda of mechanical and automatic painting: Brice Marden, Warhol and Frank Stella, now born again with all the glitter and tinsel of a new expressionism. Finally, came the 'new blood'; the names that in a couple of years have risen from obscurity to become the common currency of the 'art scene'. From Germany: Baselitz, Fetting, Hödicke, Kiefer, Koberling, Lüpertz, Penck and Polke; from Italy: Calzolari, Chia and Paladino; and from America: Schnabel. And they, and their absent colleagues, like Clemente, Salome and Salle, are what it is all about.

When I went to Sydney, last spring, I realised that this 'great wave of painting' had even swept through the outback: the Biennale was littered with gaudy pictures, the size of cricket-pitches, reeking of wet linseed oil, by all the masters and mistresses of the New Expressionism. New Imagism, Nuovi Nuovi, La

Transavantguardia, Bad Painting, etc.: it comes under a score or more of different names. There is even an indigenous antipodean version – with stars like Davida Allen, whose epic smudges (bearing titles like *Eschatological Dog*) are to be seen in every Australian provincial art museum. But it isn't just Australia. At all the art fairs, Kunst hassles and state-backed culture binges, 'The New Spirit' is being peddled for all it is worth which, despite worldwide recession, remains quite a bit. Busy little art bureaucrats are jetting around the capitals of the world assisting in their usual tight-lipped way in the birth of a new style; new critics are popping up prepared to mouth a new art rhetoric and endorse a new repertoire of 'approved' artists.

All this may make you begin to feel a twinge or two of sympathy for the conceptualists, performance people, political and theoretical artists who constituted *Un Certain Art Anglais* and got all the exposure in the paintless 'seventies. Don't worry. Old avant-gardists never die: they just clamber on to whatever new wave is going. Many of today's new tendency painters were yesterday's mixed media pranksters. Bruce McLean is an obvious example. But even Ms Mary Kelly is now playing with pigmented shit, rather than the real thing. Who knows – perhaps Burgin is mixing coloured muds. Nor is 'the great tide of paint' necessarily *opposed to* all the proliferating anti-aesthetic practices of the 1970s. Rather, it splatters them. As Helena Kontova puts it, 'media such as performance, installation and photography' are being 'contaminated', or 'taken over by anilines, colour and painting'. She argues that 'in the space of just a few years or a few months', artists who had succeeded in frustrating their manual skill and creative abilities by adopting a 'moral severity' that often impoverished their work have now 'abandoned the technicalities of installation and the mental and physical stress of performance'. (As if Leonardo, Poussin, Van Gogh, Bonnard and Rothko had always been taking some sort of mindless, amoral, easy option!)

If I had any money to spare, I would buy shares in Rowney and Winsor and Newton – and probably put a bit into Crown and Berger, too. But one question is rarely asked in all this manic splatter: Is any of it any good? Take Baselitz, a German, and, by

all accounts, one of the *best* of the new tendency painters. His work is inept: expressionistic, though not expressionist, he has made a mannerism and a great deal of money by prostituting an indigenous German tradition. Baselitz's painting lacks even an echo of authentic experience, let alone achieved technical skill, or 'working-through' of expressively original forms. Inflated in scale and price, overweening, ugly, bombastic, vapid, loose, and awash with the sentimentality of borrowed angst, Baselitz paints a sort of seamless Misery Me Gift-Wrap. He suffers from some stultifying occlusion of the imagination, lacks touch and sensitivity as a draughtsman, and possesses none but the most degraded 'studio' colour sense. He gives the impression he has neither looked at the world, nor into himself. Indeed, his works are so drab and lacking in any painterly competence that, despite their enormous size, one would scarcely notice them unless they were hung upside down – which many of them are. And yet this sort of drivel is being bought, arse over eyes, by collectors, dealers and museums throughout the Western world. It was not just painting which was deserted by the 'art scene' in the 1970s, but also, it would seem, the ability to see and evaluate it with any sensitivity.

Even so, Julian Schnabel, an American, whose one-man show runs at the Tate until September 5, is a painter so bad that he makes Baselitz look quite good. Firstly, his imagination is acned and adolescent: at best, it is John W. Hinckley Jnr stuff, sick, immature, sexually unsavoury, strung up on a few improbable, external, cultural hooks. Schnabel appears to have needed 'New Tendency' painting for much the same reasons that Sonny Liston needed prizefighting. But he seems ignorant of the most basic elements of his chosen art-form. Works like *Starting to Sing: Florence Loeb* (4), of 1981, indicate that he has not yet realised that working on a surface the size of a boxing ring will tend to expose, rather than to conceal, his inability to draw. Nor, of course, will heaping broken crockery into a bed of body-filler mounted on canvas disguise the fact that Schnabel has rather less touch than an incompetent washer-upper. As for his colour, pictures like *The unexpected death of Blinky Palermo in the tropics* have all the chromatic subtlety of ghost-train decor. I have gazed and gazed at those Schnabels I have come across, and I have

been quite unable to find *any* qualities in them (except inordinate size) which are not also readily visible in the fantasy paintings of the average disturbed adolescent. It is now common knowledge that Schnabel was 'manufactured' in much the same way as Jasper Johns was 'manufactured' in 1958, as a way out of the vacuum created by an ailing Tenth Street Abstract Expressionism. (Even the cast has not changed entirely; the long arm of Leo Castelli was involved in both operations.) I have never been a great admirer of Johns: but at least he had *some* real qualities around which the hype could be built. Schnabel does not. But this naked emperor – 'one of the most celebrated young artists working anywhere in the world today' according to the Tate catalogue – dazzles the eyeless press which throngs around him. Thus in 1974, Richard Cork purchased art for the Arts Council collection under the rubric, 'Beyond Painting and Sculpture'. He dismissed all but a handful of diehard conceptualists as 'obsolescent practitioners of our own time', and celebrated the deposition of 'the hegemony of painted surfaces or sculptural presences'. As I have had occasion to remark before, there is a tide in the affairs of corks and they tend to bob wherever it leads, even if it means re-entering a sea of paint. Today, Cork perceives 'a shimmering, opalescent beauty' in Schnabel's shattered tea-cup pictures which, he feels, have the 'bitter-sweet ambiguity' of 'broken shells cast up on a sea-shore'. Cork has yet to realise that the oil on the beaches of the new romanticism is a sign not so much of hidden wealth as of poisonous pollution.

Why is the new tendency painting *so* bad? As it happens, there is much in the rhetoric which surrounds it that I find perfectly acceptable, even congenial. For example, the text in the catalogue of 'The New Spirit in Painting' affirmed 'a new consciousness of the contemporary significance' of this art form; it stressed the relationship between painting and 'a certain subjective vision' which included *both* 'a search for self-realisation' *and* awareness of 'a wider historical stage'. It celebrated 'joy in the senses', and proclaimed: 'This exhibition presents a position in art which conspicuously asserts traditional values, such as individual creativity, accountability, quality, which throw light on the condition of contemporary art, and, by association, on the society in

which it is produced. Thus for all its apparent conservatism the art on show here is, in the true sense, progressive. Consciously or instinctively, then, painters are turning back to traditional concerns.' I suspect Christos Joachimides may have experienced the joy of corroboration when he first read similar sentiments in my own work. But such ideas float like brightly coloured pollen through the new cultural climate.

One reason why so many new tendency painters lack that great quality to which they purportedly aspire is quite simple: with the exception of Chia, those who today are so avidly turning to *paint* appear to have next to no knowledge or mastery of *painting*. Paint itself is not a magical or fetishistic substance whose mere application endows special qualities. Paint demands profound transformation through imaginative and physical *working*: those who were formed as artists in the wasteland of Late Modernism tend to lack any apprenticeship in the practice and its traditions. But this is not simply a matter of *individual* failings. We can best understand the plight of the transavantgardist by considering two of the most insistent themes of new tendency criticism: its antihistoricism, and its avowed biologism.

New expressionist literature tends to harp on what one writer has called 'the crisis in the avant-garde's Darwinistic and evolutionary mentality'. Such emphases, of course, are not in themselves new. Elsewhere, I myself have tried to demonstrate how this mentality gave rise to the sterile reductions, in both art and criticism, of the 1960s and 1970s. Through his exhibition, 'Towards Another Picture', and its accompanying polemic, Andrew Brighton, too, cast doubt on the very concept of a self-evolving continuum of 'mainstream' styles, and demonstrated that such a historicist approach was worse than useless as an instrument for determining what was, and what was not, of value in art.

But, of course, when the 'evolutionary mentality' has been rejected, the central problem still remains: if stylistic evolution, or art history, does not confer aesthetic value, then what does? Exhibitions like 'Prophecy and Vision' indicate that God is in fashion once again. I have repeatedly argued, however, that there are significant elements in the production of good art which spring from relatively constant *biological* roots: these involve both

enduring representations (of birth, reproduction, love, death, etc.) *and* the very nature of the material practices involved. And here too it would seem that I have something in common with new tendency criticism which, having abandoned the trajectory of evolving styles, tends to be sprinkled with vague appeals to human biological destiny, and to the biological and sensuous aspects of art-making itself.

Thus Nicholas Serota claims that Lüpertz is reinterpreting 'universals such as the creation and awakening of life, the interaction of natural forces, human emotions and ideologies and the experience of death'. (Ideologies universal? An original idea, anyway . . .) Seymour rhapsodises about the alleged 'autobiography' manifest in Chia's work. And Achille Bonito Oliva (whose book *La Transavanguardia Italiana* is relentlessly plagiarised by all other operators in this field) litters his texts with references to 'manuality', 'sensorial pleasure', 'the rhythm and pulsion of pure subjectivity', and the 'concentrating point of a biology of art'. He has even gone so far as to speak of art having its own 'internal genetic code' – though whether this is a literal or a metaphoric formulation remains unclear.

And yet if there are similarities, there are also sharp distinctions from the position I have been trying to articulate, and these, I believe, are vital to any understanding of the *failure* of this new tendency work. For I have always argued that if there is a continuity between human aesthetic experience and 'natural' (or biological) life, there is also a rupture: and this has much to do with man's unique capacity for the elaboration of socially shared symbolic orders, for *culture*. Though culture itself is grounded in man's highly specific psycho-biological nature, it is also the means through which human history transcends natural history. Indeed, the 'biological' elements in our aesthetic life require a 'facilitating environment', in the form of appropriate modes of work and materials, and a socially-given symbolic order such as that provided by a religion, before they can be fully realised. They require, in effect, an enabling and yet resistant tradition, and this is dependent upon the survival of propitious historical circumstances. But the waning of religious belief dismantled the socially shared symbolic order; and the rise of industrial production

deaestheticised work itself. This led to the disappearance of any true *style* with deep tendrils in communal life.

Whatever else this may have been, it constituted a tremendous cultural loss. Donald Winnicott once pointed out that there could be no originality except on the basis of tradition. He thus unwittingly echoed John Ruskin, who wrote:

> Originality in expression does not depend on invention of new words; nor originality in poetry on invention of new measures; nor, in painting, on invention of new colours, or new modes of using them . . . Originality depends on nothing of the kind. A man who has the gift, will take up any style that is going, the style of his day, and will work in that, and be great in that, and make everything that he does in it look as fresh as if every thought of it had just come down from heaven . . . I do not say that he will not take liberties with his materials, or with his rules: I do not say that strange changes will not sometimes be wrought by his efforts, or his fancies, in both. But those liberties will be like the liberties that a great speaker takes with the language, not a defiance of its rules for the sake of singularity; but inevitable, uncalculated, and brilliant consequences of an effort to express what the language, without such infraction, could not.

But what if culture became so warped it could sustain no widely-shared artistic language, nor give rise to a style that was any more deeply rooted than a passing fashion? What would happen to those men and women who had 'the gift' then? Ruskin knew this was the central problem facing architects and artists in the nineteenth century. As they thrashed around in an inevitable 'Battle of the Styles', he consistently advocated the continuance of a living Gothic tradition rooted in (Protestant) Christian belief. But he, too, saw that as secularisation shattered the shared symbolic order, and industrialisation squeezed the space for imaginative and creative work, aesthetic expression tended to be forced out of life: alternatively, it became reduced to the level of *aesthesis* – simple sensual, or biological, pleasure of which Ruskin tended to be contemptuous. Nonetheless, the space for a true

aesthetic dimension – 'theoria as opposed to "aesthesis"' – which, though rooted in the senses, reached up into moral (or symbolic) life could, Ruskin believed, be held open in the illusory world behind the picture plane. Thus, for him, 'The English school of landscape culminating in Turner is in reality nothing else than a healthy effort to fill the void which destruction of architecture has left.'

As long as Ruskin sustained belief, he thought that nature was the handiwork of God – and that Turner, through his scrupulous attention to that handiwork, had seen through the veil of appearances to the divine essence which lay behind them. But a religious view of nature became culturally increasingly untenable, and Modernism abandoned the search for a universal style which could affirm individual difference within collective spiritual unity. In architecture, the modern movement opted for functionalism; in art, after a period in which it was hoped that pure form itself could constitute a new symbolic order, it lapsed into that reductionist succession of fashions in which the aesthetic dimension was eventually betrayed altogether. In the sense that the transavant-garde has *seen through* this historicist evasion of the acute problem of the absence of a living style, its claim to be the first 'post-modern' movement seems tenable.

But Achille Bonito Oliva 'solves' this problem at the level of critical discourse (just as his chosen clan of artists do at the level of practice) by arguing that art need not enter into any moral or 'theoretic' dimension at all; however, unlike the pure formalist painters he does not defend aesthesis (or merely sensuous, retinal pleasure) so much as a miasma of competing and fragmented styles, a legion of broken symbolic orders which do not even seek to constitute a whole.

'The myth of unity, a unitarian vision backed up by an ideology which could explain any contradiction or antinomy, has been replaced', he writes, 'by a more healthy, open-minded position, ready to follow different directions. The myth of unity has been replaced by the possibility of fragmentation, of an experience characterised by movement and a personal approach.' 'Art', according to Oliva, 'is a continuous landslide of languages toppling over the artist.' He goes on to say that it is no accident that

the artist 'permanently resides in his own reserve, where physical and mental layers of experience accumulate'. Thus, he argues, 'we now find ourselves faced by artists who choose to hitch-hike down many roads.' But is this a 'healthy' situation, or a lapsing of art into a mire of subjectivity, a mixture not so much of 'biological' as of animal function, and a sort of semiotic side-salad, a solipsistic chaos of signs and signals, signifying nothing? These artists are as unable to enter into social life through their work as a child who has been taught to speak through a hundred languages rather than one (or two). Or, as Bonito Oliva puts it, 'Art cannot be the practice of reconciliation because it always produces difference. Difference means the assertion of the fragment, negation of every homologation (sic) . . .', etc. He regards this as a virtue. But if art *both* denies the pursuit of aesthesis, *and* refuses any moral or 'theoretic' aspect, if it, in effect, *renounces the practice of reconciliation*, it becomes stripped of the aesthetic dimension, and reduces itself to the application, through merely manual gestures, of substances to bits and pieces of broken symbolic orders. Not even in illusion can it create an 'other reality' which challenges the existing one: in as far as it has a style, it is *punk* bricolage. Marcuse argued that when art abandons its transcendent autonomy it succumbs to that reality it seeks to grasp and indict. 'While the abandonment of the aesthetic form', he wrote, 'may well provide the most immediate, most direct mirror of a society in which subjects and objects are shattered, atomised, robbed of their words and images, the rejection of the aesthetic sublimation turns such works into bits and pieces of the very society whose "anti-art" they want to be.' He went on to say that certain modernists held collage, the juxtaposition of media, the confusion of languages and the renunciation of any aesthetic mimesis to be adequate responses to given reality, which they saw as disjointed and fragmented, and which certainly militated against any aesthetic formation. But, he stressed, this idea that social reality itself was fragmented was wrong. 'We are experiencing, not the destruction of every whole, every unit or unity, every meaning, but rather the rule and power of the whole, the superimposed administered unification . . . And in the intellectual culture of our society, it is the aesthetic form which, by virtue of its otherness,

can stand up against this integration.' It is precisely this possibility that the transavantgardists refuse.

Indeed, the 'new expressionism's' inability to articulate, even within the illusory world of the picture, any coherent symbolic order indicates that it is much closer to the 'Late Modernist' problematic than its protagonists like to pretend. For the new tendencies make sense only in terms of *reaction* to the modernist art that went before. The pendulum has swung, certainly, but it has done so within that ever narrowing, and ever more restricting, funnel of modernist art history.

A 'landslide of languages toppling over the artist' is no compensation at all for the absence of a shared symbolic order, and *an* accompanying artistic language, or style. And it is precisely this great lacuna, common to the avantgarde and the transavantgarde alike, which eliminates the possibility of true aesthetic experience. To express nuance of feeling, language is necessary – and this is why, even in its 'sensuality', the new painting seems so coarse and vitiated. 'It's not expressionism, it is feelings that are important,' writes Schnabel: and yet, of course, there is infinitely more subtlety of feeling in the way Vermeer modulates light across an illusory wall than in any of Schnabel's wild outpourings.

In effect, an anally retentive conceptualism – stamped by meanness of mind, fear of feeling, obsession with control, systematization, over-ordering, dematerialisation, over-intellectualisation, etc. – has been replaced by its exact corollary, an anally expulsive expressionism, characterised by regressive splurging of sticky substances, lack of control, disorder, mindless splattering, compulsive inflation of scale, etc., etc. The proximity of the two phenomena will not surprise anyone with a modest degree of psychoanalytic knowledge. Elsewhere, I have tried to show how the anti-art of the 1960s and 1970s was reflective of the anaesthetic practices of contemporary culture, for example in its predilection for documentation, modular production, imaginative suppression, spectacle, etc. So, too, the new expressionism fails to offer any *alternative* to this anaesthetic reality, or the anti-art which it spawned. As Kontova herself puts it: 'At the beginning of the 'seventies painting seemed to have been finally overridden, but with the arrival of postmodern, it made a trium-

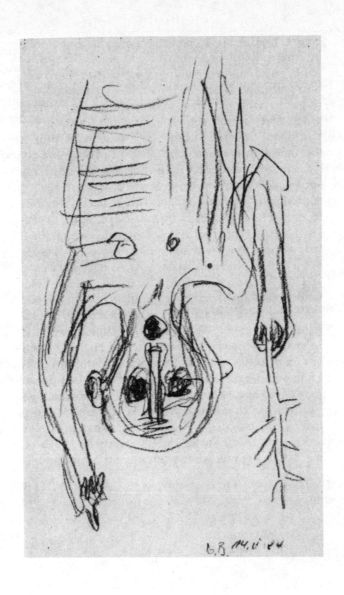

I
14.11.1984
Georg Baselitz

phant return to the art scene, displaying its great ability to assimilate the most diverse elements (such as some aspects of performance, installation or photography), to the point of formulating anti-painting, kitsch, neo-naif, neo-expressionism, and neo-baroque, to name but a few.' Thus painting is prostituted: its capacity to offer 'other realities within the existing one', to participate in the cosmos of hope, is lost sight of entirely . . . Artists become like children who, instead of learning to play creatively, remain at the level of smearing the real, of smothering the nursery walls with their own excrement.

As for what painting can be: that is another story. But the roots of good painting remain in its traditions, its real skills, its accumulated knowledges, techniques and practices, for which the trans-avantgardists show only contempt, or ignorance. And, as for that absence of a shared symbolic order . . . Even if we have ceased to believe in God, nature can provide it for us: the answer lies not in the reproduction of appearances, but in an *imaginative perception* of natural form, in which its particularities are not denied, but grasped and transfigured. None of this, of course, precludes the somatic element, the part brought by the rhythms and activity of the artist's own body – but it redeems it from infantilism. This is why the late Bomberg, Auerbach or Kossoff (so often invoked as old masters of the new expressionism) are infinitely more powerful and convincing than the fashionable upstarts of the trans-avantgarde. Their practice *is* one of reconciliation, in illusion, between the self and the social and physical worlds. They offer something the new expressionists cannot: a redemption through form.

1982

2
Goodbye MOMA, and all that

Let us begin with a statement of fact. American cultural influence in what is sometimes called 'the International Art World' has declined dramatically and is still declining. Critics and curators in Europe are no longer straining their eyes to see what is happening on the other side of the Atlantic. Art students in London, Paris, Rome and Düsseldorf have stopped rolling out all-over canvases and making obeisance in the direction of MOMA three times a day. Few, if any, significant artists here now feel the need to make their art conform to American styles or prototypes.

New York is no longer the first city of the avant-garde. Actually, there isn't an avant-garde any more. American art has even ceased to have the status of *primus inter pares*. It has become just one ingredient in an art scene which has suffered a sea-change into a mélange which, if it is not rich, is certainly strange.

To comprehend the extent of what has changed, we have to remind ourselves of how things once were. So I recently looked up a legendary but dusty number of *The Times Literary Supplement*, issued in the Cold War days of November 1959, and devoted to 'The American Imagination: Its Strength and Scope'. 'The flowering of the American imagination', declared that august guardian of British cultural taste, 'has been the chief event in the sphere of living art since the end of the First World War.' It went on to say that 'the current style of painting known as Abstract Expressionism radiates the world over from Manhattan Island, more specifically from West Fifty-third Street, where the Museum of Modern Art stands as the Parthenon on this particular acropolis.'

The effect of this radiation on British cultural life in the late 1950s and throughout the 1960s can hardly be imagined by those who did not have to live through it. It was more a matter of onslaught than of influence. Our leading galleries and museums gave way to wave upon wave of star-spangled exhibitions ema-

nating from New York. New British artists who wanted to be shown and patronised by the public art institutions felt they had to imitate fashionable American modes. The Abstract Expressionist, and later Pop, ethics and aesthetics swept through the British art schools.

It would be naive to believe this deep penetration of British artistic life to be based on a just assessment of the aesthetic achievements of American artists. Certainly, some of the classical generation of Abstract Expressionists were fine painters. But it is now a matter of public knowledge rather than left paranoia that the energy which led to this proliferation stemmed from sources which had little to do with art. Nor was it just a matter of American economic and ideological expansionism: American agencies whose primary interest was the furtherance of the Cold War not only promoted new American art, but exercised a decisive influence over what sort of art was, or was not, exported.

One effect of all this was the acceptance, throughout the West, of Alfred Barr's, and MOMA's, reading of Modernism. Modern art museums over here mimicked the idea that the best way of approaching contemporary art was historicist: art should be seen as a succession of mainstream styles progressing with a sort of historical inevitability from Cézanne to American lavender mists. Anything which did not fit into this continuum was regarded as being at best secondary, at worst inconsiderable. Each fad or fashion of American taste – Post-Painterly Abstraction, Pop Art, Op Art, Minimalism, etc. – was, however, treated with reverential awe.

I began writing about art professionally in the late 1960s; at that time there was an unremitting emphasis on giant museum 'retrospectives' of artists like Lichtenstein, Oldenburg, Warhol, Stella and Louis. Shows like 'The Art of the Real', a major minimalist exhibition, continued to unveil the latest twist of the Late Modernist drama as it was understood by the High Priests of Fifty-third Street.

It was difficult not to be dazzled and seduced, and, as a very young critic, I was. But very soon I began, literally, to see through all this hyping. At this time I was deeply influenced by John Berger, one of the very few critics in Britain who retained a critical

distance from the new art emanating from America, even in the
1950s. For Berger, Pollock was not the epitome of 'the Triumph of
American Painting' so much as a good artist defeated by his
difficulties. Equally important for my own critical development
was the Warhol retrospective which opened at the Tate Gallery in
1971. Warhol's relinquishment of imagination, skill and tradi-
tion, his collusion with the creatively sterile techniques of anony-
mous mass-production and contemporary advertising, his refusal
of aesthetic values, all represented the occlusion and eclipse of
everything I believed to be worthwhile about the production of art.

As the 1970s progressed, many different voices were raised
questioning this American intrusion. For example, in 1974, the
Guardian ran a 13,000-word article (the longest it has ever
published) by the British painter and critic Patrick Heron. Heron
had been an early enthusiast for American abstract art, and a
polemical opponent of John Berger's. But he now argued that, in
effect, most of the new ideas in American Post-Painterly Abstrac-
tion, in both practice and criticism, had been plagiarised from a
group of British artists: he wrote, 'So far from having always been
at the receiving end of influence emanating from New York – a
myth still enjoying wide currency – several painters of my own
generation . . . have consistently exerted crucial influence upon
New York painting from the late fifties onward.' The case was
minutely argued with a mass of documentary and visual evidence.
It has not, to my knowledge, ever been answered from the other
side of the Atlantic.

Heron was putting forward an argument about priority rather
than quality; but he eroded the view that the only significant
post-second-world-war art had been produced in the shadow of
the Statue of Liberty. Even more radical critiques soon began to
emerge. For example, Andrew Brighton pointed out that the view
of recent art as a succession of styles led to a narrow conception of
what was worth attending to; it elevated a particular, often
aesthetically banal, esoteric taste above all others. Much good and
interesting work was thereby exiled both from the museums and
the critical discourses about art. Similarly, Ron Kitaj, an Amer-
ican artist resident in Britain, wrote articles and organised exhibi-
tions celebrating the work produced within certain indigenous,

British figurative traditions which the Late Modernist orthodoxy had tended to obscure.

Interestingly, arguments like these could be applied to American art itself. Despite the enthusiasm for Americana Hopper was virtually unknown in Britain in the mid 1970s. No major British museum owned an example of his work; he had barely been exhibited here; and there was no critical discussion of his achievement. Andrew Wyeth had, if anything, been exposed rather less. But could that really be right when the vacuous banalities of Warhol, Stella or Andre were ubiquitously displayed and bought by the public museums and endlessly written about in the art press?

Such questions began to be asked against a decline of confidence in Modernism itself. There was growing awareness of a gap between the rhetoric of recent modern tendencies and their actual achievements. A new and more isolationist mood came to characterise American culture and politics; the manic expansionism of the 1950s and 1960s faded. Ideologies of progress came to be regarded with greater scepticism: the assumption of a necessary link between 'progressive' politics (whether of the capitalist or socialist variety) and aesthetic achievement became less and less credible. The Modernist ethic was further undermined by the waning of belief in technological advance and the awakening of a new interest in ecology, and man's relationship to the natural world.

The 1970s were a time of peculiar barrenness for the modern movement in the visual arts: the field was left, in America and Europe, to the silliest and emptiest sub-tendencies – like conceptualism, theoretical art, political art, feminist art. Modernism's reductive and self-critical programmes were transparently burning themselves out in tedium and disintegration. And, in this situation, the *authority* of New York toppled and fell.

The *coup de grâce* really came in the closing years of the decade with the emergence of something which has variously been described as 'A New Spirit in Painting', 'New Art' or *Zeitgeist*. It erupted, or so it seemed, simultaneously in art centres throughout the Western world; it was characterised by a return to the use of paint, often in a loose, expressionistic manner; by stylistic eclec-

ticism and funky figuration. The New Art made no appeal to the idea of a historically developing tradition, least of all to that of some ultramontane authority. Some said the avantgarde had been replaced by a transavantgarde. Certainly, a new list of names was ushered on to the international art world's centre stage, and for the first time in more than two decades only a tiny minority of them were American. Some had been around, in Rome and Berlin, doing this sort of thing for a long time, unnoticed; others had just jumped off the floundering Late Modernist bandwagon. Yet more were jumped up from nowhere out of nothing by dealers and museum men to meet the demand.

There are those who see all this as a cause for celebration. In the catalogue of a major exhibition of New Art at the Tate Gallery, Michael Compton talked about 'the exciting energy and multiplicity' of what is happening now. Today, he argued, 'there is perhaps an open society in western art as never before.' I cannot share this enthusiasm: it is an 'opcnnness' based on the exclusion of the aspiration for those aesthetic values which make art worthwhile. Of course, some of the new artists are better than others: Chia is better than Baselitz, who is better than Kiefer, who is better than Clemente; who is better than Schnabel; who is better than Salle – who is unspeakably awful. But these are gradations of ineptitude.

The New Art is depressing. It has not tried to recuperate what an 'advancing' Late Modernist tradition jettisoned and ultimately destroyed. In Late Modernism, we can now see, there was a contradiction between relentless historicising and, until the late 1960s at least, a desire to affirm some sort of residue of aesthetic value. This is apparent in the writings of the greatest of the New York critics, Clement Greenberg.

On the one hand, Greenberg wished to affirm the independence of aesthetic results from 'methods or means', and the continuity of the best American art with the 'compulsion to maintain past standards of excellence'. On the other, he at times appeared committed to the reductive, historicising movement of Later Modernism, which made the maintenance of those standards impossible. In the hands of lesser critics and practitioners, of course, the historicising won out altogether.

Unfortunately, however, though it has rejected the historicising movement of styles, the New Art has not rehabilitated or affirmed the pursuit of those threatened aesthetic values. Rather it is a kind of wallowing in the wreck of art in an advanced, secular, industrial society, a parading of its wounds.

In many ways, it is hardly 'new' at all, in that much of it simply restates the cul-de-sac positions of the 1950s and 1960s. Art is severed from any quest for higher values. It is identified either with infantilism, for example in the compulsive smearing of a Jenney; the defiance of reason and intellect; and the collapse of all tentativeness, or intelligence of feeling, into 'expressionistic' rage. Alternatively, in Polke's pictures made of poisonous substances or Salle's admass obsessions, it is interpreted as collusion with anti-aesthetic elements in the dominant culture. This time round, however, even that faint residue of an appeal to aesthetic value and continuing tradition which characterised Late Modernism has gone.

Societies, as Ruskin perceived, tend to get the art they deserve. It could be said that the unparalleled decadence of the New Art is an apt expression of the reality of Western cultures. We are left with a sort of ethical and aesthetic chaos, in which any attempt at discrimination necessarily appears to be arbitrary, and there is no longer even the limited possibility of an appeal to form or tradition. The New Art is a precise reflection of this state of affairs.

Whether one accepts or rejects it depends on one's attitude towards this present: I still believe in the affirmative possibilities of an alternative aesthetic tradition. For these to become generally realised, however, a much more radical critique of the Late Modernist episode would seem to be necessary. Such a critique, I think, could draw a great deal from certain culturally conservationist tendencies in British art whose histories and continuing achievements tended to be obscured while American Late Modernism raged.

I am thinking, for example, of the work of that pioneer post-Modernist, David Bomberg; and of his pupils, Leon Kossoff and Frank Auerbach; of the best of the British Slade painters; and certain members of our Royal Academy, too; of the continuing

life in the British Neo-Romantic tradition; the superlative accomplishment of Henry Moore, and the more problematic case of Francis Bacon.

Now these artists simply did not enter into the arguments about art while that succession of styles was wafting over the Atlantic from the 1950s to the 1970s. (For example, when I wrote my first essay on Kossoff in 1978, his bibliography amounted to only four items, though he had been exhibiting consistently in commercial galleries since the 1950s, and commanded high prices among a small circle of discriminating collectors. A Pop poseur like Richard Hamilton, however, had a bibliography running into hundreds of items.) Now all these artists are very different one from another; but they have in common a respect for the skills and material practices of the arts in which they are engaged; a sense of tradition, and of the importance of the quest for value; and, above all, a perception that the aesthetic can be preserved as something more than mere sensation, if one pursues it through an imaginative response to nature, including the human figure itself. In short, they indicate that despite the retraction of religion from social and cultural life, a shared symbolic order may still be available to us in nature itself.

They insist that the roots, if not all the branches, of aesthetic value lie in elements of our experience which have a relative constancy about them – rather than in the shifting movements of history or mechanism. Thus they affirm precisely that of which Late Modernism lost sight. At a time when there is a growing recognition that the roots of both ethics and aesthetics may be ecological, this continuing tradition acquires a growing significance. Indeed, if a worthwhile Post-Modernist art is to begin to emerge out of the decadence of the New Art, it may be that American artists, among others, have much more to learn from the British experience than that mimicking of certain stylistic details to which Heron drew attention ten years ago.

1983

3
Questions of Taste

Design likes to present itself as clean-cut, rational and efficient. Taste, however, is always awkward and elusive; it springs out of the vagaries of sensuous response and seems to lose itself in nebulous vapours of value. Questions of taste have thus tended to be regarded by designers as no more than messy intrusions into the rational resolution of 'design problems'. Alternatively, others have attempted to eradicate the issue altogether by reducing 'good taste' to the efficient functioning of mechanisms.

But taste has conspicuously refused to allow itself to be stamped out – in either sense of that phrase. As the premises of the modern movement have been called into question, so taste has been protruding its awkward tongue again. For many of us, it is becoming more and more evident that pure 'Functionalism' is, and indeed always has been, a myth; taste enters deeply even into design decisions which purport to have eliminated it. But, more fundamentally, it is now, at least, beginning to be asked whether *good* taste and mechanism are in fact compatible, i.e. whether the Modernist ethic did not build into itself some fundamental thwarting or distorting of the potentialities of human taste.

A recent exhibition at the Boilerhouse, in the Victoria and Albert Museum, reflected both the revival of interest in questions of taste, and the confusion among designers concerning them. Stephen Bayley's exhibition, called simply 'Taste', chronicled the history of the concept through 'The Antique Ideal'; the impact of mechanisation in the nineteenth century and the reaction against it; 'The Romance of the Machine'; contemporary pluralism; and the growing 'Cult of Kitsch' – or bad taste which acknowledges itself as such.

But Minale Tattersfield, who designed the exhibition, opted to exhibit those items which had gained approval in their own time on reproduction classical plinths, and those which had not on

inverted dustbins. An exhibition which attempted to tell us that 'Taste' was a neglected issue of importance was thus, itself, in the worst possible taste. I believe this contradiction reflects a deep-rooted contemporary ambivalence about the nature and value of the concept of 'Taste', an ambivalence which is nowhere more manifest than in Stephen Bayley's muddled commentary.

In the introduction to the little book produced to accompany the exhibition, Bayley committed himself to the view that taste is 'really just another word for choice, whether that choice is to discriminate between flavours in the mouth or objects before the eye'. Thus Bayley claimed that taste did not have anything to do with values, beyond questions of personal whim. He claimed there really can be no such thing as 'good' or 'bad' taste: 'These adjectives were added more than a hundred years after the concept was defined by people seeking to give the process of selection particular moral values which would help them justify a style which satisfied their image of themselves . . . or condemn one which affronted it.' So, Bayley claimed, 'Taste derives its force from data that is (sic) a part of culture rather than pure science.' Taste, he argued, should be separated out from design 'so that in future each can be better understood'.

Just a few pages later on, however, Bayley took a different tack. Unexpectedly, he began to argue there was a transcultural and transhistorical consensus about those qualities of an object which led to good design. (These he itemised as intelligibility in form; an appropriate choice of materials to the function; and an intelligent equation between construction and purpose, so that the available technology is exploited to the full.) Bayley then went on to say that those 'principles of design' were in fact 'the Rules of Taste'. In an interview, he once said his own taste was 'just Le Corbusier, really': and his universals turn out to be suspiciously close to the sort of thing Le Corbusier might have said about his own style, though they would appear to eliminate numerous works in other styles.

And so, in effect, there are two Stephen Bayleys: one who believes that the issue of taste is as unimportant, and as unresolvable, as individual whim or fancy; and the other, who, like every good Modernist, wants to assimilate taste to the inhuman author-

ity of the machine. This confusion about taste in the heart and mind of the Director of the Boilerhouse project is at least fashionable in that it is symptomatic of a confusion which prevails among the 'cultured' urban middle-classes at large. With the weakening of Modernist dogmatism – at least outside the bunker of the Boilerhouse – it is the tendency to trivialise taste, however, which is uppermost. Again and again aesthetic taste is reduced to the lowest level of consumer preference; almost always, it is assumed to be a mere sense preference and usually the paradigm is taste in food. Such attitudes are inevitably commonly associated with the cult of Kitsch.

For example, among the extracts reproduced in Bayley's book is one from an American writer, John Pile, who wrote an influential article, 'In Praise of Tasteless Products'. Taste, according to Pile, means, 'simply "preference" – what one likes or dislikes'. He notes that taste is the name of one of the five senses which lead 'one person to prefer chocolate and another to prefer strawberry'. The very concept, he claims, 'suggests an element of arbitrariness or even a lack of sense, that is, irrationality'. Taste, Pile concludes, 'is a somewhat superficial matter, subject to alteration on a rather casual basis'.

Similarly, for John Blake, Deputy Director of the British Design Council, 'the notion that qualitative judgements can be made about a person's taste makes little sense if the word is used correctly.' In an article entitled 'Don't Forget that Bad Taste is Popular', Blake defends that pariah of all 'good design': the electric fire, embellished with imitation coal. For Blake, the designer has no right to reject such things if the market indicates that people want them. 'A person's taste', writes Blake, 'is characteristic of the person, like his height, the shape of his nose or the colour of his hair.' He adds, 'I have a taste for Golden Delicious apples, but my son prefers Cox's. Does that mean that my taste is therefore superior to his, or vice versa?'

As we shall see, perhaps it does. But, for the moment, let us leave on one side the fact that in matters of taste it would be advisable to trust neither an American (who comes from an anaesthetized culture) nor someone who prefers Golden Delicious apples to Cox's. My argument runs deeper than that. I believe that

modern technological development, in conjunction with a market economy, has demeaned and diminished the great human faculty of taste. Bayley, Pile, Blake and Co. passively reflect in their theories a tragic corrosion brought about by current productive and social processes. Unlike them, I am not interested in rubber-stamping what is happening; rather, I am concerned about seeking ways of reversing these developments so that taste, with its sensuous and evaluative dimensions, can flourish once again.

But what sort of faculty is (or was) taste? In *Keywords*, Raymond Williams explains that 'taste' dates back to the thirteenth century, when it was used in an exclusively sensual sense — although the senses it embraced included those of touch and feeling, as well as those received through the mouth. Gradually, however, the associations of 'taste' with sense contracted until they became exclusively oral; while its metaphorical usages extended, at first to take in the whole field of human understanding. By the seventeenth century, taste had acquired its associations with aesthetic discrimination.

'Taste' was like having a new sense or faculty added to the human soul, as Lord Shaftesbury put it. For Edmund Burke, 'what is called Taste . . . is not a simple idea, but is partly made up of a perception of the primary pleasures of sense, of the secondary pleasures of the imagination, and of the reasoning faculty, concerning the various relations of these, and concerning the human passions, manners, and actions.'

Immanuel Kant, too, insisted again and again that true taste went far beyond the fancy to which Bayley, Pile and Blake would have us reduce it. Kant once argued that, as regards the pleasant, everyone is content that his judgment, based on private feeling, should be limited to his own person. The example he gives is that if a man says, 'Canary wine is pleasant', he can logically be corrected and reminded that he ought to say, 'It is pleasant *to me* .' And this, according to Kant, is the case not only as regards the taste of the tongue, the palate, and the throat, but for whatever is pleasant to anyone's eyes and ears. Some people find the colour violet soft and lovely; others feel it washed out and dead; one man likes the tone of wind instruments; another that of strings. Kant argues that to try in such matters to reprove as incorrect another

man's judgment which is different from our own, as if such judgments could be logically opposed, 'would be folly'. And so he insists, as regards the pleasant, 'the fundamental proposition is valid: *everyone has his own taste* (the taste of sense).' Thus, one might say, Bayley, Pile, Blake and Kant would all agree that it is a matter of no consequence if a man prefers lemon to orange squash, pork to beef, Brooke Bond to Lipton's tea, or, I suppose, Golden Delicious to Cox's.

But Kant immediately goes on to say that the case is quite different with the beautiful, as distinct from the pleasant. For Kant, it would be simply 'laughable' if a man who imagined anything to his own taste tried to justify himself by saying, 'This object (the house we see, the coat that person wears, the concert we hear, the poem submitted to our judgment) is beautiful *for me*.'

Kant argues a man must not call a thing beautiful just because it pleases him. All sorts of things have charm and pleasantness, 'and no one troubles himself at that'. But, claims Kant, if a man says that something or other is beautiful, 'he supposes in others the same satisfaction; he judges not merely for himself, but for everyone, and speaks of beauty as if it were a property of things.' Thus Kant concludes that in questions of the beautiful, we cannot say that each man has his own particular taste: 'For this would be as much as to say that there is no taste whatever, i.e. no aesthetical judgment which can make a rightful claim upon everyone's assent.'

Kant, of course, regarded such a position as simply a logical *reductio ad absurdum*; but it is just this *reductio ad absurdum* which Bayley, Pile, Blake and Co. wish to serve up to us as the very latest thinking on taste. It does not even occur to them that there may be a category of the beautiful which seeks to make claims beyond those of the vagaries of personal fancy; for them, all 'aesthetical judgments' are not only subjective, but arbitrary. The only escape from such extreme relativism is Bayley's last-minute appeal to the 'objectivity' of 'principles of design' rooted in talk about efficiency, practical function, technological sophistication and so on.

But my argument against Kant works in the opposite direction from theirs: for I believe that he conceded the relativity of even

sensual taste much too quickly. For although tastes vary, it is *not* true to say that everyone has his or her own taste, in any absolute way, even in matters of sense. For human senses are rooted in biological being, and emerged out of biological functions; though variable, they are far from being infinitely so. Even at the level of sensuous experience, discriminative judgments about taste are not only possible, but commonplace. It is not just that we readily acknowledge one man has a better ear, or eye, than another. Judgments about sense experience imply an underlying consensus of qualitative assumptions. For example, a man who judged excrement to have a more pleasant smell than roses would, almost universally, be held to have an aberrant or perverse taste.

The problem is complicated, however, because this consensus is not simply 'given' to us: rather it can only be reached through culturally and socially determined habits, and these can obscure even more than they reveal. For example, we can easily imagine a society in which the odour of filth is widely preferred to the aroma of roses, and no doubt the social anthropologists can tell us of one. But what of individuals who prefer, say, rayon to silk; fibreglass to elm-wood; the dullness of paste to the lustre and brilliance of true diamonds; insipid white sliced bread to the best wholemeals; cheap and nasty Spanish plonk to vintage Château Margaux; factory-made Axminsters to hand-woven carpets; or tasteless Golden Delicious to Cox's apples?

I am suggesting that modern productive, economic, and cultural systems, in the West, are conspiring to create a situation not so very different from that of our hypothetical example in which the odour of excrement was widely preferred to that of roses. In our society it may well be that a majority prefers, say, white, sliced, plimsoll bread to wholemeal. Bayley, Pile, Blake and Co. advocate uncritical collusion with this distortion and suppression of the full development of human sense and evaluative responses. But the judgment of true taste will inevitably be made 'against the grain', and equally inevitably run the risk of being condemned as elitist.

In aesthetically healthy societies a continuity between the responses of sense and fully aesthetic responses can be assumed. The rupturing of this continuity is, I believe, one of the most conspicuous symptoms of this crisis of taste in our time. This continuity

still survives, of course, in numerous sub-cultural activities: for
example in the sub-culture of fine wines. The production of these
wines has only the remotest root in the function of quenching
human thirst; they constitute the higher reaches of sensual re-
sponse, where taste reigns supreme. In the connoisseurship of
them, questions parallel to those Kant raised about true aesthetic
response, as opposed to merely pleasant sensations, soon bubble
towards the neck of the bottle. For, when he pronounces, the
connoisseur certainly wants to say that such and such a wine is (or
is not) good 'for me'; but that is not all he wants to say.

Our connoisseur will certainly be prepared to admit his person-
al fancies, and even, perhaps, the idiosyncratic or sentimental
tinges and flushes to his taste. He may well have a general
preference for clarets rather than burgundies, and a particular
liking for that distinctive, though hardly superb, wine he first
drank on his wedding day. But, he will tell us, his fancies do not
prevent him from discriminating between a bad claret and a good
burgundy; nor from recognising that there are, in fact, better
vintages of his wedding day wine than the one he personally
prefers. When he makes statements of this kind, our connoisseur
is acknowledging that he, too, is not merely judging for himself,
but for everyone. He regards quality more as if it was a property of
the wine itself rather than an arbitrary response of the taste buds.

Furthermore, he is aware that he exercises his taste in the
context of an evolving tradition of the manufacture of and
response to fine wines. Of course, this tradition is inflected by a
plethora of local and regional preferences and prejudices; but
such variations do not exclude the possibility of an authoritative
consensus of evaluative responses. Indeed, most disputes between
connoisseurs concern the fine tuning of the hierarchy of the
vintage years. Connoisseurs assume that the tradition has arrived
at judgments which are something more than individual whim or
local prejudice. Anyone who consistently inverted the consensus,
e.g. who regularly preferred *vin ordinare* to the supreme vintages
of the greatest *premier cru* wines could safely be assumed to have a
bad or aberrant taste in wines.

Even taste of the senses, therefore, can take us far beyond the
arbitrariness of pleasant 'for me' responses; and as soon as we

move into the various branches of craft manufacture, of, say, tapestry-making, furniture design, jewellery and pottery, we realise just how inadequate such responses are. For example, if a man said that a mass-produced Woolworth's bowl, embellished with floral transfers, was as 'good' as a great Bernard Leach pot, I could not simply assent that he was entitled to his taste; rather I would assume that some sad occlusion of his aesthetic faculties had taken place. In the case of the fine arts, Bayley, Pile and Blake notwithstanding, it is quite impossible to evade the universalising claims of judgments of taste. It may be that there are those who believe David Wynne's *Boy on a Dolphin* is a greater sculpture than Michelangelo's last Pietà. But it is nothing better than vulgar philistinism to concede that this judgment is as good as any other, *even if it happens to be a majority judgment.*

The concept of taste then was an attempt to describe the way in which human affective, imaginative, symbolic, aesthetic and evaluative responses are rooted in, and emerge out of, data given to us through the senses. The idea of taste acknowledges the fact that, in our species, the senses are not simply a means of acquiring practical or immediately functional information for the purposes of survival. Nor is it just that we come to enjoy certain sensuous experiences for their own sake; the senses also enter into that terrain of imaginative transformation and evaluative response which seems unique to man.

Elsewhere, I have tried to explain this phenomenon, upon which the capacity for culture depends, in terms of the long period of dependency of the human infant upon the mother. For us, the senses play into a world of illusion and imaginative creation *before* they become a means of acquiring knowledge about the outside world. Even after he has come to accept the existence of an autonomous, external reality he did not create, man is compensated through his cultural life; there, at least, things can be imbued with value, and tasted through this faculty added to the human soul.

Predictably, the concept of taste only required conceptualisation and philosophical analysis at that moment in history when it became problematic. So long as men and women could 'Taste and see how good the Lord is', so long, in other words, as sensuous

experience continued to flow uninterruptedly into cultural life, evaluative response and symbolic belief, the *idea* of taste (as something over and above sensuous experience) was simply redundant. It is not surprising, therefore, to discover that almost from the moment it was first used, 'taste' was already a concept fraught with difficulties.

The eighteenth century, for example, was preoccupied with the idea of 'true' educated taste, rooted in the recovery of the Golden Age of the classical past, as against popular taste – or the lack of it. The assumption was that this rift could be healed through education. But even before the end of the century, educated 'Taste' had acquired a capital 'T' and become suspect. Wordsworth and others railed against the reduction of taste to empty manners. In his history of *Victorian Taste* John Steegman argues that about 1830, taste 'underwent a change more violent than any it had undergone for a hundred and fifty years previously.' This change, he says, was not merely one of direction. 'It lay rather in abandoning the signposts of authority for the fancies of the individual.' Throughout the later nineteenth century, lone prophets like Ruskin, Eastlake and Morris denounced the decay of taste into 'Taste' or manners among the elite, and its general absence elsewhere in society. But they were bereft of authority. By the twentieth century, all the great critical voices had fallen silent. Even high aesthetic taste was widely assumed to be a 'for me' response. The thin relativism of Bayley, Pile and Blake became the order of the day. Commentators began to argue there was 'no aesthetical judgment which can make a rightful claim upon everyone's assent.' Even a knowing middle class turned enthusiastically to Kitsch.

The causes of this destruction of taste are various and complex. The puncturing of the illusions of religious faith certainly made it harder and harder to sustain belief in a continuity between the evidence of the senses and affective or evaluative response. Values came to be characterised as being 'subjective' and therefore, by implication, arbitrary; that area of experience which had once united them with physical and social reality began to disappear.

Mechanism began to replace organism, not only as the assumed model for all production and creativity, but as the paradigm for cultural activity itself. Modernism celebrated this elevation of the

machine, decrying the ornamental and aesthetic aspects of work in favour of at least a look of standardisation and efficiency. The prevalent taste became the affirmation of those elements in contemporary productive life inimical to the development of taste; hence the attempt to identify the universals of taste with the principles of functional design.

Meanwhile, the growth of a market economy based on the principles of economic competition tended to lead to the triumph of exchange values over the judgments of taste. Indeed, the intensification of the market led to the eradication of many of the traditional and qualitative preconditions for the exercise of taste. The market in fact encourages the homogenisation of sensuous experience: it gives us Golden Delicious rather than more than two hundred local varieties. Simultaneously, however, through advertising and ideology, the market proclaims the value of choice. But a preference for Coke rather than Pepsi really has no qualitative significance; there can be no such thing as a connoisseur of cola. At the same time, political democratisation has somehow become conflated into a cultural rejection of any kind of discrimination or preference: taste has become bereft of authority and has sunk back into the solipsistic narcissisms of the subcultures, or the trivialising relativisms of individual fancy.

And yet, and yet . . . despite nerves and doubt about the status of taste, most of us still try to exercise it. And most of us demonstrate by our actions that we believe it to be something more than a 'for me' response. Indeed, proof against the assertions of Bayley, Pile, Blake and Co. is readily to be found in everyday life. Today, it is possible to question with relative impunity the politics, ethics, actions and even religious convictions of most of the men and women one encounters. There is widespread understanding that all such areas and issues offer legitimate scope for radical divergences and oppositions. No such generosity prevails over questions of taste. Rare indeed are the circumstances under which it is acceptable 'decently' to challenge an individual's taste in, say, clothing, interior design, or works of art.

Indeed, I find that because, as an art critic, I offer preferential judgments of taste, by profession, I am exposed to intemperately energetic responses of a kind that simply do not arise in other

areas of human discourse. Whatever these responses may or may not indicate about the nature of taste, they do not suggest that there is a general agreement that it is a 'somewhat superficial matter', of no greater significance than whether a man has black or brown hair, or prefers Scotch to gin.

Rather, this continuing agitation about taste suggests that it is a significant human responsive faculty, whose roots reach back into natural, rather than cultural or social history. But taste requires a facilitating cultural environment if it is to thrive – and it is denied this in a society which, as it were, chooses mechanism and competition, rather than organism and co-operation, as its models in productive life. Elsewhere, I have argued the case for the regulation of automated industrial production; and for restraint and control of such effects of market competition as advertising and market-orientated styling. I have suggested that, even in the absence of a religion, nature itself can provide that 'shared symbolic order' which allows for the restitution of a continuity between sense experience and affective life. But even such drastic (and improbable) developments as these would not, in themselves, be sufficient to ensure a widespread revival of the faculty of taste. For, if it is to emerge out of narcissism and individualism, taste requires rooting in a cultural tradition; taste cannot transmute itself into anything other than passing fashion if its conventions, however arbitrary in themselves, are lacking in authority. There is, of course, no possibility that the church, or the court, can ever again be guardians of more than sub-cultural tastes. The history of Modernism has demonstrated that it is folly to believe that the functioning of machines can provide a substitute for such lost authority. We therefore have no choice but to turn to the idea of new human agencies.

One of the most interesting texts in Bayley's little book is a private memorandum by Sherban Cantacuzino, Secretary of the Royal Fine Art Commission, which deals with this possibility. Cantacuzino, too, cites Kant's view that although aesthetic judgment is grounded in a feeling of pleasure personal to every individual, this pleasure aspires to be universally valid. Thus he seeks a greater authority for the Commission – an authority rooted in democratic representation, rather than public participa-

tion. 'The Commission,' he writes, 'as a body passing aesthetic judgment, must feel compelled and also entitled to, as it were, legislate its pleasures for all rational beings.'

Many people understandably have a revulsion against any suggestion of social control in matters of taste or aesthetics; and yet the greatest achievements in this terrain, along with some of the worst, were effected under conditions where such controls applied. In our society, in their absence, the market and advancing technology, are having unmitigatedly detrimental effects on the aesthetic life of society. It is not the fact of institutional regulation, so much as its content, that should concern us: and I am arguing for an institution which, as it were, exercises a positive discrimination in favour of the aesthetic dimension. Unlike Cantacuzino, I do not believe this institution should necessarily be the Royal Fine Art Commission: rather, it might be some new agency, drawn from the Design, Crafts and Arts Councils, as well as from the Commission. But, unlike these bodies, it would have powers of direct patronage, and, as Cantacuzino puts it, 'feel compelled and also entitled to . . . legislate its pleasures for all rational beings'. Indeed, I believe that such a rooting of taste in the authority of an effective institution of state would not be a limitation on aesthetic life so much as a *sine qua non* of its continued survival. For what is certain is that left to their own considerable devices, the development of technology and the expansion of the market will succeed in holding the faculty of taste in a state of limbo, if not in suppressing it altogether. But some kind of effective cultural conservationism, in the face of the philistinism even of 'experts' like Bayley, Pile and Blake, seems to me to be as much an obligation of good Government as the protection of our forests and national parks from the intrusions of technological development; or the provision of adequate educational and health facilities, free from distorting effects of market pressures.

1983

4
Roger Scruton and Right Thinking

Roger Scruton is best known as a prolific polemicist of the British 'New Right'. In the first issue of *The Salisbury Review*, a journal of 'Higher Conservative' thinking which he edits, Scruton wrote about 'the importance of regaining the commanding heights of the moral and intellectual economy' for conservatism.

It is hard to believe, however, that even he thinks that is what he is doing through, say, his occasional column in *The Times*. Apparently he intended no irony when, in the wake of the Falklands fiasco, he expressed the view that dying for one's country was 'the most vivid human example of the sacred, of the temporal order overcome by a transcendent meaning'. Could this metaphysical transfiguration of futile deaths amongst tundra and penguin shit have inspired Scruton's condemnation (without ever having seen it) of *The Day After* – an American TV film on the effects of nuclear war – as 'pornography'? Perhaps he felt that such a film should depict the blinding light of millions of transcendent meanings, rather than a vision of fire storms, radiation sickness, cinders and General Anaesthesia.

But those who know Scruton only through his hasty and intemperate journalism, in which he seems to be engaged in some personal stampede to speak the unspeakable, should not be put off from his books, which are different in both tone and content. Some of them show a searching after the truth, a distaste for conventional cant and a vigorous critical independence of mind which should commend them even to those who, like myself, are of very different political persuasions.

Over the last ten years, Scruton has published a number of works on aesthetics, including *Art and Imagination* and the exemplary *The Aesthetics of Architecture* of 1979. There can be little doubt that these explorations are among the most rewarding of their kind to have appeared in English in recent years. This new

volume, *The Aesthetic Understanding* (Carcanet, 1983), is a collection of substantial and considered essays which provide an excellent introduction to the depth and breadth of his aesthetic concerns.

For Scruton, the primary question is not 'What is Art?' but 'What is aesthetic experience, and what is its importance for human conduct?' He is unaffected by any of the fashionable tendencies to deny, dissolve or reduce aesthetic experience; the tools he uses for his investigation are those of analytical philosophy, and the conclusions he arrives at are notable for their emphasis upon *imagination*.

'In the light of a theory of imagination', Scruton writes, 'we can explain why aesthetic judgment aims at objectivity, why it is connected to the sensuous experience of its object, and why it is an inescapable feature of moral life.' For him, aesthetic experience also has practical value: it represents the world as informed by the values of the observer. But his position is not one of unalloyed subjectivism: he insists, and rightly so, upon the dependence of aesthetic and moral life on the existence of a 'common culture', a system of shared beliefs and practices that tell a man how to see the situation that besets him.

I am with him here; but such emphases seem rare elsewhere in contemporary critical writing. Scruton understandably argues that Marxist, sociological, structuralist and semiotic schools of thought have contributed little or nothing to the answers to the questions that concern him. Such practitioners miss the point that there is a relative autonomy to aesthetic experience, that it can genuinely be distinguished from, say, scientific, moral or political understanding. Nonetheless he shows an exemplary concern for, and knowledge of, the material bases of each of the several arts and pursuits he discusses.

There is, for example, something refreshing, in the light of recent controversies, about his defence of the literary critic as a reader with taste, judgment and 'a certain kind of responsiveness to literature' who addresses his remarks to readers of literature who are not also professionals. (Nonetheless, the least convincing text in this volume for me was Scruton's own excursion as a literary critic. His study of Beckett labours the none-too-original

point that he was a 'post-Romantic' writer of genius whose vision
was entirely integrated into his style.)

More original and intriguing is a selection of his texts on music,
dealing, with illuminating clarity, with themes like representation
in music, musical motion, and especially musical understanding.
Scruton makes the point that anyone who is ingenious enough can
interpret music as a language, code, or system of signs. But
perhaps the relation between such semantic analyses and musical
understanding itself 'is no closer than the relation between the
ability to ride a horse, and the semantic interpretation of piebald
markings'. Scruton convincingly describes musical understanding
as 'a complex system of metaphor which is the true description of
no material fact'. Characteristically, he stresses the imaginative
activity involved in the *hearing* of music, through which sound is
transfigured into figurative space.

Similarly, his essay on photography provides far and away the
most authoritative exposition of the profound differences be-
tween photography and painting of which I know. Scruton argues
that 'representation' is a complex pattern of intentional activity,
the object of highly specialized responses. Photography, when it is
true to itself, necessarily eliminates such intentional activity; the
photograph is, as it were, too closely wedded to the appearances
of given reality, especially in terms of its details, to represent
anything at all.

Of course, he acknowledges that representations can be photo-
graphed; for example, when a photographer takes a picture of a
woman posing as Venus. But a photograph of a representation is
no more a representation than a picture of a man is a man. Scruton
argues that painting is essentially a representational art – though
he undoubtedly underestimates the decorative contribution to
this art form – whereas photography is not. Insofar as there is
representation in film, as opposed to photography, its origin is not
photographic but theatrical. Scruton then successfully deploys the
distinction between 'fantasy' and true imagination to argue that,
to its detriment, the cinema has been indissolubly wedded to the
former – and that this has something to do with the nature of the
medium itself.

Scruton's views on architecture will already be known to

readers of his earlier books: he conclusively demonstrates the
vacuity of the modernist 'functionalist' theory and practice, and
revives the idea of the history of architecture as 'the history not of
engineering but of stones, in their expressive aspect'. There is no
necessary, causal link between proposed functions and ultimate
forms which can be extrapolated without considering the linking
term of *style*. In any event, the functions of good buildings often
change through historical use. Churches become museums; rail-
way stations, as at the Angel, Islington, in London, shopping
arcades. Scruton maintains that it is through aesthetic under-
standing that the eye is trained and that the architect is thereby
able to envisage the effect of his building. Without this process of
education, there is no way an architect can seriously know what
he is doing when he begins to build.

This leads Scruton to a defence of the present possibilities for
the classical tradition in architecture, whereas it has led me (for
very similar reasons) to a belief in the enduring potentialities of a
neo-Gothic style. Perhaps it is Scruton's tendency to slide from
belief in authority towards rigid authoritarianism which causes
him to prefer the former to the latter: in any event, he not only
ignores the achievements of, say, nineteenth-century Gothic, but
seems unaware of the strong continuities between Classicism and
the modernism he abhors.

This is admittedly a difference of taste; it is none the less
important for that. But the real question, for me, is whether
Scruton's aesthetic position necessitates, or even implies, adher-
ence to his political ideas. Scruton's own view, at least at times, is
that it does. Thus, in a private communication, he has welcomed
the positions I have taken on aesthetics, but regretted that I have
refused to adopt the politics which, for him, seem to stem from
them.

But his own position involves him in a profound contradiction
of which he seems blissfully unaware. For example, he is frequent-
ly at pains to dissociate himself from any espousal of the ideology
of the 'Free Market' economy, which he perceives as a product of
nineteenth-century Liberalism. This is understandable because
competitive market capitalism has indeed shown itself to be
singularly incompatible with those aesthetic and ethical values

rooted in a conception of a common human nature, and a common culture, which he and I both seek to uphold. Nonetheless, his practical politics are invariably those of vigorous support for the most archaic revivalists of a nineteenth-century, free-market economy. Thus Scruton's article about the Royal Academy Summer Show, published in *The Times* last June, was headed, improbably, 'A Victory for Art at the Polls'.

Scruton should take a more careful look at the architecture of Peterhouse, which formed us both. He accuses Sir Leslie Martin, head of the Centre for Land Use and Built Form in Cambridge, and architect of the hideous 'functionalist' William Stone building in the grounds of the College, of what he calls 'the Architecture of Leninism'. He fails to point out, however, that the Great Hall of Peterhouse is embellished by William Morris's superb decorative restoration, affirming the values of tradition and aesthetic experience. Sir Leslie is a member of the British cultural establishment; William Morris was a revolutionary socialist.

I do not, for one moment, wish to imply that the left has provided a true haven for the ethical and aesthetic values eroded by the right. That would be palpably absurd. My point is rather that if Sir Leslie can epitomise 'the Architecture of Leninism', and Morris can affirm true aesthetic values and experience, then there is no *necessary* connection between Scruton's sound aesthetic insights, and so-called 'conservative' political ideas.

Nonetheless E. P. Thompson pointed out that the true vandals of British laws, customs, and liberties in the 1970s were 'not the raging revolutionaries of the extreme Left', but the Tory establishment itself. It may well be that there is no hope for the maintenance of conditions favourable to those authentic and ethical experiences, rooted in a common culture, in which Scruton and I both believe. But if there is, I believe it will be found in a revised socialism rather than in the ravagings of a 'Free Market' capitalist economy. I cannot see the June 1983 elections as a 'Victory for Art at the Polls' and I do not think Roger Scruton could either, if he was as honest and critical in his politics as he is in his aesthetics.

1983

II

EXPRESSIONS

5

Rouault: In the Image of God

Rouault sometimes wrote about himself almost as if he *was* the
Christ: 'I am the silent friend of all those who labour in the fields; I
am the ivy of eternal wretchedness clinging to the leprous wall
behind which rebellious humanity hides its vices and its virtues
alike.' But, he added, 'Being a Christian in these hazardous times, I
can believe only in Christ on the Cross.'

This belief did not lead Rouault to cut himself off from contact
with the world and its sins. Between 1902 and 1908, he painted
the whores of Paris. The large water-colour picture, *Prostitute at
Her Mirror* of 1906, is one of the most terrifying images in this
century's painting. Her skin, though smooth, is as pallid and
unappetising as raw dough kneaded with grubby fingers. The
expression she wears is one of dour implacability in the face of her
own corruption: typically, we are only permitted to glimpse
something of her 'real self' in the detached reflection in the mirror.
There, we sense a scream of anguish behind the jaded crust of
rouge and mascara.

Unlike Toulouse-Lautrec, Rouault did not look on these women
from the point of view of the habitual client. One of his whores
was once described as a 'pus-filled goatskin with slimy thighs'.
They can hardly be associated with the awakening of even
transient desire. And yet Rouault is neither a satirist sneering at
raddled old powdered sluts; nor a strident moralist railing to us
about the wages of sin. For though his rejection of the sin he
depicts is conspicuous, so is his love of the sinner. And this love
gains material expression in the transfigurations of colour and
form. The squalor of the woman's surroundings is metamorph-
osed into splendour through Rouault's relish in his painterly
means and materials. Thus her hideous hues are transformed into
translucent veils; and her sagging and degraded flesh is brought
alive by the energy of his life-affirming line. If vicarious redemp-

tion were possible within the illusory spaces of art, then this
woman would be saved!

As Gustave Coquiot, a contemporary critic, once put it:

You have dared to torture the female who was so certain that
she would always be adored! You have scourged her, flogged
her, rent her in two; you have debased her in all her pride; you
have emptied her breasts, creviced her belly, blown up her
buttocks, twisted her legs, battered her face! And over it all you
have spread a noxious colour, composed of all the reds of blood
and all the greens of putrefaction. You have executed, for a
pope with genius, the rarest, the most eloquent, the most
magnificent of windows for the cathedral to come.

It is an image of which Rouault would have approved. 'I do not
feel as if I belong to this modern life on the streets where we are
walking at this moment,' he once said. 'My real life is back in the
age of the cathedrals.' But he never advocated nostalgia or
revivalism.

Rouault was born in 1871: as his mother went into labour, the
house was struck by shells from government troops bombarding
the Paris Commune. Mother and child survived. Rouault's father
was a skilled craftsman, and Rouault himself started his working
life in the studio of a stained glass painter, where his particular
pleasure came from handling the fragments of medieval glass
which came into the workshop for repair. Apart from a general-
ised preference for religious themes, little of these experiences can
be detected in Rouault's earliest painting, which was strongly
influenced by his love of Rembrandt, and the time he had spent in
the studio of Gustave Moreau, the great symbolist painter.

Soon after the turn of the century, however, Rouault began to
feel a quickening of his faith. At this time, he began painting the
Parisian whores, and his work started to show those qualities of
glowing, phosphorescent colour and thick, 'leaded' outlines
which recalled stained glass. The extent of the influence of the
glass workshop on his mature painting style has sometimes been
questioned; but there can be no doubt about the fact that Rouault

ruminated a great deal about the artists and craftsmen who built
the cathedrals.

'The medieval craftsman loved his stone, his wood, and
wrought lovingly', he once wrote. He went on to say that the
anonymous builders of the great cathedrals were vastly superior
to 'many pseudo-personalities' of our time, who proliferated
when the ideal of collaboration between architect, painter, and
sculptor had been abolished. 'The art of the cathedrals', he
argued, 'is at once collective and personal, but the way of life, the
modes of feeling, understanding, and loving that were at the root
of this art cannot be artificially revived. We can do other things,
but we cannot recreate what the spontaneous, collective effort of
generations built with the faith that was theirs.' What were these
other things? Rouault had no doubts: 'It is no exaggeration to say
in spite of the achievements of the ancients, the language of forms
and colours is a realm that still remains to be explored.'

Rouault was convinced he had found the key to a fully 'spir-
itual' art in our time. His religious associates could see only the
manifest subject matter, and they rarely agreed. Thus Rouault
was close to Leopold Bloy, a writer and religious reformer. But
Bloy reacted virulently against Rouault's art, accusing him of
being attracted solely by what is ugly and of pursuing 'a vertigo of
hideousness'. 'If you were a man who prayed, a religious man, a
communicant', Bloy wrote, 'you could not paint those horrible
pictures.' Rouault was unmoved. 'To understand sacred art,' he
once said, 'may require special gifts.'

He thought that 'subjective artists are one-eyed, but objective
artists are blind.' Nonetheless, Rouault remains one of this cen-
tury's finest draughtsmen: he *does* look intensely at the object,
face or figure in the world. He did not, however, seek to reproduce
its appearance. One of Rouault's biographers once called him 'the
painter of inwardness, of the supernatural light that glows in the
profoundest depths'. This wasn't just hagiography; Rouault was a
seer in both senses of the word. And the literal 'transformations'
of appearance he brought about through the act of painting
reflected the *spiritual* vision he wished to bring to bear.

For example, Rouault took endless pains in the laying down of
layer upon layer of transparent colour, often reworking the same

picture over several years, and then destroying it if it was not 'right'. He sought to create the illusion that light was somehow radiating out from the objects depicted in his paintings rather than falling upon them from outside. It is this effect, more than any other, which puts us in mind of the resplendent glories of the Gothic cathedral windows when we look at Rouault. But, of course, the strength of his colour does not simply arise by association with this tradition: not only is it alluring in itself, but its redeeming power arises from the way in which it functions as a metaphor, or symbol, of Christian teaching. Rouault's colour proclaims that however wretched, disfigured, degraded and sinful his subjects may be, they can be transfigured, and made whole, if, through the grace of God, they repent and become fused with the Body of Christ, i.e. the Church. Thus, for Rouault, the exploration of new colours and forms was inseparable from the 'message' he wished to convey through them.

Rouault was not, of course, by any means alone in believing that, in the absence of a living tradition of religious iconography, the 'spiritual' could be expressed in art through new formal means. Rouault was a devout Roman Catholic; but many protestant artists, critics and theologians thought something very similar – though not always with such enduring confidence. But what if science demonstrated that natural form was the product of natural history, rather than the handiwork of God? As Ruskin discovered the nakedness of the shingles of the world, their separateness from the 'Sea of Faith', he found his views rendered him liable to a depressingly grey sense of a 'failure of nature' itself and of the art which mirrored it. When overtaken by these feelings, he could not even bear to gaze upon his beloved Turners. Many artists turned to the forms and conventions of art itself in search of the spiritual dimension. 'I want to paint men and women', Van Gogh once wrote, 'with that something of the eternal which the halo used to symbolise, but which we now seek to counter through the actual radiance of colour vibrations.'

Paul Tillich, a Protestant theologian, wrote something very similar when he referred to 'the directly religious effect of a style which is under the predominance of the expressive element, even if no material from any of the religious traditions is used.' The

effect was achieved, Tillich believed, because 'the expressive element in a style implies a radical transformation of the ordinarily encountered reality by using elements of it in a way which does not exist in the ordinarily encountered reality.' Expression disrupts the naturally given appearance of things: the new unity into which it orders elements of the 'ordinarily encountered reality' can be differentiated from imitation, idealisation and realism. But that which is expressed was, for Tillich, not simply the subjectivity of the artist – as in Impressionism, or Romanticism. The expressive element, he thought, 'expressed . . . "the dimension of depth" in the encountered reality, the ground and abyss in which everything is rooted.'

Tillich himself favoured a figurative expressionism, and endorsed the Museum of Modern Art's 'New Images of Man' exhibition at the Museum of Modern Art in New York in 1958, which presented work by Bacon, Giacometti, De Kooning and Pollock. But a very similar line of reasoning had been used by many pure abstractionists – from Kandinsky to Mark Rothko – to explain what they were doing. Tillich notwithstanding, none of these artists could ever be sure that the 'expressive element' they were using to explore the 'dimension of depth' and to create the 'new reality' of the picture was anything other than an aspect of their own subjectivity, if not in the narrow optical sense implicit in Impressionism then perhaps in some sense that might be revealed by advances in depth-psychology.

Indeed there was no way in which Tillich's artistic theories and preferences could differentiate between a religious dimension and one explicable in terms of existential humanism. For example, no one came closer than Mark Rothko to revealing the 'ground of our being' through his art; but in the ultimate grey monochromes painted just before his suicide he discovered not so much a benign and loving personal God as something like that 'blank psychosis' which many psychoanalysts now assume lies at the base of consciousness. And if the new forms were merely humanist then of course they risked not only aesthetic greyness but also losing their redeeming efficacy. Ruskin went mad, Van Gogh's fate is well enough known, and Rothko, too, took his own life.

Most of the work included in 'Prophecy and Vision' – a large

exhibition of religious art which recently toured Britain – was prone to this criticism. It looked very much like the sort of confused art you find in any mixed show – including everything from blank minimalism to the new expressionism. And, after all, what artist, Christian, Jewish, agnostic or downright atheist, would ever deny that he was seeking a 'dimension of depth', trying to see, and to transform given appearances?

At least one major Protestant theologian realised this. Karl Barth once argued against all those (including his sometime disciple Emil Brunner, and, incidentally, John Ruskin) who believed that God could be revealed through nature, or through the face of a fallen man. Similarly, he insisted on a complete divide, or diastasis, between human culture and divine revelation – which had only been made manifest in the Person of the Christ, and the Word of God, the Bible. God was *wholly other*; he was revealed by his own Grace, not by mountain strata, or 'the actual radiance of colour vibrations'.

The logic of Barth's argument is that though 'religious' art may be possible, painting which is objectively revelatory of the divine is not.

As an atheist, of course, I can only agree. Nonetheless, when I move from such Protestant thinkers and practitioners back to the luminous world of Rouault, I am convinced that I am confronted by a genuinely 'spiritual' dimension which is in no easy sense reducible either to sensations of colour, or psychoanalytic insights.

This 'something more', I am certain, arises from Rouault's immersion in what was, for him, a still living 'symbolic order' which could speak, without reductionism, of revelation, incarnation, repentance, redemption, salvation and eternal life. God, for Rouault, was certainly not immediately discernible in nature ('Objective artists are blind'). Nor had he retreated solely into the invisible depths of the individual human soul ('Subjective artists are one-eyed'). Nor was he yet utterly inaccessible in some 'wholly other', ineffable, otherworldly space. Rather, or so Rouault believed, his revealing grace was made manifest through the iconography, life, work, liturgy, and physical fabric of the Church. He longed for his own art to be part of this collective experience,

this divine tradition . . . Even though that could not be, it remains the revelatory radiance of the stained glass window above the high altar which gives his pictures of whores a dimension that is entirely absent from say, Bacon's existential butchery.

Thus, those of us who are already deprived (through intellectual insight or cultural habit) of the consolations of religion can hardly look to Rouault for comfort: for he forces us to ask whether the full consolations of art can ever really be fully available to those who are not prepared, or are not able, to commit themselves to illusions more radical than the merely 'aesthetic'.

1982

6
Soutine

On the back of the catalogue for the Chaim Soutine exhibition at the Hayward Gallery there is a photograph of the artist standing next to a suspended fowl. The dead bird's beak is open. Soutine himself is shabbily dressed; his hair is tousled; his clothes and shoes covered in filth. Behind him looms a sinister opening in a brick wall. On his face, he bears a salacious leer.

What manner of man was he? Born into a poor, closed, Jewish community near Minsk, in Russia, Soutine was punished as a child for drawing (which infringed Jewish laws about graven images). In 1913, aged twenty, he came to Paris, where he lived in abject poverty as a 'bohemian' in Montparnasse. In 1923, he was 'discovered' by a rich collector: the rest of his life was spent in materially pampered circumstances, in which he could be wholly preoccupied by his painting, the malfunctioning of his digestive system, and his numerous phobias and anxieties.

No amount of romanticisation can disguise the fact that Soutine was a noxious individual. He was egocentric, and mean, and he stank in every sense of that word. 'I knew Soutine well,' said André Salmon, one of his contemporaries, 'and saw little of him. His art deserved the closest attention, but I confess there was much about the physical presence of the man himself that revolted me. Not only the filthy state in which he stumbled through life, but above all his slobbering speech.'

Salmon described how when Soutine finally consulted an ear specialist about his terrible earache, in the canal of the painter's ear the doctor discovered 'not an abscess but a nest of bed-bugs'.

Self-evidently, Soutine's obsessions with food, ugliness, squalor and death penetrated his art. For example, among Soutine's greatest canvases are those he painted of a suspended carcass of beef. A legion of anecdotes has been told about how he made

those works. He would string up a flayed ox in the studio, and paint in a frenzy in front of it. The terror of the act for him may have been intensified by the fact that he thereby violated Jewish laws about the handling of flesh and blood. When the meat began to rot, he carried on oblivious of the stench; an assistant fanned away the flies. When the colours became jaded, he brought them back again by pouring buckets of fresh blood over the meat. He was self-righteously indignant when neighbours and hygiene officials dared to intervene.

Superficially, then, Soutine's imagination seems close to those 'pornographers of despair' who have proliferated in the art world in recent years. 'Artists' have ritually slaughtered chickens; exhibited 'sculptures' of rotting meat; sat, for days, in a bath of bull's blood; and appeared draped only in blood and offal. Such comparisons are made more credible because Soutine assailed many of his finished canvases with paraffin, fire and sharp knives. And yet, and yet . . .

Soutine *never* stopped at such acts of violation and desecration. When he completed a successful work, a process of transformation had taken place. The painting emerged resplendent from the degrading circumstances of its making. Even when the subject matter is morbid, or downright ugly, a good Soutine picture commands, not sickening revulsion, but rather a giddy exhilaration, a sense of relish in the possibilities of life.

How can this be? Soutine painted in two distinct ways at different times in his life. (The Hayward exhibition introduces us to them both.) Always, however, he took almost pathological pains to get the 'right' carcass, fowl, horse, peasant woman or row of trees. He was obsessed with the otherness of objects in the world, with their particular ugliness: he could only paint in the presence of the model. But in his first phase (the pictures up to about 1923) whatever he sees in the world is transfigured by strange, compelling rhythms which come from something other than looking. They seem to spring from himself and his own somatic processes.

Indeed, he seems to be trying to compel inner and outer to congeal in an opalescent skin of viscous paint; he wants something different from illusion. In its opulence of colour, its physical-

ity, its rhythmic ordering, the picture strains towards an actuality all of its own. It bears witness to a secular sense of re-ligion (or re-binding): a kind of healing fusion in which tortured self and degraded world are both merged and surpassed through the redeeming power of form. And it is this 'new reality' within the picture which we find exalting – regardless of the artist's *angst*, or the tawdriness of what is shown.

Soutine came to hate these early works (especially the marvellous Ceret landscapes) and destroyed as many as he could. In his later pictures, the imagery and paint handling remain unmistakably Soutine's. So does the compulsive fidelity to the object; indeed, the people and things are allowed to become more 'real' in that, though the taut skin of paint is never torn away, it is allowed to billow so that they are able to breathe within an illusion of space.

What enters, to transfigure and hold, is no longer simply a plastic sense of innovative form, but rather the embrace of tradition – a sense of continuity with the art of Rembrandt, Goya, Courbet and, behind them, the wealth of a Christian iconography of redeeming sacrifice. This should not be misinterpreted: Soutine never became a mannerist who derived art from other art. For all his denials, he retained much that he had learned in his earlier years; and he always remained wedded to the object in the world. He turns to tradition because he no longer wishes that transforming power over the thing seen to emanate from himself alone.

Modernists have always tended to prefer the early Soutines, which, if you view them in terms of the stylistic evolution of picture space, can be seen as an extension of Cézanne, and an anticipation of De Kooning. This preference was accentuated because, in later life, Soutine himself polemicised about the sins of modernism. But such historicist criteria can blind us to what he was attempting in the latter part of his life.

Take the *Carcass of Beef* of 1925, now at the Hayward: it is not the finest picture in the series, but it is extraordinarily powerful. When shopping for a carcass, Soutine once said, 'They say Courbet was able in one of his paintings of a nude woman to evoke the whole atmosphere of Paris. I want to show Paris in the

carcass of an ox.' Exceptionally, Soutine was being too modest. There is more than Paris here: much more.

Who could doubt this picture had been painted in the presence of the flesh? By rupturing the veil of his earlier pictorial skin, Soutine allows the bloody actuality of the flayed meat to be accentuated. But he does not lose that terrifying simplicity which comes from insistent frontality and virtual planar unity. The power of the picture no longer springs, however, from the redemption of its subject matter through these formal and physical means alone.

For Soutine is claiming a continuity with a 'great tradition' which extends back through Rembrandt's *Carcass of Beef* to the myriad of representations of the crucifixion upon which he gazed in the Louvre. Thus form and content become one; without concession to religiosity as such, Soutine realises an image of redemption achieved simultaneously through a symbolism of form and colour *and* through that lingering iconography of redeeming sacrifice embedded within Western cultural history. In the presence of death, he found the means to affirm life.

Now it would not be difficult to elaborate a psychoanalytic account of Soutine's development; indeed, one is offered in the catalogue, and though it is interesting, it is inadequate in that it relies on a discussion of his imagery alone. Hanna Segal has shown that 'there can be a psychoanalytic view of art which can contribute to our understanding of artistic form and process no less than content.'

Kleinians have associated the desire to create with the need for 'reparation', or the restoration of a harmonious internal world, which the artist feels himself to have lost through the raging of his own aggression. Such an approach need not be reductive, in that it emphasises that the way in which the artist carries out his 'reparation', through the external handling of forms and materials, is decisive. (A sentimental artist is one who too easily reconstitutes his lost object in the world, denying his own aggression and evading any 'working through' of it.)

Adrian Stokes has argued that negative expressions can feature

very strongly in the finished work, so long as a 'reparative nucleus' remains; one sign of this, he says, can be a richness, or excellence, attributed to the medium itself – or even to 'art in general'. It is not difficult to see the immediate relevance of all this to Soutine: presumably the urge to destroy his pictures became compulsive when he felt that the redeeming power of form was insufficiently realised to contain those primitive, destructive impulses. Indeed, all the burning, scouring, and savaging he wreaked upon 'unsuccessful' paintings accords very closely with those phantasies which the Kleinians say the infant feels towards its first object, the mother.

One can even see in his two phases those two modes of aesthetic redemption to which Stokes drew attention: the 'modelling mode' (of the early years) which emphasises ecstatic fusion with the object; and a later 'carving model,' which allows it a certain autonomy, a separateness, a right to exist in its own space. Perhaps Soutine could only feel sufficiently confident to explore this mode, however tentatively, when the pampering patrons of his later years had removed the violent impingements of a destructive, all too real, reality from his life.

And yet, though such an account of Soutine's quest for realised images of redemption would be revealing, it would remain, in the end, insufficient. For, in the latter part of his life, Soutine seems to be insisting, through his appeal to tradition, that his artistic acts of reparation should reach beyond the expiation of the personal – that they should have some communal, or shared quality about them.

Kenneth Clark once suggested a 'law' in the relationship between art and society: 'that it is valuable only when the spiritual life is strong enough to insist on some sort of expression through symbols. No great social arts can be based on material values or physical sensations alone.' This has been the curse of expressionism: all attempts to evolve a universally available symbolism of pure form have lapsed into the traps of solipsism on the one hand, or dead technical mannerism on the other.

Soutine realised that this was the dilemma to which modernism would succumb: the great carcass of beef paintings – with all their fidelity to the flesh, relish in compositional unity and materials,

and resonances of the lost, shared symbolic order – were his unique solution. They remain among the finest pictures the twentieth century has yet seen.

1982

7
Auerbach versus Clemente

If you too are sick of 'bad painting', you should have seen Frank Auerbach's exhibition at Marlborough Gallery. (Auerbach does not exhibit frequently: this was his first one-man London show since the retrospective at the Hayward in 1978.) If you had done so, you would have seen some very good pictures indeed.

I especially enjoyed a head and two seated portraits of J.Y.M.; and a reclining head of Gerda Boehm who has modelled for Auerbach over many years. But there were many fine paintings, both portraits and landscapes based on familiar territory for this artist – Primrose Hill, Euston Steps and The Studios, where he works. Auerbach also offered a consummate series of drawings, mostly of heads, including those of the Arts Council's Catherine Lampert, Charlotte Podro, Julia, and J.Y.M.

In 'Fragments from a Conversation', a gnomic interview published in a quarterly review, X, in 1959, Auerbach once explained that he had painted the same model as many as thirty times. (I wonder what the relevant figure would be today, almost a quarter of a century later. How many times can Auerbach now have painted, say, E.O.W., J.Y.M. or Gerda Boehm?) But Auerbach confessed that he got the courage 'to do the improvisation' only at the end. This improvisation he identified with 'gaiety', which he described as 'a serious word'.

But what has been true of his relationship with individual sitters may be even more so of his project as a painter itself. Frank Auerbach was born in Berlin in 1931 and is thus still in his early fifties; I do not wish to suggest for one moment that he is near the end of his working life. He is, however, getting better as a painter all the time; and the strength of his recent work (so apparent in this exhibition) seems to have a great deal to do with qualities which derive from his increasing confidence in his own ability 'to do the improvisation'.

This statement requires some explanation. Just a few years ago in an article in *Art Monthly* (reprinted in *Beyond The Crisis in Art*) I compared Auerbach and Kossoff. I argued that Auerbach's work was manifesting a growing detachment from perceived objects and persons. At that time, I felt that Kossoff was superior to Auerbach, and I suggested that the qualitative distinction between the two might have something to do with this difference. I felt Auerbach was tending to pursue the sensual qualities of painting (as substance and process) in a way which meant that his pictures were becoming more and more severed from empirical response to the real world. I tried to relate this difference to certain biographical distinctions between the two painters. But, without seeking for one moment to diminish the high esteem in which I hold Kossoff's work, I would like to emphasise the degree to which these marvellous new paintings by Auerbach show up certain fallacies in my previous line of reasoning.

For it is now clear to me that the 'looseness' (if that is an appropriate word) of Auerbach's recent painting is not the result of any loss of the sense of real, beyond the world of painting itself. Indeed, Auerbach's superb drawings – and what a draughtsman this man is – seem to me to be the proof of this. He is certainly drawing from the model better than ever before – and he was always among the best. (Look, for example, at the fine *Head of Julia*, of 1981, illustrated on the cover of the Marlborough catalogue.) Whatever is happening in Auerbach's painting cannot be ascribed to any attempt to veil given reality before he has taught himself to see it clearly; Auerbach is not intent upon evasion, or the drowning of the appearances of the real in numbing illusions, or a curtain of subjective, expressionistic gestures. Rather, he seems less and less intimidated by the impinging facticity of the real (to use the sorts of words he understandably rejects as being too 'windy') only because he is more and more familiar with it.

If the outside world was once like a forbidding father with whom he had to wrestle, and ultimately to subdue, it has recently become more like the face of a well-loved friend with whom he can afford a reciprocal relationship. Auerbach has thoroughly confronted its otherness, scrutinised its physiognomy, and accur-

ately observed its changing moods; because it is no longer intract-
able to him, he has acquired the courage to take what some might
mistake as cavalier liberties in his painting and drawing. Look
how that brush-stroke seems urgently to be seeking not the twist
of a particular lip, but itself! But, in Auerbach, these are signs not
of incompetence, or some brash insensitivity, but rather of a true
intimacy with both the visual world, and his own practice,
painting.

Indeed, I think his willingness to improvise from a position of
achieved mastery is edging his work from the good towards the
great. For Auerbach is among the very best of our living British
artists. Indeed, I know of only one other British painter alive today
whose work is of comparable stature, and that is Kossoff. Beside
Auerbach, Francis Bacon is simply an able caricaturist and sen-
timentalist: the emotions Bacon wishes to evoke are all too rarely
earned in the material handling of his forms and colours.

There are those who say that such distinctions are arbitrary and
unimportant; that they reveal only the 'taste', or the arrogance, of
those who make them; and that all such judgments are no more
than the exercise of personal whim, or fancy. The case of Frank
Auerbach, however, demonstrates why evaluation is so important
in our response to works of art.

Auerbach has long enjoyed the admiration of a limited and
discriminating circle of artists, critics, collectors and other viewers.
His paintings have not lacked buyers. But, as I have argued before,
he has rarely been allocated even a niche in 'The Story of Modern
Art'. (Not a mention, let alone a reproduction, in Lynton's book
of that name.) For reasons I have tried to analyze elsewhere,
during the late 1950s, 1960s and early 1970s the art world was
blind to the fact that in the late David Bomberg, Auerbach,
Kossoff and Creffield Britain had artists every bit as good as, say,
De Kooning, and incomparably better than all the fashionable
rubbish brought to prominence through the successive vogues of
Late Modernism.

But today this position is changing. In 'A New Spirit in Paint-
ing', at the Royal Academy two years ago, Auerbach was 'reha-
bilitated' as the precursor, or Old Master, of a new expressionistic
movement. Even though Auerbach is at last getting the sort of

exposure he deserves, this 'rehabilitation' is as distorting as the previous neglect. Let me explain. If you pick up any history of Pop Art, you will see on around page eight a reproduction of Edward Hopper's painting, *Gas*: the text will imply that the importance of Hopper lies in the fact that, as an early painter of petrol pumps, he anticipated Pop. Or have a look at the catalogue for 'The Art of the Real' exhibition which introduced American Minimalism at the Tate in 1969. A Rothko is similarly reproduced as if his true significance lay in the fact that he precursed all those blank squares and dead cubes, all that insensible ephemera.

Now the fashions for Pop and Minimalism have mercifully gone the same way as wide lapels, no one except the art historians should need reminding that Hopper was opposed to the anaesthesia the Pop artists instigated; or that Rothko's pursuit of a symbolism of pure forms and colours which could convey high sentiments had nothing in common with that trendy renunciation of illusion, emotion and material skill which characterised minimalist anti-art.

Auerbach's 'relation' to today's 'New Expressionism' is equally fortuitous. It has been elaborated from the observation of trivial and contingent resemblances, which depend upon putting all substantive question of value in brackets. The relationship between Hopper and Pop, Rothko and Minimalism, or Auerbach and the Transavantgarde is really no stronger than that between Piero della Francesca's *Nativity* and a plastic madonna from Lourdes.

Some will undoubtedly want to know in what Auerbach's superior quality resides, and how it is to be recognised. Aesthetic quality is not some figment constructed outside the work through discourse, ideology, interest or promotional opportunism. Rather, it is realised, or not, as the case may be, through material transformations of paint, canvas and pictorial conventions. The capacity to recognise it, however, appears to be rooted in a genetically variable ability for intuitive judgment and/or the cultivation of exceptional taste.

But painting, as Auerbach once said, is a 'practical thing', and 'words are so windy'. Although we can never strike the ground and reveal the source of aesthetic quality in a way which places it

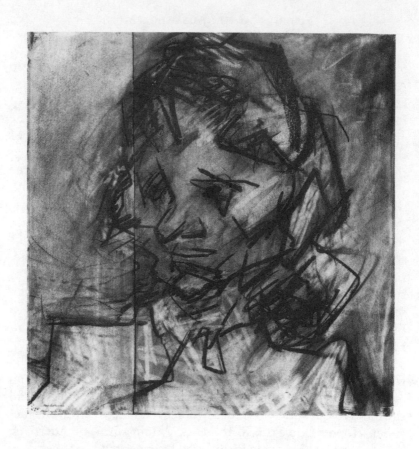

2
Portrait of Catherine Lampert II
Frank Auerbach

beyond dispute, we can always indicate its necessary, if not sufficient, conditions in things more practical and substantial than verbal exhalations. I would, for example, emphasise here Auerbach's consummate mastery of drawing; his relatively recent flowering as a colourist capable of playing the full emotional range; the increasing sureness of touch, which has enabled him to shift from mere accretion of pigment to a vividly lyrical handling which loses nothing in sensuousness; and his evocation of the 'Great Tradition' of Rembrandt's humanist painting, which he calls upon to redeem his expressionism from solipsistic subjectivity.

But the mastery of such material and technical elements, though seemingly essential, *guarantees* nothing. And I believe Auerbach to have been right when he spoke of the seriousness of those qualities (like painterly gaiety) which spring immediately from improvisation.

For, in the absence of a widely accepted iconography, the way in which such improvisation is elaborated becomes decisive. As you can currently see at the Royal Academy, a painter like Murillo could call upon the iconography of the Madonna, celestial utopias and flying putti as the means of changing his childhood yearnings into a present and socially comprehensible vision of a spiritually redolent world. But that transformation of the physically perceived which could once be made manifest by allegoric devices, like haloes and 'human' wings, can now only be realised through the transfiguration of formal means like drawing, colour and touch. And I think it is because his indubitable technical mastery has transcended itself and entered this arena of imaginative, and improvised, transfiguration that Auerbach is able to produce works of such exceptional quality.

This transfiguration, or what I have called elsewhere 'redemption through form', is the hallmark of successful expressionism. It is something which Auerbach shares with Rouault (in his great paintings of Parisian whores) or Soutine (especially in the carcass of beef canvases.) However sour the subject matter they are presenting, or *angst*-ridden the emotions that inform their work, these painters know how to bring about an illusory aesthetic redemption, and to leave their viewers with a feeling of the 'good',

through the way in which they improvise upon the formal means they have learned and mastered.

But today's new expressionistic painters know *nothing* about this; they want to *evoke* their feelings, to *allude* to them, not really to express them at all. Go and look at Clemente at D'Offay's, and the Whitechapel . . . and then return to Auerbach. Clemente has never looked at the world; at least, he has not yet seen it. He has no idea how a head meets the shoulders, a limb the torso, or a wall the ceiling. But nor can he have looked much at art. He is pictorially illiterate. He has not achieved competence, let alone mastery, in the necessary material skills of painting: he cannot draw; he has no sense of colour at all; his grasp of composition is weak; and he seems to have no virtuosity in the handling of his materials. Little wonder then that there is infinitely more of this magic of aesthetic transfiguration in a single drawing by Auerbach of Catherine Lampert's head than in both Clemente's bombastic series of daubings. Clemente cannot even come out fighting, let alone dance like a butterfly, or sting like a bee.

If we compare Auerbach to Clemente we can see revealed (as clearly as it is ever revealed) the palpable difference between work of potentially enduring stature and fashionable trash. Clemente has been elevated to his present cultural prominence on tides of fashion and interest (tendentious as well as financial). But Auerbach is one of very few painters working in Europe or America today of whom it is possible to say with any degree of credibility that here, I believe, is a master in the making.

1983

8
Raw Bacon

Their heads are eyeless and tiny. Their mouths, huge. Two of them are baring their teeth. All have long, stalk-like necks. The one on the left, hunched on a table, has the sacked torso of a mutilated woman; the body of the centre creature is more like an inflated abdomen propped up on flamingo legs behind an empty pedestal; the third could be a cross between a lion and an ox: its single front leg disappears into a patch of scrawny grass.

They exude a sense of nature's errors; errors caused by some unspeakable genetic pollution, embroidered with physical wounding. One has a white bandage where its eyes might have been. All are an ominous grey, tinted with fleshly pinks: they are set off against backgrounds of garish orange containing suggestions of unspecified architectural spaces.

Francis Bacon painted this triptych, *Three Studies for Figures at the Base of a Crucifixion*, now in the Tate Gallery, in 1944. It was first exhibited at the Lefevre Gallery the following April, where it hung alongside works by Moore, Sutherland and others who had sought to redeem the horrors of war through the consolations of art. Although Bacon referred to traditional religious iconography, he did not wish to console anyone about anything. Indeed, he seemed to want to rub the nose of the dog of history in its own excrement.

When the *Three Studies* was first shown, the war was ending and it was spring. Bacon was out of tune with the mood of his times. Certainly, as far as the fashionable movements in art were concerned, he was to remain so. And yet his star steadily ascended. By the late 1950s he was one of an elite handful of 'distinguished British artists'. Today his stature among contemporary painters seems unassailable. And yet Bacon – who recently held an exhibition of new work at Marlborough Fine Art to mark the publication by Phaidon of a major monograph, *Francis*

Bacon, by Michel Leiris – must be the most difficult of all living painters to evaluate justly. His work is so extreme it seems to demand an equally extreme response.

Bacon has always denied that he set out to emphasise horror or violence. In a chilling series of interviews conducted by David Sylvester, he qualified this by saying, 'I've always hoped to put over things as directly and rawly as I possibly can, and perhaps, if a thing comes across directly, people feel that that is horrific.' He explained that people 'tend to be offended by facts, or what used to be called truth.' He has repeatedly said that his work has no message, meaning or statement to make beyond the revelation of that naked truth.

Bacon's serious critics have largely gone along with his own view of his painting. Michel Leiris, a personal friend of the painter's, is no exception; Leiris argues that Bacon presents us with a radically demystified art, 'cleansed both of its religious halo and its moral dimension'. Again and again, Leiris calls Bacon a 'realist', who strips down the thing he is looking at in a way which retains 'only its naked reality'. He echoes Bacon himself in arguing that his pictures have no hidden depths and call for no interpretation 'other than the apprehension of what is immediately visible'.

No doubt the 'horror' has been overdone in popular and journalistic responses to Bacon. But it is just as naive to think Bacon is simply recording visual facts, let alone transcribing 'truth'. Creatures like those depicted in *Three Studies* can no more be observed slouching around London streets than haloes can be seen above the heads of good men, or angels in our skies. Of course Bacon's violent imagination distorts what he sees.

But the clash between Bacon's supporters and the populists cannot be dismissed as easily as that. The point remains whether Bacon's distortions are indeed revelatory of a significant truth about men and women beyond the facts of their appearances; or whether they are simply a horrible assault upon our image of ourselves and each other, pursued for sensationalist effects. And this, whether Bacon and his friends like it or not, involves us in questions of interpretation, value and meaning.

The stature of Bacon's achievement from the most unpropitious beginnings is not to be denied. Although his father named his only

son after their ancestor, the Elizabethan philosopher of sweet reason, he was himself an unreasonable and tyrannical man, a racehorse trainer by profession. Nonetheless, Francis, a sickly and asthmatic child, felt sexually attracted to him. Francis received no conventional schooling and left home at sixteen, following an incident in which he was discovered trying on his mother's clothes.

He worked in menial jobs before briefly visiting Berlin and Paris in the late 1920s; soon after, he began painting and drawing, at first without real commitment, direction or success. In the early 1930s, he was better known as a derivative designer of modern rugs and furniture, although an early *Crucifixion*, in oils, was reproduced by Herbert Read in *Art Now*. Bacon subsequently destroyed almost all his early work; his public career thus effectively began only with the exhibition of *Three Studies* in 1944.

Bacon then began to produce the paintings for which he has become famous: at first there were some figures in a landscape; but soon he moved definitively indoors. He displayed splayed bodies, surrounded by tubular furniture of the kind he had once designed, in silent interiors. A fascination with the crucifix and triptych format continued; but he painted the naked, human body – usually male – in all sorts of situations of struggle, suffering and embuggerment. A picture of two naked figures wrestling on a bed of 1953 is surely among his best. But a series of variations on Velázquez's *Portrait of Pope Innocent X* – which he now regrets – became among his most celebrated. By the 1960s, the echoes of religious iconography and the Grand Tradition of painting had become more muted. Bacon could never be accused of 'intimism': 'homeliness' is one of the qualities he hates most. The large, bloody, set-piece interiors continued; but the forms of their figures became less energetic, more statuesque. Bacon seemed increasingly preoccupied with portraits, usually in a triptych format, of his friends and associates: Isabel Rawsthorne, Henrietta Moraes, Lucian Freud, George Dyer (his lover), Muriel Belcher, the owner of a drinking club in Soho he frequented, and himself.

Bacon has repeatedly said that he is not an 'expressionist'; it is easy to show what he means by this by contrasting his work with

that of the currently fashionable, but lesser, painter George Baselitz (at the Whitechapel Gallery) – who is. Baselitz deals with a similar subject matter; but he invariably handles paint in an 'abstract expressionist' manner; i.e. in a way which refers not so much to his subjects as to his own activity and sentiments as an artist. Anatomy, physiognomy, gesture and the composition of an architectural illusion of space mean nothing to him: to Bacon, they are everything. Or rather *almost* everything.

For if he has sought to work in continuity with the High Art of the past, Bacon recognises that the painter, today, is in fact in a very different position. He has regretted the absence of a 'valid myth' within which to work: 'When you're outside tradition, as every artist is today, one can only want to record one's own feelings about certain situations as closely to one's nervous system as one possibly can.'

He stresses that the echoes of religion in his pictures are intended to evoke no residue of spiritual values; Bacon is a man for whom Cimabue's great *Crucifixion* is no more than an image of 'a worm crawling down the cross'. He is interested in the crucifix for the same reason he is fascinated by meat and slaught-erhouses; and also for its compositional possibilities: 'The central figure of Christ is raised into a very pronounced and isolated position, which gives it, from a formal point of view, greater possibilities than having all the different figures placed on the same level. The alteration of level is, from my point of view, very important.' But, for Bacon, the myths of vicarious sacrifice, incarnation, redemption, resurrection, salvation and victory over death mean nothing – even as consoling illusions.

The appeal to a meaningful religious iconography is, in effect, replaced in his work by an appeal to photography; similarly, in his pictures, as in his life, the myth of a jealous and omnipotent god has been replaced by the arbitrary operations of chance.

Bacon's fascination with Muybridge's sequential photographs of men, women and animals in motion is well-known. References to specific Muybridge images are often discernible in his pictures; even his triptych format seems to relate more to them than to traditional altarpieces. He seems to believe that Muybridge ex-posed the illusions of art, and freed it from the need to construct

such illusions in the future. Unlike many who reached similar conclusions, they did not, of course, lead Bacon to narrow aestheticism or abstraction. Rather, he sometimes insists that the artist should become even more 'realist' than the photographer, by getting yet closer to the object; and, at others, that as a result of photography's annexation of appearance, good art today has become just a game.

But this insistence on 'realism', and reduction of art to its ludic and aleatory aspects, are not, in Bacon's philosophy, necessarily opposed. Accident and chance play a central role in his pursuit of 'realistic' images of men; they enter into his painting technique through his reliance on throwing and splattering. In fact, of course, Bacon exercises a consummate control over the effects chance gives him; but, as he once said, 'I want a very ordered image, but I want it to come about by chance.' He fantasizes about the creation of a masterpiece by means of accident. The religious artists of the High Tradition attributed their 'inspiration' to impersonal agencies, like the muses or gods; and Bacon, too, is possessed of an overwhelming need to locate the origins of his own imaginative activity outside of himself.

The role of photography and chance in his creative process relate immediately to the view of man he is seeking to realise. 'Man,' he has said, 'now realizes that he is an accident, that he is a completely futile being, that he has to play out the game without reason.' Thus, in reducing itself to 'a game by which man distracts himself' (rather than a purveyor of moral or spiritual values) art more accurately reflects the human situation even than photography . . . The human situation, that is, as seen by Bacon.

Bacon then has achieved something quite extraordinary. He has used the shell of the High Tradition of European painting to express, in form as much as in content, a view of man which is utterly at odds with everything that tradition proclaims and affirms. Moreover, it must be admitted that he has done so to compelling effect. It is perfectly possible to fault Bacon, technically and formally: he has a tendency to 'fill-in' his backgrounds with bland expanses of colour; recently, he has not always proved able to escape the trap of self-parody, leading to mannerism and stereotyping of some of his forms. But these are quibbles. Bacon,

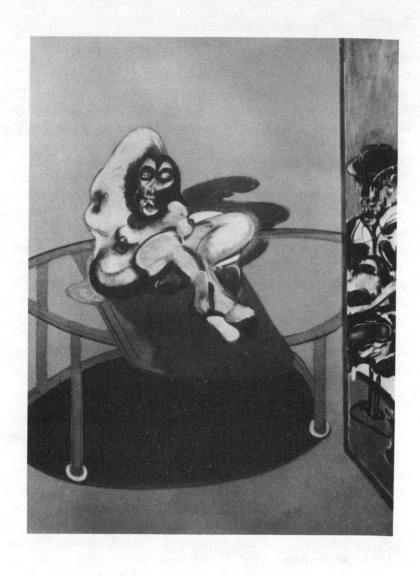

3
Study of Nude with Figure in a Mirror
Francis Bacon

in interviews, has good reason constantly to refer back to the formal aspects of his work; he is indeed the master of them.

But this cannot be the end of the matter in our evaluation of him. Leiris maintains his 'realism' lies in his image of 'man dispossessed of any durable paradise ... able to contemplate himself clear-sightedly'. But is it 'realistic' to have a Baconian vision of man closer to that of a side of streaky pig's meat, skewered at random, than to anything envisaged by his rational ancestor?

Nor can we evade the fact that Bacon's view of man is consonant with the way he lives his life. He emerges from his many interviews as a man with no religious beliefs, no secular ethical values, no faith in human relationships, and no meaningful social or political values either. 'All life,' he says, 'is completely artificial, but I think that what is called social justice makes it more pointlessly artificial ... Who remembers or cares about a happy society?' One may sympathise with Bacon because death wiped out so many of his significant relationships; but his life seems to have been dedicated to futility and chance. It has been said that, for him, the inner city is a 'sexual gymnasium'. He is obsessed with roulette, and the milieu of Soho drinking clubs. He wants to live in 'gilded squalor' in a state of 'exhilarated despair'. He is not so much honest as appallingly frank about his overwhelming 'greed'.

And it is, of course, just such a view of man which Bacon made so powerfully real through his painterly skills. Because he refuses the 'expressionist' option, he also relinquishes that 'redemption through form' which characterises Soutine's carcasses of beef, or Rouault's prostitutes. But it may, nonetheless, be that there is something more to life than the spasmodic activities of perverse hunks of meat in closed rooms. And perhaps, even if the gods are dead, there are secular values more profound and worthwhile than the random decisions of the roulette wheel.

I believe there are; and so I cannot accept Bacon as the great realist of our time. He is a good painter: he is arguably the nearest to a great one to have emerged in Britain since the last war. (Though I believe Frank Auerbach and Leon Kossoff are better.) Nonetheless, in the end, I find the vision of man he uses his undeniable painterly talents to express quite odious. We are not

mere victims of chance; we possess *imagination* – or the capacity to conceive of the world other than the way it is. We also have powers of moral choice, and relatively effective action, whether or not we believe in God. And so I turn away from Bacon's work with a sense of disgust, and relief: relief that it gives us neither the 'facts' nor the necessary 'truth' about our condition.

1983

9
Julian Schnabel

Over the last four years I have seen a good many of Schnabel's paintings, but I had not, until this exhibition, set eyes on one that manifested any painterly qualities at all. I was therefore pleasantly surprised to look at a picture like *Alexander Pope*, which indicates that Schnabel could conceivably learn to draw; or at *Seed*, which shows that, after all, he might have some decorative sensibility. Drawing and decorative sensibility are, you must understand, two of the necessary prerequisites for good painting.

But I don't want to exaggerate Schnabel's slender talents. At the private view, I stood beside Kasmin and Gillian Ayres (yes, we were *all* there) in front of *Alexander Pope*, and Kasmin confided that if he had seen the painting in a studio in Wapping he wouldn't have given it a second thought. Nor should he have. The average first-year intake in any British art school includes several painters capable of realising better work than Schnabel at his best.

At least I hope it does. For whatever flickerings of potential this young tyro possesses, they cannot cover up the fact that he is a painter with the imagination of a retarded adolescent; no technical mastery; no intuitive feeling for pictorial space; no sensitivity towards, or grasp of, tradition; and a colour sense rather less developed than that of Congo, the chimpanzee who was taught (among other things) a crude responsiveness to colour harmonies by Desmond Morris in the late 1950s. However potentially educable as a painter Schnabel may or may not be, his work is just not worthy of serious attention by anyone with a developed taste in this particular art form.

And yet, sadly, this cannot be the end of the matter. We also have to contend with the fact that, as Richard Francis so accurately put it in his hagiographic Tate catalogue, 'Julian Schnabel, born in 1951, has become, since his first exhibition at Mary Boone's

gallery in New York in 1979, one of the most celebrated young artists working anywhere in the world today.' How can this be?

More than once, the comparison has been made with Jasper Johns, who was an overnight success following his first one-man show with Leo Castelli (a business associate of Boone's) in 1958. Johns appeared on the cover of *Artnews* – until that point a tendentious 'abstract' journal. MOMA immediately bought work and the show was a sell-out even before it opened. 'Abstract Expressionism is Dead! Long live Pop Art!' they cried. And Castelli totted up the takings from his cultural *coup*.

There are similarities, of course; but the comparison is unfair to Johns. He may not have been Leonardo, but he did have some realised talent. He could, and still can, draw quite well. He worked terribly hard at getting his intractable surfaces *right*. He could even think a bit too – even if not as much as his fruity protagonists and fruitier prices suggest. If Johns was hyped, it was on the basis of some remote kernel of achievement. But Schnabel?

The qualitative distinction is important because it is often implied that market activity, on its own, provides a complete 'explanation' of why an artist of such low quality as Schnabel has achieved such cultural prominence. The thesis underlying this view is that good art and entrepreneurial economic activity are somehow *necessarily* antithetical, whereas cultural prominence and market success are *necessarily* linked: though fashionable and congenial, I believe this theory to be nonsense.

If you disagree with me, you clearly have not got round to visiting 'The Genius of Venice' at the Royal Academy: this you really should do since it is undoubtedly the finest art exhibition to have been staged in the capital in living memory. Sixteenth-century Venetian painting was flushed with the residues of religious illusions; but it was, *par excellence*, an art created for a new breed of princely merchants. In form and in content, the free-standing oil pictures of the day reflect this emergent secular mercantilism; they are enthused by the values of the Rialto rather than St Mark's.

Sixteenth-century Venetian art celebrated mercantile materialism in its subject matter; it manifested a relish in exotic fabrics, fine furs and silks, precious metals and stones, and ample acreages

of enticing female flesh. It also showed a parallel sensuality in the medium itself: the sensuous possibilities of oil were excitedly discovered and exploited. Now, of course, we may or may not like the ethical values and economic systems which provided the social soil for these sumptuous pictures: but we could deny neither that they were closely related to intense market activity, nor that sixteenth-century Venetian painting is one of the very greatest of all human achievements in the plastic arts.

Nor is this association between a market economy and the efflorescence of creative activity an isolated instance. There is, for example, the lesser, but none the less considerable, case of the achievement of seventeenth-century Dutch painters, which evolved in conjunction with the expansion of a domestic picture market. The vision of these painters was petty bourgeois in content, subject matter, and form. (How neatly their pictures fitted into the trim interiors they depicted.) And yet who would deny that, say, Vermeer was one of the finest painters to have emerged in the West?

Even in more recent times, there is no necessary connection between the determinative influence of an active market, and degradation of aesthetic quality: the worst that can be said of the market in our time is that it is fragmented, but all its differing sectors taken together are effectively aesthetically neutral, since they elevate good and bad alike. Thus whereas it is perfectly true the market can sell anything – even folded blankets, canned shit, twigs, bricks and so forth – there is no evidence that such phenomena were *caused* by the market, nor that the market prefers such things, nor even that it welcomed their arrival. Indeed, it could credibly be argued that much of the most decadent art of our time only came into view because those who produced it were insulated from the full impact of market forces, either through the possession of private wealth, or, more recently, through the existing system of 'hands-off' government patronage.

Dealers do not have to be altruistic to prefer works of quality to fashionable rubbish; not only is good art an easier sell, it is also a much better long-term investment prospect. But there is, of course, no direct channel between market success and cultural prominence. If you study the art market in Britain over the last

quarter-century, you will quickly discover that there has been an active market in high-priced, high-quality English painting – for example in the work of Freud, Auerbach or Kossoff. But, until four or five years ago, despite their buoyancy within the market-place, these painters received virtually no art world attention: their bibliographies are still very much shorter than Schnabel's today. There has also been a very active market in high-priced works of low or negligible quality (e.g. Terence Cuneo, David Shepherd, Montagu Dawson) which still have received little or no critical attention. I conclude nothing from all this, except that intensification of market activity is neither an indication of the presence of aesthetic quality, nor yet of its absence; nor does market success lead in any simple or necessary way to the sort of cultural over-exposure which young Schnabel is currently enjoying.

So we have to look deeper. We have to ask what sort of market, and who is it serving? What sort of cultural values do the patrons of this kind of art hold? The point is not that the Saatchis are rich: it is rather that, despite their wealth, they do not have the taste of those merchant princes, honest innkeepers of seventeenth-century Holland, or even the wealthy country-house aristocrats who have been buying Lucian Freuds all these years.

The Saatchis spend their working lives promoting a dominant cultural form, advertising, which allows no space for the social expression of individual subjectivity. It is therefore predictable that, unlike merchant princes, aristocrats, Dutch innkeepers and others who possessed both wealth and taste, they prefer fine art forms which are *nothing but* a solipsistic, infantile wallowing in the excremental gold of the otherwise excluded subjective dimension. Schnabel and Waddington are entitled, if they so wish, to serve the tasteless sensibilities of the advertising tycoons. But it is one thing for such people to pursue their degraded tastes in private, and quite another for our leading modern art institution, the Tate Gallery, to indulge those tastes in public. I believe that Alan Bowness should indicate to us what the true aesthetic qualities of the Schnabels he has so freely purchased are: and if he cannot do so, he should resign.

1984

III

ARS BRITANNICA

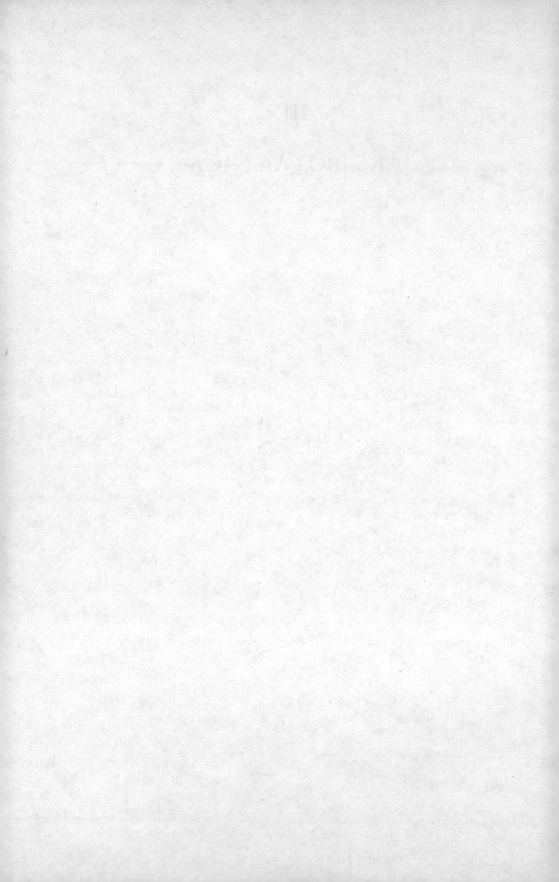

Mother Nature

British landscape painting began to flower in the mid-eighteenth century, and soon showed extraordinary richness and variety. Its heyday lasted until the death of Turner in 1851. This first century was the subject of a magnificent exhibition, *Landscape in Britain: circa 1750–1850*, at the Tate Gallery a decade ago. The Arts Council has offered a successor, *Landscape in Britain, 1850–1950*.

The Tate show – which included Wilson, Gainsborough, Turner and Constable – celebrated a vision which, for all its variety, was nonetheless confident in itself. The best work at the Hayward is also deeply moving, and there is nothing there which is not interesting. But the exhibition chronicles the faltering of that once confident vision, its transformation, fragmentation and, finally, its disintegration.

How are we to understand the rise and fall of British landscape painting? It began as a shift in taste, a reaction against, or rather a modification of, the classical, Arcadian tradition of Claude and the two Poussins. These painters created whole, separate and radically other worlds within their pictures. The present, immediate and particular were excluded. Their idealised vistas were peopled with gods and heroes. The British artists, beginning with Richard Wilson, allowed a fresh experience of nature to replenish their work. This was partly empirical, in that they began to look at natural form more closely than ever before; but it also involved a profound change in sentiment – a shift from an aesthetic based on the otherness of the world depicted towards the celebration of fusion; from the beautiful to the sublime.

One factor which led British painters to adapt tradition in this way was the good old English weather. The older painters had required the apparatus of classical composition and mythology to make their pictures expressive of high sentiment. But the

changeability, nuance and underlying temperateness of the English climate encouraged artists to evoke human moods and feelings through attending to natural phenomena alone. The relentless glare of the Mediterranean sun may be good for the growth of grapes; it is less so for the cultivation of the Pathetic Fallacy.

But there were also, of course, historical reasons. Gothic craft traditions, associated with the building of the great cathedrals and the celebration of a "divine" creation, expired here abruptly in the early sixteenth century. But iconoclastic and puritanical tendencies in British culture, stemming from the Reformation, inhibited the emergence of a secular system of visual symbolism, based on pagan myth and the human figure.

Simultaneously, a new breed of capitalist farmers encouraged the production of mundane rural imagery, depicting their estates, houses, livestock and hunts. This common-or-garden tradition provided the subsoil for the emergence of a 'higher' landscape painting which could offer an illusion of hope, healing and reconciliation (like a cathedral) through an image of the world transfigured. 'The English school of landscape,' as Ruskin so vividly put it, 'culminating in Turner, is in reality nothing else than a healthy effort to fill the void which destruction of Gothic architecture has left.'

Turner had as acute an eye for the curl of that particular leaf, and the twist of that particular stem, as the carvers of those extraordinary capitals on the columns in Southwell Minster, and similarly his imagination led him to create a sublime, boundless, engulfing and suffusing image of nature, which drew the viewer into itself, and in which he could lose himself, and feel at one with what was depicted. In Turner's vision of nature, as in Amiens Cathedral, a believing critic, like Ruskin, could see (or so he thought) God revealed.

Today it is possible to talk about these phenomena in secular terms. Donald Winnicott, the psychoanalyst, once pointed out that the infant's emotional experience of the mother tends to split her into two: 'the object mother', who is the focus of excited, instinctual attentions – say, during, feeding – and 'the environment mother', whose holding, sustaining and providing forms the

ground of the infant's 'going-on-being' before he becomes a separate person. I believe that the aesthetic feelings we call 'beautiful' have their roots in the former infantile experiences, and those we call 'sublime' in the latter.

I am not trying to reduce our responses to Poussin's *Nurture of Jupiter* (circa 1635), or Turner's mountain scenes, to the feelings which accompanied infantile feeding, or the blissful sensation of fusion with the mother, respectively. Winnicott assumed that, in the beginning, each of us entertains the illusion that we created the mother (and by extension, the world) who sustains and supports us. But, as the child develops, he gradually intuits the separateness of the world, and accepts the disillusioning idea he did not create it.

At this time, Winnicott argued, the infant establishes a "potential space" in which through play, toys and so on, the fantasized and the real are mingled through imagination in consoling and creative ways. In aesthetically and spiritually healthy societies there is a continuity between these infantile activities and culture itself as realised in creative work, religious and artistic pursuits. But with the decline of belief, and the industrialisation of labour, 'the potential space' was squeezed out of ordinary life.

It came to reside in those imaginary worlds which painters created behind the picture plane. This is not, of course, a matter of regressing to the lost paradise of early infancy. Rather, the painter sought to create an *adult* equivalent which drew upon developed sentiments, acquired skills and mature perceptions of the external world. The pictures he offered were then 'other realities within the existing one'; those who enjoyed them did not recognise there the world they already knew. Rather, they witnessed a vision of a world transformed, which was both memories and promise, personal and potentially historic.

However, as the nineteenth century progressed, it became harder and harder for landscape painters to offer these reconciling illusions, in either the beautiful or the sublime modes. The outside world became increasingly resilient to imaginative transformation. It was easy enough for landscape painters to avert their eyes from the impinging apparatus of modern industry, and most, of course, did. But it proved much harder to evade the changes in the

structure of feeling which the continued retraction of religious belief, rise of uncreative factory work and estrangement from nature brought about.

Recently, sociologically inclined art historians have insistently argued that the omission of, say, rural poverty and the signs of advancing industrialisation from much nineteenth-century landscape was somehow morally, or imaginatively, reprehensible – 'escapist', rather than desirably 'realist'.

But I believe this argument needs to be stood on its head: for what wrecked the higher landscape was not a flight from reality, but rather its progressive intrusion and impingement in a way which shattered the 'potential space'. As Ian Jeffrey puts it in his interesting article in the catalogue to the Hayward exhibition, 'Prosaic matter crops up again and again in paintings by Ford Madox Brown, William Holman Hunt and John Everett Millais, in views and close-ups seemingly cut at random from Nature.'

The question arises, Jeffrey continues, 'why this rather than some other more or less insignificant sample of earth?' These were the first intimations of the landscape painter's historic crisis: his growing inability to transfigure the world convincingly even in imaginative illusion.

The higher landscape, however, had one last incarnation before it withered away. In 1871, following the death of his mother, John Ruskin withdrew to Brantwood, a house overlooking Coniston Water, where he suddenly became oppressed by a sense of 'the failure of nature'. He thought he could detect a storm cloud, and a menacing plague wind, out there in the real landscape, which portended some ultimate annihilation brought about by the blasphemous actions of men.

Ruskin's 'storm cloud of the nineteenth century' has been interpreted in many ways: as the literal observation of phenomena brought about by growing industrial pollution; as an emotional reaction to the failure of the harvests of the early 1870s; or simply as a symptom of his incipient insanity. Aesthetic theorists, however, had long recognised that, within the sublime, there was an element of terror; the loss of self might be absolute. Winnicott, too, spoke of that 'threat of annihilation' which tinges the infant's

experience in his state of absolute dependency. Perhaps Ruskin's vision was a depressive projection, brought about by the death of his mother (to whom he was peculiarly close). If so, it was a projection which illuminated a historical relationship to nature, too. For this desolate wasteland, this 'negative utopia', was the last, desperate offering of the higher landscape tradition.

You can see one of the finest examples of it in Millais's magnificent picture, *Chill October*, painted in 1870, in the Hayward exhibition. The bleak, brown and grey world Millais reveals to us, with its dead foliage, ominous birds and murkily glimmering water, is the inverse of any image of Arcady. It is the sort of lake on whose shores we might expect to find a corpse.

And yet, as we look at it, we do not experience that absolute depressive despair of which Ruskin complained. For nature may have failed; but Millais demonstrates that art has not – yet. The redeeming power of his image comes not through what he reveals to us, but rather from the way he does so; from the skill through which he has realised this terrifying sight in paint.

The last retreat of the aesthetic response was indeed via the negative sublime into the world of fully abstract painting: Peter Lanyon, who often referred to 'immersion in landscape', provides a compelling intermediate example in his *Ground Sea*, in this exhibition. But the aesthetic dimension did not long survive even there. Modernist dogmas of 'truth to materials' reflected the relentless intrusion of the real, the remorseless sealing over of the 'potential space' in every area of adult experience, even painting. Just as the higher landscape has sunk into the desolation of *Chill October*, the higher abstraction, too, disappeared into the complete negation of the blank grey monochrome.

Landscape, of course, persisted: but it tended to become sentimental. Some painters offered images of consolation, or even desolation, without ever having experienced those sentiments which would have enabled them to make their pictures convincing. Alternatively, landscape became the reproduction of the appearances of the real – in 'photographic' paintings, and photography itself, in natural history illustration, Shell Guides, Ordnance Survey maps, postcards and rambler's brochures. (The Hayward contains many intriguing examples of such items.)

Certainly, these things have their use, place and fascination. But they are no substitute for lost illusions.

Had this exhibition, however, taken matters up to the present, it might have been able to end on a more hopeful note. Present ecological concern; disillusionment with the joys of endlessly increasing production; and the evident failure of Modernism's quest for a machine-based aesthetic, all provide the background to the attempt of some artists to evolve a new, imaginative vision of nature.

One thing seems to me to be certain: Donald Davie is right, in the catalogue, when he defends the tradition of the higher landscape from the criticisms of the reductionists. 'A work of art which paints a picture of a Britain that once was, or once may have been, may be commenting sharply on the very different Britain that we inhabit', he writes. Indeed, it may be revealing to us precisely those elements of human being, potentiality and sentiment, which we need to foster and encourage if we are to avoid that ultimate extinction which Ruskin and Millais, in their different ways, both prophesied.

1983

'Neo-Romanticism': a Defence of English Pastoralism

In 1903, George Gissing wrote of 'true England': 'This fair broad land of the lovely villages signifies little save to the antiquary, the poet, the painter.' He continued, 'Vainly, indeed, should I show its beauty and its peace to the observant foreigner; he would but smile, and, with a glance at the traction-engine just coming along the road, indicate the direction of his thoughts.'

Eighty years later, the traction engines have been replaced by High Speed Passenger Trains and juggernauts; but, despite the advance of American culture and the microchip, this yearning for a 'fair broad land of lovely villages' persists. Antiquaries, poets and painters continue to turn to a vision of 'true England' for inspiration and consolation.

Indeed, the return to landscape has become something of a stampede. Ten years ago, no self-respecting art student (with one eye on the Modernist tradition, and the other on a future Arts Council Grant) would have touched a box of watercolours or have gone near lakes, valleys, rolling fields and small Gothic churches. Today, the hills are alive with the sight of *plein air* painters once again.

Predictably, this cultural shift has been accompanied by a rewriting of the recent past; the traction engine, and the foreigner's glance, are no longer seen as the harbingers of all that is worth attending to in contemporary art. The exhibition 'The British Neo-Romantics' is a significant contribution to this revision.

In the catalogue, the organisers argue that the waning of the European 'historicist' account of Modernism has been accompanied by a parallel waning of the belief that abstract art is the only true expression of the Modern spirit. They report 'a dramatic renewal of interest in both Romanticism outside the French tradition and the figurative and landscape traditions in twentieth

century art'. This celebration of the moment of British 'Neo-Romantic' painting, between 1935 and 1950, is presented as part of that renewal.

The exhibition begins with a section of nineteenth-century antecedents. Surprisingly, these turn out to be solely the *prints* of Blake, Linnell, Calvert and Palmer. The argument runs that the spirit of these etchings was handed down to Frederick Landseer Maur Griggs, who began to produce fine work in 1912, the year he was received into the Roman Catholic Church. The 'Neo-Romantic' mantle descended, thereby, on to the shoulders of Graham Sutherland, who started to exhibit etchings, with strong affinities to the Palmer tradition, at the Royal Academy in the 1920s.

In 1931, Sutherland abandoned etching for painting: and thus was twentieth-century British 'Neo-Romanticism' born. The 'new style' emerged in the 1930s, through the work of Sutherland himself, Piper, Moore (as draughtsman and painter), Katharine Church, Charles Murray, Alan Sorrell, Julian Trevelyan and John Aldridge. It flowered during the war years with additional contributions from Ayrton, Minton, Craxton, Vaughan, Colquhoun, Richards, Wynter, Clough, Jones, Hitchens, Pasmore and others.

Like all 'romantic' movements, this one proves almost impossible to define in stylistic terms alone. But its characteristics were a persistent Englishness of vision, intimately linked to a preoccupation with the particularities of our landscape. (Richards elaborated similar painterly sentiments in Welsh terms.) But, for all these artists, the pursuit of landscape was always something more than the quest for phenomena, or the appearances of natural and human forms. They were intent upon a transfiguration of what they saw: often, they laid claim to a religious or spiritual vision; always, they wanted to rupture the surfaces of the given with imaginative transformations. Landscape, for them, was an arena in which the subjective and the objective, the deeply personal and the richly traditional, could be mingled in new and previously unseen ways.

Now in one sense, this seems to me a worthwhile, even an important exhibition. The recovery of both the continuing 'romantic' tradition, and the celebration of a uniquely British

cultural tendency, at odds with the alleged 'mainstream' of Modernist development, are projects with which I have every sympathy. Nonetheless, two significant questions are raised by this show. The first concerns its presentation of 'Neo-Romanticism' as a narrowly defined artistic movement springing out of a particular tributary of etching history; and the second, the actual quality and stature of many of the works shown.

It is perhaps typical of art dealers and historians that they require direct lines of linkage. They assume that influence and development are a matter of contiguity alone. X knew of Y and borrowed such and such a convention, such and such a device from him. This 'etching' line into Neo-Romanticism neglects the unseen soil into which, however unknowingly, Neo-Romanticism's roots reach back. English Romanticism, after all, is a much richer, broader, and more pervasive phenomenon than a nineteenth-century etching tradition. (In one sense, this is tacitly admitted in the show; Hitchens, for one, cannot really be accommodated by the art-historical 'line' traced here.) Whatever the superficial elaborations of Modernism, this Romantic sensibility has – to use one of those awful vogue words – 'subtended' a great deal of our national cultural production. It permeates important tributaries of literature, painting, poetry and critical thought alike.

I cannot recapitulate here all the arguments concerning the source of this peculiarly English sensibility. I have done so often enough elsewhere. I believe its roots are to be found deep in the heart of our national history; it arises, as others have tried to demonstrate, from the fact that in Britain capitalism was initiated in the countryside, in the great agrarian estates, even before it emerged in its industrial forms.

Britain experienced no clash between the cultures of an *ancien régime* and that of a stridently emerging 'bourgeois' industrial class; rather, the latter incorporated and adapted traditional rural values. The first and the greatest 'industrial revolution' involved no radical rejection of a prior culture. There was always, in British cultural life, a profound *ideological* reluctance concerning the spread of industrial capitalism. This reluctance is manifest in the writings of the great nineteenth-century critics, Ruskin, Arnold

and Morris among them, for whom the model of culture remained nature rather than mechanism. In painting, the vitality of this persistent 'pastoralism' can be seen in the vigour of the landscape tradition, personified in Turner's contribution, and perpetuated later in the century through the best work of the pre-Raphaelites.

Admittedly, as the century wore on, this rural vision became increasingly impinged upon; in the writings of Ruskin, from 1870 onwards, and in a great picture, like Millais's *Chill October* of that year, landscape acquired a desolate and foreboding presence. The hope of Eden, projected as a vision for the future, was replaced by the purgatory of the present. Art came not so much to reflect the consolations of an idyll, but rather to chronicle the pain of a spreading alienation. The Higher Landscape tended to become drained of content, and, in the twentieth century, to fade into abstraction. In this situation, the spurious optimism of a profoundly collusive and collaborationist Modernism, celebrating the new technology, began to gain ground, even in Britain. But its 'victory' in this island was never as absolute as elsewhere.

In 'life', of course, the rural alternative had become increasingly marginalised as the nineteenth century wore on. As Jan Marsh has written in her study of the pastoral impulse in Victorian England, from 1880 to 1914, 'Only a handful of "cranks" kept the alternative ideas alive, eating vegetarian health foods, and sending their children to notoriously permissive "progressive" schools.' She adds, 'The disregard of the whole cluster of back-to-nature and Simple Life ideas was almost total.'

Nonetheless, she points out that in other, cultural respects, this 'pastoralism' did not fail. That same idea which motivated Ruskin's vision of rural England under the aegis of the Guild of St George, and Morris's more vigorous image of 'The Garden City', spilled over in the twentieth century into the 'pastoralism' of Georgian poetry, and even into such academic phenomena as the rise of anthropology. This, according to Marsh, was associated with the belief that 'the savage may no longer be noble, but he has a mythical contentment not known to the rest of us'. Marsh even traces what she regards as similar modes of thinking into belief in fairies, strange religious cults, occultism and claims to various forms of divine knowledge. Such phenomena, she supposes, 'like

the same soil as Pastoralism'. Had she known about 'Neo-Romanticism', and the quirkiness of so many of its practitioners, she would have had no difficulty in fitting it into her thesis.

This strand of British culture, of which the 'Neo-Romantic' movement in painting from 1935 to 1950s formed a significant part, has recently excited a considerable amount of comment – most of it, whether coming from the right or the left, decidedly negative. Marsh argues that this pastoralism has had the destructive effect of encouraging men and women to believe that the urban, industrial way of life is 'fundamentally unnatural, a chief cause of modern ills'. Such erroneous ideas, she suggests, contribute towards our failure to make the cities better places in which to live. And so we should learn to reject this 'imprinted pastoralism', and begin to come to terms with the fact that the modern city is here to stay.

Others have complained that this pastoralism has had corrosive effects on Britain's potential for economic growth. In his seminal *English Culture and the Decline of the Industrial Spirit*, Martin J. Wiener sets out to demonstrate how the British middle classes were, from the beginning, absorbed into 'a quasi-aristocratic elite, which nurtured both the rustic and nostalgic myth of an "English way of life" and the transfer of interest and energies away from the creation of wealth.' This, he claims, has led to a pattern of industrial behaviour suspicious of change, reluctant to innovate, energetic only in maintaining the status quo.

He concludes that 'it may be that Margaret Thatcher will find her most fundamental challenge not in holding down the money supply or inhibiting government spending, or even in fighting the shop stewards, but in changing this frame of mind.'

Thus 'progressive' critics of both the left and the right are united in their denigration of pastoralism. This we might have expected. The true heroine of the technicist 'avant-garde', despite its leftist veneer, is, of course, Margaret Thatcher, with her unrestrained enthusiasm for the ravaging of what survives of our culture by new technologies, her contempt for tradition, conservationism and the natural environment.

The issue is not quite as simple as that. In his brilliant analysis of the way in which the Falklands crisis illuminated British culture,

Anthony Barnett demonstrated how Thatcher herself was fully prepared to invoke the myth of pastoralism when it suited her purpose. This she did over the Falklands issue by playing up the idea that a pastoral idyll had been punctured by an alien invader, that the Nazis had, as it were, stormed into Ambridge. (See *Iron Britannia*, Allison & Busby 1982, p. 102 ff.) Pastoralism has certainly been subject to other corrupt usages, too. For example, Enoch Powell's early speeches freely invoked an image of Merrie England, 'so sweetly mixed of opposites in climate that all the seasons of the year appear there in their greatest perfection . . . where the same blackthorn showered its petals upon them as upon us,' etc., etc. And yet this somehow became transmuted into a backdrop for divisive racism, and a prophecy of 'rivers of blood'.

Similarly the Christian concept of Jesus, the god-man, saviour, reconciler and redeemer of man from his sin, could become transmuted into a justification for the torture chambers of the Inquisition, or, in the writings of Nazi theologians, into an image of 'Christ the Fuehrer' whose teaching was finally coming to fruition in Hitler's Third Reich. The Communist symbol of class-struggle as the initiator of 'the end of history', and of a peaceful Utopia on earth, could be invoked by Stalin to legitimise his purges, or by Pol Pot to underwrite the systematic murder and annihilation of whole classes and sections of society. Certainly, of course, such historical facts demand attention and analysis; but they are not, in and of themselves, 'demolitions' of those symbolic ideas from which they purport to trace descent.

Indeed, the problem, for me, is the reverse of the 'demythologis-ing' approach usually celebrated on the left. A society which has no hegemonising religious beliefs lacks a shared symbolic order, with disastrous effects on both aesthetics and ethics. As that great anthropologist Gregory Bateson (who, like me, was no believer) once saw, the decline since the nineteenth century of the belief in the immanence of god within nature has tended to lead men to regard nature as alien, as unworthy of ethical or aesthetic consid-eration. When this was combined with an advanced technological development, Bateson argued, a society's chances of survival were likely to be no greater than that of a snowball in hell.

Whatever its class and culture-specific origins, the phenomenon the critics dismiss as 'pastoralism' is one of the few symbolic ideas in our culture from which we can draw some hope. It stands as a continuing, secular image of a man's reconciliation to himself, of reconciliation between man and man, and, indeed, between man and nature. Argument about whether such an age 'really' existed in the past no more demolishes the validity of the symbol than the discovery of a distinction between 'The Christ of Faith' and 'The Jesus of History' automatically invalidates the achievements and consolations of Christian Faith. What matters is that it is not just fantastic; it is rooted not only in history, but also in a vision of present potentialities. Thus it constitutes a paradox which demands not so much 'demystification' as acceptance, nurture and respect.

For all the corruptions to which it may be subjected, 'pastoralism' seems to me infinitely more potent and relevant as a cultural symbol than Modernist-quasi-Marxist-Thatcherite models of 'progress' and triumphalist subjection of, and emancipation from, nature. Surely, whatever their specific social determinants, all such positions are, at bottom, infantilist denials of dependency upon the mother. Indeed, the critics of pastoralism persistently represent it as something marginal, eccentric and nostalgic. (Jan Marsh, for example, seems to think it will go the way of macrobiotic foods and flower-power.) But such commentators seem blissfully unaware of the fact that we are entering a cultural era which is – Mr Kevin Gough-Yates's bigoted film reviews in *Art Monthly* notwithstanding – post-modern, and post-industrial. In this new era, there is a growing rejection of the idea that increased production, *per se*, is the saviour of civilisation. Greater emphasis is being placed on the quality, rather than the quantity, of both products and labour itself. Concern about the ecological care of the planet is increasing. In this situation, the imaginings of Vorticists, the Futurists, and the video-freaks begin to appear archaic and insular; movements like 'Neo-Romanticism' can be seen, in retrospective, as the truly prophetic developments in British art of this century.

And yet, and yet . . . When all has been said and done, the question of the quality of these works remains. William Feaver

wrote in the *Observer* that the Neo-Romantics were characterised by an 'adolescent' vision; and there is a sense in which he was indubitably right. If you visit the Fischer show, it is hard to escape the feeling that there is something eccentric, petty, puny, even crabbed and stunted about this vision. Oh yes, certainly there are exceptions. A revelation to me were Piper's extraordinary water-colours of Welsh mountains. They looked so like the best of Ruskin's great drawings, where he set out to 'anatomise' moun-tain scenery, and, almost unbeknown to himself, enthused the rocks and stones with intimations of his tender imaginings about loved human objects; so his 'fiery peaks' not only reflected with extraordinary accuracy the strata of the world, they were en-thused and redolent with his subjective sentiments. Something like this, I believe, is always characteristic of aesthetically healthy vision, where men and women do not feel alienated from the natural world they inhabit:

> This thy stature is like to a palm tree,
> And thy breasts to clusters of grapes.
> I said, I will go up to the palm tree,
> I will take hold of the boughs thereof:
> Now also thy breasts shall be as clusters of the vine,
> And the smell of thy nose like apples;
> And the roof of thy mouth like the best wine.

Yet the Piper images are exceptions. And, if 'Neo-Romanticism' was weak, its cultural successors, since the 1950s, have often been weaker still. I have analysed elsewhere the collusive and corrupted pseudo-pastoralism of Peter Blake and his fellow 'Ruralists' in the 1970s (who would deserve the worst of Marsh's scorn). An exception may well be the 'mystical' landscape of Norman Adams, which has always (unlike Blake) been consistently under-rated.

But how are we to account for this weakness? No painter, I believe, manifests it more than Graham Sutherland; and no painter reveals more lucidly its causes. For Sutherland did every-thing I believe a painter 'ought' to do. Sutherland studied nature; he drew incessantly and attended relentlessly to the specificities of

natural form. He had a developed sense of tradition, of belonging to, and emerging out of, the greatest art of the past. All his work was, however, uncompromisingly contemporary, characterised by a search for imaginative transfiguration, a desire to redeem sacred nature, bombed cities and mutilated men and women through the exercise of aesthetic transformation. Yet for all the daunting scale and ambition of his work, for all his undeniably productivity and achievement, in the end, so much of what he did seems to me lifeless, dead and unconvincing.

There are, of course, no guarantees in aesthetic work; and in part, Sutherland's failure – and failure, I believe, it was – may have been simply the result of the limitation of talents which he pushed to the uttermost. But I feel it was also because he did not press his secular pastoralism far enough. Instead, as a believer, he fell back on residual intimations of the iconography of faith; he saw not that new imaginative engagement with nature which man must develop if he is to save himself, but fragments of the sacred crown in the thorn bush; hints of the cross in the crumbling lintel.

Sutherland's failure is underlined, I believe, by Moore's success. Certainly, Moore cannot be projected beyond criticism: I have attempted a 'fully-cylindrical' assessment of his achievement elsewhere. But here, suffice it to say that, at his best, he evaded the deprivation of the absence of a shared symbolic order in our society by revealing a fully secular vision of reconciliation through his mastery, and imaginative elaboration, of natural and human form. The best of Henry Moore's work, of course, will survive long after most of the Modernist by-products of our synthetic culture have been forgotten or destroyed. Moore's achievement, and *especially*, for me, his achievement up until the mid 1950s, at once testifies to the validity, indeed the necessity, of the British 'pastoralist' quest; and reveals why so many of those who set out on this path got nowhere. Neither the iconography of the past (Sutherland's mistake) nor that of the present (Peter Blake's) can be of much help: the language has to be found anew, in nature itself.

1983

12
Pleasing Decay: John Piper

Recently, Fraser Harrison, a country writer, and I have taken up an activity John Betjeman and John Piper have been engaging in for most of their lives. Betjeman once called it 'church-crawling'. At weekends we arm ourselves with a bundle of maps and *The Buildings of Suffolk* by the man whom Betjeman likes to call 'Herr Doktor Professor' and set off into the Suffolk countryside in search of Gothic pleasures.

We soon ran through the conspicuous splendour of Lavenham's lovely woolmerchants' church; Long Melford's airy clerestory; and the angel roof at St Mary's in Bury St Edmunds, which you can light up by dropping ten pence in a slot. We are now into more esoteric things: the carved bench ends and backs at Stowlangtoft; the tower at Eye; the twelfth-century ruins behind St Bartholomew's at Orford-Nigh-the-Seas; and the soaring font cover at Ufford, which miraculously escaped the attentions of that assiduous iconoclast, William Dowsing.

And so it was, I suppose, predictable that I should warm to John Piper's exhibition at the Tate Gallery. Some of the best of Piper's images of places are of Suffolk churches: for example his ink, watercolour and gouache of *Three Suffolk Towers* of 1962 and 1963 – though one of them happens to be across the Norfolk border; or his magnificently lively watercolour and gouache of Syleham church of 1971. Piper has the sort of vision which responds immediately to the decorative flint flush-work which is such a feature of these buildings, and which, in the nineteenth century, inspired the 'constructional polychromy' of that great Victorian architect, William Butterfield.

And yet Harrison and I are all too conscious that we have a long, long way to go in following in Piper's tyre-treads. Piper has been church-crawling all over Britain for more than sixty years. In *Piper's Places*, his new book on the artist published by Chatto &

Windus, Richard Ingrams reports how, back in the 1920s, Piper visited churches at Thaxted, Chickney, Newport, Wendens Ambo, Great Chishill, Barley, Wimbish, Melbourn, Harston, Trumpington, and Cambridge *in a single summer's day.* Nor was this in any way exceptional. Later on, even the indefatigable Betjeman was to complain to Piper, 'I can't do more than ten churches a day, old boy.' But then Piper had at least one distinct advantage over me; from an early age, he could drive. My licence is still only provisional, though I am hoping that through these *sorties* into the remoter regions of Suffolk I will gain sufficient experience behind the wheel to impress the examiner next time round.

All this has led me to realise how, for all his predilections for the past, Piper's vision of England has been more thoroughly rooted in the possibilities of the present than mine, or many of those who have criticised him. Certainly, Piper's art has continuities with nineteenth-century romanticism, and much earlier traditions than that. He has a taste for lowering skies and images of 'pleasing decay', and an exceptional sensitivity to the effects which the passage of time have had in shaping the landscape and architectural inheritance of Britain. But he is not nostalgic.

For the medieval peasant, the parish church must have seemed to be the enduring centre of communal life, where local history accreted, monuments were erected, the dead were buried, and the living given in marriage. The next church, even if visible on the horizon, was already a long journey away in an alien domain. 'The basic and unexplainable thing about my paintings', Piper once said, 'is a feeling for places. Not for "travel", but just for going somewhere – anywhere, really – and trying to see what hasn't been seen before.'

Piper was not interested in the blinkered glances of the busy, snap-happy tourist. But he wanted to find a way of recording what he saw which was adaptable to this thoroughly twentieth-century possibility of responding to the particular essence of a given place . . . and then moving on, and on: perhaps up to ten times in a single day. He achieved this in his best paintings through a unique combination of the best of English romantic and empirical painting traditions, and an intelligent assimilation of the findings of the

modern movements in art. And so, yes, certainly, there is something Gothic, romantic, and Ruskinian about much of what he does; but it was not for nothing that he spent so many years working on the Shell Guides, or that Mobil decided to sponsor this exhibition. The carburettor has been as essential to the development of his art as the crumbling cloister wall: Piper teaches us that modernity in art need not be synonymous with the denial of the past, the parading of mechanism, or the refusal of an imaginative response to the visible present.

In a short introduction he wrote for a catalogue of one of his own exhibitions in 1948, Piper described how he had come to value Ruskin's view that 'you will never love art well till you love what she mirrors better'; and what she mirrored, for Ruskin, was *nature*. Piper wrote, too, of his love of Rouault 'for his powerful use of colour irrespective of the even more powerful story he has to tell'. 'Today,' Piper continued, 'I hope to be a painter who reacts in favour of early loves without being reactionary, and who paints churches both medieval and Victorian, mountains, beaches, downs and valleys, without for a moment forgetting that on most downs there is an aerodrome, from most mountains you can see factories in the valleys, that many churches are nearly empty on Sundays, and that on any English beach there may be an unexploded mine.'

Piper was born in 1903 at Arlesford House, Epsom. His background was one of deference, not without tension, to his father's impeccable, and cultivated, English middle-class, professional values. From Piper Senior, he inherited his meticulous concern for architecture and topography. He was sent to Epsom College, starting there the term after Graham Sutherland left, and forty-four years before the young Peter Fuller arrived. The experience rendered me unable to look at any Victorian architecture for at least ten years; it apparently did not have the same effect on Piper, but then he was only a day-boy, and was thus spared having to sleep under those hideous castellated turrets. On leaving school, however, Piper became under parental pressure an articled clerk in his father's offices in Vincent Square. When the latter died in 1926, he immediately took up the study of art, first at Richmond, then at the Royal College.

In 1927, when he was being taught stained glass by Francis Spear, Piper met the Cubist painter, Braque, at Jim Ede's house in Hampstead. His own early work included meticulous copies of medieval glass, and collaged landscapes. His first signs of real originality emerged in a series of abstract constructions and paintings, and, for some time in the 1930s, he and his second wife, Myfanwy Evans, were deeply involved in the polemics and publishing activities of the abstract movement. But Piper infuriated the purists by regarding his involvement with abstraction as a kind of exploratory excursion which would shake up, and in the end extend, his English topographic inheritance with a new, decorative sensibility. Apart from Braque, twentieth-century artists who most deeply influenced him were Rouault, Picasso and, significantly, Dufy. When he visited the Paris International Exhibition of 1937, he was profoundly affected by Dufy's vast decorative mural on the theme of *L'Electricité*. By a happy chance, Piper at the Tate coincides with Dufy at the Hayward, and it is easy to see how similar they are, in both style and standing. But there was one profound difference between them: Piper was English, and not French; his decorative vision has been filtered through an Anglo-Saxon rather than a Mediterranean culture.

In 1935, Piper set up home in a flint and brick farm house at Fawley Bottom, near Henley-on-Thames, where he has lived ever since. Piper pursued his art in a wide variety of ways: before the war, he was already involved in the production of Shell Guides, and beautiful illustrated books, and in that work as a theatrical designer which was to flower in the late 1940s. During the war, he threw himself into his work as an official war artist, producing exceptional paintings of bombed churches at Bristol, Coventry and London. In the best of them, even the cinders and ruins seem to sparkle with the promise of decorative redemption, through Piper's fluent lines, and jewel-like dashes of colour.

But he also found time to pursue his personal, picturesque vision, too, painting some of his finest pictures at Stourhead, Hafod, Lacock Abbey and Renishaw Hall. The best of all, I believe, are the drawings and paintings he made in the 1940s, of the Welsh mountains and rocks. Although it was then unfashionable to do so, Piper had been studying Ruskin, and had under-

stood his ideas about the need for an acute and particular
perception of geological conformations which somehow metamorphosed itself without any loss of detail into an imaginative or
'spiritual' vision of nature. Later, he was to make stained glass
for Eton College Chapel, and the famous abstract window for
the Baptistery at Coventry Cathedral. There were tapestries,
too, and in the 1970s less than successful decorated pots and
ceramics.

But Piper has always regarded his painting as the root of all his
activities as an artist. His pictures, in particular, have often been
dismissed as 'provincial' in outlook, and 'retrograde' in their
aesthetic concerns. In art history books, he is often portrayed as a
minor figure, and contrasted unfavourably with those artists who
uncritically adopted European, and later, American, styles and
mannerisms.

Piper has always been a painter of English landscape – though
recently he has worked successfully in the Dordogne and in Venice
– through a conspicuously English sensibility. But if he sought a
continuity with romantic traditions in English culture, it was a
replenished continuity. His painting affirms that though life in the
twentieth century necessarily involves a changed vision, and
changed values, it need not, or perhaps *ought* not, to involve some
absolute, philistine rupture with the achievements of our cultural
past, nor yet with art's capacity to give pleasure through decoration.

Indeed, I sometimes wonder whether Piper did not concede *too
much* to contemporary ways of seeing, and making images. For
though I enjoy many of his works, his thin inks and washes often
lack the splendour of Rouault's cathedral colours, and his virtuoso lines can become locked in stereotypes. Piper may never
have flown in an aeroplane, but at his worst, his painting can come
uncomfortably close to the tasteful commercial decor that you see
on the boards before they lower them to reveal the screens for the
in-flight movie. It is, I think, salutary that the best things he did
were those marvellous Welsh paintings, with one eye on the rocks
and the other on Ruskin's *Modern Painters*; and among the worst
a late series called *Eve and Camera* in which cut-outs of pin-upstyle nude photographs collide, uneasily, with drawings. In the

latter, a characteristically 'modern' preoccupation with mechanism and chance seems to have eclipsed his 'romantic' imagination altogether.

1983

13
The Hard-Won Image

So now we have all seen it: 'The Hard-Won Image'. And let us be in no shadow of doubt; there were some beautiful things in this exhibition, more beautiful, by far, than anything paraded in Michael Compton's abysmal 'The New Art' at the Tate last year. How we had to scratch around for anything to affirm then: a Kiff with some qualities here, a Kiefer that was not totally inept there! But this year, as soon as one walked into Richard Morphet's exhibition, one was confronted by a masterpiece.

I am referring, of course, to Henry Moore's great elmwood *Reclining Figure* of 1959–64. Last year I was lucky enough to see this marvellous sculpture in the Great Medieval Hall in Winchester, where it formed part of an exhibition celebrating Henry Moore's 85th birthday. This experience made me reflect on how few – how very few – sculptures made in the last quarter of a century could conceivably have held their own in an environment of such Gothic splendour. But this *Reclining Figure* did.

This carving, which took five years to complete, was a confident recapitulation of more than thirty years of exploration – through sculptural metaphor – of the reclining female figure as both a nurturing and consoling human body, and as landscape. In many ways the piece was not even particularly innovative; formally, it looks backward, rather than forward. It seems to quote and echo other reclining figures, dating back to the 1930s; but only that enigmatically impinging rectangular shape, jutting up where the trunk meets the lower limbs, hints at what was to come.

This *Reclining Figure* is a consummate expression of all that Moore knew, for certain, about this theme. Its strength derives in part from the fact that during all the years he worked on this piece, his conception of the figure was undergoing cataclysmic changes. Other sculptures made at this time show how his epic female figures were fragmenting and cleaving into their several parts. The

great rocks and cliff-faces of breasts, torso and mountainously raised knees were severing, and drifting apart, as if some epochal geological convulsion was trembling upwards from the lower strata of Moore's imagination itself.

These changes led to some of the strangest of Moore's sculptures based on the female body, sculptures which seem to be menaced by a constant threat of disintegration. In these works, the image is redeemed from dissolution only at the last moment through the cohesive and unifying power of Moore's forms. It was not, I feel, just the accident of a commission which led to the terrifying, potentially destructive, immensity of *Atom Piece* of 1964. But the *Reclining Figure* of 1959–64 seems to have been an affirmative denial of such disruptive themes: in its mingling of inner and outer into a new kind of unity, its serenity, authority and silent equilibrium, it embraces us with the consoling power of a great cathedral in wood.

Altogether different in mood and tone are the recent drawings Morphet saw fit to hang behind this superb elmwood figure. Since the mid 1970s, Henry Moore's drawing has become enthused by a masterly tentativeness; his line manifests a tender authority peculiar to the old age of genius. These works have been insufficiently studied and appreciated; I believe that eventually it will come to be recognised that, from his mid seventies onwards, Moore began to produce drawings comparable to those of Michelangelo's last years. And yet it must be admitted that – despite the fine study after Bellini's Pietà – we were not shown the best of these works; nor was the decision to hang them with the elmwood figure judicious. Who could really appreciate Michelangelo's quivering late drawings of the crucifixion in the nave of the Sistine Chapel?

There were, of course, other fine things in this exhibition besides Henry Moore's. I was impressed by the wall of Leon Kossoff pictures which dominated the centre of the show. This included one of his memorable *Children's Swimming Pool* paintings of 1971; *Two Seated Figures No. 2*, a portrait of his parents and one of the few indubitable masterpieces of the current decade; and the disturbing *The Family Party*, of 1983. (What a remarkable contrast this picture makes with Henry Moore's serene and

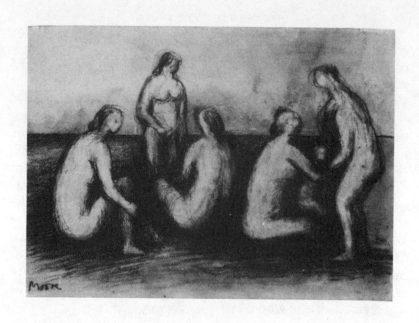

4
Five Bathers
Henry Moore

idealised evocations of family life!) We do not doubt, when looking at these pictures, that they are permeated by experience on the very brink of madness; but Kossoff, unlike the younger expressionistic painters, combines empirical acuity with an appeal to the highest achievements of the Western tradition of painting. On the surface, he wreaks an authentic, if at times seemingly precarious, redemption through form. His remarkable showing in this exhibition should convince the doubters; we have, in Kossoff, a talent comparable to Soutine, or Rouault, at their best. Beside this work, Bacon's merely looks like the mannerism of horror.

There were minor pleasures in this exhibition, too. For example, we had another chance to see Lucian Freud's intractable *Large Interior, W.II (after Watteau)*; a miniature Auerbach retrospective, which sadly did not show him to his best advantage – where, for example, were those splendid recent drawings of Catherine Lampert?; Cecil Collins's tender and angelically symbolic landscapes of the mind; Adrian Berg's exacting, and yet moving, landscapes of Regent's and Windsor Parks; Colin Self's unexpectedly subtle drawings of the Norfolk countryside; Adrian Stokes' evocatively hazy last paintings; and Peter Greenham's intimate and humane portraiture, in which the face is built up through floating patches of living colour.

But there was also much mediocrity, and worse besides, in this exhibition. We know from Coldstream's show earlier this year that he is now painting much more sensitively than he has done for many years. What a shame, then, that he should be represented by three works from perhaps his lowest ebb as a painter – the mid 1970s. But if Coldstream himself sometimes seems lacking in authentic sentiment, how are we to describe the work of his followers?

I, too, believe that the artist should study the human figure – living and dead – as part of his, or her, education in the whole range of natural form. But although manure may be necessary to the cultivation of strawberries, we do not wish to find any but the most indirect evidence of it in our fruit salad. It is now almost a century since John Ruskin raged against art which smelled of 'the morgue, brothel, and vivisection-room'. And yet such an art

5
Pauline II
Leon Kossoff

remains alive, and sick, to this day. Uglow seems capable of experiencing only the emotions of necrophilia, even in front of the living flesh; his gymnastics of death are simply not to be endured.

Patrick George is an even sadder case. In his pictures, the colour, light and life of the English countryside itself is crushed; it stinks of the silence of well-rubbed turpentine. Apparently, George wrote Morphet a letter saying, 'Landscape painting is bedevilled by whimsy and dream.' He went on to explain that his pictures were 'efforts at an exact imitation of the subject at each moment when the brush stroke is made'. They were, he added, 'anti-dream landscapes'.

But I have only to turn my head, as I write, and to gaze across a field of Suffolk corn, now sparkling, now dimmed, as a blanket of cloud passes across the face of the sun, to realise the falsity of George's position as a painter. Indeed, George himself admits it. 'One moment's glance at a shimmering, changing, weather-prone, crop-ridden landscape,' he confided in Morphet, 'shows the absurdity' of his procedures as a painter.

Richard Morphet says that George can be accused less than anyone else of drawing his images from the imagination. But as so often with Morphet, the remark reveals nothing except that he has inoculated himself against aesthetic experience. For George's opposition between whimsy and 'exact imitation' is itself mis-leading; it evades the fact that a painter cannot be true to his experience of nature *unless* he uses his imagination as well as his eyes.

It is not just that George's procedures end up with a representa-tion of nature which, like Uglow's depiction of the human person, is mendacious, boring, perverse and dead. Let us suppose, for a moment, that he succeeded and produced the impossible, 'an exact imitation' of a slice of the countryside through the illusions of paint. The paradox is that, even then, he would not escape that sense of arbitrariness and futility which cloys and clouds every brush-stroke he makes. For George, having allowed his imagina-tion to atrophy, can no longer recognise that good landscape painting never offers mere mimesis. I believe there is much more 'truth content' in a Cecil Collins or a Norman Adams – sadly not included in this show – than in a George. But what, one wonders,

can the poor fellow make of the achievement of Turner, where the most acute perception of particular form combines with the highest and deepest exercise of the imaginative faculty? Would you say, Mr George, that Turner, too, is bedevilled by whimsy and dream? Perhaps you could let us know ... The mannerisms of Slade academics notwithstanding, landscape painting, if it is worth having, is invariably the vehicle for truths more profound than those of verisimilitude. Higher landscape painting does not evade or deny sensuous impressions; rather it transmutes them into symbols of feeling. Certainly, we need to use our eyes to learn to look at nature aright; but that looking is worthless unless it leads us to love what we see ... or, conceivably, to hate it. Patrick George's lifeless paintings reveal nothing beyond inaccurate appearances except one man's inability to feel anything when confronted with nature, one man's anaesthesia.

But there were worse things, by far, than merely bad painting in this exhibition. Take, for example, Richard Hamilton's two-panel painting, *The Citizen*, which purports to show a 'dirty protest' prisoner in The Maze. The right-hand section reveals the man himself, with a blanket, and long tresses of black hair, draped around his shoulders. The left consists of representations of excremental smears all over the cell walls.

Hamilton's painting is certainly – as Marina Vaizey described it in the *Sunday Times* – pretentious. We have known for more than ten years now that this artist has developed an unwholesome preoccupation with human excrement. This has manifested itself in his flower paintings fouled by turds, his reworked Andrex toilet tissue advertisements, images of glamour girls defecating, and water-colour seascapes dominated by mountainous mounds of shit.

But excrement does not appeal to Hamilton as a pervasive image of human frailty, corruption, or anything as noble as that. There is nothing Swiftian about his merely lavatorial vision. On the contrary, there is something effete, childishly perverse, even prissy about it. It is as if Hamilton still expected some puritanical mother to walk in at any moment and tell him to wipe that nasty mess off his Sunday-best clothes. Typically, in *The Citizen* not only is the prisoner given a chest reminiscent of the Apollo

Belvedere's, but the pattern of shit on the wall is all very nicely done, as if it was just a pretty abstract painting.

In front of this work it would be hard not to recognise that Hamilton has undergone a profound and debilitating regression in his life as an artist; he has become effectively incapable of acts more creative than those of smearing, besmirching and defiling. *The Citizen*, of course, is not so much a representation of an inmate of The Maze as a self-portrait. It would have been more honest if he had depicted himself not as a hero, but as a fussy and discredited aesthete, who, having uncovered the fundamental source of his vision, could not avert his eyes, or his nose, there-from ... But this self-indulgent attempt to legitimize an un-savoury, regressive, personal pathology through a vicarious appeal to public events transforms this work from the merely pretentious to the evil. As Dr Leavis would have said, turning away with disdain, 'Hamilton does dirt on life.' This degrading picture ought never to have been shown in a public exhibition; nor would it have been if Richard Morphet had any aesthetic taste. But clearly he doesn't.'

Nor should Mr Morphet be put out by this remark; for his catalogue introduction goes out of its way to denigrate the exercise of discriminatory judgment in relation to art. 'Thus,' Morphet tells us, 'while an Auty or Fuller, from quite different standpoints, have something positive to urge, the impact of their message is blunted by the extent to which they inveigh against the art they loathe.' (I would have minded much more about the company with whom I am coupled had Morphet not made it so clear that the distinction between good and bad, between work of quality and worthless production, means nothing to him.)

Now I, as much as anyone, have argued over the years for an openness of taste. I am in complete agreement with Clement Greenberg when he argues that aesthetic quality reveals itself through results, never through methods or means. Ruskin, too, described 'false taste' well when he said it may be known by its fastidiousness, 'by its enjoyment only of particular styles and modes of things, and by its pride also'. False taste, he maintained, 'is for ever meddling, mending, accumulating, and self-exulting; its eye is always upon itself, and it tests all things around it by the

way they fit it.' But 'true taste', he went on to say, is 'for ever growing, learning, reading, worshipping, laying its hand upon its mouth because it is astonished, lamenting over itself, and testing itself by the way that it fits things.' But in arguing for this openness, neither Greenberg, nor Ruskin, nor I, ever meant to say that the tongue of one's eye should be plucked out altogether; yet Morphet endeavours to substitute a torrent of tepid, universal enthusiasm, or a cool shower of genial eclecticism, for the exercise of any kind of evaluative faculty in relation to art.

Again and again, Morphet goes out of his way to assure us that he is against nothing, only for everything! If only the Tate Gallery had been big enough, this accommodating fellow would put in the art he unfortunately had to leave out. All of it, everything ever made, in fact. Thus he constantly seeks to reassure us that in affirming the painters of the hard-won image – that is those who, in his view, make use of traditional methods and subjects – he has no quarrel to pick with current trends, new expressionism, 'Bad Painting', or the so-called 'New Sculpture', which, of course, isn't sculpture at all. Nor does he want to say a word against the whimsical conceptualism which has so bedevilled Tate taste in the last decade.

Now I have nothing whatever against openness of taste. Far from it. Works of genius can often present themselves in the most unpromising of stylistic clothes. Vermeer, Rothko and Natkin bear witness to the fact that even an artistic terrain as unpromising as that of new expressionism might suddenly and unexpectedly give rise to a talent of outstanding quality. Hitherto, however, that has not happened; but this absence of good work does nothing whatever to inhibit Morphet's all-embracing enthusiasm. Indeed, so great is his fear of making a negative judgment of any kind that he ends up behaving with breathtaking aesthetic promiscuity. Morphet doesn't want even one of the lovely ladies and gentlemen of the art world to end up feeling rejected, and so he bestows his favours – 'Oh how terribly *interesting*' – on absolutely anyone bold enough to proffer him their cheek, or come to that, any other part of their artistic anatomy. You know, Henry Moore, Gilbert and George, Meredith Frampton, David Wynne, Leonardo da Vinci, Mary Kelly, Uncle Tolly Cobbold and all!

What's the difference! They've all got *real* qualities, if only you lick and see.

If this seems terribly unfair, just shake down the dusty Tate catalogues on your shelves, and you'll see what I mean. Mr Morphet, you will observe, has been with us a lot longer than the short time in which he has cottoned on to the hard-won image, and all that.

One of the silliest catalogues the Tate has ever published is that which Morphet wrote of 'the immensely important operation' in Andy Warhol's work of 'passivity, detachment and chance', yet he managed to detect (or so he thought) a flickering residue of artistic imagination in the way the things were made. I must have read this passage to a hundred audiences of art students. It raises a laugh every time; and so for that reason alone, it must be worth reproducing yet again. About one work, *Marilyn Monroe's Lips* of 1962, Morphet wrote:

> To depict Marilyn's lips 168 times in 49 square feet is a more remarkable innovation than may at first appear. Requiring selection, masking, processing, enlargement, transposition and application, in conjunction with decisions on canvas size, placing, colour and handling, it means that the finished painting is a complex and calculated artefact, which is not only unique, but strikingly different from any that another individual might have produced.

So much for the hard-worked image.

One understands why, when the Carl Andre Tate Bricks Affair blew up, the authorities on Millbank recognised that they had a real sucker of a spokesman in Morphet. So, naturally, they put him up to a defence of the brick-stack; and Morphet, always eager for positive qualities, managed to find limpid clarity, and echoes of the classical tradition of sculpture even there ... And, of course, he doesn't regret his silly error of judgment – of what? – one bit. On the contrary, in a footnote to his ramblingly disingenuous text for *The Hard-Won Image*, he actually endeavours to defend his indefensible defence of the acquisition of Andre's *Equivalent VIII*.

Steep yourself in the utterances of Morphet, and you will soon come to realise that it is not a question of the man being possessed of a generous taste; he has no taste at all. Indeed, he is so ignorant about art that Henry Moore's *Reclining Figure* of 1959–64 is not, in any meaningful sense, *better than* Andre's *Equivalent VIII*, or Robert Mason's unspeakable 'sculpture' *The Grape Pickers*, which concluded this exhibition. (The title, 'The Hard-Won Image', incidentally, was coined by Mason, among the most facile and empty of all contemporary 'sculptors'.) If art matters, then the choices we make concerning art – both positive and negative – also matter. Good criticism cannot aspire to the condition of prostitution, and offer its favours to all comers. We could have had a good exhibition about a neglected British 'realist' tradition in art; but it would have been much more 'hard-won', and discriminating, than this. After all, only a bureaucrat as insipid, confused, and ingratiating as Mr Morphet could come before us and try to say that a Henry Moore figure is as worthy of our attention as Mason's despicable fantasies in epoxy resin; or that Kossoff's *Two Seated Figures, No. 2* is comparable with Hamilton's contemptible picture *The Citizen*.

1984

14
Academic Choices

In Bernard Dunstan's *Bathroom, Spoleto*, we look across what seems to be a pink and blue hotel bedroom, through an open bathroom door; there, we see a woman standing by the wash-basin, wrapped in a large blue towel. In the bathroom mirror we can faintly pick out the reflection of a man, standing, leaning and looking.

The pictorial conventions on which the work is based are commonplace. So, too, is the style through which the paint has been applied: it is latter-day impressionism. Hundreds of thousands of pictures have been painted in this manner in the last century, many of them as a direct result of Dunstan's own articles and books about how to do it. And yet *Bathroom, Spoleto* is still a good painting: not a great one, but a good one. Better than most of its kind; better than a great many of quite different kinds.

It is a conventional painting, but not a mannerist one: by this I mean that when we look at it, although we recognise the familiar devices, we do not doubt that the artist's genuine perceptions, and his authentic sentiments, have been engaged in the creation of the image. Through the 'impressionist' play of light, Dunstan's love of world, flesh and woman is self-evident. Nonetheless, if I try to tell anyone in the 'art world' that I have enjoyed some of Dunstan's pictures, this produces an amused titter; it is assumed to be one of my 'perverse' or 'provocative' judgments. These days, however, the titter tends to be increasingly uncertain and uneasy. 'We' – the art world – no longer know what to think about the Royal Academy and its painters.

In the late 1960s, 'We' were all agreed: the Royal Academy was a joke. If 'We' noticed the Summer Exhibition at all it was to do a knockabout piece. Naked women of uncertain age seated on kitchen chairs; poor old RAs, not so well hung, having difficulty getting up their pictures, and much else besides, even in front of

girls on swings; drooping daffodils; an abstract Blow job or two
to liven things up. You remember the sort of piece. The Academy
was easy game. Only Terence Mullaly actually seemed to take it
all seriously. And, in Mandy Rice-Davies's immortal words, 'He
would, wouldn't he?' *Daily Telegraph* and all that. Times change;
values don't. But the Academy goes on for ever.

Around the mid 1970s, however, the response to the Royal
Academy Summer Exhibition, if not the exhibition itself, did
begin to change. The Academy became something of a Newfound-
land for critics. New approaches to art like Andrew Brighton's
'Towards Another Picture' made it quite respectable to talk
about, say, Russell Flint in the same breath as Richard Hamilton,
and to suggest not only that they had a great deal in common, but
also that Flint was, perhaps, *better* than Hamilton. The question,
at any rate, was vigorously raised as to why such large sectors of
art production – from portraits to popular painting of wildlife and
trains, to natural history painting, sea painting and most land-
scape painting – was simply elided from critical 'discourse' (the
trendy word of that moment) altogether. The critics of the
populist left and aesthetic 'progressives' of all kinds began peering
inquisitively at what was going onto the walls at Burlington
House. By June 1977, *Art Monthly* could even run a front page
cartoon showing two trendies talking, at the ICA, with the
caption, 'The new director's very avant-garde. Next year he's even
staging the summer show of the Academy.'

All that seems to be over again now. We are back to the
knowing jokes. William Feaver does a 'nice' piece about going
round the Academy backwards this year starting with the
architectural drawings, to see if it makes it look any different.
Even if an eclectic, sociological 'net' has replaced the avant-garde
'arrow' as a model, or map, for contemporary art practice, the
Royal Academy Summer Show is slipping through the discourse
again.

Yet such is the parlous state of the 'alternative' Modernist
tradition that the jibes sound more than a little hollow. Perhaps
Flint really *was* a better painter than Richard Hamilton, after all?
Perhaps I *am* right when I say that Bernard Dunstan is a much
better painter not only than Euan Uglow, but also than John

MacClean, Geoff Rigden, or any one of a hundred currently fashionable younger abstractionists?

And then again, it is not quite true to say that the Royal Academy has been entirely deserted critically. The old New Left and the avant-gardists might never have been able to make their brief flirtation flower into true marriage; but the new New Right is now vigorously pursuing the multi-coloured Woman of Burlington House.

For example, Roger Scruton recently wrote a combative, if hasty, column in *The Times*, just after June 9th, headed 'A Victory for Art at the Polls.' 'Can natural bourgeois man,' Scruton asked, 'regain the right to his own tastes or will he be for ever put upon by modernist aesthetes?' Scruton thought those tastes adequately met by the 'derivative' (his word) pictures at Burlington House. 'A few abstracts glare out in ferocious primary colours,' he wrote, 'but their stares are not reciprocated. The favoured images are quiet, comforting and figurative: a tree in a field; two cups in a shaft of sunlight; a face by a window.' Scruton went on to point out that many were miniatures; others were confined in Baroque or Renaissance frames; 'a welcome recognition of the truth that painting is furniture.' Most, he claimed, are 'wonderfully old-fashioned'. But is this courtship of the New Right any more likely to come to anything than the overtures of the left a few years ago? I think not. I think that Scruton, too, has profoundly misunderstood what sort of creature the Royal Academy Summer Exhibition is.

The first thing that needs to be stressed about the Summer Exhibition is that it is not unified by any *academic* criteria whatsoever: indeed, the Royal Academy selectors are much less academic, much more stylistically generous, or at least eclectic, than, say, those who choose pictures for Hayward Annuals, or the Arts Council Collection. For at Burlington House the gamut of painterly conventions, and to a lesser extent that of sculptural conventions too, is included. A great many of the styles and techniques which have proliferated over the last century are represented in one way or another: examples abound of impressionism, pointillism, fauvism, empiricism, surrealism and many varieties of abstraction. Nor has the Academy any difficulty in

incorporating fragments of many recent Modernist tendencies, too; certain Pop painters and latter-day Abstract Expressionists are strongly represented.

No one style, or approach, however, is given primacy over any other, least of all on historicist or generational grounds. In other words, if you are twenty-five, rather than eighty-five, and working in an impressionist mode, you have every chance of being included if your work is good enough. If the Academy affirms nothing else it is a belief in the independence of quality in art from any idea of 'progress', or any commitment to the shifts of style and fashion.

Nonetheless, if the Royal Academy's Summer Exhibition is characterised neither by a unifying style, nor by the chronological movement of artistic fashions, it nonetheless exudes a feeling of coherence, a sense of constituting a living, developing tradition. The Summer Exhibition incorporates varying levels of talent and accomplishment; unlike the packaged uniformity of, say, the average Hayward Annual, it thus immediately invites the intelligent exercise of aesthetic judgment.

The Royal Academy Summer Exhibition clearly has its masters, professionals, journeymen and also-rans. The perception of the real difference between works by such truly talented painters as Peter Greenham, John Ward, Richard Eurich and Bernard Dunstan, and aspirant pictures sent in from the shires which clearly just squeezed past the judges, is part of the pleasure the Academy has to offer.

But the tradition is not hermetic, or enclosed. Rather, the Academy sucks in, incorporates and makes its own, elements from all sorts of adjacent traditions and tendencies; others, it simply 'borrows' for the duration of the exhibition. When this occurs, of course, we are forced to re-evaluate the incorporated or borrowed component, and the tradition from which it sprung.

For example, Peter Blake's reputation was built upon being a fey maverick in Modernist 'Pop' circles. Admass plus nostalgia; badges and collage plus tried-and-tested painting techniques. He is now firmly entrenched in Academic circles, too. This year, Blake was involved in the selection of the Summer Exhibition. At the Academy, however, one realises immediately how much he owes

to Ruskin Spear. And not only that: Spear's imagination, his handling of paint substances and conventions, in the end, the overall *quality* of his pictures, is clearly superior to Blake's. Yet Spear, never having ventured forth beyond the Academic tradition, is little loved or discussed in the institutions and journals of contemporary art – let alone given retrospectives at the Tate.

But here we must pause. The cohesion of that tradition established through the Royal Academy's Summer Exhibition is undeniable; that is why, for all its variety, it is so easily affirmed, or dismissed, *in toto*. If the roots of this tradition lie neither in style, nor the movement of style, they are lodged nonetheless in something much more cogent than eclecticism. But what?

The old Left critics used to say the Royal Academy presented the values of a particular section of the ruling class, one which could, for example, be sharply distinguished from the cultural intelligentsia, Museum civil servants and art bureaucrats engaged in the purveyance of esoteric modernism. The cohesion of the Academy show, they maintained, was related to the internal coherence of that vision. Now the new Right, too, seems intent on defining Royal Academic coherence in terms of bourgeois values, true bourgeois values, severed from the contamination of 'modernist aesthetes'.

But this seems to me an unlikely thesis. For the typical bourgeois is present largely through his absence in Royal Academic painting. One does not get even an inkling of English middle-class business, professional or domestic life from scrutinising these works. Few of the Academy's paintings relate, even tangentially, to social relations, wealth, power, possessions, position, technologies, city life . . . or indeed any of the themes with which we might have expected 'bourgeois man' to have been uniquely or specifically obsessed.

I am not denying that there is a 'class orientation' to the appeal of the Academic tradition; but it is *rural*, rather than sophisticated urban bourgeois in character. (A high percentage of the purchases will go back to the shires, and the squirearchies, to houses where *Country Life* is read, and Harold Macmillan, or even Alec Douglas-Home, rather than Margaret Thatcher, is seen as embodying the true spirit of Conservatism.) Nonetheless, it would

be wrong to argue that many, or indeed any, of the paintings on show at the Academy were constructed from within the ideology of even this class; again, almost none of the particular fears, hopes and *mores*, of this class as a social entity are reproduced, or even alluded to, in the pictures on show. Most of the painters producing Summer Exhibition pictures do not belong to the rural ruling class; have no particular sympathy for it; and make no concession to it – despite the fact that their work appeals to some members of it.

Moreover, whatever it is that binds the Royal Academy Summer Exhibition together is also apparent in *amateur* art exhibitions a long way away from the shires and grouse moors: if you go to such events in Birmingham, Glasgow, Sheffield, Bognor Regis, the Orkneys, Walthamstow or Chelsea the mixture is the same; single nudes, flower paintings, landscapes, fantasies, torsos, tasteful abstracts, animals, portraits – all executed in a wide range of painterly styles and techniques, at varying levels of achievement and accomplishment.

So if it is neither a question of style, nor yet of class-specific ideologies, which gives the Royal Academy Summer Exhibition its cohesion, what then is it? I would describe it as *a certain sensibility*. Far from being the embodiment of contemporary bourgeois values, this sensibility finds itself in a minority enclave, wherever it persists. It is characterised by rejection of the publicly organised modes of seeing, and of representing, and is hence thrown back on a pervasive sense of privacy, of isolated intimacy. It also involves a longing for a way of seeing, and of working, in the midst of the small change of everyday life, which is imbued with a living affective, evaluative and aesthetic component. Predictably, it tends to be directed towards human bodies (often isolated, naked figures), natural forms, and phenomena (like the play of light), rather than towards machines, social formations or their products.

Bernard Dunstan's impressionistic *Bathroom, Spoleto* is a fine instance of all this. But the Royal Academy's Summer Exhibition recognises any means as acceptable, so long as they endeavour (or can be construed as endeavouring) to serve these ends. Like the great traditions of the past, it celebrates variation in accomplish-

ment, welcoming minor talent, and even failure, alongside the major.

But I am not of course trying to say the Royal Academy represents some 'true', 'uncontaminated' or 'healthy' visual tradition as opposed either to the Mega-Visual outpourings of technologically mass-produced imagery, or its analogue in much recent Modernism. 'Sensibility' alone is not enough for aesthetic health. And that is precisely the Academician's dilemma. He eschews the ethic of the Machine and the Advertisement; but he is too worldly to embrace religious belief. So the tradition in which he situates himself inevitably appears imaginatively impoverished: it is cut off from social symbols of any kind. Characteristically, where the imagination returns in Academic art it is in the form of Sub-Spencerian fancy, of the Swanwick variety. But here, as elsewhere, the Academy manifests the characteristics of *dissident* art. Its uncertain constraint, relentless privacy, sense of aesthetic residualism – all these things reflect the social displacement of that sensibility the Academic tradition is seeking to affirm. The best Summer Exhibition painters seem to believe that all we have left are our *petites sensations*, inflected with tenderness, experienced in the presence of the beloved, the green field, the valley, or of light playing over fruit. Far from thinking art achieved a victory at the polls last month, they recognise that there is no socially rooted, living stylistic tradition through which these *sensations* can be organised and elevated; no ideology prepared to affirm them, beyond the domain of aesthetics . . . And they may well be right.

1983

15
Peter Blake: Un Certain Art Anglais

There must be some (Peter Blake is probably among them) who setting out to read this will be expecting a 'grudge' or 'needle' review. Let me explain. Back in 1977, Blake began a war against three then prominent newspaper critics (Cork, Overy and Tisdall) by hanging up a letter attacking them as part of his contribution to the Hayward Annual of that year. The following spring, I said a few words in defence of the accused. I was promptly added to the blacklist: Blake declared I was 'the most vindictive of the Four', that I was 'completely destructive and pessimistic', and that I wanted 'to get rid of all existing art'.

'I'm not a right-wing person attacking a left-wing person,' he said soon after. 'It's not about that. It's about a personal attack on my beliefs and aesthetics.' All this led to acres of grey print in the art magazine *Aspects* – and a lot of bitterness. Once Blake came with the editors of *Aspects* to Graham Road, where I lived in London, to tape a discussion with me. After many misunderstandings, and much muttering about legal proceedings on my part, revised and unrevised versions of this were published in the magazine. (For the full story, see *Aspects* Nos 3, 4, 5, 6, and 7 – all oddly omitted from the otherwise thorough bibliography in the catalogue to Blake's current show.)

In the course of this discussion Blake, among other things, criticised my 'revolutionary' politics; defended his belief in fantasy and fairies – 'I tend to believe in fairies rather than not . . . It's no less interesting than believing in the revolution'; attacked the critics for putting forward 'art-political feelings' rather than looking at pictures; and spoke up for his vision of nature.

Since those days, a lot of paint has been squeezed from the tubes. Had it not been for our embarrassing little contretemps, I imagine that, today, there would have been those who expected me to be rather sympathetic to Peter Blake. After all, Blake has just

ended a ten-year stint as a ruralist, whereas I have just become one. I am writing this article not in noisy, metropolitan Graham Road, where Blake and I met, but in my flint-and-brick cottage in the village of Stowlangtoft. I fondly imagine the thick walls, trim dormer windows and pointed arch in the porch were designed by the great Victorian Gothicist and constructional polychromist, William Butterfield, who restored the fifteenth-century Church of St George's across the fields. Reproduction William Morris *Vine* climbs all over my living room. Very Sanderson's! The *Wheat* wallpaper in the kitchen is hand-blocked. And the oilcloth on the kitchen table (stripped pine) is adapted from William Morris *Honeysuckle* too. A Liberty print. A real honeysuckle grows against the outside wall. A log fire roars in the grate. The birds are singing in those gently rolling, softly snow-covered Suffolk fields and copses.

If the Peter Blake who came to Graham Road in 1978, three years after the founding of the Brotherhood of Ruralists, were to come here today (and this is *not* an invitation), he would, I imagine, feel pretty much at home. Certainly, he would have no great need to defend his 'beliefs and aesthetics'. It is not just that I value the experience of nature much more than I did. I have become increasingly sceptical about the politics and ethics of the late 1960s, about which Blake challenged me when we last met. Victor Burgin has recently called me a 'Red Tory'. It is certainly true that I have come to admire, much more than I did, a peculiarly *English* tradition of making and writing about art, which has its roots in the nineteenth century, in a certain Victorian imagination, which runs from Ruskin, through Morris, into Arts and Crafts, and Eric Gill . . . All of which, I know, is dear to Peter Blake's heart too.

And, looking back five years on, I am perfectly prepared to concede that yes, Blake *did* have a point. Criticism in the late 1970s *was* too preoccupied with 'social context': much of it had an art-shaped hole at its centre. Even in those days, of course, I had my 'moments of becoming', and suchlike. But a lot of what I was writing and saying about art was still saturated with that woolly, historicist relativism, the legacy of all that arid late 1960s 'revolutionary' thinking. It was not until I wrote *Art and*

Psychoanalysis in 1979 that I really began to come to terms with the importance of imagination, the encounter with (and transformation of) natural form, and the material practices of painting and sculpture themselves.

Blake, however, had in his own way been advocating these things for a long time. He held up imaginative vision against all 'realist' reductions; and stressed the importance of preserving painting's craft skills. Similarly, he was interested in reviving a sense of tradition – hence the 'Heroes', and all that; and in looking, again, at nature. Above all, in the face of all the silly arguments, he emphasised the *pleasure* good painting can give. Recently, Peter Blake declined to appear on Channel Four's 'Voices' programme with me on the grounds that, since he now entirely agreed with what I was arguing about art, he would have nothing to say. I fully accept that this reflects a shift in *my* thinking over the last five years, rather than his.

And so, is it possible to put the acrimony of the late 1970s behind us? The times, after all, seem ripe for reconciliation. Cork, who these days perceives hidden qualities even in the Duke of Edinburgh's painting, has made his peace with Blake in the *Standard*. Overy and Tisdall no longer have their platforms. A new batch of critics is heartily singing Blake's praises. Thus, writing in Radio Three's magazine, *3*, John Fletcher declares, 'If Peter Blake's art asserts anything, it asserts his and our humanity, that without our humanity we are nothing. Long may he triumph!' Can I, too, succumb to this new mood, reach out, at last, and say, 'Bonjour, Monsieur Blake . . . I was mistaken. You are a great painter and a hero. I take my hat off to you'? Oh, would that life was as simple as that!

As I wandered round the Tate, where Blake's life's work is presently laid out like the contents from a kid's satchel, with various extra bits and pieces added belonging to his chums, I reflected on the fact that the quality of a work of art cannot be affected by shifts in taste, whether purely personal, or more culturally widespread. And *none* of Blake's paintings has the ring of true quality about it. His contribution is slight and ephemeral, like last season's souvenirs. In a quarter of a century's time, Blake's work will not be admired, looked at or talked about. Whatever

critics like myself did, or did not, say about him, he was a poor painter in the 1950s and 1960s; he remained a poor painter throughout the 1970s; in the 1980s, he has if anything, been getting rather worse.

This judgment, of course, can neither be proved, nor disproved. Yet it is not difficult to evince supporting arguments. Back in the 1950s, Blake seems intuitively to have recognised the central problem. As a result of industrialisation, most forms of adult work are unimaginative and sterile. There is thus no easy route through which the innate creativity of the child can develop into an adult aesthetic practice. Much art has tended to remain retarded at the infantile level, as in the work of 'infantilist' abstract painters like Geoff Rigden. Alternatively, it has capitulated to the anaesthetics of the prevailing anti-culture, as in the work of Richard Hamilton, many Pop painters, and their conceptualist successors.

Blake did not take either of these options. Certainly, he wanted to retain the imaginative, creative and 'transitional' experiences of childhood; but he wished to develop them, through painting, into a sophisticated, adult aesthetic practice. Moreover, he wanted his pictures to *celebrate* the images, products, and processes of modern, mass-producing, technological society. (See, for example, pictures like *Children reading Comics* or *On the Balcony*.)

But these images are not convincing. The reason is not, as has often been argued, that Blake is 'nostalgic'. On the contrary, I would say one weakness of these works is that they refuse to make a radical break with what I have called elsewhere the 'mega-visual tradition'. This is not a magical Aladdin's cave, or Land of Oz, where the promise of childhood's transitional experiences, mingling subjective and objective, can be finally fulfilled; rather it is an alienating torrent.

Instead of elaborating in illusion an alternative world, organised according to alternative values, Blake brought his creativity into contact with the symbols and techniques of the torrent, which, of course, proceeded to corrupt and submerge it. Take the case of the *Pin-Ups* Blake painted in the mid-1960s. Robert Melville once wrote of these that Blake 'finds human warmth where others find only cliché and exploitation'. This is hard to

accept. Of course, a painter like Toulouse-Lautrec, or Degas, could enter a bordello and do precisely that. But when I look at Blake's images, I experience a deadness, or veneer, in the handling – a sense of insensitivity, and obsessional indifference, all too close to the callous aesthetic and personal values of the Page Three photographer.

It comes as no surprise to learn that Blake intended these paintings 'to serve as pin-ups' themselves. Moreover, most of them were painted, not from life, but from girlie magazines: and the exceptions show only that Blake had been looking at so many girlie magazines (and suchlike) that he could not see the woman for the pin-up, the person for her image, even when she really was there in front of her eyes.

Not seeing, Blake was unable to reveal, let alone to transfigure or transform. The best he could do was literally to re-present images and objects pilfered from the 'mega-visual' tradition. Predictably, in the late 1950s and 1960s we find Blake relinquishing the expressive and transformative powers of painting altogether, in favour of collage and mixed media techniques (e.g. in *Love Wall* and *Toy Shop*).

By the late 1960s, Blake himself seems to have realised that something had gone radically wrong. In any event, he underwent a radical change in both his lifestyle and his manner of painting. He left London and went to live in a disused railway station in Wellow; by 1976, he had become one of the founder members of the Brotherhood of Ruralists. Again, Blake has been much criticised for this episode. I believe, however, that he was absolutely right to endeavour to replenish his art through an imaginative encounter with nature, and wrong only insofar as he failed.

In his unrevealing study, *The Brotherhood of Ruralists*, Nicholas Usherwood explains that the original intention of the group was 'to express through personal vision and experience of our native heritage a celebration of the English countryside'. But where are Blake's great pictures of nature? Certainly, there are none to be seen at the Tate; nor were there any included in the Ruralists' touring exhibition of two years ago. There is no evidence from any of Blake's drawings or paintings of the 1970s that he has seen the particular furl of a leaf, the play of light through

the trees, the softness of damp moss, the translucence of clouds racing against the morning sun, the twist of a twig or the flight of a curlew. And not having seen such particular things, Blake is unable to create a convincing new whole. The problem is much the same as with the stripper and pin-up paintings. He is like a man who has been blinded by the mega-visual tradition: when faced with the infinite variety of actual nature, in all its changeability and underlying constancy, he can see nothing, feel nothing, except what he already knows; even his intimations of childhood experience somehow become frozen, locked and destroyed by that 'media landscape' which will not fall from his eyes, even in Wellow. In the end, insofar as he offers us a vision of nature at all, it is highly depersonalised: eternal Lymeswold.

It would be wrong to blame Blake's imaginative inadequacies entirely for this (though they certainly come into it.) As anyone will know who has been to the fascinating show at the Hayward, *Landscape in Britain, 1850–1950*, the capacity to create convincing, replenishing and consoling images of nature depends not only on seeing, but also on believing. And if one is by nature an imaginative collaborator (as Blake so clearly is) then, in this day and age, the vision of nature in which one believes is, precisely, Lymeswold.

What Blake and his fellow 'Ruralists' have never understood is that the tradition they so glibly evoke would have despised them. It is all very well for Blake to gesture back towards the *real* Blake, Palmer, Ruskin and so on. But does he know *anything* about what nature was to these men? Let me put him right about just one of them – John Ruskin. Ruskin believed Turner was a great painter because he revealed nature to be the *literal* handiwork of God. Turner, or so Ruskin thought, had looked at the mountains, rocks and trees so closely that he was actually able to make manifest through his paintings the working of God within them. Thus he ended the first volume of his great vindication of Turner, *Modern Painters*: 'He [Turner] stands upon an eminence from which he looks back over the universe of God and forward over the generations of men. Let every work of his hand be a history of the one, and a lesson to the other. Let each extortion of his mighty mind be both hymn and prophecy; adoration to the Deity,

revelation to mankind.' All a very long way from *Puck, Peaseblossom, Cobweb, Moth and Mustard Seed* – or Lymeswold.

Nor can the God stuff be seen as some sort of optional extra: when the sea of faith drew back to reveal the naked shingles of the world, the nineteenth-century vision of nature collapsed into a darkling plain. Nature risked becoming at best meaningless, at worst a menacing, negative utopia. Blake often invokes the tradition of the Pre-Raphaelite Brotherhood; but he should go to the Hayward and gaze at Millais's *Chill October* of 1870 – one of the most terrifying pictures of this foul and deathly vision. Alternatively, he should read Ruskin's *Brantwood Diary*, or study what he had to say about 'The Storm Cloud of the Nineteenth Century', the plague wind, and his premonition of 'blanched sun, blighted grass, and blinded man.' For the waning of his religious faith, Ruskin became convinced of 'The Failure of Nature'. And, more generally, decline of belief in the immanence of God within his creation, and the continuing onslaught of technology and industrialism, rendered the old consoling visions of harmony inauthentic, or even inconceivable.

Blake assumes he can paint good pictures today as if that historic crisis had never happened; but of course he cannot. So he is forced to fall back on the false and inauthentic fancies of the present. Nature, fickle, freckled (who knows how?) fathering forth the beauty of God, and enfolding men unto itself: that was one thing. Lymeswold is another.

Blake has often been described as 'Victorian'; but what could be less 'Victorian' than his *Monarch of the Glen*, completed in 1966? Landseer's original, of 1851, is still able to make use of nature as a wholly convincing alternative to religious iconography. Nature provided Landseer with that 'symbolic order' which he needed for the mingling of his inner and outer worlds. Thus, he sees all the details that are there in the world, all the particularities of the glint of mucus in the creature's nose, the wetness in the grass, the lightness of the clouds as they touch the distant mountain range . . . But all this is articulated into a coherent, symbolic vision. The proud stag, with its antlers raised above the sublime scene, is an image of the conquering son, as convincing as the best of those produced within the religious tradition. Everything in the picture

sparkles, glints and glows; it possesses a life in the handling which springs from the success with which 'inner' and 'outer' have been fused in the practice of painting. Blake's *Monarch of the Glen*, however, signifies nothing: it is a reproduction of a photograph of someone else's painting. And, in the end, its relationship to Victorian imagination, and the best of Victorian art, is merely associative – like the labels on John Dewar's whisky. This shows in the colour and the handling which, for all the work put into them, are dull and dead. And that is why, in the end. Blake's *Monarch* is such a dreary thing; it is the product of a man who wants to see, who wants to believe, but cannot. And because he cannot, he is unable to make the paint sing for him.

But Blake has one area of 'belief' which is neither stolen second-hand from the Victorians, nor a by-product of the mega-visual tradition: his preoccupation with fairies. Yes, evidently, he owes a good deal to the Victorian fairy painters: but the fairies in his pictures are much more genuinely his own than the landscape. This, however, indicates the *pettiness* of Blake's imaginative life: it is one thing to believe in the world-transforming illusions of religion, or even of revolution; it is quite another to project one's regressive fantasies into the world, and to treat them as an adequate 'symbolic order'. Blake's fairy pictures have all the locked and blocked feel of an imagination which has become stuck in perverse, even paedophiliac grooves; they show not the world of childhood, but an adult leering at that world. They indicate that it was not just the ideology of the mega-visual tradition which prevented Blake from seeing, and from growing when he set off for Wellow. Just as important was some psychological failure which compelled him to insist on past fantasies, and prevented him from relating imaginatively to the adult world before his eyes.

And it is precisely this failure in Blake which should be an encouragement to others. It indicates that, if one comes to terms with oneself, it is possible (or at least might be) to overcome the historic crisis in our responses to nature, to begin, again, to *see* – and having seen, to create illusory and genuinely consoling worlds again, based on imaginative transformation. And that, I believe, is what the best artists of today are trying to do. *1983*

Cecil Collins: Fallen Angels

Kingfishers catch fire and dragonflies draw flame. Once Cecil Collins's *Wounded Angel* was such a glinting creature: no Lucifer, he lies, rather, like some fallen bird, or once flighted insect, perilously ensnared in his own tangled limbs and wings. In the purplish background, a mountain rises up towards the sky. The image is weird and wonderful, and yet simultaneously familiar in a way which only just stops short of the sentimental or the banal.

We do not doubt that the picture was fashioned through a personal vision; it is redolent with things half-seen, dreamed, remembered or imagined. And yet it draws for part of its effect on an ancient iconography: that of Christian pictorial symbolism. Paradoxically, Collins enthuses that iconography with new life and feeling by breathing into it the hollow whispers of death. We know what an angel is, yet we do not believe, even the believers among us, in angels. And so this sick creature, more like a crushed dragonfly than St Michael, dying upon the naked and inhospitable shingles of the world, has more poignancy for us, much more poignancy, than the crowded celestial hosts of conventional pious painting.

Or for some of us at least. For Cecil Collins is one of those artists who has practised for many decades, and gained himself a reputation, a following, literature and a market, but always beyond the periphery of what messy little puddle of agitated, murky water which passes for the British art scene. In the catalogue to Collins's Plymouth retrospective, John Lane claims that since the mid-thirties, Collins has remained (and chosen to remain) relatively unknown. Perhaps Lane exaggerates when he calls him 'the great outsider of modern British painting – so neglected, so unfavoured, by an art establishment otherwise content to demonstrate a rash, almost giddy, appetite for novelty.' But there is enough truth in the claim for it not to be absurd.

Personally, I see Collins rather as one of many major talents who, like marvellous and forgotten beasts, are ambling out of the hidden crevices of our past and our present as the freaks and pygmies, brought to light by the misdirected glares of modernist historicism, now scuttle for cover.

For Collins stands for quite different sorts of values from theirs, in life and in art. He was born a son of Plymouth in 1908. In 1936, he exhibited in the International Surrealist Exhibition, though he hardly hung easily there. Soon after, he moved to Devon, where he struck up a lasting friendship with Mark Tobey, and taught for a time at Dartington Hall. In 1940, when the world was at war, he began his first series of paintings on 'The Vision of the Fool'. Since then, he has developed, quite literally, according to his own lights.

I do not want to say that Collins is without tradition: rather, he has chosen tradition for himself; for him, it is a peculiar amalgam of English Romanticism – one cannot discuss him for long without the name of Blake being raised; of French Symbolism, especially Gustave Moreau and Redon; of the 'Gothic' arts of Christendom; and of American Abstract Expressionism, from its earlier days when it was still a search for High Sentiment and symbolic values. But Collins has never belonged, or sought to belong, to 'The Story of Modern Art', the successive 'movements' (what an evocative word that is!) of our time.

If I were to coin a single phrase for what his work is about, it would be a search for a secular spiritualism. Secular in the sense that though Collins may evoke (for his own purposes) the iconography of Christianity, though he once even painted *The Icon of Divine Light* for Chichester Cathedral's altarpiece, his vision is *this-worldy* in a way which, say, Sutherland's was not; but spiritual in the sense that he seeks to go beyond simple imaginative empathy with the world of things seen and sensed, beyond even a psychological dimension of depth. His illusions demand of us the suspension, however momentary, of mundane disbelief.

Collins may not like the comparison, for their differences are as great as their similarities; but his paintings remind me of the decorated prose and pessimistic cadences of that great nineteenth-century secular spiritualist and atheist, author of *Marius the Epicurean*, Walter Pater. Like Collins, Pater savoured each par-

ticular sensation, and allowed it to become transformed by his imaginative activity; but he found that in order to raise experience into the realm of values and high symbolism, he needed at least the ghost of the religious mode, though he had sloughed it off.

Unlike Pater's, however, Collins's vision is rooted in a certain specific sensibility towards the world of nature, a sensibility which he himself has described: 'The Divine Reality should be felt everywhere, in an insect, in an ant, in a fly on the window pane, in a speck of dust.' We know from Collins's writings (some of which are quoted in the interesting introductory essay in the catalogue to this exhibition) a good deal about the origins of this feeling.

Collins has explained how, as a child, he experienced 'the vision that has lasted me my whole life. You could say it was the seed experience, the discovery that paradise is in the minutiae of life, the minute details of life, in the particulars.' He has recounted how, in a wood near his parents' home, he learned 'the language of stones and grass and especially clouds and especially a white cloud which played a great part in my life later on. It seemed that this cloud was a gateway to Paradise.' Such experiences were repeated, in more sophisticated forms, after he had become an adult. Thus he tells how, one April afternoon, something similar happened in the gardens at Dartington Hall: 'There'd been a shower and the sun was shining on this bush, and it had drops of rain on the leaves, and the light was shining through them. They were like diamonds. And on top was a thrush singing. I suddenly saw this bush was the shape of the song of the bird.' This is the vision of the Fool: the shape of the three figures in *Dawn*, of 1971, is the music of the spheres.

It is, of course, easy to deride such thinking: we know that, in our time, few 'rational' men allow themselves to succumb to sentiments of union and fusion with nature, which appear so intense they partake of the character of religious experience. We know, too, that the insane, the perverse, the inadequate and the alienated are particularly quick to report equivalents. An article like this has two certain results: one is more hectoring abuse from the 'scientific' theorists who are convinced that I am sliding down a slippery slope which leads to a conversion in Bury St Edmunds Cathedral; the other is another batch of letters, replete with slides,

from second-rate artists who commune with the life spirit, and are convinced they know 'exactly what I am talking about'. Nonetheless, I insist: when such experiences are conveyed to us with aesthetic conviction of the stature which Collins, at his best, commands, we are missing something if we mock, or reject, his fool's vision.

Such experiences lie at the very root of the English response to landscape. That great poet Thomas Traherne saw vividly how they sprang out of the particular modes of seeing and feeling peculiar to childhood. 'Is it not strange,' he marvelled, 'that an infant should be heir to the whole World, and see those mysteries which the books of the learned never unfold?' For Traherne there was an explanation. For him, as a child, 'The corn was orient and immortal wheat, which never should be reaped, nor was ever sown.' The child lives outside the tyranny of time passing. He thought, as other children do, that the corn had stood 'from everlasting to everlasting'. In childhood, 'the dust and stones of the street were as precious as gold: the gates were at first the end of the world. The green trees when I saw them first through one of the gates transported and ravished me, their sweetness and unusual beauty made my heart leap, and almost mad with ecstasy, they were such strange and wonderful things.'

Traherne, like Collins, believed that, as an adult, it was essential to retain and cultivate this childhood sense of wonder at the infinite in the particular, of unity with what Collins calls 'the dance of creation'. Many British painters and writers in the nineteenth century succeeded in doing this. Richard Jefferies, an essayist of genius, characteristically recalls a moment when: 'Touching the crumble of earth, the blade of grass, the thyme flower, breathing the earth-encircling air, thinking of the sea and the sky, holding out my hand for the sunbeams to touch it, prone on the sward in token of deep reverence, this I prayed that I might touch to the unutterable existence infinitely higher than deity.' And he believed that he did.

This is the sort of vision which Collins's glowing pictures reveal to us. I do not want to pretend that it has no equivalents in cultures other than our own. No one who has dipped into the writings of Jacob Böhme, or seen Philipp Otto Runge's extraordinary picture

6
The Happy Hour
Cecil Collins

of a naked infant lying in ecstasy on wet green grass, *The Child in the Meadow*, could ever assert that. But this island has a climatic and geographic temperament which has played its part in forming our 'structures of feeling': the complexion of our skies, the trim physiognomy of our fields and hedgerows, the characters of our mountains, lakes and coastlines, the gentle variability of our weather, have all encouraged and inflected such sensibilities. Nowhere have they played a greater part in a national, cultural tradition than here. Last month, I stood overlooking Plymouth Hoe, which Collins knew as a child and a young man: the mists hung low; the sea broke on the rugged rocks beneath me. The sprawling city exuded its sense of history behind me. I tried to suspend knowledge and reason, to yield to the elements. At such moments, we approach, however falteringly, the sort of experience which a painter, like Collins, has the gift to express vividly through his pictures.

Of course, it is easy to 'demythologise' such responses. After all, that is what modern art, modern science, modern psychology and modern technology encourage 'rational' men and women to do. Certainly, I could easily 'explain' the sort of phenomena I have been describing: I have, after all, often enough laid stress on the importance of the continuance into adult life of childhood feelings of fusion and separation, of that capacity to mingle subjective and objective which Winnicott saw as the root of all subsequent cultural experience. Such interpretations may well be 'true' on their own level, and in their own terms; but I begin to doubt their value. The point is rather that in order to live at peace with ourselves, each other and the world, in order to transmute sensations into values, we need consoling illusions. *The* consoling illusion of God has been pricked for ever. Perhaps we have to learn to gaze like grown-up children, or Collins's fools, who can still sustain 'moments of illusion' in which they can see, and know not to challenge, their wounded angels.

1983

IV

MARBLE BRITANNIA

Epstein

Few people who hurry past Zimbabwe House, on the corner of Agar Street and the Strand, even pause to look up at the remnants of sculpted figures lurking uneasily in the niches at the second-floor level, over forty feet above the busy street. Those who do see only a series of headless and sometimes legless trunks of stone whose shattered visages indicate that they have suffered indignities worse even than those wreaked by pigeons and pollution.

Certainly, these mutilated statues look more like respectable relics of some long-lost civilisation than anything which could conceivably relate to the shock of the new. But, in the summer of 1908, almost everyone who passed this way glanced up; never before, it seemed to many of them, had they seen such scandalous sculptures. The appearance of these figures on the façade of what was then the British Medical Association Building marked the sudden arrival of Jacob Epstein, a sculptor whose long career was to be studded with controversies.

Now that the battles which once raged around his work have subsided, Epstein seems strangely unregarded. Although his portrait heads can readily be seen in provincial galleries up and down the country, where sculpture is made, talked of and written about Epstein is but rarely mentioned. There are no available illustrated monographs on his work. There is, however, a real sense in which sculpture today is just beginning to rediscover truths of which Epstein became aware seventy years ago. Abstraction, construction, and rabid modernist experimentation seem to have run their course. There is a return to traditional techniques and figuration, and deep confusion about how this can be done without lapsing into solipsistic primitivism. In this climate, no major figure in British art seems riper for a revaluation than Epstein.

Epstein was born in 1880, of Russian-Polish parents, in Hester Street, on the East Side of New York. The money he made from

illustrations for a book about ghetto life enabled him to come to Europe. After a brief stay in Paris, he moved to London in 1905; he was to be based in Britain for the rest of his working life. He began to associate with members of the New English Art Club; and, after just two years, he received his first major commission.

Charles Holden, architect of the BMA building, was an improbable patron for a man whose sculpture was to lead him to be accused of indecency, Bolshevism, paganism, anarchism and worse besides. As a Jew who evoked Christian iconography in controversial ways, Epstein sometimes brought down on himself the most virulent anti-semitic charges. Holden was a Quaker and a man of sober, even ponderous, classical tastes. And yet he gave the virtually unknown youthful immigrant a free hand over the BMA sculptures.

Epstein decided he would carve figures which represented man and woman in their various stages from birth to old age; as he later put it, 'a primitive but in no way a bizarre programme'. Most of the themes he chose sound bland enough on paper: Youth, Joy, Motherhood, the Continuity of Life. Others have a more dated ring: Chemical Research, Hygeia and Primal Energy.

In June, 1908, the scaffolding came down and the first four figures were revealed to a waiting world. The capital came alive with the screams of outraged decency. The Council of the BMA consulted with the Director of the National Gallery, earnestly discussed the matter among themselves, and decided the commission should stand. Even when one sees the photographs of the way the statues once were, it is hard to make out what all the fuss was about.

Epstein's carvings were nothing if not deeply traditional. As Sir Charles Holmes wrote to *The Times*, they were 'in the grave, heroic mood of pre-Pheidian Greece'. Even their departures from these ancient precedents were hardly stunningly original. Certainly, shades of the still controversial Rodin hovered around several of the figures. But Epstein was also subject to influences much closer to home. As Susan Beattie has recently demonstrated, British sculpture in the last two decades of the nineteenth century was altogether livelier and more innovative than has often been admitted. For example, Epstein would seem to have looked long

and hard at the remarkable stone carvings and bronze statuettes which George Frampton had made a few years earlier for Lloyd's Registry building in Fenchurch Street.

But revulsion against Epstein's carving was no nine-day wonder. In 1935, the Rhodesian Government acquired the building and officially sanctioned the mutilation of the figures. During the intervening quarter of a century, Epstein's work was at the centre of a succession of storms, not all of which could be explained in terms of Mrs Grundy's prudery.

For example, in 1912, Epstein's tomb for Oscar Wilde was unveiled at Père Lachaise cemetery in Paris. Epstein evoked the monumental majesty of Assyrian funerary sculpture he had seen in the British Museum; he adorned a huge stone slab, mounted on a plinth, with a great winged figure of a fallen angel of debauchery. The French authorities, however, objected to the size of the angel's private parts. The fig-leaf upon which they insisted was removed by a group of writers and artists; thereafter, the whole tomb was kept covered by a tarpaulin until the outbreak of war focused French minds on yet more pressing matters.

Even the beautiful bas-relief, 'Rima', which Epstein carved in 1925 as a memorial to the naturalist W. H. Hudson at the request of the Royal Society for the Protection of Birds, gave rise to a vigorous and vicious campaign for its removal from the bird sanctuary in Kensington Gardens. This was led by Frank Dicksee, President of the Royal Academy, and bolstered by the *Morning Post*. Vandals daubed the carving with green paint.

None of all this seems to have perturbed the dour and respectable Charles Holden when, in 1928, the time came to decorate the London Passenger Transport Board's headquarters building in St James's. Holden prevailed upon a somewhat reluctant Frank Pick, of LPTB, to let Epstein play a central part in the provision of sculpture for the building. Epstein was given the two prime sites over the doorways, at street level. (The bas-reliefs of the winds made by other sculptors including Eric Gill and Henry Moore are very difficult to see, situated as they are more than eighty feet above the ground.) Epstein once again seems to have been allowed to carve exactly what he wanted: he chose the themes of 'Day' and 'Night'.

'Night', above the doorway on the north-east side, is a rework-
ing of the traditional Pietà theme. But the seated female figure,
with her great arm hovering over the vulnerable naked male
falling asleep on her lap, could not be more unlike a grieving
mother of Christ. There is something atavistic about both the
woman's features, and the carving itself. 'Day' is a father and son
group; but again, there is a self-consciously pagan feel to this
piece. The grimacing father looks like some strange and forbid-
ding Aztec god, who might as easily eat his naked son as protect
him from the world.

By this time, it seemed there was almost a preordained ritual for
the unveiling of a new Epstein sculpture; the press campaign was
immediate, sustained and vituperative. The *Daily Express* de-
scribed 'Night' as a 'prehistoric blood-sodden cannibal intoning a
horrid ritual over a dead victim'. Vandals responded by tarring
and feathering the sculpture. And twenty-one years after the B M A
Council meeting, the London Underground Company held a
board meeting at which Epstein was again the principal topic
under discussion. This time, however, things went against the
sculptor. One of the aged directors declared that he, personally,
was prepared to pay for more appropriate embellishments to the
building, if the offensive Epsteins were removed. His offer was
received with relief and gratitude.

Frank Pick tendered his resignation, and a compromise appears
to have been reached whereby it was agreed that one and a half
inches should be removed from the penis of the boy figure in
'Day'. Partial emasculation seems to have been a standard way
out of such dilemmas; at least it was to be invoked two years later
when the Board of Governors of the B B C instructed Eric Gill to
reduce the size of the penis on his controversial figure of Ariel
outside Broadcasting House. One suspects the father in Epstein's
'Day' might well have approved of these goings-on.

Although this strange god is still there, grimacing above the
heads of the morning rush-hour crowds, Epstein himself was not
to receive any more public commissions for twenty-two years. But
his sculpture continued to excite agitated responses. As John
Rothenstein put it, 'the very name Epstein became, from drawing-
room to music-hall, a synonym for something compounded of

dark primitivism with a ruthless and irresponsible radicalism.'
Epstein's 'Adam' was acquired by a showman, exhibited in an
Oxford Street fun-fair, and then taken on a tour round the
country to be paraded in side-shows. Finally, 'Adam' ended up
alongside several of Epstein's finest free-standing pieces – includ-
ing 'Genesis', 'Jacob and the Angel', and the elegiac tomb figure,
'Consummatum Est' – in Louis Tussaud's waxwork exhibition in
Blackpool.

Art historians, looking back over Epstein's stormy early career,
often like to suggest he was an avant-gardist confronted by a
baying herd of traditionalists and philistines armed with sackfuls
of brickbats. Thus Simon Wilson once wrote, 'Epstein was the
father of modern British sculpture and, more generally, one of the
pioneers of modern sculpture in the whole Western world, both
through the force of his style and to some extent through the
intense controversy aroused by his work throughout his life.' The
only trouble with this view is that Epstein was not at all sympathe-
tic to Modernism; rather, as Rothenstein wrote, he was 'the most
traditional of the handful of major sculptors of his time'.

It is true that before the first world war Epstein came under the
influence of the Vorticists, and especially of T. E. Hulme, the
philosopher and critic. Hulme urged Epstein to pursue abstract
and mechanical forms and to reject what he saw as the outmoded
Renaissance 'humanist' tradition. In 1913, Epstein began to make
his notorious 'Rock Drill', in his own words, 'a machine-like
robot, visored, menacing, and carrying within itself its progeny,
protectively ensconced'.

Epstein may have partially derived this creature from an earlier
self-portrait, with a sculptor's visor; he mounted the mechanical
'thing' on an actual industrial drill, which he even thought of
running when the sculpture was on exhibition. 'Here,' he com-
mented later, 'is the armed, sinister figure of today and tomorrow.
No humanity, only the terrible Frankenstein's monster we have
made ourselves into.'

Art historians fetishize this figure. Epstein himself quickly came
to dislike it. He was no Futurist, and had no wish to celebrate
mechanisation and war. He soon disposed of the drill, and
truncated the sculpture by slicing it in half. When he went back to

carving and modelling faces with human features, he complained
that 'advanced critics' spoke of his having 'thrown in the sponge'.
He was, he says, lost to the modern movement; but he never
regretted this. He continued to regard abstraction as 'a cul-de-sac'
which would lead only to exhaustion and impotence. Again and
again, he stressed he was a traditionalist; 'all great innovators in
art,' he said, 'were in the great tradition.'

His work was not technically 'progressive'; everything he did
depended upon carving and modelling – not *objet trouvé*, con-
struction, collage or any of the new techniques. Much has been
made of his 'introduction' of direct carving. (He chiselled the
stone himself rather than allowing craftsmen to point up for him
from maquettes.) But even in the nineteenth century, direct
carving was less rare among academicians, ecclesiastical and
architectural sculptors and master-masons than is sometimes
suggested. It was simply that Epstein used carving more vividly,
rawly and expressively than others.

Nor is it true that Epstein was especially concerned about that
other great rhetorical tenet of modern sculpture, 'Truth to mate-
rials'. His great forte was modelling in clay for bronze casting;
and, as Henry Moore himself has pointed out, the concept of
'truth to bronze' has no meaning. Epstein poured forth a stream of
vigorously modelled likenesses in that most traditional of all
sculptural modes, the portrait head. His studies of Jacob Kramer,
Einstein, Shaw, Conrad, Nehru and Menuhin are all masterpieces
of a genre no modernist would have touched. 'Personally,' he once
said, 'I place my portrait work in as important a category as I place
any other work of mine, and I am content to be judged by it.'

Why then did Epstein evoke such relentless controversy? The
affairs surrounding his work were different in kind from those
which spring up over, say, Carl Andre's bricks, or whatever piece
of avant-garde nonsense today. Epstein was not just a good
traditional sculptor; he also wanted his work to be expressive of
something beyond its own physical presence. 'My outstanding
merit in my own eyes,' he once wrote, 'is that I believe myself to be
a return in sculpture to the human outlook.'

And the vision Epstein expressed through sculptural forms and
images *was* accessible to others. One can hardly expect Epstein to

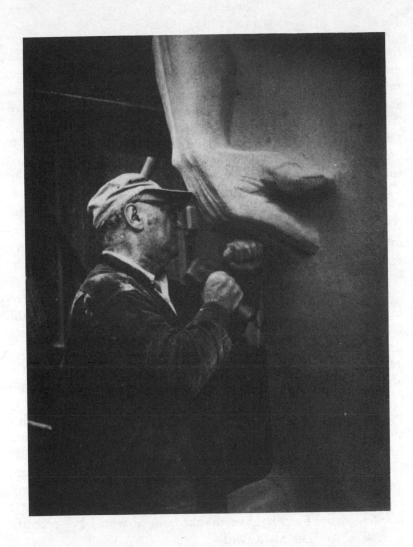

7
Epstein at work

have appreciated the fact – and he didn't – but the daubing, abuse, emasculation and so on were perverse acts of homage. Epstein rarely evoked cynicism, indifference or perplexity. People did not stand in front of his sculptures and ask, 'How much did it cost?' or 'What is it meant to be?' Conversely, no showman would want to purchase *Equivalent VIII*, the bricks, as a pier attraction. People could see clearly the vision of men and women Epstein expressed through his sculptural skills; and, at first, many of them hated it. Theirs was the sort of hate, however, which transmutes into love: I suspect that if today anyone did to those figures of 'Night' and 'Day' what the Rhodesian Government did to the Epsteins they inherited, there would be a ferocious campaign – in Epstein's favour. No one is ever likely to give a damn about what happens to *Equivalent VIII*.

It must also be admitted that the first angry public response to Epstein was not unasked for. Epstein's carving – in contrast to the sensitive refinement of modelling in his portrait heads – was a deliberate provocation. He remained within the great tradition, yes. But he stretched it to its limits. His public works drew attention to what he liked to call the 'elemental' aspects of life – birth, procreation, sexuality and death – in an unrelentingly physical or sensualist way. Yet it is not difficult to see why this should be so. What widely understood symbolical language could Epstein have used to raise his trammelled Lazarus from the dead? He felt the Greek conventions had been devalued – although, unlike many, he never lost his respect for the sculptural achievement of the Greeks. He abhorred the new images of mechanical man; he would never have thanked those who have recently reconstructed 'The Rock Drill'.

It was often said of Epstein that though he adhered to no religion himself, he remained a deeply, if eclectically, religious man. He certainly wanted to use his sculpture to express the activity of spirit, soul and imagination, as well as the mere presence of flesh. In the end, though always conscious of his Jewishness, he was to find the answer in a secular reworking of Christian imagery. The beautiful *Madonna and Child* he modelled in 1951 for a convent in London's Cavendish Square did not provoke the usual ritual assaults and denunciations. Arnold

Haskell may exaggerate a little when he calls it one of the finest
religious sculptures in England since the Reformation; but it is
certainly one of our greatest sculptures, of any kind, this century.

1984

Gaudier-Brzeska

If you came across the sculpture, *Bird Swallowing a Fish*, without knowing when it was made, where, or by whom, you would, I think, be fascinated and perplexed. *Bird* is undeniably a work of exceptional sculptural strength, but it is of a kind which cannot easily be identified.

Unlike much Western sculpture on animal themes, *Bird* does not depend upon the reproduction of surface appearance, nor yet on the expressive power of gesture. Even though it deals with a dramatic subject it is neither theatrical, nor sentimental, nor anthropomorphic. Rather, this taut and compacted piece works upon us through a tightly orchestrated rhythm of planes. But, despite this degree of abstraction, *Bird* seems to have been made by someone who knew his animals well, who has seen, and noted, what actually happens when a water-bird swallows its prey.

Could it be a mythologically inspired artefact from some ancient and little-known African kingdom? Perhaps, but there is something resolutely modern about both its imagery and handling: the former shows more than a hint of missiles and mechanism in the fish forms; the latter indicates a characteristically twentieth-century grasp not only of structure, but also of *movement*.

Bird was, in fact, made in 1914, by Henri Gaudier-Brzeska, the year before he died. It is, perhaps, his finest work. Like many Cambridge undergraduates of my generation I first saw *Bird*, and got to know about Gaudier, through Jim Ede, who was then still living at Kettle's Yard, his home beyond Magdalene Bridge. Today, Kettle's Yard is an art centre administered by the University, where a major exhibition of Gaudier-Brzeska's work can be seen.

There were several pieces by Gaudier-Brzeska permanently at Kettle's Yard, and casts of many more. Ede championed Gaudier

before he was generally acclaimed. In 1931, he published *Savage Messiah*, a vivid biography, later the basis for Ken Russell's melodramatic film. It is thus appropriate that this major exhibition – the largest since Gaudier's memorial show of 1918 – should be staged at Kettle's Yard. Sadly, however, the catalogue is not only intellectually bankrupt, but an insult to Ede, now 88 and living in retirement in Edinburgh.

It treats us to a 'deconstruction' of Gaudier as 'an artistic subject'. Gaudier was invented, or so it claims, by professional art historians, 'through specific texts written between 1916 and 1933' – especially *Savage Messiah*. Art history, these art historians tell us, is 'a field of knowledge, invested with power', which it deploys to present artists 'as paradigms of individuality in terms of self expression'. In the case of Gaudier, the texts commit the 'bourgeois humanist' sin of depicting him as male, a creative genius, and at odds with the cultural, social and sexual norms of his day. He was, of course, all of these things; and neither Ede, nor Pound, nor any of those who wrote about Gaudier at that time, were, in fact, professional art historians . . . But, for these writers, that makes no difference since, as they put it, 'It is not suggested . . . that one reading is any more or less valid than another, for this would imply that there is in fact a 'real' Henri Gaudier to be identified.'

Indeed, there is. And he has always produced strong reactions. Henri Gaudier was born at St Jean de Braye, near Orleans, in 1891. His father was a carpenter and wood-carver; from him Henri learned to love the countryside and its creatures, and acquired the skill, knowledge and values of a craftsman. At six, he was already making detailed drawings of insects.

Gaudier was exceptionally bright, and his family wanted him to pursue a career in commerce. In 1907, he came to Bristol to study business, but he was already consumed by his interests in painting and drawing. He found his subjects in the countryside, the Bristol Museum, with its casts and aquaria, and the zoo.

The landscape, museums and zoos were to remain important sources of inspiration throughout his short life. In 1908, he completed his business studies with practical work for a coal-importing firm in Cardiff. A colleague there recalled that he spent

'virtually all of his time drawing, with a special passion for pen. and ink pictures of bits of old churches, and Ruskin was his guide'.

Gaudier's heart was evidently never going to be in commerce. He travelled to Germany and Paris, where, in 1910, he met Sophie Brzeska, while he was drawing from the antique in the Louvre. She was a formidable Polish poetess, twenty years his senior. Gaudier quickly developed a compulsive attraction for her. For her part, Sophie's previous relationships had been largely lesbian, and she was looking for a son. Their love was stormy and intense, but never explicitly sexual. They took, however, to calling themselves Gaudier-Brzeska, and came to England, where they lived together apparently as brother and sister.

It is clear from Gaudier's letters that he had more in common with Ruskin (who loved nature, had no sexual relations, and yet got mother figures to sing him to sleep even in old age) than drawing style. During one of their many separations, Gaudier wrote to Sophie confessing he had broken a jug, and regretting there was 'no Mamus to beat Pik's bottom with a slipper' (these were his pet names for Sophie and himself respectively). 'For several nights', he continued, 'I've dreamt about my beloved Maman – such lovely things, like the dreams of quite little children: little Mamus, magnificent, radiant with great suns all around her, bending low over Pik to bless him – and the sentimental Pikus, who always takes the mask to bed with him, wakes in the morning kissing it, in the belief that it is his real Maman.' (The 'mask' is a reference to a clay portrait of Sophie as an earth goddess which he made about 1911.)

The year Gaudier met Sophie, he became clear about his desire to devote himself to sculpture. He was a 'natural' sculptor, in the sense that he had an intuitive understanding of the fact that 'sculptural feeling', as he once wrote, 'is the appreciation of masses in relation. Sculptural ability is the defining of these masses by planes.' The work he produced over the next four years was inventive, varied and often exploratory; but it is sustained by an imaginative coherence.

As early as 1910 he declared that he was rid of his obsession with Ruskin and the English; but his 'aesthetic' remained a secular parallel of Ruskin's. 'When I face the beauty of nature', he once

wrote, 'I am no longer sensitive to art, but in the town I appreciate its myriad benefits – the more I go into the woods and the fields, the more distrustful I become of art and wish all civilisation to the devil; the more I wander about amidst filth and sweat, the better I understand art and love it; the desire for it becomes my crying need.'

Similarly, he had an acute sense of the properties and values of the wide range of materials which he used and a deep understanding of the transforming power of the sculptor's *work*: 'The sculpture I admire is the work of master craftsmen. Every inch of the surface is won at the point of the chisel – every stroke of the hammer is a physical and a mental effort.'

Gaudier possessed a voracious and eclectic appetite for the best sculpture of the past. He knew well not only Greek work, but also Rodin, Egyptian, African, and the whole range of 'primitive' scupture – and he knew how to find in all this just what he needed, when he needed it. For example, the waning of his admiration for Rodin, and his growing interest in the 'primitive', related to a realisation that the conventional forms in the latter could, as he put it, 'give enormous satisfaction, through severe happiness or expressive sorrow'. He felt they often revealed an understanding 'more at one with nature, in other words greater' than the 'modern' sculpture of Pisani, Donatello, Rodin and contemporary French sculptors.

But Gaudier was not interested in primitivist nostalgia. He was well aware of, and from 1912 onwards moved amongst, avant-garde circles of his day. He met and was influenced by Epstein; he knew Wyndham Lewis well, wrote for *Blast*, and exhibited with the Vorticists. But as Mervyn Levy has put it, Gaudier was the only member of the intellectual hard-core of the Vorticist movement who could 'think, and yet draw and sculpt without thinking'. In Gaudier, Levy wrote, 'there was an intuitive flow: a sense of surging, irresistible life that refused to be filtered through the smoke-screen of polemics which eventually subsumed the movement.'

Significantly, Gaudier was the first on his feet to attack the Italian Futurist Marinetti when, in 1912, he came to England and urged his audience to 'disencumber yourselves of the lymphatic

ideology of your deplorable Ruskin . . . with his hatred of the machine, of steam and electricity, this maniac for antique simplicity resembles a man who in full maturity wants to sleep in his cot again.' Gaudier, after all, was not averse to sleeping in his cot when he could.

In 1914, Gaudier enlisted in the French army. His letters from the front reveal how he saw nature as the repository of values and hopes radically other than those of the destructive technology of men. 'The bursting shells,' he wrote for *Blast*, 'the volleys, wire entanglements, projectors, motors, the chaos of battle, do not alter in the least the outline of the hill we are besieging. A company of partridges scuttle along before our very trench.' And again: 'The shells do not disturb the songsters. In the Champagne woods the nightingales took no notice of the fight either. They solemnly proclaim man's foolery and sacrilege of nature. I respect their disdain.' Gaudier was killed in action, near the village of Neuville St Vaast, in June 1915; Marinetti 'progressed' to Fascism, and the open aestheticisation of war. 'War is beautiful', he was to write, 'because it creates new architecture, like that of the big tanks, the geometrical formation flights, the smoke spirals from burning villages . . .'

Some have seen in *Bird Swallowing a Fish* a conscious reference to that conflict which, when Gaudier made this work, was beginning to subsume the world. Certainly, Gaudier wanted to affirm that nature, with its potentially healing and restorative powers, would continue; that, however improbably, the partridges and nightingales would defeat the missiles in the end. Unlike the modernists, the roots of his aesthetic were always organisms rather than mechanisms.

Gaudier's vision of a harmonious relationship with nature achieved its realisation in the world only through his growing mastery of the techniques and traditions of sculpture. But there can be no doubt that the energy to achieve this mastery derived, in part, from his lifelong obsession with the infant-mother relationship, the pathological side of which was manifest in his relationship with Sophie.

Of course, it has suited some to over-emphasise Gaudier's infantilism, and to argue that even in his work he was some sort of

raw primitive, unaffected by culture. Thus in 1914, Richard Aldington wrote that Gaudier was 'the sort of person who would dye his statues in the gore of goats if he thought it would give them a more virile appearance.' Gaudier has been reduced from the other side, too. He is sometimes represented as an immature proto-Modernist, fumbling towards a mechanist abstraction he almost achieved at the end of his life, and would certainly have embraced had he lived. Study of the chronology of his work quickly reveals what nonsense this is.

Sophie's ideas about 'a society founded on motherhood' appealed to Gaudier, and two of his most important sculptures deal, in very different ways, with *Maternity*. Gaudier brought all his acquired skills, knowledge of tradition and innate sculptural intelligence to bear on the creation of his sculptural forms. But these affirm in the midst of modern, adult life, the value of imaginative mingling of subjective and objective, which is in continuity with the infant's experience in the infant-mother relationship. This continuity, as Gaudier so well knew, is tragically ruptured in bellicose, technological societies, which have lost touch with, and respect for, nature, and seem intent on destruction rather than creation. These are the societies whose dehumanised values Marinetti, and today's structuralist critics, celebrate.

But it is easy to see why Jim Ede responded so strongly to Gaudier. He once described Kettle's Yard as 'a continuing way of life . . . in which stray objects, stones, glass, pictures, sculpture in light and in space, have been used to make manifest the underlying stability which more and more we need to recognise if we are not to be swamped by all that is so rapidly opening up before us.' Ede had no patience with those who looked on art simply as a series of specimens for art historical studies. He brought many, including myself, to 'see' Gaudier's sculptures for the first time, and to learn to love them. He deserves our thanks, not crude and cruel 'deconstruction'.

1983

The Success and Failure of Henry Moore

In the Great Medieval Hall at Winchester Castle, you can currently see the plaster of Henry Moore's enigmatic *King and Queen*, seated on their bench-like throne; his twisted *Fallen Warrior*, dying beside his shield; and a monumental, elmwood *Reclining Figure*, made over five years between 1959 and 1964, a magnificent recapitulation of a theme Moore had already been exploring for many years.

The Great Hall, with its voluminous spaces and high Gothic vaulting, houses what is reputed to be the top of King Arthur's Round Table: it is hard to think of many contemporary sculptures which would look other than impoverished in such surroundings. A vast bronze statue of Queen Victoria, wearing her crown and skirts and clutching an orb, appears peculiarly uncomfortable in this place. But the best of the Henry Moores do not. They seem to belong to that tradition which the Hall affirms.

At the moment you can see Henry Moore's work in all manner of different places and contexts. There are exhibitions of late sculpture and drawings at the Tate Gallery, and a good commercial show at Marlborough Fine Art in London; and retrospectives at the Arts Centre in Folkestone and the Metropolitan Museum in New York. There is even a retrospective at Ljubljana City Museum in Yugoslavia. Henry Moore was eighty-five in 1983, and he has become something of a monument in himself.

Moore, deservedly, enjoys the reputation of being the world's greatest living sculptor. His work stands in parks, piazzas, town squares, and outside banks, museums and all manner of institutional buildings throughout the non-communist world. No sculptor in the history of human civilisation has been so extensively exhibited.

But the response to Moore's work has been anything other than constant. Up until the second world war, his sculpture was subject

to popular ridicule. But he was supported by the cognoscenti of modernism to such a degree that, by the 1950s, any sort of intelligent or informed negative criticism of his work seemed virtually impossible. (John Berger has described how when he reviewed an exhibition of Henry Moore's, arguing that it revealed a falling-off from his earlier achievements, the British Council actually telephoned the artist to apologise for such a regrettable thing having occurred in London.)

By the 1960s this situation had changed dramatically. Popular resistance to Moore's work diminished; he became an accepted, even an appreciated, part of the environment. Within the art world, however, the high esteem in which he had been held waned. Clement Greenberg, the most influential American critic of the 1960s, simply refused to acknowledge Moore's achievement. And Greenberg, regrettably, had a profound influence on the development of British sculpture in the 1960s, with its shift away from traditional subjects and materials towards the welding together of industrial, steel elements. For many years, Moore simply was not attended to in sculpture departments and studios; and the younger artists and critics ignored what he was doing.

Now that is changing too; the best contemporary sculpture is returning to its true self, its traditions and its roots. Many younger sculptors are realising that it is Moore's towering achievement which they have to reckon with; never has the pursuit of that elusive 'just assessment' of his work been more necessary, or urgent.

In one sense, the range of Moore's sensibility, if not his subject matter, is extraordinary. Take, for example, his *Mother and Child* of 1924/5, now in the Manchester City Art Gallery. This monumental piece in Horton stone was the first work which revealed Moore as a sculptor of potential genius. Its massive, yet closed and compacted forms differ radically from those he was later to prefer. But his emphasis on strength and power has a freshness and energy almost unique in the handling of this theme by Western sculptors.

But Moore could also see the tenderness of the infant-mother relationship. This is drawn out in the famous *Northampton Madonna* he produced almost twenty years later, after a period of

confusion and blankness in his development. Yet there is nothing sentimental, mawkish or – paradoxically, given its title and context – religious about this work. It is one of the great *secular* sculptures of a mother and child.

Or take the *Memorial Figure* of 1945/6, so impressively placed in the grounds of Dartington Hall. The huge, swathed stone woman reclines with her weight resting on one elbow, one knee raised in the air, in a pose which has always fascinated Moore. She is surrounded by moss, plants and trees, and she exudes a sense of majestic serenity, wholeness and completeness, which defies time and circumstance. How different she feels from the mysterious, cut-open and exposed forms of, say, the elmwood *Reclining Figure*, now lounging in the Great Hall at Winchester, where everything radiates out from the revealed inner centre of the woman's body.

Moore's success in the realisation of works like these depends, in part, on the intensity with which he has observed and transformed natural and human forms. He once said that life-drawing was 'the most exacting form of concentrated activity that exists.' Carving, by comparison, was 'like digging up the garden'. Moore's sculpture, unlike that of many of his contemporaries, springs out of drawing, which he describes as 'a deep, strong, fundamental struggle to understand oneself as much as to understand what one's drawing'.

Indeed, his capacity to achieve 'full cylindrical roundness' of form seems to depend on a prior mastery of two-dimensional drawing. But to render it fully sculptural, Moore also had to embrace tradition; but from the beginning, he recognised he would have to re-invent that tradition for himself. He did so by turning to models which had had little influence on western sculpture; by exploring Sumerian and archaic Greek work, Etruscan, ancient Mexican, Fourth and Twelfth Dynasty Egyptian, Romanesque and early Gothic – in preference to High Greek art.

But, for Moore, the involvement with technique, and the art of the past, was always a means to an end: the realisation, through sculpture, of a contemporary vision. In one sense, his preoccupations have been remarkably limited; the core of his concerns has always been the reclining female figure and the mother with her

child. The first of these types he extended outwards, towards an image of woman as landscape, and an involvement with the range of natural forms, including those of animals; he also pressed it inwards, towards an exploration of vertebrae, knuckles, bones – the interior structures of the body. The latter theme too (the more significant one for him) was occasionally extended into relationships between other kinds of figures: adult couples, like the *King and Queen*, and whole family groups. Sometimes, Moore has also engaged with the single male figure – usually as a broken warrior, or a helmeted head. But he is not, and never has been, moved by mechanical, industrial or synthetic forms. As he once put it, for him the 'humanist-organicist' dimension is the essential root of sculpture.

Moore has given many clues as to how his concerns emerged from his early, formative years. His work rarely shows signs of intense conflict, and it seems to stand in a direct continuity with his life as a child. His father was a miner who was deeply interested in culture and the arts. Moore's work always seems to have much to do with tunnelling and cutting through the Yorkshire landscape and with the view of the Gothic churches he saw at that time.

Moore has often told the story of how his mother suffered from bad rheumatism in the back. 'She would often say to me in winter when I came back from school, "Henry, boy, come and rub my back." Then I would massage her back with liniment.' He relates this experience to a particular seated figure of a mature woman he made in 1957. 'I found that I was unconsciously giving to its back the long-forgotten shape of the one that I had so often rubbed as a boy.' But one feels that such early experiences somehow inform the vision he wished to convey through all his later sophisticated sculptural skills.

For Moore, I believe, is one of the very few artists of our time who has managed to circumvent the absence of a shared symbolic order through an imaginative, and emotionally charged, involvement with human and natural form. I have written before of the roots of human aesthetic experience in the infant-mother relationship; its polarities correspond to the duality of that relationship. On the one hand, the mother is the sustaining environ-

ment, the landscape that engulfs, holds and provides. On the other, she is the specific object of the infant's affections and excited needs. These two poles relate, in art, on the one hand to the engulfing experiences associated with the sublime, and on the other to the defined, limited and formal experiences of the beautiful.

More than any other twentieth-century artist, Moore draws *directly* upon these areas of experience. They constitute his literal and sole subject matter. In his hands, however, they are much more than just the expression of a private subjectivity; through his re-invention of sculptural tradition, and his rigorous exploration of natural form, he is able to give them that sort of universality which otherwise we would only expect from an artist who had access to a living, iconographic, religious tradition. Moore shows that a secular art of high sentiment is still possible in our time.

But he is not without his weaknesses. At times, his flirtation with the European Modernist movements led him into unfortunate culs-de-sac; on other occasions, the transitional tension between image and materials seemed to be coming down too heavily on the side of the latter: the image seemed to disappear into mere explorations of matter. Such faults he has explicitly acknowledged, and rectified. A greater one springs out of the very scale of his ambition.

At times, Moore seems to have been motivated almost by a desire to fill the world with Moores; in the last twenty years, the size of his works had tended to inflate, and their scale, often, to diminish. 'The most striking quality common to all primitive art,' he once said, 'is its intense vitality. It is something made by people with a direct and immediate response to life. Sculpture and painting for them was not an activity of calculation or academicism, but a channel for expressing powerful beliefs, hopes, and fears.' Much of Moore's work from the late 1920s until the 1950s has precisely these qualities. Most of the pieces which have been hauled up outside public buildings in recent years, however, do not. At times, Moore seems to have become something of an airport artist, or mannerist, within the very tradition he invented for himself. Some of his figures testify to the fact that they were made by Henry Moore – and little else. And even that is not

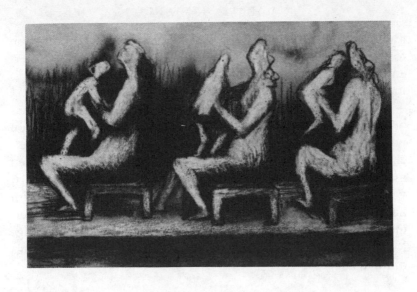

8
Woman Nursing Child – Three Studies
Henry Moore

always strictly true; many recent carvings have been pointed up for him by craftsmen. For all their smooth sleekness, the difference from the taut energy of the earlier, directly-carved pieces is immediately apparent.

But it would be wrong to suggest that Moore's great vision has been swamped. If you go to the current exhibition at the Tate, you will see a cabinet of small bronze maquettes of mothers and their children, most no more than a few inches high. All have been made in the last few years. There, and at Marlborough Fine Art, you will also see superb drawings of heads, a mother playing with her children, and studies of trees, clouds and the sky. For all their modesty and casualness, these seem to me among the finest things Moore has done – comparable with the last, quivering drawings of Michelangelo.

1983

Glynn Williams: Carving a Niche
for Sculpture

Glynn Williams made the sculpture, *Squatting, Holding, Looking* — now permanently sited in the Conniburrow Estate, Milton Keynes — last year. I believe it is one of the most remarkable carvings to have been produced in Britain during the last quarter of a century.

There can be no doubt about what the sculpture shows; unlike so many recent works, it is unequivocally representational. It is expressive of the physical activities referred to in its title. A woman crouches down on her haunches; the weight of her huge thighs slaps against her calves; her arms form a ring protectively encircling herself and a standing child. But Williams is also clearly interested in evoking the feeling of *being within* that primary maternal embrace.

The ring of the arms merges the two figures, but both their heads are turned outwards to look, as if alerted, into the world. The thrust of the child's raised right arm and hand also evokes the theme of autonomy in unity. Thus Williams expresses the paradox of the beginnings of individuation which require a complete trust in the sustaining power of the mother, and her supporting arms.

There is nothing sentimental or mawkish about this work; indeed, the mood evoked by the woman's huge sloping back is, if anything, public and monumental. Although neither archaising nor nostalgic, it has nonetheless been fashioned with a sense of belonging to a sculptural tradition. The sculpture is characterised by freshness and originality of form, but it is redolent with echoes of Moore; the 'classical' modernist sculpture of Picasso and Matisse; and even Egyptian and African carving. The work bears witness to the fact that the man who made it was not only innovative, but also aware that he was engaged in a practice as old as human civilisation itself.

It is not just that in the working of the piece, form appears to have become content; so, it would seem, has the material itself. This mother-and-child is wrought in limestone, quarried from sedimentary layers of sea-life which are laid down in a great band stretching from Portland, in Dorset, to above Ancaster, from where this particular stone came. No two pieces of limestone are ever identical, but it comes in diverse and identifiable varieties which bear the names of those towns and villages where they were quarried. In its warm whiteness, individuality and soft smoothness when polished, Ancaster is evocative of flesh.

Thus the very matter out of which this mother-and-child has been fashioned was once living, remains natural, and has evidently been shaped, formed and given its distinctive character through the workings of nature as well as man.

In one sense, the creation of this mother-and-child represented the redemption of Williams's work from a long, dark night of his sculptural soul. But it can also be seen as a symbol of a renaissance in carving after what has been a very barren quarter of a century.

Williams was born a virtuoso carver, one of those rare men who can chisel stone so confidently that they are unable to see anything special or significant in their facility. Williams's ability was nurtured by a traditional 'academic' training in sculpture. Although he made several extremely fine early pieces, his innate talent and acquired knowledge of tradition did not combine in a way which provided a bed-rock for sculptural growth.

During the 1960s, Williams became seduced by the fashionable dogmas of Late Modernism, and what Henry Moore once called our 'synthetic culture'. His work became drained of imagery; and he pursued collage, mixed media and construction rather than carving. Mere placement of material, often without discernible symbolic intent, became a substitute for imaginative and physical working. Predictably, too, the substances he selected tended to be 'synthetic' rather than natural.

For example in the 1960s, like many other younger sculptors, Glynn Williams began to make works in fibreglass – believing that he could do anything he wanted with it. But, by its very nature, fibreglass is an inauthentic substance, repellent to the nose, dead, inert, sans history, warmth or sensuosity. Not only is the rela-

tionship between its volume and its weight always an unnatural lie, but it lacks any significant variety and kills the nuances of light that fall upon it. Thus fibreglass presents the sculptor's imagination with nothing but its own uniform nastiness. As it offers no resistance at the level of materials, no amount of transfiguring work can ever spring it into sculptural life. No sculpture of any aesthetic significance has ever been made in fibreglass, nor could it ever be since in its intrinsic identity, it is evil and anti-aesthetic.

As he struggled his way out of the Late Modernist cul-de-sac Williams began to rediscover the importance of the image and the continuing expressive potentialities of traditional techniques (like carving) and materials (like wood and stone). Williams, of course, was by no means alone in this, nor is the path he is travelling peculiar to fine art sculpture. It may even be that, in the late twentieth century, we are beginning to experience something of a new 'Gothic Revival', in the wake of a waning Modernism.

For example, Rattee and Kett, of Cambridge, recently installed a £400,000 crane in their yard. It soars up as a symbol of the way in which business is suddenly booming for one of Britain's largest stonemasonry companies. A few years ago stone quarries were closing down all over Britain, and it seemed as if Rattee and Kett would stop offering apprenticeships in stonemasonry altogether. Today, the quarries are opening again; the company now employs eighty masons, of whom twenty are apprentices. As a result, Cambridge College of Arts and Technology have brought back their stonemasonry course which was shelved a few years ago because no one wanted to enrol.

Certainly, much of the work the firm does is restoration, for example of King's College Chapel and Westminster Abbey. But the recent sudden growth in business, despite the general economic recession, undoubtedly reflects a significant cultural shift, a growing interest in conservation, tradition, stone and carving rather than demolition, 'progressive' architecture, curtain walls and standardisation.

But this Gothic Revivalism is far from being just a matter of care of ancient buildings. For example, in New York, work has restarted on the building of the world's largest Gothic Cathedral, St John the Divine. This was begun in 1892, but stopped half a

century later. The way the building is being made recalls the Victorian idealisations of the Gothic ethos. Thus James Bambridge, master builder, and Alan Bird, master stonemason, both British, have apprenticed to them formerly unemployed youths from Harlem who are carving and hand-hewing the 24,000 blocks that will go into the towers.

The resurrection of St John the Divine in this mecca of the curtain wall and the 'International Style' is indicative of a changing cultural climate. This change involves a recognition that, whatever the achievements of Modernism, it involved a massive cultural loss. I am reminded of this whenever I pass the fourteenth-century parish church of St George's in Stowlangtoft, Suffolk. The building is structurally patterned in flint and stone; but its finest feature is the rich wood-carving which proliferates over the backs and ends of the benches and in the stalls. Each bench end is different from every other, and each is adorned with a carving of some creature, animal or human.

In work of this kind, one can see how the opposition between the personal and the social has been fully overcome. Gothic ornament created the space for imaginative and individually expressive work; simultaneously, however, it bore witness to the symbolic order by which the community lived their lives. For us, this option has effectively disappeared. In his everyday work, the artist is menaced by unredeemable subjectivity, whereas most other workers find precious little space for individuated expression at all.

The problem has always been, however, that desirable as the Gothic solution may be aesthetically and imaginatively, it depends on an informing religious faith. No secular authority could have initiated a building project resembling that of St John the Divine. But something of the Gothic ethos can, I believe, be evoked through the autonomy of the free-standing sculpture. And this, I believe, may be the real importance of Williams's mother-and-child.

Though resolutely secular, it is, in a worldly sense, religious; it is concerned with a literal re-binding, or healing, a recuperation of an image of separateness in fusion, and individuation within union. At the level of both what it shows, and the way it has been

made, it can be seen as a secular equivalent of the sort of work currently being carried out in that New York cathedral.

Williams, of course, has to invent his iconography; to construct his informing tradition for himself; and to choose, and learn, his own ways of working. Little wonder, then, that he once expressed envy for what he called the 'given Subject Matter' of the medieval carvers, a subject matter so well-known and well-worked that 'to make a fresh sculpture the only thing left to use was the activity inside the image'. But this, of course, is precisely what differentiates the artist from the craftsman or stonemason.

Williams seems intuitively to have recognised that carving itself, when combined with 'universal' imagery deriving from the human body, and informed by knowledge of the sculptural tradition, is the nearest we can get to a substitute for a shared symbolic order.

Williams's sculptures in his recent exhibition at Blond Fine Art, in London, reflect his concern with 'relative constants' of human being and experience; not only the relationship between the mother and her child, but the father lifting and protecting his son; or a hunter shouldering a carcass. One of his most recent works, more violently expressive than the rest, is called *Shout* and deals with a mother's reaction to the death of her child.

Once the 'symbolic order' of Christianity redeemed a Pietà from naturalism; for Williams, that transfiguration has to come from art, from his sculptural means: thus the tradition he appeals to is not that of dogma and iconography, but of the best that has been done within sculpture itself. His *Hunter* strongly echoes African work, though its vaulting, and opening up of the stone, evokes the Gothic carving he loves. Similarly his *Sisters*, a study of his own two daughters, undisguisedly alludes to Matisse. But it would be wrong to see this as plagiarism; nor is he interested in playing with formal solutions for their own sake. Lacking a Church, he needs something to redeem his work from subjective expressionism on the one hand, or dead naturalism on the other. And he finds it in the tradition of sculpture itself.

Williams is not alone in this quest. Recently, a major sculpture, *Man and Child*, in Clipsham stone, was acquired by the Cavendish School in Hemel Hempstead. This was made by Lee Grand-

jean, a younger sculptor who has been associated with Williams through the Wimbledon School of Art, where they both teach. Grandjean, too, rejects the contemporary addiction to transience and fashion, and claims that a great many artists mistake emptiness for a sublime freedom. In seeking an art with true content, sculpture with 'something to tell', he too has returned to the figure, and to carving.

The redemption from the purely private on the one hand and the naturalist on the other, again comes from an appeal to tradition: 'The sculptural range and expression of African wood carvers; the work of Oceanic peoples; stone silence of the Assyrian expression; Egyptian stride of mountain power; lyrical spirits of the ancient Mediterranean; perfection of Chinese voluptuousness or Indian grace; Celtic tracery song; silent devotion of stone edge and vaulting in English church and Cathedral mass,' Grandjean has written. 'With all these great and usually anonymous sculptors, I share the ambition to render raw material into another expressive existence.' And this may be the best that we can hope for, now that, the resurrection of St John the Divine notwithstanding, the age of the great cathedrals, and the faith that informed them, is undoubtedly past.

1982

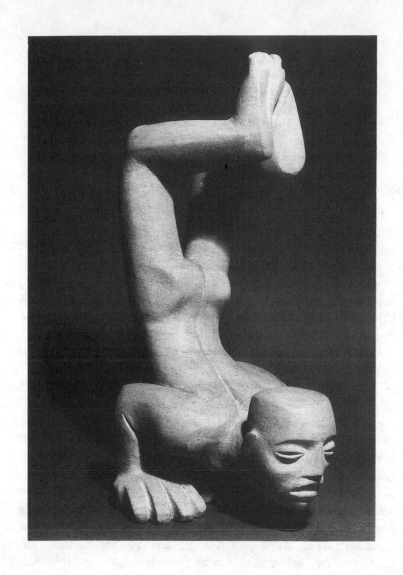

9
Headstand 1982
Glynn Williams

A Black Cloud over the Hayward

This summer, in London, it was really rather difficult to avoid
'The Sculpture Show': after all, it filled the Hayward Gallery,
splurged over the South Bank, crept throughout the Serpentine
and littered Kensington Gardens too. And, though none of the
works were heroic or monumental, none were modest either;
most were built on a Disneyland scale. Furthermore, since 'The
Sculpture Show' was brought to you courtesy not only of the Arts
Council, but also of the Henry Moore Foundation and United
Technologies, all this (for the first time in the Hayward's history)
was absolutely free.

The promotional warblings of the organisers predictably be-
came deafening. There was much talk about the largest sculpture
show ever held in this country and more about unprecedentedly
high attendance for *very* modern art. But a black cloud soon came
to hover over the proceedings. A literal black cloud. David Mach
had constructed a 'sculpture' called *Polaris* on the walkway
behind the Festival Hall, running from the Hayward towards
(ironically) the Shell Building. This was a rough representation of
a nuclear submarine fabricated out of 3,300 tyres. On the night of
August 21st, Mr James Gore-Graham, a frustrated designer with
classical tastes, threw petrol at Polaris, ignited it, and thereby
caused an explosion in which he himself was so severely burned
that he subsequently died.

Far be it from me to condone such behaviour. (Unlike many of
those associated with 'The Sculpture Show' I have never had much
patience with anarchistic or Dada traditions.) Nonetheless, in
retrospect, this tragic incident seems not only comprehensible, but
almost inevitable. When the art establishment itself acts wasteful-
ly, indulgently and provocatively, it can hardly be surprised if it
succeeds in provoking. And though I regret the events of that

ill-fated August night, it is not only they, but also the exhibition itself, which should never have taken place.

I went round the 160 'sculptures' on show carefully and open-mindedly; with the best will in the world, I could not detect a single piece of real sculptural merit. The nearest were probably Hilary Cartmel's painted wood constructions; though I would not wish to be thought of as endorsing her flabby work. Many of the pieces were imaginatively tacky (e.g. Sarah Bradpiece's *Wash Station*, featuring pink washbasins, and Richard Wentworth's endless column of buckets); some were simply shoddily made; others – like Boyd Webb's unsavoury photographs, Joel Fisher's over-exposed, stringy scraps of hand-made paper, Stephen Willats's (oh, when will we be rid of his impinging tedium) sub-sociological ranting, and Audio Arts's 'Tape Installation' of 'sound encoded onto magnetic tape' – were not only aesthetically worthless but by no stretch of the imagination could be considered as sculptures at all.

Now it is one thing (though not in my view a particularly admirable one) for an artist to take a leak over an academy by presenting it with a urinal inscribed with the words R. Mutt; but it is quite another when an academy itself – with the extravagant backing of the Arts Council, the GLC, a large commercial corporation and a Foundation run by our most distinguished sculptor – should start pissing all over the public. If it does so what possible response can it expect other than indignation and resentment at the waste of aesthetic, financial and institutional resources?

The only apologies I ever heard for this exhibition emphasised that it was young, fun and new, viz. the review by that ageing schoolmarm of the late 1960s, Sarah Kent, in *Time Out*: 'the mood of this show is abrasive, confrontive, witty and assertive . . . so trip off down to the Hayward and Serpentine for a revitalising dose of culture shock,' etc., etc. (Presumably, don't forget to wear a wilting flower in your hair either.) Or take Corkballs in *The Standard*: for him, 'The Sculpture Show' was 'alive', 'revels in showmanship, exotic flourishes, and outrageous humour', 'boisterous', 'mocks the concrete drabness of the South Bank', 'lolls cheekily', etc., etc.

The first point to make about this sort of argument is that 'The

Sculpture Show' could only conceivably seem to be young, fun and new to jaded hacks in the throes of mid-life crises which led them to live out, all over again, the artistic thrills of their youth. (Some of us, be it said, are weathering the mid-point rather differently.) John Spurling did the figures. Thirty-three out of fifty artists were from the 25–40 generation; only 'twelve token oldies' and even fewer under-25s were included. This was a *middle-aged* exhibition, in fact and in ethos. As for 'fun': well, whatever turns you on. I found it a dreary cultural duty. Most of the visitors I saw were not laughing, grinning or nudging each other in the ribs. Most looked irritated or perplexed – at best, bemused. There's much more fun to be had in fairs, on piers and in discos; and they tend not to ask for Government grants. And as for all this talk about 'newness': never had the claim for a radical new aesthetic of the 1980s looked thinner than in the face of all this dead, derivative and dispiriting clutter. The truth is that there was not one sculptural idea at the Hayward or the Serpentine which had not already been tried in the 1960s or early 1970s. Tried and failed.

But whether or not these works really were young, fun, or new is beside the point. For the very idea that youngness, funness and newness have some sort of *necessary* relationship to sculptural achievement is itself no more than a delusion of the 'youth culture' of the 1960s; it tends to lead to the elevation of novelties and frivolities, and to disregard for those enduring and relatively permanent aesthetic practices and values on which realised accomplishment in sculpture depends. An exhibition of this kind, size and scale stands, or falls, by its ability to bring forward before the public works which manifest such achievement and accomplishment.

Surely, by now, we have grown out of the aesthetic mistake, first made by Anthony Caro, of believing that 'sculpture can be anything'? Until I saw 'The Sculpture Show', and read the literature produced in connection with it, I would have said that only the most passé, pensionable cultural reactionary could possibly still believe, today, that dissolving the several arts into each other, mixing the media, blurring the boundaries between them, was somehow necessary to the realisation of aesthetic quality. And

yet, not only did 'The Sculpture Show' try and pass off Webb, Willats, Audio Arts and Co. as 'sculpture'; it also wheeled out all that jaded and discredited rhetoric to defend such foolish choices.

Thus in *Looking at Sculpture*, a leaflet produced to accompany the exhibition, Norbert Lynton (young? fun? new?) wrote 'Sculpture is what sculptors do. No other definition fits . . . Let us not delay over definitions.' And, in the catalogue itself, Kate Blacker, one of the selectors, commented, 'Sculpture has widened its doors, and if you are a sculptor and your work develops through philosophy, through the use of poetry or prose, I believe that in sentiment you are still a sculptor.'

It is not just that such ideas are hopelessly idealist (in the philosophical sense), dated and wrong; they lead to cultural vandalism of the kind exemplified by this exhibition. 'Sculpture is what sculptors do'! No wonder Norbert doesn't want to 'delay' over definitions. Sculptors, after all, get up in the morning, clean their teeth, shit, make the tea, have breakfast, argue with their wives or husbands, take the dog for a walk, copulate, join political parties, and attend ceremonies for the burial of the dead. Some of them also wrap up coastlines in polythene, fold blankets, take long walks with Ordnance Survey maps or tie bent twigs together. None of this is sculpture. Nor, whatever certain sculptors may do or say, can sculpture be advanced one iota through philosophy, poetry, prose or magnetic tape. Sculpture, as Rodin once said, is 'the science of the bump and the hollow': it is a specific and delimited art form, rooted in expression through the twin practices of carving and modelling – of which three-dimensional construction is no more than a particular, eccentric refinement.

How much longer are we going to have to put up with the discredited and old-fashioned dogma that the dissolution of the several arts into a disintegrative mélange is synonymous with moral and aesthetic virtue? This fallacy seems to arise from a confusion of 'freedom' with licence and incompetence. There can be no freedom, in any art, without prior mastery; a *sine qua non* of such mastery is acceptance of its conventions, limitations and traditions. There is no hope of originality (as the Hayward show confirms yet again) without such acceptance.

If a sculptor (or any one else) bought tickets to the opera and found he was treated to a display of amateur painting instead; or if he went to the ballet and was presented with a survey about the sex habits of athletes . . . he would be furious. Nor would he be mollified if he was told that opera singers and ballet dancers had 'widened the doors' of their arts and were pursuing new media. Opera singers and ballet dancers may be able to do all manner of things well, or badly: but opera is opera, and ballet is ballet. In the context of these arts, singers and dancers are deserving of attention and public patronage *only* on the basis of their competence (or excellence) in opera singing and ballet dancing respectively. The case is not, or rather ought not to be, so very different with sculpture and sculptors.

I have discussed why it is elsewhere. There is no point in reiterating, yet again, the details of that 'betrayal' which took place in the late 1950s and early 1960s. Caro, of course, had a lot to do with it. (One can only smile when Lynton mentions Caro in the same breath as Brancusi, Picasso, Giacometti and Moore!) But the decadence of this art form has proved chronic. Stockwell sculpture (none of which was included in this exhibition) was a falling-off from Caro; the 'de-objectified' 'sculpture' of the late 1960s and 1970s was worse than Stockwell steel . . . And this 'new' work is the worst of all.

The saddest practitioners of all seem to be those who are trying to grab back lost elements of tradition by making muddled nods in the direction of figurative content, or gesturing towards carving by scratching at the surface of stone, such as Anne Nicholson, Roger Partridge or Christine Angus. In this exhibition, these things were being done without any understanding of what sculpture is, of what, at its best, it can do, and has done. As soon as you put these giant trinkets and novelties beside the best work of, say, Epstein, Gaudier-Brzeska, Dobson or Moore (let alone Rodin, Bernini or Michelangelo), you realise that something tragic has happened to the sculptural tradition in our time.

Or has it? Bryan Robertson (rightly described by Terence Mullaly in the *Daily Telegraph* as a 'poor, old, spent force') says in the catalogue, 'The present show seems to me to be a very decent account of what is in the air at this particular moment in sculpture

in England, with a good range of work to exemplify it.' But if Robertson did not know this was untrue, he ought to have done. For the truth is that there is much worthwhile sculpture going on in this country which has nothing to do with Arts Council onanism.

For example, if, during the course of this exhibition, you had visited Blond Fine Art, off Piccadilly, you would have seen a new small sculpture by Glynn Williams, called *Walking*, which, though only a few inches high, was worth more than all the Hayward and Serpentine rubble art put together. Williams is a good sculptor who may yet become a great one. I know of many other sculptors, too, who, whatever their realised level of achievement, are at least taking sculpture seriously. A sound exhibition could have been organised around work of this kind. It is not just a matter of producing an alternative list of names. The sculptural tradition in this country needs to be revived, so that work of real stature can readily emerge again. But for this to happen the system of training sculptors, and of patronage of sculpture, needs to be reconstituted in a way which actively prefers work rooted in mastery of the particular skills and traditions of sculpture, acknowledging the limited, but vital, aesthetic possibilities this art form affords.

Of course, we live in a divided society, with divided values, and the conspicuous absence of a hegemonising system of shared religious beliefs. I am not here advocating the resolute imposition of a particular set of tendentious values over all the others. Rather, I am saying that of all the great human arts, good sculpture thrives on a continuity of skills and materials; it is, by its very nature, conservative and traditional. More than literature, more even than painting, sculpture draws upon those elements of experience which do not change greatly from one culture to another, from one moment of history to the next.

Indeed, nothing offers a better insight into the way in which the culturally specific can be a key to the enduring, and relatively constant, than the practice and pursuit of good sculpture. And that is why, in a 'synthetic culture', singularly addicted to transience, fads, ephemera and the relativising of all values, this practice and pursuit is so important.

'The Sculpture Show' should never have been left to those 'poor old spent forces' at the Arts Council, and their cronies in criticism and the sculpture departments. If sculpture is to survive and prosper, we need educators and patrons with sufficient courage and authority to affirm specifically *sculptural* values. But where, I wonder, are they to be found?

1983

V

THE WORLD UPSIDE DOWN

22
Aboriginal Arts

On my desk, as I write, lies a flat piece of stone on which is painted a spider-like being with two great eyes set in a large, mouthless head crowned with spiky bristles of hair. This creature could have been the invention of a precocious child: in fact, it was painted by Lily Karadada, an Australian Aboriginal woman, and depicts Wandjina, a cloud spirit and source of fertility.

Like the news that, this week, eight aborigines will 'present their culture and lifestyle' at the Commonwealth Institute, the stone evokes ambivalent feelings in me. There are Wandjinas more than twenty foot across in the caves of Kimberley, Western Australia: but this one measures rather less than three inches. Lily Karadada probably got about £1 for making it; I bought it for around £2.50 from a shop in Perth, Western Australia, called 'Aboriginal Traditional Arts'. The Wandjina came with a piece of paper, signed by the shop manager, quoting an individual catalogue number, and assuring me I had acquired 'An Authentic Aboriginal Work of Art'.

I also purchased other stones etched with ornamental snakes; a gourd-like seed with abstract patterns incised; and some fine wooden carvings of reptiles and marsupials. When I arrived home, I distributed most of these among my friends and relations, keeping a wooden carving of a perenti lizard for myself, and giving the Wandjina stone to my small daughter.

I derive considerable aesthetic pleasure from these pieces; the wooden carvings, for example, are skilfully wrought with a shrewd eye for natural form, a strong sense of tradition and decorative pattern, and an acute respect for the given qualities of the materials used. And yet, of course, guilt and shame are bound to penetrate deeply into any sensitive white response to the relics of aboriginal culture. I realised this when I visited the Biennale of Sydney, a jamboree of contemporary art from all over the Western

world, which had brought me out to Australia in the first place. This year's message was that although 'performance' was not out, painting, or rather *paint* itself, was definitely *in*. Thus the Biennale was littered with slovenly 'Transavantgarde' pictures the size of cricket pitches; and one also tended to stumble over a pretentious Argentinian who melted an ice-effigy of himself; an English public schoolboy who rolled around in a sack . . . and so on.

But a central courtyard at the Gallery of New South Wales had been cleared and filled to a depth of several inches with red desert earth. And there, surrounded by all this Government-sponsored decadence, were members of the Walpiri tribe from Lajamanu in Central Australia. They created a beautiful sand painting of *Snake Dreaming* to the accompaniment of traditional rituals, story-telling, body adornment, rhythmic dancing, and a bevy of flashing white newspapermen, obscenely over-eager in their pursuit of swaying ebony buttocks.

Once, of course, aboriginal art had nothing to do with the provision of trinkets, or exotic spectacles for white outsiders. Traditional aboriginal culture was bound up with myths not of the art world, but of 'The Dream Time'. Aborigines believed that long ago the dreaming world belonged to Ancestor Beings, and was just a flat surface covered by darkness. The Ancestor Beings then ruptured the darkling plain to create the rich variety of natural forms, and all living plants and animals, including men and women. The way the world appeared was bound up with these stories of its making: for example, Ancestors were believed to have embedded themselves in certain rocks, or valleys, which became sacred sites. 'Dreamings', or mythical stories containing secret knowledge, were passed down through oral tradition.

The Aborigines believed that all ritual and ceremonies originated in 'The Dream Time'. Aboriginal aesthetic activity began in body painting, adornment, mutilation, pattern and rhythm; it extended out from such somatic elements to the ornamental transformation of environmental features – like rocks, trees and shells. But all such sensuous expressions enmeshed immediately with collective religious beliefs. Since these concerned the history and nature of the natural world, aesthetic and symbolic components permeated deeply into every aspect of daily life.

Indeed, in traditional aboriginal culture there was no clear boundary between art and other forms of work. The aborigines decorated many of the things they made; naturalistic and geometric designs proliferated over paddles, spear-throwers, boomerangs, baskets, shields, message sticks and all sorts of useful objects. Their forms were determined not just by practical function, but also through symbolic intent and attention to the aesthetic qualities of materials used. But, as far as we know, there were no professional artists among the aboriginal tribes. Everyone participated in artistic production; or, to be more precise, art was a dimension of everyone's productive life. Unevenness of talent was recognised and those who showed exceptional artistic ability were specially encouraged.

All this, of course, changed with the coming of the white man. Two centuries ago there were about 300,000 Aborigines in Australia, divided into six hundred or so tribes, each of which had its own traditional hunting lands. White men destroyed all this; they settled the homelands themselves, herded the Aborigines into reservations and missions, and infected them with decimating diseases against which they had little or no resistance. 'Regret concerning the disappearance of the aborigine', wrote one commentator in 1847, 'is hardly more reasonable than it would be to complain of drainage of marshes or the disappearance of wild animals.' As Bernard Smith, a fine historian of Australian art and culture, has written, 'For white Australians the Aborigine was not a human being; he was an embarrassing joke.'

Today, only a little over one per cent of Australians are Aborigines; of 45,000 pure Aboriginals, about two-thirds live something resembling a traditional tribal life. But these numbers are growing again. This century, white Australians have not often gone out to hunt the Aborigines to make a change from shooting kangaroos. Genocide has been replaced by an uneasy accommodation. Since 1972, the key Aboriginal political issue has been Land Rights, or the restitution of, or compensation for the loss of, traditional lands.

But, as anyone who has ever witnessed an aboriginal ghetto will know, there are no grounds for optimism. The damage which has been done, and is still being done, is irreparable. How can 'The

Dream Time' co-exist with skyscrapers, the Coca Cola Corporation, the cathode ray tube, Trans-Australian Airlines, the Sydney Biennale, or 'Aboriginal Traditional Arts'? And if 'The Dream Time' disappears, then the Aborigine will lose not only his living arts, crafts and rituals, but everything which he has traditionally believed, valued and held dear.

Once, it seemed to many anthropologists that the Aborigine was teaching them something about the first emergence of human beings from a natural, or biological, history into a fully social history, in which technological development was possible. Today, however, the Aborigine seems rather to be underlining what happens when that social and technological history turns against men and women, and robs them of their biologically given potentialities for symbolic life and aesthetic expression – for, in effect, a true *culture*.

Whatever the quality of her work, Lily Karadada, who now spends her life in the highly specialist pursuit of stone painting for a market, is clearly 'An Artist' in a sense in which those tribesmen who painted the original Wandjinas on the walls of the Kimberley caves were not. Nor should we be deceived into thinking that such performers as the Walpiri tribesmen I saw at the Sydney Biennale are 'ordinary' Aborigines, displaced into a strange environment. One of them was Maurice Jupurrula Luther, MBE, a leading light in the Aboriginal Cultural Foundation since 1977, and one of the most able of his people's cultural conservators. Luther tries to keep rituals and traditions alive, even though they are fading from Aboriginal life as lived far away from the enclaves of 'Art'.

But it isn't just a question of the emergence of 'professional' Aboriginal artists; perhaps the most interesting parallel with European historical experience is the unprecedented emergence of a fully blown Aboriginal *pictorial* art practice. In 1971, members of tribes in the Papunya settlement, west of Alice Springs, began producing vivid, resplendent paintings on board and other flat surfaces. In no sense did they seek to imitate Western picture space, or representational conventions; rather, informed by the 'dreamings' handed down to them, they used the surface as a sort of repository for meaningful patterns and symbols – in effect for the aesthetic dimension which was being squeezed out of everyday

Aboriginal life. The painting movement spread; today there are even Aboriginal 'Artists in Residence' in Australian art institutions, and examples of the new painting adorn many museums. These startling works may have much to teach us not only about the Aboriginal imagination, but about the way in which our own culture became anaesthetised, compelling the aesthetic dimension to withdraw from the real world to that illusory space behind the picture plane.

The efflorescence of Aboriginal painting is certainly a cause for celebration; but it is, of course, synonymous with a diminution of life itself. And a rich painting tradition is not long sustainable on an aesthetically diminished life. Already, some of the new Aboriginal painting has a quality of slickness – as if, despite increases in technical skills, the patterns had become severed from their roots in symbolic life. And, indeed, we may surmise that as memories of 'The Dream Time' fade, Aboriginal pictorial art, too, will come to rely more and more on merely technical skills and *individual* imaginative expressions. If it does so, it is unlikely to escape that *kenosis* (or draining away of creative power) which has been so characteristic of much recent Western art. Indeed, it is hard to avoid the thought that the artistic offspring of Maurice Jupurrula Luther may come to use their government grants to melt down ice effigies of themselves or to roll around in sacks . . . None of which will bring any more consolation to those Aborigines who have not become artists than Lily Karadada's exported stones.

1982

Fred Williams

Just before he died of cancer in 1982, Fred Williams, an Australian artist, painted a group of oils and gouaches known as 'The Pilbara Series'. These came out of two visits to the north-west of Australia at the invitation of Sir Roderick Carnegie, a businessman whose firm was beginning to exploit the region for its rich deposits of iron and minerals.

The Pilbara is a weird and wonderful terrain of bush, boulders, strangely fashioned, iridescent, infertile hills, ghost gums and red, red sand stretching out into seemingly infinite vistas of empty space. Soon after I returned from a trip there last March, I saw this series in Sydney, in an exhibition currently touring Australia.

They convinced me that Williams was not just another interesting painter of the outback. Rather I have come to see him as the finest – and yet in many ways an unrepresentative – exponent of an Australian tradition of 'Higher Landscape'. This offers nothing less than a new aesthetic, an imaginative and artistic response to nature for which there was no precedent in European culture.

From the beginning, the Australian landscape presented difficulties to its painters. It wasn't just that the early settlers and convict artists tended to paint oak trees instead of the gums and acacias before their eyes. In nineteenth-century England, Higher Landscape painting had offered a symbolic illusion of a reality which seemed to be being lost . . . or an image of a harmonious natural world, in which man could find the evidence of God. Ruskin argued that this sort of painting depended for its force on the existence of ruins, traditions, agricultural features and architectural remains. He said, 'It arises eminently out of the contrast of the beautiful past with the frightful and monotonous present.'

Such painting depended on a particular geography and a particular history; it began to wither with mid-century disillusion-

ment, and the discovery that nature was not the handiwork of a caring God. The English countryside could no longer be held up as a Garden of Eden from which man had fallen after committing the sin of industrialisation.

But the first Australian painters really only had the conventions and traditions of this aesthetic to work with. As Mark O'Connor points out in his introduction to a recent anthology of Australian poetry, the very language the colonisers brought with them 'offered few words or appropriate concepts to apply to an immense barren island at the end of the Earth, home of stone-age tribes and of a second and separate marsupial creation, where only the coastal rim, varying from tropical forest to Alpine heath, was fertile.'

Australia never lacked talented artists. In the late nineteenth century Heidelberg painters – Charles Conder, Tom Roberts, Frederick McCubbin and Arthur Streeton – produced some exceptionally beautiful works in an Impressionist style. Their pictures often show an intensity of light and a sense of extended space unkown to their European contemporaries. But the region round Heidelberg, where they worked, has been described as 'the Barbizon and Fontainebleau of Australia'. Lionel Lindsay, an Australian painter and writer, recalled 'the ravishing pink of the peaches breaking the masses of white plum and pear blossom, the tangle of intertwining branches, the sound of bees, the paean of the rising sap in all nature.' But beyond this Antipodean Eden, part of the cultivated fringe, lay another and much vaster Australia.

When D. H. Lawrence visited Australia in 1922, he wrote about 'the weird, white, dead trees, and . . . the hollow distances of the bush'. A few years later, the painter Hans Heysen 'discovered' the Flinders Ranges, 'a very old land where the primitive forces of Nature were constantly evident'.

Heysen admitted immense technical difficulties in painting the outback. The Ranges evoked in him a 'sense of infinity that a land of moist atmosphere could never give'. He had to learn to do without 'that kind atmospheric envelope which unifies and brings into more apparent harmony our southern and coastal landscapes'.

In the 1930s and 1940s, Russell Drysdale, Albert Tucker and

Sidney Nolan also took up the challenge of the Australian desert. Nolan even flew over Central Australia, sketching from the plane window. But these artists recognised more profoundly than Heysen that the difficulties this strange land presented to the painter were not simply technical.

They knew they had to invent an Australian tradition, more or less from scratch. They borrowed conventions from where they could. Tucker took something from Aboriginal art; Drysdale plundered Moore and Sutherland for forms; Nolan turned, among others, to Rousseau. But all of them twisted and transformed what they plundered for their own ends. They were seeking a new 'Higher Landscape', which went beyond topography to enter the realms of sentiment, myth and even national identity. They wanted an Australian aesthetic.

The view of nature at the centre of the new Australian landscape had nothing to do with the idea of the world as a Garden of Eden, nor with the 'paean of rising sap'. Kenneth Slessor, an Australian poet, once wrote about how even in the relatively fertile country of South Australia he felt that 'something below' was pushing up 'a knob of skull'. These painters, too, responded to the whole of Australia as if it was a giant *memento mori*; they emphasised the alienness of the outback and the frailty and fragility of all forms of life within it. They relentlessly deployed the iconographic symbols the terrain so readily offered them: croaking ravens, ghost gums, burned bush, petrified trees, parched earth, and the bleached white skulls of horses, sheep and cattle. Through their narrative content, they affirmed man's struggle against, and transitory triumph over, nature's incessant, abrasive hostility to life. Drysdale deployed a cast of aboriginal characters, not always without sentimentality. But the greatest painting of this kind was Nolan's 'Ned Kelly' series of the late 1940s, based on the life of a notorious outlaw and folk hero.

When Nolan's pictures were first shown, Fred Williams was still a student at the Gallery School in Melbourne. We know he admired Nolan, even defending his work against his teacher's criticisms. But Williams's own painting was at first unaffected by the emerging Australian aesthetic.

In 1951 Williams, aged twenty-four, came to London and studied for a further six years at Chelsea School of Art. The portraits, landscapes, music hall and London life scenes he produced here reflected an evident but unfulfilled talent; a consuming interest in Daumier; an acquired taste for Sickert; and a passing acquaintance with English, 'sensitive' socialist realism. Williams also came into contact with the work of Cézanne, Monet and Matisse for the first time, and absorbed what he needed from them into his own gradually emerging style.

When Williams returned to Australia in 1956, he had served his long apprenticeship as a painter; but he found Australian art in a confused state. The achievement of Drysdale and Nolan was already being denigrated by 'progressive' artists as ethnic eccentricity. A younger generation was imitating American Abstract Expressionism, the first of what turned out to be a succession of imported avant-garde trends. These swept like bush fires through the Australian cultural outback, bringing devastation or spreading the seeds of new life according to your taste.

A group of younger landscape painters, many of whom Williams had known before he left for Europe, was resisting these developments. 'The Antipodeans', as they called themselves, included Arthur and David Boyd, John Brack, Charles Blackman and Clifton Pugh. Williams wanted to associate himself with this group, but they rejected him because they felt his painting was not 'Australian' enough.

Williams was to pursue his own path. But the argument persisted between the followers of international fashions and those seeking not just Australian content, but an Australian aesthetic. The former group soon started to make all the headway. Today, with certain notable exceptions, the avant-garde, official art institutions, magazines and art schools in Australia all assume there is almost nothing to be learned from Nolan's or the Antipodean generation; their 'parochialism' is contrasted with avant-garde 'internationalism'.

For example, one of the most over-exposed and over-exported of the younger Australian painters working today is Juan Davila. He produces 'Popist' pictures based on advertisements, sadistic homosexual pornography and current American art fads. His

works are often so violent that exhibition of them has to be restricted to adults only. In Europe, we have seen almost nothing of Australian landscape painting since the era of Nolan and the Antipodeans. Yet Davila is included in every international art fair and touring exhibition of Australian painting.

Predictably, Davila has written a violent attack on Australian landscape painting. His objection seems to be that the landscape painters tried to compel meaning out of a terrain which possessed none. Typically, Davila complains that in Nolan's pictures, 'The void of the land is forced to signify, ignoring the suture it offers.' Nolan, it seems, should have simply accepted the intractable, unsignifying 'alien-ness' of the desert and turned his attention to the delights of imported American sex magazines, television programmes and art styles.

But Nolan and the Antipodeans had at least recognised that American fashions in art were 'international' only in the sense that *Playboy* magazine, McDonald's hamburgers or Hilton Hotels are 'international'. In their best pictures, Nolan and the Antipodeans demonstrated an enduring paradox; genuinely culturally transcendent work is always rooted in specific natural forms, however particular or intractable these may seem to be. Constable's 'parochial' view of East Bergholt, or Cézanne's of Mont Saint-Victoire, achieve a universality which a Coca Cola advertisement does not.

Even so, it has to be admitted that there is some over-resilient content in Nolan and especially the Antipodeans; skulls, crows and scrawny bushes are sometimes overladen with significance. Williams, however, was able to develop and refine the new aesthetic.

Rejected by the Antipodeans, and unsympathetic to the imitation of imported trends for their own sake, Williams worked very much in isolation. Only rarely in his painting did he focus on the obvious iconographic features of the bush. Although he continued to produce occasional fine portraits, he never painted figures – let alone narrative incidents – into his landscapes. He had a distaste for what he called the 'picturesque', and a conviction that it was inadequate to those experiences of landscape he wished to convey.

He had responded strongly to the decorative dimension in Cézanne and Matisse, and was interested in the capacity of abstract forms, rhythms and colours to convey sentiment and meaning. His painting has often, and rightly, been compared to music. Williams was prepared to learn from Abstract Expressionism, or even certain aspects of Minimalism, without feeling the need to affiliate himself to them as tendencies. His own work differed from the false internationalists' in that it was always rooted in his experience of the specific, of things seen in nature. The traditional painting of China, which he once visited, was at least as useful to him as that of America; from the Chinese he learned much about ways of suggesting an infinite, boundless vista, without violating the imposed unity of his picture surface. The graceful patterns he orchestrated across vibrating fields of colour always also constitute an illusion of space, indeed of very particular places.

In the early 1970s Williams painted some powerful pictures which were arrangements of burned trees, devastated by bush fires; the rhythms, and beautiful colours, seem to agitate the blackened branches into new life. But, for many years, Williams seemed to be holding off from the desert itself as his central subject matter. And then, in 1979, he went to the Pilbara. 'Anyone who could *not* paint this country', he recorded in his diary, 'is probably in the wrong profession.'

And yet the Pilbara could never conform to European ideas about nature, nor could it be depicted through a European aesthetic. Not even the idea of inevitably recurring seasons makes sense here; the face of the earth is transformed by unpredictable events: great bush fires, and occasional cyclonic storms.

I went to the Pilbara soon after the heaviest cyclone for more than a decade. Wreckage could be seen everywhere in uprooted trees, and the unroofed Whim Creek Pub. But the storms had also provoked a sudden, frantic stampede for life. Flowers, brightly coloured insects and foliage had sprung up seemingly from nowhere.

The land was already parched again; but the rich red of the sand, and the myriad colours of the rocks glistening with a light effect known as 'desert varnish', made everything look moist. A

green grass proliferated everywhere in the aftermath of the rains; it looked lush. In fact, it was the saw-edged spinifex, which rips the skin and is inedible even to sheep.

Agriculture, such as it is, has never tamed the desert. The wizened north-western pastoralists do little more than bore water-holes, and fence vast 'stations' the size of English counties. Spinifex proliferates as a result of the over-grazing of sparse native grasses. The pastoralists blame the dingos, the Government and the 'abos' for the ever-falling yield from their fleeces; everything and everyone, that is, except their own bad practices. Soon the land will be useless for any sort of grazing, and the desert will have reclaimed it. Meanwhile, another kind of exploitation of the Pilbara is opening up for the first time. Iron, and even gold and diamonds, are being mined. Great trains, heaped high with ore, head south every day.

Whatever the Pilbara may or may not be, it is no Garden of Eden where men and women lived in a state of harmonious reciprocity with a nurturing Nature until the fall of industrialisation. Here, Nature taunts and deceives. Her beauty is less than skin deep; she offers a prospect of death, rather than life. Even before the white man came, men existed here by committing appalling violence against Nature, snatching a living where they could, and thereby further reducing the land's already slight capacity to sustain life.

But just as, in the early nineteenth century, English landscape provided a compelling illusion whose relevance was by no means confined to England, so, in the twentieth, the Australian landscape provides a powerful image even for those who have never ventured beyond Lymeswold. For today, even here in England, we can no longer dream of a return to the Garden of Eden. It isn't just that the Nature Conservancy Council is warning that, such is the destruction of the countryside, it is in danger of decaying into a prairie; even Constable's beloved Suffolk is violated by the metallic serpents of Cruise. We live, even those of us who are not Australian, on the periphery of a potential desert.

We have become peculiarly ill at ease in the nature that nurtures us, constantly worried that through our own actions we will cause it to fail, certain that no God resides within the rocks and trees to

save and console, sure that not much is for the best in this our only possible world.

When Fred Williams went to the Pilbara in 1979, he must have known that his own life was coming to and end. He painted numerous gouaches on the spot; he made a return visit a few weeks later. Then he went back to Melbourne, and worked on other things. In 1981, the year before he died, Williams began to pour out his Pilbara pictures, in his Melbourne studio.

Gregory Bateson, himself an atheist, once argued that loss of belief in the immanence of God within his creation, when combined with an escalating technology, was leading men to lose respect for the environment and rendering them unable to find beauty in it, or to affirm a sense of oneness with it. Bateson argued that, if civilisation was to survive, we needed to develop a new secular aesthetic which enabled us to do these things, regardless of unbelief. Heysen, Drysdale and Nolan went a long way towards finding that aesthetic through their response to the Australian outback. And Williams brought it closer still.

His Pilbara paintings are self-evidently both personal and parochial. But they are more than just the finest examples of the recent Australian landscape tradition. For even when confronted with the Pilbara, and haunted by the imminence of his own extinction, Williams managed to transcend the 'alien-ness' and intractability of the land, to work upon it a magic of aesthetic transformation. Through the gorgeous colours and strange rhythms of his Pilbara pictures he brings about a redemption through form of the desert itself. Those who try to follow in Constable's footsteps today may seem merely sentimental; but Williams came closer than anyone to articulating a twentieth-century aesthetic, whose significance extends far beyond the shores of the Antipodes.

1984

VI

ART IN THE WORLD

24
Prophecy and Vision

'Prophecy and Vision' was an exhibition dreamed up by the Reverend Donald Reeves, Vicar of St James's Piccadilly and Chaplain to the Royal Academy, and Paul Walker, an exhibition organiser and member of the Catholic Liturgy Commission. It was subtitled 'Expressions of the Spirit in Contemporary Art'; but clearly our worthy aesthetical divines meant, by 'Spirit', something broader than the third person of the Trinity.

The promotional material explained that 'prophecy' was the ability to see beyond the conventional wisdom of the day to the roots of oppressions, violence, suffering and evil; whereas 'vision' was an awareness of hope and healing beyond the danger and sickness against which 'prophecy' warns us. These qualities were seen as being synonymous with the expression of the spiritual, and were held to abound in contemporary art. The churches, according to the exhibition organisers, should recognise this; and artists who shared these concerns should, in turn, recognise that 'the churches could provide a basis for their work'.

The exhibition was put together on an ambitious scale. Paintings and sculptures were selected from an open submission (including such familiar names as Norman Adams, Craigie Aitchison, Anthony Green and Elisabeth Frink); the intention was to demonstrate that works 'of the highest artistic merit' could be 'expressive of a Christian concern for society, whether or not the artist is a professed Christian'. A complementary section on 'The Fabric of the Church' showed the work of conservationists, architects and craftsmen and women who carry out commissions for the Anglican and Catholic churches today. All this came complete with a conference 'Concerning the Spiritual in Art'.

But, despite the angelic fanfares, the event proved something of a disappointment. For one thing, the connection between most of the selected works and 'a Christian concern for society' (whatever

that may be) was far from being immediately apparent. Peter Koenig, a former President of the Society of Catholic Artists, was exceptional in declaring that he wanted his paintings to be a 'song of praise' to being a baptised and communicating member of the Body of Christ, i.e. the Church. Koenig (who is of an irrepressibly allegoric turn of mind) even wrote in the catalogue that God was his 'playful gazelle', and he, himself, God's 'fluttering dove-moth'. His pictures were hermetic scenes based on fusions of biblical incidents, recent historical events and a very private symbolism.

Others attempted a less full-blooded relationship to Christian imagery. Thus Anthony Green offered a self-portrait as a crucified Christ stretched out over characters from his tiresome little sub-suburban world. I can only hope that this picture turns out to be prophetic, because it certainly was not visionary.

But most of the works shown did not even have this sort of contingent relationship to Christian iconography; nor, of course, was there any sense whatever of a Christian *style* of working. Indeed, taken as a whole, the painting and sculpture section was reflective of that crisis and fragmentation of values which, as we all know, is so typical of Late Modernism. And, with the exception of Adams, Frink and Aitchison, most of the work shown was of an irredeemably low standard.

There were dead formalist abstractions by Steve Joy and Margaret Organ (their real names, I swear it) apparently included on the assumption that vacuity in art is *necessarily* synonymous with glimpsing the ground of your being, or something; Paul Butler's hollow socialist realist image in graphite on paper of a girl putting documents into an office file; and even a sprinkling of neo-new expressionist daubing. If the exhibition had been selected to illustrate 'The Crisis in Modernism', 'Tendencies in Art Today', or 'Modern Art, Yesterday, Today and Tomorrow', it would probably have looked very much the same.

Inevitably, however, the 'Fabric of the Church' section had a different sort of feel. This indicated, if nothing else, that some sound conservationist work is being carried out in some of the 25,000 churches owned by the Anglican and Catholic authorities. It also demonstrated that there are some craftsmen about who can produce intelligent pastiches of the ecclesiastical accoutrements of

the past – there are, after all, worse things one can do with a life; and even a few who accept the history of the Christian tradition of craftsmanship, and go on to produce genuinely living, innovative work within it. But the dilemmas of Late Modernism have insinuated themselves even here. Personally, I find the beautifully carved bench ends and backs in many Suffolk churches uplift the heart as well as more fundamental parts; but I cannot see anything prophetic, or visionary, in Derek Goreham's functional, plain, linking-stacking chairs. Even if they are sometimes put to use in church halls or even naves, they remain mere bum-racks.

But I do not want to sound disparaging. I believe a debate about the spiritual in art is long overdue. Indeed, in all that chatter about the political and social dimensions of art which went on during the last fifteen years, very little attention was paid to what, after all, must be seen as among the most central of all questions affecting art and craft in our century: the severance of the arts from religious tradition and their existence within an increasingly secular culture. Modernist art historians tend to regard this as unproblematic. But incorrigible aetheist and aesthete that I am, I believe it to be a moot point whether art can ever thrive outside that sort of living, symbolic order, with deep tendrils in communal life, which, it seems, a flourishing religion alone can provide.

Certainly, historically, in most aesthetically healthy societies religion and aesthetic life were inextricably intertwined: this is true whether you look at Aboriginal arts, ancient Egypt, Greek sculpture and architecture, African tribal cultures, Muslim decoration, seventeenth-century Spanish painting or the arts of the East. Traditionally, religion has sustained the ornamental systems of a society, shaped its principal architectural forms and given rise to its iconography.

Perhaps the most successful example of this was medieval Christendom. The Gothic world's aesthetic achievement had rarely been approached by any previous culture; nothing like it has been seen since. And this achievement, of course, was inextricably bound up with the cultural triumph of the Christian church.

Gothic architecture, in both its ornamental detail and its structural brilliance, is a material elaboration of Christian belief. The great cathedrals were, in effect, symbolic shelters within

which all the major and minor arts (including architecture, music, painting, sculpture, all manner of liturgical, poetic and ceremonial skills, metalwork, jewellery, book illustration, etc.) merged into one total art, to the glory of God, and for the consolation of man.

In Gothic work, no distinction can be made between 'functional' (or 'practical') elements in a work and its aesthetic or symbolic components. The 'function' of a spire, chalice, reliquary, or, indeed, a cathedral itself doesn't have much to do with provision for physical or 'worldly' needs; the function itself is symbolic. Gothic pointed arches and flying buttresses certainly spring out of architectural necessities; but the structure of a Cathedral is more like that of a hymn than a house. Those necessities, themselves, serve to celebrate the grand and tender illusions of Christian faith.

Unbelievers, of course, can enjoy the cathedrals; but we could never have made them. Much of my own work in recent years has been concerned with trying to understand what happens to art when the hegemonising force of a religious world view, and feelings, is dissipated. The problem has been compounded in our own time by the changes in the nature of work brought about by the industrial revolution and the rise of modern technology.

One thing, however, seems clear: art does not prosper if it is separated from religion for long. Industrialisation compels a division between the crafts and 'Art'. The former largely become metamorphosed into industries, whose products are determined by practical or economic (but certainly not spiritual) necessities. Ornament is, at best, reduced to sensual stimulation; at worst corrupted to meaningless accretion, or abolished altogether.

But high 'Art', split off from living religious iconography, and thriving traditions of creative craft work, does not flourish either. Indeed, the Fine Art tradition has tended (since the early nineteenth century) towards fragmentation and disintegration. The romantic artists hoped that nature itself would provide some alternative universal symbolism to that which religion had once proffered. This is why Ruskin could see Turner as being engaged in a healthy attempt to fill the void the destruction of Gothic architecture had left. This position, however, seemed threatened by a growing recognition that nature was not the handiwork of

God, but rather its own creation. Early Modernists, like Kandinsky, Malevitch and Mondrian, hoped that abstract forms and colours in themselves might be able to evoke, express, and convey deep spiritual values. Van Gogh, like many expressionists, also wanted to conjure 'that something of the eternal which the halo used to symbolise', but to do so 'through the actual radiance of colour vibrations'. But, as it moved further and further away from any informing religious tradition, the modernist movement lost sight of these 'spiritual' goals. Rather, it tended towards psychological subjectivism; 'verist' reproduction of appearances, as in photography; or, alternatively, a stultifying 'truth to materials', in which mere stuffs and substances were presented as art, without any illusory or symbolic transformation at all.

So can art be redeemed by taking on board again the social and spiritual illusions of faith? The evidence of this exhibition, at least, is that it cannot. And the reason seems to me self-evident. Anyone who has studied the history of Christianity in Europe over the last two centuries will know that it has been confronted by similar dilemmas, and dilutions, to those which have eroded art.

Society has become increasingly secularised; and the Church reduced to a relatively marginal institution. Different sectors have reacted to this in different ways. Catholicism, at least until the changes of the Second Vatican Council, chose a 'fortress' response, an insulating of itself from the modern world. It is Protestantism, however, which so vividly parallels what occurred within Modern Art. The nineteenth century saw the beginnings of relentless biblical scholarship, and research into the origins and history of Christianity. (This was accompanied by a growing understanding, through scientific advance, of the natural and physical world, and a weakening of the Church's institutional power and cultural influence.) These investigations led not to entrenchment, but to an unrestricted questioning of the bases of the Christian faith.

Little of the gospel stories, and less of the traditional teaching of the church about Christ, the god-man, withstood this analysis. Protestant theologians, in the twentieth century, succeeded in severing themselves from all possible sources of authority — biblical, traditional or institutional. They ended their scholarly

researches by confronting, as Rudolph Bultmann, the great New Testament scholar, once put it, 'a god-shaped hole'. They thus ceased in any meaningful sense to be Christian and tended towards a diffuse and woolly psychological, or philosophical, humanism, often embellished with the tatters of various fashionable ethical and political, or social, concerns. Christian theology and iconography were in ruins: Protestant Christianity seemed increasingly incapable of offering a 'shared symbolic order' to any one.

Significantly, when he talked about art, Paul Tillich, the Protestant theologian, who identified God with 'the ground of our being', affirmed 'the directly religious effect of a style which is under the predominance of the expressive element, even if no material from any of the religious traditions is used'. This 'expressive element', he thought, 'expressed . . . "the dimension of depth" in the encountered reality, the ground and abyss in which everything is rooted.' So, *any* expressionistic art was religious, for him, because it revealed (or so he thought) something beyond immediately given reality. We need hardly marvel that the organisers of 'Prophecy and Vision' felt they could see their spiritual values reflected in Modernism; or that they think the Church can provide the basis for the work of many Modern artists, whether or not they are believers, and whether or not they make use of specifically Christian iconography.

However, just as there is a reaction against many of the debilitating assumptions of the Modernist tradition in art, so, too, there is presently a reaction among many intelligent Christians against the dissolution of Christianity into an ethical-humanist mélange. Most Cambridge theologians seem not to have believed that Jesus was God in any comprehensible sense for many years now. But Edward Norman, who comes from my own college, Peterhouse, recently argued in his Reith lectures that the justification for Christianity lay not in its espousal of contemporaneous philosophical, psychological or political beliefs, but rather in its soteriology and christology. (That is, in its teaching about repentance, salvation, redemption, resurrection and eternal life, made possible through the person and work of a Christ or god-man, who intervened in history.)

Though I myself reject the Christian claims, I believe there is no other ground Christianity can stake out for itself. Indeed Norman's seems to me the only sort of Christian position with any degree of intellectual, spiritual or cultural credibility about it. I also feel that Christians who hold such views are far more likely to commission, or to create, vigorous, living, 'spiritual' art than those who, like us poor atheists, have lost all their redeeming illusions and are thrashing around in an all too human and depressingly material world. It is a pity that 'Prophecy and Vision' was not put on by those holding Norman's beliefs. Like the cathedrals, it might then have been able to provide some consolation even to those of us who are *not* Christian. As it is, I cannot believe it did very much for *anyone*.

1983

25
Art in Education

When I was about eleven years old, at Prep School, I was taught art by a middle-aged lady who sat a boy at the front of the class and told the rest of us to draw him. I found it difficult to get the proportions of the figure remotely right, and I had no knack for catching a likeness. Things were little better when she arranged a bowl of apples in place of the boy. I was also rather messy and I tended to smudge the charcoal. I think it was just assumed I had no natural talent for art.

At the age of fourteen, I went to a minor public school where the art master had been a fighter pilot during the Second World War. He talked to me about my paintings in a way no one had ever done before; I produced torrential outpourings of work.

Certainly, he encouraged self-expression – but not self-indulgence; he insisted on continuous, critical self-assessment. From him, I learned for the first time that there was such a thing as a 'visual language'. He also related the work I produced both to what I could see in nature, and to the greatest art of the modern movement and the past. For him, the production of art involved sentiment, reason, knowledge, skill and judgment.

Sometimes he tried to teach me to get over my difficulties with proportions. I remember labouring over some exercises with lighted eggshells. But I never did learn to draw 'properly', nor did I attempt any kind of exam in art. Nonetheless, I owe this teacher an enormous amount. Not only did he help to make life tolerable in an abysmal environment; many of my aesthetic interests and enthusiasms can be traced back to him.

Looking back, it seems almost incredible he was able to achieve as much as he did. He worked in a tiny, cramped nineteenth-century art room, on the far side of the Quad. He had no assistants, nor much understanding from other members of staff. Once he recommended my paintings to the Headmaster for a

'Distinction'; the only time I ever saw the Head in the art room was when he came across to inspect my work. Presumably he was offended by the fact that I still could not get those proportions right, nor catch a likeness. I was probably still pretty messy, too. Anyway, the 'Distinction' was duly refused and the art master (not to mention myself) humiliated once again. It was at that time I first developed my beliefs that good art bears witness to a reality other and better than the existing one . . .

But how should you teach an eleven- to sixteen-year-old art? Art is about values and skills – but which values and skills are open questions. They are, however, questions which Her Majesty's Inspectors of art education have to put to themselves every day. HMI have recently produced an intriguing report describing art teaching in fourteen secondary schools ranging from Fred Longworth High School, a mixed comprehensive in Wigan, to Marlborough College, a leading public school in Wiltshire. (Department of Education and Science, *Art in Secondary Education 11–16*, HMSO.)

The methods of teaching in these establishments vary enormously. In Wigan, 'art and design' is part of a faculty of 'creative studies': there is an emphasis on craftsmanship, and imaginative use of a wide range of materials and processes (especially in fabrics and textiles). There are no formal lessons, as such; and teaching is geared heavily to individual needs.

At Marlborough, however, the art department is proud of a long tradition of learning and scholarship; emphasis is on acute perception, understanding of pictorial language, and the ability to appreciate the great masterpieces of the past. 'Constant talk about art', and the exercise of evaluative judgment, are encouraged. Fred Longworth High School and Marlborough College have one thing in common: they both offer examples of what HMI regard as 'successful art teaching'.

But what is 'successful art teaching' in a secondary school? To answer this question, we have to go back in history a bit. In the nineteenth century, images *of* children may have been sentimentalised, but images *by* children were virtually ignored. Child art was seen simply as the activity of those who had not yet adequately learned an adult skill; the only noteworthy art by

children was thought to be precociously competent work by prodigies like the young Landseer, or Millais. In so far as it existed at all, 'art education' was synonymous with the earliest possible acquisition of academic skills.

At the end of the nineteenth century, all this began to change. Within the Fine Art tradition, the academic consensus was increasingly eroded. All kinds of new ways of making art began to be regarded as being expressively valid. Child art, like 'primitive' and tribal art, was no longer seen as crude and incompetent but rather began to be appreciated for its own sake as something sensitive and expressive.

One positive effect of this was that during the twentieth century understanding of the aesthetic activities of children steadily rose; indeed, something called 'The Child Art Movement' began to emerge. This influenced a range of educational and psychological practices. For example, Rhoda Kellogg's detailed studies established that early artistic development in young children – granted only a facilitating environment – followed certain innate and largely culture-free patterns. Thus it was increasingly recognised that though talents varied, creative, imaginative and aesthetic work was effectively a 'universal', biologically given, human potentiality.

Paradoxically, however, the spread of advanced technologies and mechanical production meant that the opportunities for such work in *adult* life were constantly diminished. In this situation, 'Art' became increasingly segregated from other forms of social production: in much abstraction, emphasis shifted towards immediate appeals to the senses, or other forms of subjective, 'culture-free', self-expression. In effect, child art became one of the norms for the aesthetic production of *adults*. Another was a sort of mimicking of the anaesthetic means of modern production, in Pop Art, Video Art, Conceptual Art, etc. Indeed, in the 1960s, many art schools seemed to be offering students a choice between education in what was an essentially infantile aesthetic (slurpy abstraction, unrestrained 'self-expression') or the anaesthesia of Pop imagery, and mechanical processes, like photography, silkscreening and so on.

These developments placed a peculiar strain on the teaching of

art at secondary school level. Studies of other cultures show that, from the age of about eight onwards, innate, biologically given patterns of aesthetic development are insufficient; the individual needs to encounter a living artistic tradition. The sameness of much psychotic and 'insane' art is legendary. Originality, health and growth in aesthetic life appear to depend on something more than talent; they also require contact with a living tradition, rooted in a society's shared symbolic order — a tradition which provides meaningful iconography and patterns, and specific techniques with which to work and develop them. Indeed, far from being opposed to tradition and convention, individual aesthetic development cannot progress beyond the infantile without them.

If we lived in an aesthetically healthy society, it would be the job of art teachers in secondary schools to introduce their pupils to the values and skills of the living artistic tradition. But where no such tradition exists, what are they to do? And what can 'successful art teaching' mean?

Because there are no easy answers to these questions, secondary school art education is in confusion. For example, the boy-and-bowl-of-apples approach to which I was subjected at preparatory school is really based on the assumption that the academic tradition is still the only culturally valid one. But, paradoxically, this method of teaching no longer prepares those pupils who can master it for the sort of 'professional' life in the arts that opened up to a Landseer or a Millais. Rather, such skills lead towards proficiency in the sub-culture of amateur and leisure painting, where the seated figure and still-life-with-flowers are still stocks-in-trade.

Many post-war art school teachers have seen it as their first duty to break down any such quasi-academic skills a student might previously have acquired when at school; they seek to restore the pristine infantilism of the pre-secondary school years as a prerequisite for any kind of contemporary professionalism in the arts.

I certainly would not wish to defend the use of the old academic methods of art teaching in schools; but this teaching of a defunct aesthetic tradition seems less dangerous than a contemporary tendency to replace any attempt at aesthetic education with

dexterity in anaesthetic processes, in the handling of machines, cameras, calculators and so on. This is often done under the guise of 'broadening the syllabus', that is, reducing the time spent on drawing, painting, sculpture, pottery. If this kind of 'art education' spreads, it will complete the de-aestheticisation of our culture within a generation.

Fortunately, however, HMI themselves are advocating neither of these alternatives. Somehow, I think they would have approved of my public school art master; in their report, they stress that the purpose of art education at secondary school level ought not to be to train professional (or indeed amateur) artists. 'What marks the particular contribution of art and design to the secondary curriculum', they write, 'is that it emphasises the skills and understandings rooted in the senses of sight and touch, as well as in feeling and intellect.'

They say that the chief concern of successful art and design teaching is to provide pupils with tools – 'practical, sensory and intellectual tools' – by means of which they can become more of a person and make more sense of their experience. These include manual and practical skills; skills of acute perception and of effective discourse; knowledge of cultural and historical inheritance; 'above all, they include a growth of artistic and aesthetic sensibilities and the personal values attached to them.'

These values and sensibilities, of course, will be at odds with those of the culture at large. But HMI stress that they can be pursued through a great variety of activities. In effect they imply that a good secondary school art department will make its own tradition, by relating art work produced to the social life of the school, on a local level.

Perhaps this is the best we can hope for in a divided society, glossed with a homogenised and cynical 'mass culture'. Unlike HMI, however, I believe there are powerful arguments favouring the relative unification of secondary school art education. There is, of course, something arbitrary in the insistence that aesthetic sensibilities and values should be pursued in certain ways rather than others; but all healthy and extensive aesthetic traditions involve the acceptance of certain techniques and conventions, and the rejection of others. The imposition of such limitations would

not so much stunt aesthetic growth as make it more possible than before.

What those limitations should be, however, could only be decided in the context of a review of art educational practices from nursery to art school levels. We need a *continuum* of aesthetic teaching, rather than a series of often oppositional systems at different stages of development. (In that continuum, secondary school art teaching would play a peculiarly important role, in extending aesthetic work beyond the 'natural' and purely subjective.) Such a revised system of art education could represent the best chance we have of nurturing a living, widely accepted, alternative tradition to the General Anaesthesia of mechanical 'mass culture'.

1983

Black Arts: Coal and Aesthetics

Art and coal is the improbable subject of an exhibition at the Science Museum. In one sense, it is hard to see how there can be any relationship between the two at all.

No one ever made a great cathedral, or painted a masterpiece, in coal. Coal is uniformly black. It lacks visible variety and is filthy to touch. It has no ornamental value. Coal is too flaky and impermanent to fashion. The qualities it possesses of use to us can only be released by destroying it through burning. Coal offers none of the pleasures of sight, smell, touch or texture which can be derived from working with wood, marble, stone, wool, leather or even paper.

Coal is antipathetic to the human senses, hands and imagination alike. Those who have made a living by hewing it, handling it or hauling it from one part of the country to another can rarely have derived much pleasure from their work. Coal blackens. Most of it has been dug in dangerous, narrow tunnels, deep in the bowels of the earth, where men toiled cabined, cribbed and confined in murky darkness; they risk clouds of noxious gases, terrible disasters, and, if they survive, crippling illnesses of limb and lungs alike. Coal is hellish stuff.

Indeed, it has often seemed to be a substance made not so much for men and women as for machines. The aesthetic element in the work of the mason, peasant, hunter, weaver, blacksmith, or even soldier, has always been much more evident than in that of the collier. But during the second half of the nineteenth century, the number of men engaged in deep mining swelled to more than a million. Coal fuelled the industrial revolution and, historically, initiated changes in the nature of the work of millions who never directly handled it. The rise of this anaesthetic substance symbolised the squeezing of art out of the everyday activities of life. Sooty clouds hanging over factory chimneys, rather than the spires and

buttresses of carved cathedrals, dominated the skylines of the great manufacturing cities.

Of course, the gradual development of modern, mechanised mining alleviated many of the worst horrors and excesses, and, with the development of new fuels, coal became less central to industrialism. Nonetheless, coalmining has never remotely come to approximate pleasure. If art is, as William Morris once argued, 'joy in labour', then mining must be rated among the most artless of human occupations.

Predictably, the traditional aesthetic pursuits of miners – pigeon-racing, gardening, brass bands, galas, etc. – have no intrinsic connections with their work activities. But Douglas Gray, who selected this exhibition and wrote the catalogue introduction, sometimes talks about 'British mining art' as if it was comparable to, say, 'The Art of the Blacksmith', or Eskimo art. But what he offers is, in fact, a fascinating pot-pourri of paintings and other images, made by all manner of different kinds and conditions of men, which have some reference to coal or mining in their subject matter.

Quite a few were produced by miners – like members of the Ashington Group (including Oliver Kilbourn and L. Brownrigg). But, evidently, the creation of such pictures involved the acquisition of skills of a quite different kind from those which could be acquired at the coal face. For example, Vincent Evans became one of the best miner-artists: but he left the Welsh pits at the age of twenty-three to take up a scholarship at the Royal College of Art. 'Authentic' experience of an anaesthetic substance, like coal, or a practice, like mining, was *never* enough. Distance – often in both time and space – and the acquisition of new aesthetic skills were necessary for the creation of good pieces of 'mining art'.

The most successful examples of the genre often seem to have precious little to do with anything which actually happened in or around the pits. Take Turner's extraordinary oil-painting, *Keelmen Heaving in Coals by Moonlight*, or his watercolour of a similar scene, *Shields on the River Tyne* (represented in this exhibition through an engraving). In these works, Turner bathed everything in sublime moonlight in a way which eerily metamorphosed the pedestrian pursuit of coal-heaving on the banks

of a dirty River Tyne into something resembling the labour of the gods. The paintings work because Turner has not only seen, but also transformed, the sights before him, through the play of his artistic imagination and the practice of his pictorial skills.

But Douglas Gray, who went to all the trouble of selecting this exhibition, is clearly suspicious of any such manifestation of imaginative transformation. Thus, writing of the early 1800s when Turner painted these works, Gray comments, 'The aesthetic philosophy of the time, coupled with the yoke of patronage and the pressures of the art market, precluded any real attempt at social realism.' He adds, 'Truth to subject matter, reality or social documentation were not the order of the early nineteenth-century day.'

Gray tends to regard as 'good' only those works which immediately reproduce the appearances of physical or social reality. Thus he is predictably derogatory about picturesque and genre paintings of mining life, and full of easily come-by scorn for 'the sentimentality, mawkishness and complacency of mid-nineteenth century art'.

He looks for an alternative, and better, tradition to such things and purports to find it in the searingly factual drawings included in the text of the *First Report of the Commissioners (Mines)*, from the Children's Employment Commission of 1842. According to Gray, these represent 'a new form of artistic realism' which radically changed attitudes of artists, and public, alike and provided 'the impetus for the growth of popular social documentation'.

This growth he sees in the occasional illustrations of pit disasters and colliery explosions which began to appear in magazines like the *Illustrated London News* and *The Graphic*. This documentary approach fed back into painting, too. Indeed, Ruskin complained that the Royal Academy was becoming 'nothing more than a large, coloured, "illustrated Times", folded in saloons'. For Gray, this is simply an instance of Ruskin's reactionary taste.

For Gray is clearly sympathetic to the attack a nineteenth-century Superintendent of Mines made on artists' images of the

industry; at least he approvingly cites the Superintendent's view that it is not 'so easy to agreeably misrepresent the real in honest photographs'. And Gray too seems to believe that the best examples of 'mining art' appeared with the start of deep mining photography.

Predictably, when he surveys contemporary work, Gray is deeply suspicious of a painter like Josef Herman who, like Turner, is not content merely to set down the appearance of what he sees. Herman spent many long years living and painting among the Welsh miners; but Gray tells us, 'The question has to be asked as to whether his particular vision embodies attributes completely out of keeping with the nature of the mining community he observed.' For Herman, we are told censoriously, 'the community had come full circle and returned to those votive symbols of primitive religions.'

Gray is clearly much more at ease when talking about the photographs of Robert Frank or Eugene Smith; or even those of Bernd and Hilla Becher, who factually recorded the appearance of pit winding towers, coal silos, and washing plants through closely controlled photographs designed to exclude any intrusions which might alter the meaning of the image. No danger of 'votive symbols' there!

Now, of course, the value of informative, photographic documentation of coal and mining activities cannot be doubted. But the danger arises when this sort of reportage is assumed to be a substitute for, and inherently superior to, works produced through an aesthetic response. And the kind of reductio ad absurdum to which this leads is well illustrated in John Latham's photographs of Carberry Bing.

Carberry Bing is a large coal tip and an eyesore. A few years ago, Latham, a conceptual artist, nominated the bing as a 'found object', and suggested it should be developed as a sculpture. As Terry Measham explains in his booklet on Latham, the removal of the bings would have been an enormous undertaking, physically and financially. Latham was therefore proposing the idea of changing people's attitudes towards them, 'so that they will not need to be moved'. His artwork consisted of a report (part of the photographic documentation for which is exhibited here) on how

the qualities of the bings can be put across so as to make them not merely desirable, but a tourist attraction.

And, in a sense, Latham's Carberry Bing represents the logical conclusion of that literalist (or social realist) view which argues that, in the face of a phenomenon like coal, and a practice like mining, we should abandon the idea of imaginative or aesthetic transformation altogether.

Certainly, when we look back at many of those Victorian mining pictures, we are struck by a sense of unease, awkwardness and inappropriateness. Imagination and sensibility do not cohabit easily with coal dust and pneumoconiosis. On the other hand, if the only thing the artist does is to imitate the investigative journalist, and tell us how it is, then of course he too ends up capitulating to the anaesthesia of that reality which provides him with his subject matter.

Keelmen Heaving in Coals by Moonlight, however, did not only record the activity of coal-heaving, or the appearance of piles of the stuff. In the illusory world of his picture, Turner enthused the activity and objects of the colliers' work with a dimension they could not possibly possess in reality. Some might say that such aesthetic transformations stand as a promise that reality, too, can be other than the way it is. At the very least, it seems to me that when the aesthetic dimension has retreated from so much of human life, when, as it were, modern technology has turned so much of our environment into the equivalent of a Carberry Bing, we are entitled to ask our artists to provide us with consoling illusions . . .

1983

The Arts of War

When Linda Kitson, aged thirty-seven, sailed to the South Atlantic on the *QE2* with a £1,500 commission from the Imperial War Museum, she was Britain's first official war artist since 1945. Kitson is Lord Strathcona's cousin and sports a barrage of naval commanders in her family tree. Indeed, on paper, her connections appear more impressive than her chiaroscuro.

In this century war has invigorated British art and artists. In the First World War, the official war artists' scheme revived decaying academic traditions, 'socialised' the innovative styles of the avant garde, turned minor figures into painters of stature and dragged unprecedented work out of those who were already in the first rank. War was midwife to innumerable works of real quality, and assisted in the birth of a handful of masterpieces. Few British pictures of this century can be put beside, say, Stanley Spencer's *Travoys arriving with wounded at a dressing-station at Smol, Macedonia*, or John Singer Sargent's epic and still underestimated *Gassed*, both of 1918. War then may draw from Kitson greater work than anything she has achieved hitherto. And yet I am inclined to doubt it.

Times have changed since the first official British war artists were appointed in 1916. Charles Masterman, then head of British propaganda, realised the public was becoming bored with yet more black-and-white photographs of troops, mud and trenches. Beginning with Muirhead Bone, an etcher, artists were thus commissioned to produce works for mass reproduction. Certainly, they were censored; no military secrets, or dead bodies, German or British, could be depicted. But there were few attempts to prescribe aesthetic decisions. Academic painters, like William Orpen or John Lavery; younger realists, such as Eric Kennington; and even those who had been influenced by European modernist movements, Paul Nash and Christopher Nevinson, for example, all produced much of their best work as war artists.

Thus while the First World War broke up the art movements in Europe and spawned the nihilism of Dada, in Britain military sponsorship gave rise to some of this country's most imaginative and effective twentieth-century art. Indeed, the first official war artists' scheme was more successful than any subsequent peace-time pattern of patronage, such as the Arts Council's ill-fated artists' bursaries.

The sheer intensity of the experience of war may have had much to do with this. But war temporarily resolved the artist's major historical problems of separation from social life; the absence of a public iconography he could use; and of a shared symbolic order he could evoke. Artists tend to give of their best when they are told what to do; and enlightened commissioners ensured that sufficient space was left for the full exercise of imaginative and aesthetic decision-making.

But was there, perhaps, some still deeper reason for the exceptional success of that first official war artists' scheme? In a provocative lecture delivered to recruits at the Royal Military Academy, Woolwich, in 1865, John Ruskin argued that 'war was the foundation of all great art'. He elaborated the line that the greatest art had flowed from warring nations – like Egypt, Greece and the Italian city states. But then, suddenly, Ruskin's oration turned into a tirade against 'modern war, scientific war, chemical and mechanic war' for which there was no aesthetic mitigation or ethical defence.

Ruskin was intent on scotching the idea that there is some inherent, ahistorical incompatibility between art and war. A visit to almost any ethnographic or art-historical museum soon confirms that the aesthetic dimension can permeate into military pursuits – through war-paint, ritual uniforms, regalia, music and the whole range of ceremonial and ornamental arts.

De-aestheticisation occurred within the historical evolution of war itself; and like the de-aestheticisation of many other aspects of life, and work, this had much to do with increasing mechanisation and automation, and with the gradual replacement of human skills (which, however destructive, nonetheless retained the space both for aesthetic refinement and for an ethics of chivalry, honour and so on) with depersonalised instruments of mass destruction

and *inhuman* power. In this situation, Ruskin argued, the status of the modern recruit was little better than that of a slave. The Spartans, he said, had won the battle of Corinth with the loss of eight men: 'The victors at indecisive Gettysburg confess to the loss of 30,000.'

The arts of war were disappearing; the aesthetic dimension of warfare was increasingly split off from combat itself. Today it survives only as a residue, or in museum pieces, like the Royal Tournament, Trooping of the Colour and ceremonial processions utterly divorced from operational activities. Indeed, we rightly take the view that if there is anything more obscene than modern military activities, it is the attempt to re-aestheticise such activities, as occurred in Nazi Germany. A decorated sword or dagger is one thing; a decorated bomb or war-plane quite another. And an ornamented inter-continental ballistic missile remains unthinkable.

At the beginning of the twentieth century, however, as technology impinged ever more deeply into the cultural space for creative and aesthetic life, there were some modernist artists who were prepared to take the most negative form of this destructiveness (the brutal functionalism of modern military machines) and to acclaim it as a kind of metaphor for the new age.

Thus, in the 1930s, Marinetti, a futurist who had predictably become a fascist, could declare: 'For twenty-seven years we futurists have rebelled against the branding of war as anti-aesthetic . . . War is beautiful because it establishes man's dominion over the subjugated machinery by means of gas masks, terrifying megaphones, flame throwers and small tanks. War is beautiful because it initiates the dreamt-of metallisation of the human body . . . War is beautiful because it creates new architecture, like that of the big tanks, the geometrical formation flights, the smoke spirals from burning villages, and many others.' And so he went on to exhort the poets and artists of futurism to 'remember these principles of an aesthetics of war so that your struggle for a new literature and a new graphic art . . . may be illumined by them'.

The first generation of British war artists were, as one of them put it, 'in' the war but not 'of' it. They certainly did not believe

that a brutish, destructive functionalism was a suitable model of the beautiful and desirable. Graham Sutherland – an exhibition of whose second world war drawings can be seen at the Imperial War Museum – once said that the war artist 'always re-created and re-presented'. And when he was successful, he transformed what he saw.

Thus Spencer's great picture, *Travoys*, reconstitutes the sordid reality of the dressing station in terms of the formal silence, stillness and majesty we expect from a great Renaissance religious painting, perhaps by Piero della Francesca, whom Spencer admired. And Nash, too, constantly transfigured the bruised, soiled and degraded landscape, even as he faithfully depicted it. Such painters did not seek merely to imitate, let alone to celebrate, the destruction of war. Rather, the forms of their paintings affirmed the possibility of life they knew their subject matter to be effacing. Through the act of aesthetic transformation, they offered illusions of other and better realities in the midst of an intolerable present.

By the second world war, this promise of redemption, even within an imaginary illusion, was becoming increasingly hard to sustain. The reality of the century was becoming too painful to bear. In the Second World War, the best pictures produced by official war artists deal, again and again, with the extreme peripheries of the conflict: Bomberg's images of bomb-stores; Moore's cocooned figures sheltering from air-raids; Piper's statuesque ruins; Sutherland's pictures of war-damage, industrial production and tin-mines . . . It is as if the most imaginative minds felt compelled to avert their eyes from the war itself. The majority of reconstructions of battles, and so forth, were left to the hacks of regimental painting.

Sutherland commented on his own distance from the front: 'I feel sure that my thinking would not have been aroused by fighting on a grand scale entailing all the speed and mechanisation of modern warfare; though no doubt individual battles, street and house-fighting, might well have been another matter." He went on to explain that the root of his work was memory, and 'the sudden unaccountable emotion which modifies and transforms facts'. But, he added, facts were 'the necessary starting point'; and

in modern warfare he felt he would have found such facts difficult or impossible to gather.

One wonders, too, whether the imagination, that 'sudden unaccountable emotion', would not simply have felt compelled to deny, rather than to modify or transform, the facts. The only way Sutherland could handle photographs he was shown of the Nazi death camps was to weave some of the forms in them into his postwar crucifixion images. As the twentieth century wore on, it became increasingly difficult for the authentic artist to offer an image which redeemed what his eye saw when confronted with war. After Hiroshima it became, in effect, impossible; the threat of general anaesthesia implicit within all contemporary war was irreconcilable with the promise of life implicit in the realised aesthetic dimension.

This, I believe, is one reason why there are so few good paintings of the Vietnam war. In the face of such phenomena, the artist cannot, if he is truthful, offer hope. Yet unless the process of aesthetic transformation (with its implicit promise) takes place, neither can he offer good art. And this is what will make Linda Kitson's task so difficult. Today it seems we have come full circle. Masterman originally appointed war artists because he believed their images would give new hope to a public jaded by the grey monotone of despair and destruction provided by frontline photographs. During the war in the south Atlantic, however, such photographs were held back from us: and instead we were treated to a stream of line drawings which were not so much alternative promises as lies.

As Peter Jenkins pointed out in the *Guardian*, in this war it has been the paucity of actuality rather than the degrading spectacles of violence which has brutalised. 'In place of live pictures of burning flesh and mutilated limbs', he wrote, 'we have seen romantic line drawings of the kind I remember from *Boys' Own Paper*. Such news as has been allowed from the front, much of it more inspirational than graphic, has been accompanied on the television screen by library film of peacetime exercises or weapon demonstrations. We hear of black mud and icy rain but what we see are coloured counters moving across a model island coloured brightest green.'

When the task of the war *artist* has become effectively imposs-ible, the prostitute war image-maker can easily step in to serve the anaesthesia of the military machine. Will Linda Kitson be able to step over the trap that history has sprung for her? We will have to wait and see.

1983

The answer to the rhetorical question, predictably, turned out to be no.

1985

The Merchants of Venice

The Royal Academy's 'The Genius of Venice' exhibition was born of nothing if not commercialism and the desire for prestige. The Academy needed a money-spinning show to forestall bankruptcy, the sale of a tondo of marble flesh, or whatever. Sir Hugh Casson, its President, now approaching retirement, naturally wanted a glittering culmination to his term of office. And so, with more than a little help from James Sherwood of the Sea Containers Group, owner of the Orient Express and a leading Venetian hotel, the idea of this huge exhibition was coaxed into reality.

Five years ago, the Doge of Burlington House instructed his emissaries to scour the world for Venetian paintings, drawings, prints and sculptures, and they have brought them in to Piccadilly, not just from the museums, churches and palaces of Italy, but from Kingston Lacy and Cambridge, from Leningrad, Washington, Vienna, São Paulo and even Adelaide. It is an achievement of which Francesco Foscari would have felt proud.

'The Genius of Venice' was heralded even before it opened as one of the truly *great* art exhibitions to have been mounted in this country. The Academy is looking for a million visitors paying up to £3.50 each: it deserves to get them.

There are those who will be repelled by the mercenary considerations underlying the show. But in a historical sense, they seem fitting. For the splendid pictures of sixteenth-century Venice are the aesthetic fruits of an Empire's spiritual decline. As that avid lover of Venice, John Ruskin, once put it, 'Now Venice, as she was once the most religious, was in her fall the most corrupt of European states; and as she was in her strength the centre of the pure currents of Christian architecture, so she is in her decline the source of the Renaissance.' By the sixteenth century, the 'structure of feeling' within the Venetian republic had changed; its peculiar, aristocratic, Christian mercantilism had become increasingly

mercantile, increasingly secular. The Rialto replaced St Mark's as the pulse of the city.

Venice's greatest collective achievements in government, religion, architecture and the decorative arts lay behind her; but the superlative accomplishments of her painters were just being realised. New private patrons wanted pictures; and the painters were able to draw upon the cultural inheritance of the city in making them. The clichés tell us of the colour and light in sixteenth-century Venetian paintings; and the clichés are right. The iridescent ornament which had once encrusted the great Gothic buildings, the light that continued to dance over the lagoons, informed the new painting in a way that happened nowhere else in Italy. But this time it served an essentially secular imagination.

The sensuality of Venetian art in the sixteenth century is legendary. It is a dual sensuality: of material things and bodies – fabulous carpets, ample and desirable women; and of the richness and opulence of oil paint itself, the properties of which were excitedly discovered, explored and exploited. There have, of course, been many who from both religious and socialist positions have derided the values of sixteenth-century Venice. But the inescapable fact remains that, in its painting, Venice found an art uniquely consonant with those values and, as the Royal Academy so superbly revealed, it was one of the most sumptuous of all moments in the history of painting. (If it did nothing else, 'The Genius of Venice' would seem to have finally demolished certain fashionable Marxist assumptions about the incompatibility between capitalism and artistic achievement.)

The greatest of the new Venetian painters was, of course, Titian. He straddles the century, and, fittingly, the Academy exhibition too, like a colossus. Nowhere can we see better this love of flesh, fabrics, and paint itself; Titian paints even the violence of Tarquin's assault upon Lucretia with a celebratory relish in the pleasures of this world. And yet his was never a mindless hedonism. The paintings of his old age bear witness to his acknowledgement of the frailties of human being. *The Flaying of Marsyas* was perhaps *the* revelation of this exhibition. Titian probably left it unfinished in his studio when he died; since the late

seventeenth century it has been hidden away in the archiepiscopal palace at Kromeria. Titian imbues the terrifying scene with a sadness unto death which springs from his growing knowledge of the finite limits of the flesh he had celebrated all his life.

But other Venetian painters showed versions of secular spirituality too. Lorenzo Lotto, Bernard Berenson's favourite painter, openly yearned for the lost faith of an earlier century; Bassano, working in the *terra firma* outside the city, mingled religious archaism with pastoral naturalism. No one needs reminding that Giorgione's shadowy presences; Tintoretto's magnificent decorativeness (which sought to wed a peculiarly Venetian sensibility for colour with a new sense of the arabesque of line); or even Veronese's uncritical sumptuousness, retain something of the religious sensibility out of which they burst.

And so the argument that these artists were painters, *par excellence*, of emergent secularism requires qualification. They succeeded because they looked back as well as forward. One painter who refused the legacy of this spiritual past was the portraitist, Moroni. His picture of a merchant in a fine fur scarf has a certain worldly splendour. But, significantly, the exhibition confirms that popular judgment has been right in according him a relatively lowly place. Secular mercantilism can give birth to unparalleled painting, so long, it seems, as it retains ghostly traces of the illusions it rejects.

1983

VII

ARTS AND CRAFTS

29
Art and Industry

I have spent a good deal of time recently in front of a Steenbeck in a film editor's cutting room. The machine is the very latest model. Every morning, when first switched on, it flashes up the word HELLO. Ironically, we are using it in the production of two documentaries, 'Memories of the Future', about John Ruskin and William Morris respectively.

They would have hated this irritatingly inauthentic salutation. But it is only a tiny instance of a spreading design tendency. We now have talking vending machines, and computers programmed to express pseudo-emotional reactions such as quasi-satisfaction and quasi-rage. Similarly, a new 'Ornamentalism' is all the rage: this involves such things as pink fridges; tables whose enamelled metal legs are designed to tremble; and floral-patterned washing-machine casings.

In short, 'Functionalism' – the reason for the inverted commas will become apparent in a moment – is waning. Modernism is in crisis. Western culture is undergoing an upheaval of taste, an apparent shift in its sensibility, or 'structure of feeling'. Profound changes are affecting almost every area of artistic activity.

For example, fifteen years ago, 'progressive' taste simply assumed that photography had rendered painting 'dead'. But today, as the editor of one avant-garde magazine put it, a 'great wave of painting' is flowing everywhere. Similarly, in architecture, ornament, which barely merited consideration in the 1960s, is flooding back. And although it seemed then that multiples and mass-production were the conditions to which all art should aspire, we have now lived through more than ten years of a continuing craft revival. There is a resurgence of hand-made studio pottery, workshop furniture, craft jewellery, hand-woven textiles and knitwear.

But the movement in design itself, from Modernist 'Functional-

ism' towards new sorts of 'Ornamentalism', cannot simply be described as an oscillation of the proverbial pendulum. The mechanism by which the clock is operated is changing. Indeed the old mechanical metaphor, so often applied in the past to movements of taste, seems inappropriate as we move into a new phase of electronic and process technology. The forms of the new clocks just cannot be derived from their functioning in the way the form of a grandfather clock had to be. The relationship between how things work and how they look is being transformed by more than a swing of taste.

What is happening in art and design is part of a wider crisis of values brought about by changes in productive processes and relationships. That design is deeply affected by all this, no one could deny. We are a long way from the 1960s when Habitat seemed to be becoming 'natural' even on the lower slopes of middle-class urban life. The profession's educational and institutional support structures may remain strong but designers are no longer confident about their place or function in the world. Recently, in the *Guardian*, a debate has raged about whether it is possible to teach design in general as opposed to the design of specific sorts of object; jewellery, for example, or industrial compressors, or computers. The design tradition has fragmented; there just isn't a cohesive, underlying design 'ethic' to which every practitioner can appeal any more.

But the real discussion may be whether there is a professional category, or function, which can legitimately be designated as 'design' at all. At one end of the argument, the way technology is developing from mechanical objects towards electronic processes appears to be rendering the designer obsolete; either he merges into the electrical engineer, or he 'designs' yet another black or white case. Alternatively, he joins the novelty trade, and punctuates the case with electronic messages, or makes it castellated or polka-dotted. But, at the other end of the argument, too, the designer tends to disappear because the revival of craft-orientated production inevitably involves the reaffirmation of a unity between conception and making.

I think we can only hope to understand the lability of today's designer if we go back into history, indeed into the *natural* history

of our species. I believe that, from the beginning, human production involved a balance between aesthetic and practical dimensions. I might have been expected to oppose the aesthetic to the 'functional' here. However, it is an important part of my argument that the aesthetic dimension of production is itself functional; whereas 'Functionalism' – in the sense of the Modernist style or tendency in architecture and design – led to the creation of objects which were neither aesthetically satisfying *nor* practical.

We know from our schoolbooks that man is not only a tool-using but also a tool-making animal. To an extent greater than that of any other creature (though not as great as he himself would sometimes like to think) man possesses the intelligence, and motor-skills, to manipulate natural materials and processes to meet – and also, of course, to extend and transform – his practical needs.

It is, however, less often stressed that the aesthetic impulse also seems to be among the basic biological potentialities of human being. Although elements of this impulse are readily discernible in species other than our own (among birds and fishes, for example), in man, uniquely, it seems to become loosened from its original biological functions (of camouflage and display), and to become enmeshed with imagination, symbolisation and expressive work.

The relationship between the practical and aesthetic dimensions of human work is always complicated. Edward Lucie-Smith is probably right to argue that long before the twentieth century there were certain objects – like flint arrow-heads and eighteenth-century rush-light holders – which came into being simply to meet practical needs, and whose forms were determined almost entirely by considerations of utilitarian efficiency. Nonetheless, prior to advanced industrialisation, the conception, physical realisation and use of even such objects seems to have involved an aesthetic component. Moreover, many of man's early practical activities (like the making of cloth to cover the body) almost certainly had their origins in aesthetic pursuits (like decorative adornment of the skin) – a fact resplendently reflected in the subsequent history of textiles.

Indeed, I would argue that not only in many of the first, but also in the greatest, cultural achievements of humanity the practical

problem-solving element is secondary or derivative. 'Design: *d'abord le problème*' may be all very well as a slogan for today's Danish Design Council, but it blurs over the fact that in, say, the great achievements of Gothic crafts and architecture, the problem was aesthetic and symbolic *before* it was practical.

The purpose of, say, a cathedral and all its constituent parts was the celebration of the glory of God and the unity in diversity of the members of Christ's Church. A steeple, Gothic vault or flying buttress just cannot be conceived of as solutions to design problems in the same sense as, say, the form of those rush-light holders, or Jørgen Rasmussen's celebrated prototype for an easy swivel castor. The symbolic, aesthetic, ornamental and spiritual aspects of the cathedral *are* its function.

Mrs Jessie Newbery, who was involved in the Scottish, turn-of-the century, Arts and Crafts movement, once said, 'the design and decoration of a pepper pot is as important, in its degree, as the conception of a cathedral.' But the two activities can in fact only reasonably be compared in an aesthetically healthy society in which the ornamentation of more common-or-garden things than cathedrals is not just some dispensable extra, intended to enhance, or underline, practical function. The contribution a healthy ornamental tradition makes to the appearance and forms of objects is itself culturally functional.

Sound ornament has its roots in a society's 'shared symbolic order', and provides the social and material space in which an individual maker can celebrate his subjective joy in labour. Simultaneously, it allows him to affirm and extend the collective beliefs and spiritual values of the group. Ornament bears material witness to those individual and social needs of men and women which cannot be reduced to physical necessity. A living, developing stylistic tradition is one of the most important ways through which individual human subjects reconcile themselves to the brute existence of the social and physical worlds they are constrained to inhabit.

But since the Renaissance, Western societies have been characterised by the break-up of these underlying 'shared symbolic orders'. Furthermore, the intensification of industrialisation, the division of labour, the spread of the factory system, and the

emergence for the first time of an industrial proletariat has transformed the nature of work.

Under nineteenth-century industrial capitalism, less and less social space was left for the full expression of the biologically given aesthetic impulse. For most men and women, the aesthetic dimension of work was simply suppressed. In factory production, and later in office work and the service industries, work became simply paid employment, unaccompanied by any expression of significant values or expectation of pleasure.

Thus the aesthetic dimension tended to be shunted towards the margins of life; indeed, for the first time in human history, to stand in opposition to life as actually lived and worked. Elsewhere, I have described how it took on a new kind of life in the 'other realities within the existing one', or the illusory worlds created behind the canvas surface by a breed of men set apart: Fine Artists. Of course, it also persisted in certain practices preserved and pursued among the relatively leisured middle and upper classes. But for most men and women, brute reality and economic necessity impinged too deeply; the space for the aesthetic dimension seemed to be being sealed over altogether.

Indeed, it is possible to see the origins of 'design' as the attempt to reinsert this displaced aesthetic dimension into the mainstream of productive life, that is into industry itself. The first industrial designers were Fine Artists, men like John Flaxman and George Stubbs, whom Josiah Wedgwood commissioned to embellish his pottery. For the first half of the nineteenth century, good design had few of the connotations it acquired in the twentieth; it was conceived of, in the words of an 1835 Select Committee, as 'the extension of a knowledge of Art' among 'the manufacturing population of the country'. When Henry Cole wanted to reform industry by 'connecting the best Art with familiar objects in daily use', he did so by persuading the 'most eminent British manufacturers' to commission famous painters to design elaborate fancy goods. Similarly, the Schools of Design were intended to train artists to 'apply' art in industry; that is to stick on to, or into, industrially produced objects the artistic or aesthetic element which, by its very nature, industrial factory production seemed to diminish, exclude or destroy.

But the early design reformers were not interested in ornament as an expression of a spiritual 'shared symbolic order'. Nor, of course, did they want to reintroduce it as a way of reviving the pleasure in work of those who carried out industrial labour. Rather, the sort of art they sought to 'apply' immediately reflected the dominance, for the first time in human history, of productive work by market values and mechanical processes. They saw ornament primarily as a potentially cheap and easy way of increasing the exchange value of products. 'Ornament', wrote Ralph Wornum in his influential *The Characteristics of Style*, 'is now as material an interest in a commercial community as even cotton itself, or, indeed, any raw material of manufacture whatever.' He argued that the principles of ornament should be studied theoretically and scientifically to realise 'its most effectual application' over the widest possible range of materials.

Now the leaves on the tops of the pillars in the Chapter House at Southwell Minster are informed by Christian ideas about creation; the vitality and variety of their carving expresses individual artistic talents, and relates to natural growth. The *raison d'être* of such ornament has nothing to do with increasing the market price of architectural pillars. Much mid-Victorian ornament superficially resembled Gothic in that it mimicked natural form. But the only real beliefs informing Victorian cast-iron foliage were certain ideas about exchange value. Endlessly repetitious, it lacked individual variation; the model for its production was not nature at all, but the machine. Neither the making nor beholding of such work could yield any deep or significant pleasure.

In this sense, of course, like any other ornament, Victorian mechanical ornament accurately reflected the values of the culture in which it was produced. Even the 'art' designers were seeking to apply had lost its aesthetic dimension. There was in fact a greater continuity between the Crystal Palace and its contents than today's design historians like to admit. For in Victorian ornament we can see what was to become *the* dominant characteristic of the Modern Movement: the replacement of human values by mechanical processes, and the futile quest for a 'Machine Aesthetic'.

But if dead Victorian ornament did nothing for aesthetic func-

tion, it often impeded practical function too. In fact, after the Great Exhibition of 1851, younger designers in the circle around Henry Cole began to recognise this. They started to forsake the idea that advanced industrial production and full aesthetic expression were compatible, and to shift all the emphasis on to the improvement of the practical functions of industrially produced goods. Thus a writer in *The Journal of Design and Manufactures* began to argue in 1852 for 'utility' and 'simplicity'. 'Not all the dogmas in the world', he wrote, would force upon the public 'the use of a tea-urn that was ugly and inconvenient, merely because there was much to be said about its propriety, aesthetically and theoretically.' Thus began a peculiarly *British* tradition of design thinking which was never to have much effect on what the market, or manufacturers, actually did, but was to have an enormous influence on what 'good design' was thought to be.

Of course, there were those in nineteenth-century society who took a more radical approach. It was Morris who first described art as man's expression of his joy in labour. 'If those are not Professor Ruskin's words,' he added, 'they embody at least his teaching on this subject.' Nor, he went on to say, 'has any truth more important ever been stated; for if pleasure in labour be generally possible, what a strange folly it must be for men to consent to labour without pleasure; and what a hideous injustice it must be for society to compel most men to labour without pleasure.' Both Ruskin and Morris recognised the dependence of true ornament on significant human values, and associated it with each individual producer's, and consumer's, sense of engagement in imaginative and creative work.

For Ruskin, the shared symbolic order sustaining sound ornament remained Christianity, and a perception of nature as the literal handiwork of God. 'All noble ornament', he once wrote, 'is the expression of man's delight in God's work.' He regarded the only conceivable style as the continuing Gothic tradition. Morris's outlook was more thoroughly secular. He saw the revival of joyous human work as coming about through an imaginative response to the universal symbolic order provided by nature; and through the conservation (within and alongside industry) of traditional arts and crafts practices.

Nonetheless, neither Ruskin nor Morris was motivated by hatred of industry as such. Their concern was rather the positive one, that human work should meet human needs. The reason it has proved possible to misrepresent both of them as proto-functionalists is simply that they recognised the place for practical and unadorned mechanical production. Ruskin detested Cole's ideas about the 'application' of art to industrially produced objects. He preferred Kings Cross to St Pancras. 'There never was,' he once wrote, 'more flagrant nor impertinent folly than the smallest portion of ornament in anything concerned with rail-roads or near them.'

Similarly, far from being guilty of the Luddism of which he is so often accused, Morris celebrated the potentially liberating pro-ductive power of 'these almost miraculous machines, which if orderly forethought had dealt with them, might even now be speedily extinguishing all irksome and unintelligent labour, leav-ing us free to raise the standard of skill of hand and energy of mind in our workmen.' A machine, Morris thought, could make any-thing *except* a work of art.

Ruskin and Morris were primarily concerned with the holding open in the midst of life (i.e. on appropriate buildings and in appropriate branches of production) of the space for what I have been calling the aesthetic dimension of work. If, at times, they were equivocal in their attitude to the development of mechanical, productive forces, it was only because they saw them as potentially sealing over that space. But Morris, in particular, began in later life (for example in his Utopian romance, *News from Nowhere*) to hint prophetically at the idea of a two-tier economy in which drudgery was fully automated, and a simultaneous resurgence of fully human, creative production took place.

And here, Morris was at odds not just with Henry Cole, but also with Cole's heirs, the emergent Modernist Movement. For, like the Great Exhibition 'ornamentalists' (and unlike the young men in the *Journal of Design* circle) the Modernists did *not* try to compel machines towards efficient, practical production. Rather they turned towards a new 'Aesthetic', based on mechanism rather than nature or human need. And so, in 1882, Lewis Day looked to 'machinery and steam power, and electricity' to provide

the 'ornament of the future'. All the 'progressive' European and British writers about art and design at the turn of the century mouthed similar sentiments. By the twentieth century, these were the received dogmas of Modernist 'Functionalism'.

Thus in his still influential *Art and Industry*, first published in 1934, Herbert Read wrote, 'We cannot . . . oppose the machine. We must let it rip, and with confidence.' With singular lack of moral compunction, he argued, 'The cause of Ruskin and Morris may have been a good cause', but it should nevertheless be abandoned because 'it is now a lost cause'. 'The machine', declared Read, 'has rejected ornament; and the machine has everywhere established itself. We are irrevocably committed to a machine age.'

Clearly, Read thought we should regard the machine as our master and not as a potential servant, or tool. Nonetheless, he recognised a biological necessity for aesthetic production, for *art*, in man. But, to reconcile these positions, he had to assimilate aesthetic experience to a mechanical model. Man's artistic life, Read argued improbably, had nothing *essentially* to do with ornament, handiwork, imagination and so on but rather found its fully realised, or ideal, character in uniform, precise and repetitious production. The problem was simply educating aesthetically retarded people to appreciate this fact.

J. M. Richards, the polemicist for modernist architecture, similarly celebrated the 'new beauties' to be found in prefabrication, standardisation and mechanisation – comparing pylons favourably with Gothic spires. And in a seemingly wilful, though enormously influential, inversion of the truth, Nikolaus Pevsner even went so far as to argue that William Morris was a 'pioneer' of 'the immense, untried possibilities of machine art'!

The great prophets of the Modern Movement, in Britain, as in Europe, did not just wish men and women to inhabit 'machines for living in'; like the good nineteenth-century determinists they really were, they regarded human beings, themselves, as aspiring towards the condition of perfectly running machinery. In human terms, of course, Modernism was never functionalist at all; by which I mean it did little to meet real aesthetic, or practical, functions. Just as the Victorian mechanical ornamentalists pro-

duced those ugly and inconvenient tea-urns, so a Modernist, like
Rietveld, produced an equally ugly and inconvenient chair,
which, as Robert Hughes rightly observed, delivers 'a severe
rebuke to the body'. The only buttocks suited to it, he added,
'would need to be a cleft, perfect solid.'

But despite the polemics of Read, Richards, Pevsner and the rest,
Modernism never really took a deep hold, even among 'progres-
sive' British designers. One reason for this was the Arts and Crafts
tradition. Few of the latterday prophets of the movement would
have agreed with Pevsner that Morris was the harbinger of
Modernism; nonetheless, many of them, including C. R. Ashbee
and W. R. Lethaby, came round to believing that the only way
forward lay in the attempt to adapt what they took to be the
essence of Morris's teaching to the reform of mainstream, indust-
rial production. Lethaby, for example, became the father-figure of
the Design and Industries Association, founded in 1914.
Although DIA members appealed endlessly to the aura and rhetor-
ic of Kelmscott, as the design historian Fiona MacCarthy has
pointed out, their approach was in fact much closer to the
post-1851 Great Exhibition, 'utilitarian' circle round Henry Cole.
For these DIA men never mentioned ornament, handiwork, mod-
els of pre-industrial production or the necessity of 'joy in labour'.
Equally, however, they were deeply suspicious of European Mod-
ernism, and all its works. The chairs Ambrose Heal sold were
designed to be sat on, not to fulfil an abstract 'Machine Aesthetic'.

And it was this sturdy, practical, downright approach, veneered
with, if anything, a touch of 'hearts of oak' Englishness, which
became orthodoxy among successive waves of British design
theorists and reformers. Since neither the manufacturers, nor the
retailers, apart from Heal and a handful of shop-window excep-
tions, paid very much attention, this sort of design thinking had
very little effect on the things ordinary people had in their homes.
An important exception was the success of Gordon Russell's
Utility Furniture Committee during the last war. Then Russell
could invoke the full force of Government Regulations to prevent
the solid principles from being betrayed. Nonetheless, it was not
long before Russell himself was writing that it was 'unfortunate
that when freedom of design came again at the end of the war the

trade made no concerted effort to build on the better foundations which had been laid, but indulged in an orgy of bad taste frequently accompanied, as bad taste so often is, by shoddy workmanship.' And, for much of his time in the post-war Council of Industrial Design, Russell was to be cast as a lone preacher for tempered, modest practicality in industrial design, in a commercial world motivated by very different tastes and values.

Today, of course, when the DIA, Russell and the early CoID are written about in the design history books, the tone tends to be excruciating; prophets of the kitchen chair and the drawing-room cushion are easily enough mocked. Yet, for all its limitations, I believe their gospel, let us call it 'Russellism', has a right to be considered the true *practical* functionalism of the twentieth century; re-interpreted, it may still have a great deal to offer to the resolution of at least one aspect of the present crisis in design.

But one reason why Russellism has so little effect, even within the limited area of production for the domestic market with which it concerned itself, was that it failed to understand the industrial producers. Russellism continued to assume that industry 'really' wanted to serve human needs, and all you had to do was to point out to manufacturers how best that could be done. In fact, of course, what motivated industry far more was the desire to stimulate, suppress and manipulate those needs in the interests of profit. When Russellism clashed with these objectives (which it nearly always did) it inevitably lost – and there was little but exhortation which could be done about it.

But Russellism also failed to understand human needs fully, tending as it did to assume that they were all practical. If industry gave men and women comfortable and pleasantly finished chairs, decent cutlery, and neat and efficient coffee blenders, there was really no point in even thinking about the role of the aesthetic, ornamental and symbolic impulse in human life and labour. Russellism might have appreciated, and indeed promoted, those eighteenth-century rush-lamp holders; but how could it explain, or give rise to, the twentieth-century equivalent of William Morris's fine hand-blocked wallpapers, let alone a great cathedral? Russellism seemed to be based on the acceptance of the irrelevance of the aesthetic dimension to everyday life.

And if the market did not set out to satisfy deep and significant spiritual values it did, unlike Russell, fully recognise that many of the human desires it could stimulate and exploit for its own ends had little to do with domestic practicality. The American architect, Robert Venturi, was not entirely foolish when he compared the magnificent West front of Amiens cathedral with the elaborately shoddy neon paraphernalia over the Golden Nugget Gambling Hall in Las Vegas; the forms of both are symbolic and ornamental, rooted in what we have been calling aesthetic rather than practical needs. And, Gordon Russell notwithstanding, modern industrial capitalists knew, as Ralph Wornum had in the nineteenth century, that 'the characteristics of style' were of material concern to the commercial community. But the difference in quality, or qualities, between carved Gothic and Las Vegas neon plastic ornament eloquently reveals the different sorts of values they serve.

While Russell was plodding around with his pamphlets on how to furnish your home, technology, driven by the market, was leapfrogging over itself. The whole industrial process was becoming infinitely more complex and elaborate, especially in the fields of mechanical and electrical engineering. In the swelling 'communications industry', and for the domestic consumer, there was an ever-widening range of products, gadgets and processes. Industry, too, was developing ever more sophisticated marketing strategies which were not, of course, solely concerned with advertising and promotion, but also with 'styling'. Market competition was thus as powerful a determinant of the forms of things as it was of the images on the billboards and posters.

Predictably, in this situation, designers became increasingly irritated with the classical Russellist stance: namely that they should function as moral reformers of a reluctant industry. Many of them wanted to play a direct and not necessarily critical part in the burgeoning of the new technology, or, alternatively, in the lucrative advertising, promotion, styling and marketing of it. Ironically, 'good design' itself briefly became one of the elements in this marketing process. But, predictably, it was the image of good design, rather than actual good design, which the market sought. Many designers know of instances where a product,

designed to be practically functional, was sent back to be redrawn because it did not look 'Functional' enough. Similarly, Terence Conran achieved such commercial success in part because he was able to seize the Morris and Russell tradition and package and sell it in the new market-orientated way. He was not of course interested in either Morris or Russell for their aesthetic and ethical stances in design, but rather as effective and saleable fashions. Thus Habitat opened offering 'instant good taste for switched-on people'. And John Stephenson, managing director of the Conran Group, once freely admitted in *The Times* that his company's philosophy was 'making money'.

The coming of the microchip appeared to put pay to Russellism for good. Who cared about the quality of dessert spoons and toy wooden trains when every decent middle-class home (always the first and last refuge of 'good design') had a video-recorder and a space-invader machine? As the technologists and marketing men began to penetrate deeper and deeper into the fabric of even everyday domestic life, designers tried to forget about the good, solid British practical functionalist tradition – never mind fidelity to that 'aesthetic dimension' functionalism itself had forgotten! Indeed, many of them came to resent the legacy of that tradition, with all its apparently restraining ethical concerns. Fiona Mac-Carthy quotes Eric Marshall as saying, 'This company believes that industrial product design, by definition, is engineering-orientated design and that industrial graphic design is market-orientated. Aesthetics alone are of no value.' There was no space left for the designer, it seemed, other than as an engineer or an advertiser.

I began, however, by arguing that what is happening in design can only be seen as part of a wider crisis of values. John Ruskin rightly taught that what happens in art reflects social and productive life; and the divisions and contradictions in aesthetic life today flow from divisions and contradictions opening up within the social fabric itself.

What might seem, at one level, to be questions of taste or, in the shallowest sense, *style* cannot be separated from, say, debates about the nature of human work at a time when the availability of paid employment is declining; from fears about the unrestrained

development of technology, especially the technology of war; or from concern about the quality of the environment.

A commitment to market-oriented styling in design is thus indicative of a certain position in the argument about the value of commitment to an ever-increasing volume of production. I would go even further. I believe the choice currently being made by the engineer designers and advertising stylists is wrong – aesthetically, ethically and politically. This sort of design colludes and collaborates with an industrial system that has lost sight of the real reason for any production: the meeting of practical and aesthetic human needs. Inevitably, of course, as long as the market exists and functions the way it does, the majority of designers are going to practise in that sort of way. Nonetheless, feeble as they might have been, the attempts of DIA, Gordon Russell and CoID to temper industrial capitalist production with a little humanity, and a concern for at least some genuine human needs, do not seem to me to be simply derisory.

The space for Russellism only came into being at all thanks to the intervention of the state through CoID, and later the Design Council. Without such state intervention, the market would have had its way – without *any* mitigating forces, or the affirmation of any alternative design ideal. Regardless of the argument about whether the means of production should be in state or private hands (or a mixture of both) it seems to me, as it did to Ruskin, that there is a very strong case indeed for *not* leaving all design decisions in manufacturing industry to those whose philosophy is making money and for whom aesthetics are of no value.

But it is here, of course, that questions of design merge into questions about the kind of society one wants to see. And the kind of society I want to see is one in which production not only exists to serve practical human needs, but is also of such a kind that the aesthetic dimension will be able to flourish again. And it is increasingly clear that neither capitalist 'free market' economies, nor socialist models, as existing or commonly advocated, are able to deliver in this respect. Socialism, for example, has tended to be even more absolute than capitalism in its suppression of the aesthetic element of labour.

For myself, I believe that an updated version of that concept of a

two-tier economy, implicit within Ruskin, and especially the later William Morris, offers the best hope for the future. Indeed, Ruskin and Morris were compelled into ambiguities that are no longer necessary for us. What, for example, is the secret source of power that keeps the factories humming in Morris's *News from Nowhere*? Morris was forced to operate with the unsatisfactory model of labour-intensive mechanical processes – or sheer fantasy. But the electronic and microchip revolution has made that liberation from drudgery of which he dreamed a real possibility.

Dennis Gabor, the inventor of that most technologically advanced process, holography, once wrote an interesting essay, 'Art and Leisure in the Age of Technology', in which he argued, 'Modern technology has taken away from the common man the joy in the work of his skilful hands; we must give it back to him.' Machines, Gabor claimed, could make anything, even *objets d'art* with the small individual imperfections which suggest a slip of the hand, but, he added, 'they must not be allowed to make everything. Let them make the articles of primary necessity, and let the rest be made by hand. We must revive the artistic crafts, to produce things such as hand-cut glass, hand-painted china, Brussels lace, inlaid furniture, individual bookbinding.'

I believe those objects of 'primary necessity' should be produced by a regulated industry, on which standards of good, practical design could be effectively imposed. But I am also looking for the efflorescence of what Gabor calls the 'artistic crafts' – not as eccentric luxuries, hobbies or 'leisure' pursuits, but rather as an integral second level or tier within the national economy itself. These crafts, of course, would provide the arena for the resurgence of the aesthetic dimension in production.

Industry should remain in a mixture of public and private hands – but the State, or one of its appointed agencies, should intervene in the productive process itself, to exercise a function of design patronage extending far beyond the imposition of safety regulations. This would, in effect, compel industry to meet real, practical needs, rather than marketing requirements. Advertising should be intensively regulated, and most of its present forms simply abolished altogether. Such controls do not seem to me to be incompatible with true freedom, but rather to be environmental prere-

quisites for it. In such a reformed industrial process, a modified
Russellism would come into its own. I would expect to see a
revival of practical functionalism (as a living tradition) in mass-
produced domestic goods; simple and efficient black and white
boxing of more complicated electronic devices would also pre-
sumably flourish.

As for that second tier in the economy, there have been signs,
for more than ten years now, that the 'craft revival' is already
occurring. But the problem which all craftsmen and women face is
that since there is no shared symbolic order, there is also no
meaningful system of ornament which can simultaneously be
expressive of individual creative *and* social values. Much recent
craft has shown a tendency either to repeat as dead mannerisms
stylistic and ornamental conventions of other times and other
cultures; or to lapse into whims, fancies and novelties of extreme
and unrestrained subjectivity. The Crafts Council's intervention
in this situation, hitherto, has been actively detrimental. The
Council has effectively created the category of 'The Artist-Crafts-
Person' – a figure alienated from the productive process
altogether. These Artist Crafts Persons are encouraged to spend
slender public resources for craft work on 'experimental produc-
tions' (e.g. 'embroidery' on wooden play-school frames; 'jewel-
lery', which is not even intended to be worn, made in ugly
synthetic materials; and monstrously distorted 'ceramic sculp-
ture', in place of pottery) which serve no practical or aesthetic
needs whatever. Any serious national policy towards the crafts,
however, will have to concern itself with the encouragement and
replenishment of craft traditions; and the revitalising of wide-
spread workshop production. It will also have to confront the
question of how meaningful systems of ornament and pattern,
which would allow craftsmen and women to produce *convincing*
forms and decoration which went beyond the practically func-
tional, could be stimulated. Such a policy would, in effect, concern
itself with filling the space which the retraction of advertising and
market-oriented 'styling' had left. Provision of such a facilitating
environment is one of the prerequisites of creative freedom in the
crafts. And again, I believe there is a great deal to be said for
William Morris's view that, in a secular, democratic society,

nature itself must provide the roots, and indeed the branches and flowers, of such an ornamental revival.

But I envisage neither that design, in the future, will be confined to practical functionalism within a reformed industry; nor that it will disappear, without residue, into a revived craft production. Indeed, one of its most important contributions may be in the exploration of that 'third area' in which these two overlap – in which aesthetic practice is possible *within appropriate industrial process.*

For if industrialisation is commonly antithetical to the aesthetic dimension, it is no part of my thesis that it is always or necessarily so. As one of the last great English textile designers, Morris was well aware that certain forms of factory organisation, and certain machines (e.g. hand-activated jacquard looms), could actually be used in a way which enhanced the aesthetic dimension of the finished product – and had nothing at all to do with the elevation of a false 'Machine Aesthetic'. Similarly, the late Ken Ponting, the textile historian, has pointed out how some of the great aesthetic achievements of the late nineteenth-century Scottish textile designers (for example Scottish tweed, twist suiting, Crombie overcoating) actually depended on factory-based ideas, and mechanical innovations.

The paradigm of such aesthetic advance through mechanical innovation is, of course, the invention of the potter's wheel. The end products produced by machines, however, cease to be works of art, or craft, when the machine replaces, rather than assists, human creative work; in other words, when it becomes not so much an instrument, as a master: those who tend such machines are not creators, but operatives.

Interestingly, Michael Cardew, perhaps the greatest studio potter in the Leach tradition, acknowledged the necessity of industrial mass-production for institutional and everyday use. But even in such production he saw a certain residual aesthetic dimension, and strongly urged, for example, that artist potters should design prototypes for the mass-manufacturers. Evidently, there is even a space for the discreet introduction of non-mechanically produced ornament into the industrial process; hand-painting of industrially produced pottery, such as that by

Clarice Cliff, can be highly successful aesthetically. Indeed, there are certain industries – textiles, clothing, jewellery, pottery and furnishings among them – where this 'third area' of the life of the aesthetic dimension within advanced industrial production is likely to be a continuing design priority . . .

But in one sense, all this is nothing but idle speculation. For the foreseeable future, we will have to endure the 'realism' of a Frank del Giudice ('We have to design things for clients that can be economically produced at a profit. That's the only reason people hire us.'); or the collaborationist mumbo-jumbo of a *Stile Industria* and an Ettore Sottsass ('Design is . . . a conscious act of clarification, of distension, of decanting the complex tangle of trajectories of actions and reactions of every sort which surround the presence of the instrument'). And the majority of 'professional' designers will no doubt continue to prostitute their skills, without compunction, in the marketplace.

Instead of good, practical, functional design for industry; sound aesthetic workmanship in revived craft production; and intelligent and sensitive exploration of the limited area of overlap between the two, we can continue to expect such travesties as the 'New Ornamentalism'. Like Victorian mechanical ornament, and the Modernist Machine Aesthetic which preceded it, this is no more than another instance of the way in which contemporary industrial capitalism betrays, suppresses or distorts man's aesthetic impulse. But there is nothing to learn from Las Vegas. Drinking Coke, rather than Pepsi, will not bring about peace on earth. Nor can ornamental appurtenances in the form of neon hamburgers, or Disneyland cut-outs, substitute for the lost aesthetic dimension in our time.

1983

The Proper Work of the Potter

In *Pioneering Pottery*, first published in 1969, Michael Cardew argued that 'the proper work' of the potter was making pots — 'pots for everyday use, for food and drink — as many of them as a man can make well by hand-processes'. Cardew commented that it was odd we should have reached a stage where it was necessary to say this. But, today, fourteen years on, judging by the work of the younger 'ceramicists' included in this exhibition, 'Fifty-Five Pots', it would seem to need saying more than ever before.

Indeed, what they are doing might lead you to believe that 'the proper work' of the potter is to do anything with clay *except* to throw it into beautifully formed and decorated pots. So what is going on in contemporary British studio pottery and what are we to make of it?

To answer these questions, we have to go back a bit. It is fit and proper that this exhibition should begin with a work by Bernard Leach. The revival of British handmade pottery began in the 1920s after Leach returned to this country from Japan. He brought with him Shoji Hamada, a Japanese potter, and together they set up a pottery in St Ives, Cornwall. Leach had spent some years studying oriental pottery traditions, especially the *raku* processes associated with Japanese tea ceremonies; he had also learned a great deal about high-temperature stoneware.

For Leach, however, it was never simply a matter of copying Eastern styles or techniques. His approach to Eastern tradition resembled that of William Morris when he tried to revive British hand-knotted carpets. As Michael Cardew, Leach's first and greatest pupil, once put it, 'It was not a question of trying to imitate the forms of Chinese or Korean pots' — Cardew does not mention the Japanese because he was by no means as keen on them as Leach — 'it was a perception about the idea or attitude which lay behind them.'

In the still-living Eastern traditions, Leach believed he had found something which, in the West, had been all but eliminated with the rise of factory production. Leach's love of anonymous, European, pre-industrial, peasant pottery was as great as his reverence for the East; for example, he was responsible .for the revival of traditional English earthenware with slip decoration, a once abundant form of pottery which began to peter out in the late eighteenth century.

Leach was a brilliant thrower. His individual masterpieces must certainly rank among the greatest pots of recent times. But it was central to Leach's philosophy that such pieces needed to rise out of a living tradition of more common-or-garden work. At his pottery, he and others produced relatively cheap handmade stoneware for everyday domestic use. For Leach, the making of these fine ornamental and functional pots had an ethical as well as an aesthetic dimension; good pottery, for Leach, bore witness to 'spiritual' ways of working which had been effectively destroyed by the way in which industrialisation had developed in the West.

At first, Leach's ideas and his pots were ridiculed; but, as his style matured, he became an increasingly effective propagandist for his views. He attracted many very talented pupils, and a multitude of disciples, through *A Potter's Book*. Indeed, Leach inspired and helped to realise a living tradition of studio-pottery in this country, a tradition which enabled many others to make both great pots and fine handmade domestic ware. It is the ethics of this whole tradition which are being so vociferously challenged today.

The roots of this challenge, however, date back a long way. William Staite-Murray was a contemporary of Leach's, who shared his esteem for Japanese work. But, as Professor of Ceramics at the Royal College of Art, Murray went against the Leach tradition by seeking, with dogmatic fervour, to elevate pottery to the status of Fine Art and to cut it off from its craft and artisanal origins. For Murray, and many who followed him in the Royal College tradition, what mattered above all else was the status of the individual pot as a unique and unrepeatable piece of 'High Art'.

But Leach's pre-eminence was more fundamentally threatened

when, in 1939, Lucie Rie emigrated to England from Vienna. Rie's way of making pots had been powerfully inflected by the style and values of the European Modernist movements with their emphasis on anti-ornamentalism, insistence on radical formal innovations, hostility to tradition, and sympathy towards a 'machine aesthetic' rather than an art of high sentiment. At first, Rie was impressed by Leach's ethic and overwhelmed by his consummate skill as a thrower. But she soon reverted to her own path; her works often have idiosyncratic shapes – although they are always thrown. Her speciality became fine textured porcelain, finished with exquisite glazes.

In 1947, Hans Coper joined Rie as an assistant; Coper worked in her studio until 1958, but quickly developed independently as a potter. In his work, the delicately coloured glazes disappeared; his approach was even more 'progressive' than Rie's. Although he retained sympathy towards Eastern and other traditional pots, this was largely formal; some of his pots were thrown, but others were made by collaging together sections from previously thrown pieces. Coper was not interested, as Rie had been, in the pot's use or domestic function. He treated the pot more as a decorative (though *not* decorated) object. Predictably, he taught for many years at the Royal College of Art.

Now it should be said that today, the estimate of Rie and Coper has never stood higher. For example, writing in a recent issue of *Crafts* magazine, Christopher Reid pointed out that the spirit of Rie's pots, like that of the work being done by more advanced architects of her acquaintance, 'could not have been less in keeping with what was proposed by the Leach school of potters'. Nonetheless, Reid claimed, 'she has produced pots that all the practitioners of her craft, however far from her in spirit or achievement, must now acknowledge as paragons of their kind. The best of them are, simply, works of unrivalled beauty, strength, subtlety and eloquence.'

Similarly, when Hans Coper died last year, David Queensberry looked back over his career and wrote, 'Slowly, it dawned on people who were sensitive to pottery that a talent had emerged far greater than Leach, Staite-Murray, or Cardew.' Queensberry went on to describe Coper as 'not only a great potter, but an

important artist of the twentieth century'. 'Hans's work', he wrote, 'could be placed beside the great sculptors of the twentieth century such as Moore, Brancusi and Hepworth, and hold its own.'

Now, of course, Rie and Coper are considerable potters; very considerable. But it is just nonsense to make claims like these for them. Coper himself was always modest, perhaps too modest, about what was possible through pottery, and he would, in any event, have been acutely embarrassed by Queensberry's judgment. I believe, however, that the *positive* qualities (and there are many) Rie and Coper's works possess – technical mastery, a certain sense of traditional continuity – are compatible with the Leach school, and indeed with all good pottery; Rie, in fact, learned far more from her contacts with Leach than many of her commentators are prepared to admit. But the innovations, so vaunted by their protagonists as being of the essence of their achievement, often involved pottery in a considerable loss.

For example, critics have said of Rie that her work is 'vibrantly modern', and belongs 'essentially to the present day'; much has been made of her compatibility not only with the Modernist movement, but also with modern modes of interior decor. Similarly, it has been said of Coper that his pottery 'relates more to the present and to the future than to the past'; he himself used to argue that, unlike a sculpture, a pot was more 'an accumulation of sensations and not an expression of emotion'.

But, for me, the *value* of Rie has little to do with her affiliation with Modernism; indeed, it lies rather in, say, her sensitivity towards natural process and natural form, and her relationship to tradition – all of which is in direct opposition to the reductive tenets of Modernism. And insofar as Rie and Coper were seduced by Modernism, they were *lesser* potters than, say, Leach or Cardew. For there is a sense in which Rie and Coper wanted a craft of 'aesthesis', that is of mere sensation, rather than of true imaginative, symbolic or 'spiritual' work, arising out of genuine use and function.

The great strength of the Leach tradition was that it recognised that in the making of studio pottery, some sort of radical rupture with one-dimensional Modernism, and modes of work, was

essential. The value of hand-made pottery lay in what it preserved, and affirmed; to be a worthwhile pursuit in the modern world, it had constantly to proclaim its essentially *conservative* character. Although Rie and Coper by no means jettisoned everything, I am convinced that they set the reductive and disintegrative process in motion. It is not surprising that when asked whether he admired 'potters like Lucie Rie', Cardew said, 'Yes, very much. Not so much her style of pottery . . . Hans Coper I tried even harder to admire. I have never made any progress, though I like him very, very much as a person.'

Unfortunately, however, a younger generation of students and followers came to believe that what was important about Rie and Coper was their departure from tradition, rather than that which they conserved. This new generation proved eager to jettison far more of that which is essential to the art and craft of pottery.

The new tendency began to become apparent in the late 1950s: it was characterised by a great deal of talk about 'liberating the clay'; by reference to 'ceramic' and 'ceramicists' rather than pots and potters; by a growing contempt for any sort of 'repetitive' or artisanal production; and by a gradual relinquishment of the wheel itself. A great many of those involved in this sort of work in Britain admired the sick and funky junk pottery coming out of the West Coast of America.

One of the most prominent (and incidentally one of the better) of this new generation of potters is Alison Britton, a former pupil of Coper's; Britton has written of the way in which, when she was at the Royal College, she regarded her pots as 'presents' for Coper. In her article on the younger British potters of the last ten years, 'Sèvres with Krazy Kat', Britton stresses that the strength and weakness of the American West Coast potters lay in their freedom from, and ignorance of, a clear line of tradition. By contrast, Britton argues, 'Our line of pot precedents, from peasant to Industrial to Arts-and-Crafts to the Oriental Drift, is unavoidable and unforgettable for most potters, fencing themselves around with taboos and truth to materials.' The 'Krazy Kat' generation, however, proceeded to produce 'ceramic sculptures', and other works, whose sole *raison d'être* seemed to be the violation of tradition and 'taboo'.

There are many examples in this exhibition; works by Glenys Barton, another pupil of Coper's, and Jill Crowley. One of the worst, and regrettably among the most fashionable, must be Carol McNicoll – a 'liberator' of clay. McNicoll clearly believes that she has done something significant when she weaves, pleats or folds clay, working it in unusual ways. Similarly, she is always questioning the conventions of whatever it is that she is making. A recent press release claimed that she once produced ceramics which told the story of their own making, but she has now gone on to 're-work conventional ceramic forms of plates, vases and bowls'. For example, she is making plates which do include flat surfaces 'but these appear, poised as a plane within a structure, or suspended by ceramic cords'.

Such works are not only quite useless and singularly unattractive to look at; they are also uninteresting. They are born of the Late Modernist dogmas that novelty, rejection of tradition and uninhibited 'questioning of the medium' are the essential, indeed the sole, criteria of value. In the Fine Arts, at least, the lesson has been painfully learned that this is simply not so. There are few more wasteful ways of handling clay than seeking to 'liberate' it from those practices and processes which can transform it into objects of use and beauty; similarly, there are few more useless and ugly pots than those which question the conventions of pottery rather than bearing witness to the mastery of them.

Regrettably, however, over the last decade, the Crafts Council of Great Britain has consistently supported such faddish novelties, and indirectly fostered the artificial 'luxury goods' market in them, with its 'Fine Art' prices, through exhibitions and publications.

It is, I think, sad that this process has been spearheaded by Victor Margrie, Director of the Crafts Council, a man who once seemed to know, and, indeed, to be prepared to teach others, what good pottery was about. But here, of course, the Crafts Council is simply mirroring the mistakes of the Arts Council. Elsewhere, I have tried to show why something very similar happened in Crafts Council-sponsored textile design; the parallels with pottery are exact. It is no good Magrie saying that he and his organisation merely follow where craftsmen and women lead. Leach showed

that, if it is lacking in society, one has to have the courage to reforge tradition. If this is not done and Government money is pumped in without the restraints of discriminatory patronage, or a true market based on real needs, then these tiresome Late Modernist excesses are bound to proliferate, and indeed to drive out serious work and corrupt young talent.

Janet Leach, the American widow of Bernard, has been critical of whimsical, indulgent pottery and of the premature exposure of immature, ill-considered work. She has argued that 'earning one's living as a potter' – through the potter's proper work – rather than potting subsidised by bursaries, grants and teaching, is an integral part of the process which leads to maturity, accomplishment and perhaps even greatness. *Crafts* magazine, and the Victoria and Albert shop notwithstanding, I believe the time has come to say clearly that work like Carol McNicoll's is just expensive, pretentious claptrap, and any one who pays the current asking price of £300 to £400 a piece must either have an inordinate amount of money to waste or no taste at all.

Of course, a great deal of good work is currently being done by well-established, and not so well-established, potters who have remained faithful, in the broadest sense, to the older tradition: I am thinking, for example, of David Leach, Richard Batterham, Michael Casson and others. It is also surprising how often one comes across exemplary pots from less than celebrated workshops, often in fashionably disregarded areas – like contemporary studio domestic ware. But I believe the time has come for a radical, critical revaluation of the Leach tradition, and of what it stood for, on the part of those officials whose responsibility it is to foster studio pottery in this country.

I am not, of course, arguing for a return to Bernard Leach's own somewhat fustian ideology (though to this day there are few sounder groundings in the elements of pottery than *A Potter's Book*.) As Cardew demonstrated, with his lifelong cynicism about the Japanese contribution and his celebration of African pots, it is by no means essential to share Leach's particular tastes to grasp what he was truly on about. And what he was on about, I believe, was the *enduring qualities of all good pottery*. To react against the Leach tradition absolutely is thus to reject the possibility of

making good pots: Victor Margrie may, as he has recently written, find no difficulty in equating Alison Britton and Elisabeth Fritsch with Richard Batterham – but this just indicates the jading of his critical imagination since taking up his current post.

For myself, like Leach, I believe in the particularity of the various arts and crafts; the achievement of excellence is only possible through acceptance of the specific traditions and limitations of any given pursuit. Originality, as Donald Winnicott once put it, is only possible on the basis of tradition. In the early twentieth century, in Britain, the tradition of handmade pottery was destroyed by mechanisation and the factory system; Leach needed to sow the seeds from which an indigenous tradition could grow again. To a considerable extent, this is what he succeeded in doing; inevitably, however, he found it difficult to establish a living system of ornament – and it is noticeable how, in the work of even his best followers, like his son, David, the throwing may be superlative, but the Japanese decorative motifs often appear to be little more than brushed-on mannerisms. Even so, those who attempt to uproot the Leach tradition absolutely, rather than to revitalise its ornamental element, to improve and develop it, can have little idea of the gravity of what they are attempting. They are trying to eradicate that which makes good and truly original work possible.

The making of handmade pots matters – and not only because it is one of the most basic of all human activities; the handmade vessel exemplifies the union of man's functional skills and his aesthetic and symbolic intents. Such a union was once characteristic of *all* human work, but in contemporary Western society it has been tragically ruptured, and is expressed only through certain rare and favoured pursuits – like studio pottery.

It has often been pointed out that the well-made pot is always, in some sense, symbolic of the human body or person, which is one reason why touch, and what Cardew once called the 'kindness' of a pot, are so important. Indeed, it is noticeable how often religious imagery evokes the potter when endeavouring to provide metaphors for the supreme creative work of God in making man. 'Hath not the potter power over the clay,' wrote Paul, 'of the same lump to make one vessel unto honour, and another unto dishon-

our.' Flesh is seen metaphorically as 'human clay', just as to the potter himself clay is 'body'.

More secular, and to me more congenial, theories of creativity, too, have originated from the contemplation of pottery. Marion Milner, a psychoanalyst who has written as sensitively as anyone on the nature of human imaginative and creative processes, once described how she came to question the nature of immediately perceived reality when she woke up one morning and saw two jugs on the table. 'Without any mental struggle', she wrote, 'I saw the edges in relation to each other, and how gaily they seemed almost to ripple now that they were freed from this grimly practical business of enclosing an object and keeping it in its place.' This, she said, was surely what painters meant about the *play* of edges.

Interestingly another psychoanalyst, Donald Winnicott, whose wife was a potter, has described how it was through thinking about this experience of Milner's that he began to elaborate his great theory of 'transitional objects', and the potential space as the location of cultural experience. I have analysed this in detail elsewhere; basically, however, Winnicott argued that the infant starts life with the illusion that he has created the breast, and by extension, the outside world, which nourishes and sustains him. As he goes through the disillusioning experience of discovering that this is not so, he seeks, through activities like play, kinds of experience which are neither subjective, nor objective, real, nor imagined . . . but minglings of these things. This, said Winnicott, is the beginnings of human creativity and cultural activity: 'Who *is* the Potter, pray, and who the Pot?'

The pot rises up at once from the hands of its maker. The inertly physical clay is transformed by imagination and skill; the individual expresses himself through transfiguring (without rejecting) both inert stuff and the constraints handed down by tradition and function. For the pot, if it is any good, transcends the materials of which it is made, while remaining true to them; the product of imagination, it can yet serve the most practical needs of containing, or storing; highly personal in its conception, and execution, it simultaneously enters immediately into tradition and social life.

Clay, of course, can legitimately be handled in many ways;

modelling, after all, is one of the twin poles of sculptural activity. But, as Leach has pointed out, there is nothing quite like throwing in any other craft. Throwing is close to the heart of any living pottery tradition; it bears witness, as it were, to the best and the finest that can be done in this craft with clay. Coiled or pinched pots may occasionally divert us, but they seem essentially regressive, anal even, whereas piece pots partake of that collaging of given segments, so typical of contemporary modes of production, and so inimical to full imaginative transformation.

The thrown pot, today, has an additional significance too: at its best it demonstrates how, under certain circumstances, a machine, as Michael Cardew once put it, can serve as an *instrument* in the musical sense: it can actually draw out, rather than inhibit and destroy, human creative and aesthetic potential. There is, as it were, an intermediate position in creative life between 'natural' activities, and soul-destroying subjection to the mechanical, a position from which true human excellence is most readily achieved. And this may be the most important meaning the good handmade pot has for us today.

There are other issues, important issues, about contemporary pottery which I hope to deal with elsewhere. The most significant of these concerns the fact that in whatever foreseeable future, much institutional and everyday pottery is going to be cast and mass-produced. What is the relationship, or potential relationship, of the studio-pottery movement to this dominant industrial production? I differ from Leach, the father, though not the son, in believing that the studio potter must try to comprehend his relationship to industry. (Bernard, apparently, once became angry with David for even visiting Stafford.) Personally I favour a two-tier economy. Ideally, one strand of this would involve the mass-production of simple, well-made, but essentially functional ware for everyday and institutional use. As a *secondary activity*, studio potters might design for industry, and even explore the possibilities of the introduction of a certain element of living yet restrained decoration (rather than mere mechanical reproduction) into the industrial process. After all, Clarice Cliff has done far more for the quality of everyday life, this century, than McNicoll or her colleagues ever will. The other strand, in this

two-tier economy of the future, would involve a rehabilitation of handmade studio pottery in a more central role in the economy: it would, I think, be characterised by a renaissance in quality domestic ware, and hence, by extension, of fine decorative pottery.

I do not believe, however, that those fine decorative pots can ever be made by those who do not seek to retain their craft roots in the creation of everyday objects for home use. 'Have nothing in your houses', William Morris once wrote, 'which you do not know to be useful, or believe to be beautiful.' The Leach tradition of potters set out to meet both these criteria simultaneously. Leach believed the humblest piece of domestic ware should be a good-looking object; and the finest pot was born, in part, from the health of that tradition which produced good domestic ware. The beautiful decorated pot thus stands as an indictment of our culture by revealing how, in *aesthetically healthy situations*, art is no more than a dimension of everyday work, and fine art, as it were, an intensification of that dimension.

Michael Cardew once complained that many commentators – including several who should have known better – were always presenting potters with what he rightly called a 'dreary dilemma': '*Either* devote your energies to designing prototypes for mass-production, *or* be content to make ceramic objects which cannot and never will be used.' I, too, would argue that if it is ever going to become possible, again, to refer to 'England, where indeed they are most potent in potting,' then this 'dreary dilemma' must simply be refused. And, tragically, the present policy of the Crafts Council – with its pseudo cult of the Fine Artist Craft Person Ceramicist, denigration of domestic ware, and celebration of these fatuous objects and deskilled practitioners – is doing nothing to help. Unfortunately, however, there seems little hope of the Leachian ideals being born again in Waterloo Place. By next year, McNicoll will probably be approaching four figures a piece. What then is to be done?

> For in the Market-place, one Dusk of Day,
> I watch'd the Potter thumping his wet clay:
> And with its all obliterated Tongue
> It murmur'd – 'Gently, Brother, gently, Pray!'

1983

31
Carpet Magic

One of the revelations of that marvellous exhibition. 'The Eastern Carpet in the Western World', was the Medici Mamluk carpet. This was rediscovered just a few months ago in the store room of the Pitti Palace where, apparently, it had been kept since it was delivered to the Grand Duke Cosimo I de Medici some time between 1557 and 1571.

Preserved in almost perfect condition, the Medici Mamluk is one of the largest known oriental carpets; it is also among the very finest of its kind. I rate it as one of the most stunning and beautiful human artefacts on which I have ever set eyes. However, I find it almost impossible adequately to describe the effect this mid-sixteenth-century carpet has upon me.

Only three colours were used in the working of the wool; the patterns are in blue and green, and they float upon a vibrant red ground. The design involves three great octagonal medallions, each of which organises a square field in which a myriad of decorative geometric devices shimmer. It has been suggested that these complex patterns may have been inspired by Buddhist diagrams and concepts alluding to the infinity of the cosmos.

Nonetheless, we do not have to be able to 'read' the patterns for the carpet to work its magic upon us. Anyone who simply looks receptively will derive the most intensely sensuous visual stimulation from it; but it will be stimulation of a kind which merges into symbolic suggestion, illusion and allusion. For the Medici Mamluk plays upon psychologically symbolic sensations of 'surface' versus depth illusions, of the perception of a skin, as against indulgence in pleasurable engulfment; and it also uses its visual effects in ways which seem to refer, 'non-discursively', to the shifting panorama of the heavens.

The Medici Mamluk is, I believe, a work comparable in stature to a great Gothic cathedral, or a major Renaissance painting, like

Michelangelo's 'Last Judgment'. It is abstract art at its finest, its greatest. And it makes those who denigrate abstraction and ornament, as such, seem merely foolish. To gainsay the beauty of this carpet is merely to reveal the philistinism and occlusion of our own taste. And yet the very sense of exultation we derive from it is inevitably accompanied by a feeling of our own impoverishment. We know, even as we look, that our own culture is not capable of producing anything even remotely comparable. Nor, of course, is it simply a question of carpets. Nowhere in our society can ornamental work of anything resembling this quality be found. Ornamental art of all kinds has been consistently debased and trivialised in our culture. Only occasionally, in the work of a great abstract painter, like Mark Rothko or Robert Natkin, do we gain a hint of what 'High Decoration' was once like. Whatever our society may, or may not, have gained through its technological, political and social advances, when we are confronted with craftsmanship as superlative as this we are compelled to admit what it is that we have *lost*.

And 'Carpets in Paintings', an intriguing exhibition at the National Gallery, went a long way towards making that loss comprehensible to me. That, it should be said, was not its intention. Since around 1300, artists have shown carpets in their paintings, and have thereby provided an invaluable visual record for the carpet historian – one which assists with identification and dating. This tight, scholarly little show was intended to demonstrate this process with examples drawn from the National Gallery's own collection. But, for me, its fascination arose from rather different considerations.

I have long tried to show how the break-up of a society's shared symbolic order, and changes in the nature of human work, tend to undermine the life of the 'aesthetic dimension' in a given culture, to destroy the ornamental tradition, and to cause it to retract into an illusory world behind the picture surface. I have always suspected that this is precisely what happened, on a grand scale, in European history: in the decline of the decorative arts, and sudden emergence of pictorial practice, which characterised the Renaissance.

And here, in these 'Carpets in Paintings', we can see this process

actually taking place. Admittedly, in this instance, the illusorily preserved craft is itself an import, an interloper into the culture: an Eastern artefact in a western world. (Though as pictures like Crivelli's demonstrate, the indigenous Gothic crafts were similarly pictorially incorporated alongside the imported Islamic varieties.) If the West could no longer give rise to craftsmanship comparable to that which had been realised in the Orient, it could, at least, generate incomparable *illusory* worlds, involving such work.

But an illusory ornamental tradition cannot long survive unless it is fed and nurtured by a living, or at very least, a vitally healthy imported tradition. The decline of even the pictorial crafts in the West was inevitable. And, in the present attempts to replenish our craft practices, we must *not* (as so often happens in contemporary textile design) seek to emulate the status or practice of the painter, but rather return to the very roots of the craft, in such supreme non-pictorial achievements as the Medici Mamluk.

Where does its greatness lie? Firstly, I think, in its conception. The Medici Mamluk must surely have been designed by one man, but a man who used his talents to draw strongly upon the informing symbolic order of his hieratic society, and to imbue his patterns with intimations of its beliefs, pleasures and values. Secondly, I think, in its workmanship. In the achievement of superlative aesthetic effect in carpet manufacture, there can be no evasion of the time- and labour-consuming business of close hand-knotting. This was carried out by workmen who were not, of course, involved in the conception. Whatever their place in the social hierarchy, however, their work was meaningful to them precisely because the pattern to which they were working sprang out of a shared symbolic order, and was not solely individualistically determined by one individual.

In Britain in recent years, policies intended to restimulate craft activity have conspicuously failed to give rise to work of true stature. I hope the exhibition of these illustrious carpets in London will provoke some rethinking of those policies. I hope, for example, it will lead the Crafts Council to see that it is worse than useless to look to craftspeople themselves for direction as to the way forward the crafts should take. The Council itself must accept

the challenge of patronage, and begin to compensate for the absence of a shared symbolic order permeating our society.

How can it do that? 'I, as a Western man and picture lover,' wrote William Morris, 'must still insist on plenty of meaning in your patterns.' Looking at the great Eastern carpets, he claimed, and fields and strange trees, boughs and tendrils or I can't do with your patterns.' Looking at the great Eastern carpets, he claimed. 'In their way they meant to tell us how the flowers grew in the gardens of Damascus, or how the tulips shone among the grass in the mid-Persian valley, and how their eyes delighted in it all and what joy they had in life.' It is only if pattern is so replenished in nature that its highest abstract achievements (such as those manifest in the Medici Mamluk) will become available again: and, if it so chose, the Council could do much to encourage that replenishment, and to discourage those tendencies which threaten it.

But the stimulation of socially comprehensible patterns is not, in and of itself, enough: the Council needs to abandon the fiction of the 'artist craftsman' altogether, and to turn its attentions to the re-establishment of widespread, small-unit, workshop production – in which the satisfaction of many producers will derive from their participation in collective work, rather than solely from individual expression. In short, the lesson of the Eastern carpet in the Western world is that unless someone takes up the challenge of creative patronage, we will *never* do better than Roger Oates.

1983

William Morris's Textiles

Interest in William Morris as a textile designer can never have been greater. Two years ago, Birmingham Museums and Art Gallery mounted a major exhibition of Morris textiles, 'Strange Blossoms and Bright Birds', accompanied by Oliver Fairclough's and Emmeline Leary's book, *Textiles by William Morris and Morris and Co., 1861–1940*. Now we have this comprehensive work, *William Morris Textiles*, by Linda Parry of the Victoria and Albert Museum (Weidenfeld and Nicolson).

Parry's is probably the most authoritative study of the subject to date. Separate sections of her book deal with the work of Morris and his close associates in embroidery, printed textiles, woven textiles, carpets and tapestries. A concluding chapter sets Morris's textile work in the context of interior design and the nineteenth-century retail trade. Parry expresses the hope that her book will 'bury a number of previous misconceptions about fabric manufacture once and for all' and that 'it will also stimulate new theories which may become the controversies of the future.' Certainly, I believe she has opened the door for a radical new assessment of Morris's achievement in textiles – one which is of great relevance to the debates which are currently raging in *Crafts* journal and elsewhere. But, before I can elucidate, we must take one step backwards into earlier studies of Morris's textile work.

Perhaps the most significant were Peter Floud's pioneering articles (e.g. 'Dating Morris Patterns', *Architectural Review*, CXXVI, 1959, pp. 14–20) which went a long way towards sorting out the previously confused chronology of Morris's pattern designs. Floud, a predecessor of Parry's at the Victoria and Albert Museum, also established the extent to which Morris had drawn upon tradition and related specific Morris designs to particular acquisitions made by the South Kensington Museum (later the V. & A).

Floud effectively demolished the once fashionable view that Morris was, to use Nikolaus Pevsner's phrase, 'a pioneer of modern design'. Rather, Morris emerged from his revaluation as a traditionalist. Morris was deeply influenced by patterns of the past; he sought to temper modern manufacture with ancient techniques; and he believed that the designer should learn through the study of natural form. If anything, he was reacting conservatively against the innovators in Victorian design, who were veering towards abstraction, abandoning tradition and nature alike, and looking towards the machine, and mechanical processes, for their models.

We will never know Floud's final thoughts on Morris's textiles. He was working on a book about them at the time of his premature death. But, as Parry points out, Floud certainly believed Morris was wasting his talents by immersing himself in the past. Parry, however, disagrees; and here I am in agreement with her.

For if Morris was no proto-avantgardist, nor was he in the least typical of those who designed for the English, Victorian commercial manufacturers; and his 'third position' is, I believe, of continuing potential importance today. Parry says that nineteenth-century commercial designers frequently copied historic patterns from books like *The Grammar of Ornament*; but Morris selected details from those patterns he most admired (usually technical repeats) and made use of them in original designs. Similarly, Parry argues that in their work with knotted carpets, he, and his associate J. H. Dearle, by no means simply copied oriental designs. Rather, they sought to emulate the symbolic traditions which lay behind them. Their carpets were, as Parry puts it, 'original in design' and often surpassed many earlier British examples.

Morris would have agreed wholeheartedly with Winnicott's dictum that 'There can be no originality except on the basis of tradition.' Morris's radicalism in aesthetics (a word he hated), though not of course in politics, lay in his conservatism, or at least his conservationism. He knew that the creative worker needed tradition in order to be original. And yet, as he himself recognised, the cultural and industrial conditions of nineteenth-century England were conspiring to destroy tradition.

Morris set about singlehandedly to preserve and where neces-
sary to recuperate it. This was not *primarily* (and this is impor-
tant) a matter of opposition to industrialisation *per se*. It is more
accurate to see Morris as seeking to *preserve* an 'aesthetic dimen-
sion' of human work. Hence his preoccupation with the revival of
traditional skills of pattern-making, which had almost dis-
appeared in England; and also his emphasis upon an aesthetic
sense of all the materials (from dyes to fibres) used in the produc-
tive process. Morris was a designer of the whole cloth, not just of
its surface.

Interestingly, an important sub-theme of Parry's book concerns
the contribution to the rejuvenated Morrisian tradition of work-
ers other than Morris himself; for example of May Morris, his
daughter; of Catherine Holiday, the finest embroideress associ-
ated with the firm; and of J. H. Dearle, who rose from being an
apprentice at Merton Abbey to becoming art director of Morris
and Co. Dearle, at his best, could be as good a pattern designer as
Morris. As Parry points out, we now know that Dearle was the
creator of the magnificent 'Compton' pattern, for many years held
by most commentators to be Morris's last and finest design. But
Parry's rehabilitation of Dearle, and others, in no way diminishes
Morris's achievement. Rather, it seems to vindicate his intuitive
understanding that a living tradition was an essential element in
the provision of a 'facilitating environment', enabling men and
women to experience a 'joy in labour' which, in turn, was
materially expressed through the quality of the work they pro-
duced.

Morris was only opposed to industrialisation insofar as it
threatened tradition. He had no objection to the introduction of
machines which did not destroy this 'aesthetic dimension' of
production; but, in the case of textiles, the line was often very hard
to draw.

For example, Parry explains that in his work with woven
textiles, Morris wished to set up sophisticated, fully automatic
jacquard looms. However, hand-activated jacquard looms were
forced on him by economic stringencies. Morris then came to
realise that the hand-activated system gave the weaver a greater
control of the process and resulted in far less mechanical-looking

(and feeling) fabrics. The firm understandably boasted in its literature about its 'hand-woven' textiles; but, as Parry adds, these were, of course, a far cry from the fabrics associated with the term today.

One great weakness of Parry's book (like so many Morrisian studies) is that, her concluding chapter notwithstanding, she fails to situate Morris's work in the wider context of textile design and manufacture in the last quarter of the nineteenth century. (It was through such comparative study, of course, that Floud was able to reveal the *conservative* way in which Morris diverged from the avant-garde textile designers of his day.) But if we compare Morris's contribution with, say, the Scottish contribution to wool textile design between 1870 and 1914, we can, I think make much greater sense of what he was attempting.

For the truth is that while English textile design (with the exception of the Morrisian enclave) was falling victim to the twin curses of incipient Modernism and degrading commercialism, Scottish textile design was thriving; mechanisation, as such, initially did very little harm to it.

There were many reasons why this should be so. They certainly include the persistence of living and meaningful patterning (e.g. in the Scottish tartans); but, even more significantly, they involve the continual emphasis on *design of the whole cloth*, that is a sense of design which includes the choice of fibre, the particular use of raw materials, and intimate understanding of the productive processes (industrial or manual) and their limitations or capabilities. Ken Ponting, the textile historian, points out that this attitude to design actually meant that industrialisation could, in certain circumstances, lead to 'aesthetic' advances. But there was no exclusive pursuit of mechanisation, *per se*; other tweeds, such as the Harris and Shetland, were, of course, purely craft concepts.

The 'moral', for the purposes of my argument, is that a strong, textile tradition (with living patterns and a continuing emphasis on the aesthetic properties of materials) could survive at least certain aspects of industrialisation. Ponting himself is well aware of the importance of this sense of tradition for the Scottish contribution. He writes that good designing was often done in the mills themselves by the Scottish pattern weavers, who were 'the

last important group of hand loom weavers in the wool textile trade'.

These designing departments, with their skilled designers, old experienced pattern weavers and young apprentices, constituted 'the key centres for the development of this great school of Scottish designing'. Ponting comments, 'There was a certain similarity between these workshops and those of Renaissance Italy where the great traditions of that major field of art taught newcomers.'

'There was', Ponting comments, 'no need for a Scottish William Morris to sweep away all the so-called bad habits in design that are said to have come to England with the industrial revolution.' But the point, surely, is unfair to Morris, who in practice, if not in theory, was trying to establish in England something similar to the Scottish experience.

But in England the tradition of textile design was already weak, even before it encountered the transforming force of industrialisation. For example, in England there was no living tradition of pattern, equivalent to the Scottish tartans. 'Child labour' took the place of creative apprenticeship. Little of the 'aesthetic dimension' survived the industrialisation of the productive process; and when extinguished from the work of those who designed and made the cloths, it tended to disappear from the finished products too.

Morris turned to the textiles of the past, and to nature, because he wanted to restore this fractured tradition – rather than from some primary hostility to industrialisation. Nonetheless, as Ponting's own study implies, *beyond a certain point* industrialisation was antithetical to the production of textiles of true aesthetic quality. Morris, as we saw, was compelled to admit a qualitative distinction between the work produced on a hand-loom, as opposed to an automatic one. Similarly, with the disappearance of the hand-loom weavers, the Scottish tradition of textile design began, if not to die, then at least to ossify. Commercial production and the aesthetic dimension no longer seemed compatible.

The overriding importance of Morris's textile work, then, lies first and foremost in his insistence on the sustaining power of tradition – and the need, when tradition has been broken, to remake it for oneself (and those around one). That, after all, is

what Bernard Leach found it necessary to do in pottery. Certainly, Morris was highly critical of much commercial, industrial textile manufacture; but *with good reason*. English textile design, by the 1870s, was in a dreadful state. Nonetheless, we can also assume that Morris would have been bitterly critical of the silly fads and fancies which pass for 'fine art weaving' today. Indeed, very little support for the studio weaving tradition can be found in anything he ever said, wrote or did.

Morris stood for replenishment of pattern (through imaginative study of nature and tradition) and for a qualitative response to all the materials and processes of production; but he did not see these things as being incompatible (at least in certain branches of textile production) with a degree of industrialisation. I believe that, today, the revival of such a 'third route', in contrast both to fully automated commercial production and fine art weaving alike, holds out the most promise for the future; although it may well be that the cloths which were actually produced would differ as radically from Morris's as do traditional tartans.

1983

33
Fabric and Form

This exhibition made me very angry indeed. Most of the works exhibited were appalling. I am thinking especially of Stephanie Berman's dyed and sewn cotton duck hangings in insipid colours and slovenly shapes. (She appears to have been trained as a painter. Did no one teach her elementary composition? Probably not, since she attended St Martin's in the early 1960s.) Of Michael Brennand-Wood's play-school wooden meshes, splattered with paint, and threaded with silk fragments, cotton, and wire; of Danielle Keunen's arbitrary marks in paint and thread on transparent organdie; of Di Livey's corrugated bulge with tabs attached in mounted canvas and murky paint; of Michael Moon's *Insulating Jacket*; of – surely not again – Richard Smith's bland and banal kite . . .

None of these works is worth seeing, let alone shipping to Australia where, I understand, 'Fabric and Form' is shortly to tour. Nor, contrary to the claims made by Julian Andrews of the British Council's Fine Arts Department, do they have anything to do with what 'young artists' in the 'traditional field' of 'fibre and textile crafts' are currently doing. Rather they bear witness to the decadence of Council-subsidised fashions – which have already played havoc with our national painting and sculpture, and now seem destined to wreck creative work in textiles too.

Of course, there are exceptions and redeeming moments in the exhibition; and they illuminate what is wrong with the rest of it. I am thinking, particularly, of Barbara Brown and Mary Restieaux. Brown, a former buyer and designer for Heal's fabrics, is a machine-knitter who makes attractive shawls and scarves which show an understanding of her chosen material, a good colour sense, and an intelligent approach to the problems of improvisation within geometric abstract patterns. Restieaux has mastered 'ikat' techniques to produce delicately coloured silk hangings

made with extraordinary skill, sensitivity and imagination. It is surprising to me that these two exemplary craftswomen were prepared to show in such shoddy company. Otherwise, Tadek Beutlich ('young artists'?) needs no introduction; and there is something, though not, it must be admitted, a great deal, to be said for Diana Harrison's splatter-dyed satins; Ingunn Skogholt's attempts to paint with tapestry weave; and Katherine Virgil's silk and wax muddles.

But why, granted these exceptions, is the level so low that it effectively fails to register? Well, the simplest answer is that Michael Brennand-Wood selected it and, fashionable as he may be, he has clearly neither skill (judging by his own work), nor taste (judging by that of others he chose); nor, it would seem, much intelligence either (judging by the remarkably silly introduction he contributed to the catalogue).

Brennand-Wood lectures at Goldsmith's College: one can only hope that his influence over his students is not great. He maintains that the study of painting and sculpture (by which he appears to mean the study of some of the silliest Late Modernist reductions of the period 1958 to 1975) has changed 'the terms of reference within which contemporary textiles are produced'. He claims 'the past constraints of use, durability and application have begun to break down', and he prophesies that this will lead to a different form of textiles which is no longer dependent upon a study of technique, 'but is free to involve and embrace any media or discipline necessary to further the concept.' Thus he welcomes the wildest excesses of mixed media, and declares himself anxious 'to dispel the myth that some work, because of its style or use of materials, is somehow more creatively valid'. Thus, one must suppose, for Brennand-Wood a mailbag is as 'creatively valid' as a Gobelin tapestry, and, granted the presence of Moon's un-bleached calico *Insulating Jacket*, beside Restieaux's subtle silks in 'Fabric and Form', this seems to be the premise on which his exhibition was selected.

But it isn't just that Brennand-Wood believes there are no specifically textile practices; there aren't even any definable textile people either. The 'best textiles' (e.g. presumably, *Insulating Jacket*, etc.) are no longer necessarily being made by those with

special skills or knowledge about textile production. In the 1960s, it was the received wisdom of the Arts Council, and the bureaucratic philistines in the modern art museums, that painting and sculpture 'could be anything'. Now, it seems, under the lavish auspices of the British and Crafts Councils, textiles are to go the same way. Or, as Brennand-Wood puts it, 'Textiles will never again be a definable area; in the same way, distinctions between painting and sculpture have become pointless.'

If that is what Brennand-Wood believes he might at least have the good grace to withdraw from the exhibiting and educational institutions concerned with textiles, and to leave the 'field' to those who take a different view. It is absurd that institutions concerned with the continuing health of a creative tradition in textiles should foster practitioners who are unable even to acknowledge that textiles exist at all. If something is not done, those of us who have been involved in the Fine Arts *know* what will happen next. Within a few months, we can confidently expect Minimal Textiles; exhibitions of mounds of raw wool and silkworms; Conceptual Textiles, consisting of photographs and documentation of the way the warp would have interacted with the weft if any weaving were to take place, which of course it won't; and Video Textiles, i.e. wall-hangings made from intermeshed lengths of videotape which, if they could be viewed, would reveal images of an erstwhile weaver picking his nose because he now has nothing better to do – or at least nothing that would be likely to qualify him for the Crafts Council awards to which he has grown accustomed.

I would suggest, in all seriousness, that the rot be stopped here and now. This exhibition should be recalled and dismantled, and those involved, from the patronising agencies, through the organiser, down to the practitioners should start to *think* about just what it is they are trying to do. Because the truth is that the recent history of painting and sculpture have much to teach contemporary textile people; but what it has to teach them is very different from what Brennand-Wood supposes.

As we all know, the officially sponsored salon avant-garde in painting and sculpture of the last quarter century has hurled itself into a headlong 'questioning of the media', which has involved the

suppression of the imaginative faculties: the erosion of basic skills and knowledges; a confusion of the parameters of the arts and their particular expressive possibilities; a denigration of aesthetic judgment; a ruthless determination to dissolve painting and sculpture into *anything* that is neither painting, nor sculpture; an indifference to tradition, material quality or realised value; and a mindlessly destructive elevation of 'innovation' as the sole criterion of worth.

As for *why* all this happened: well, books have been written on this subject – among them, some of my own. But one major factor was the lack of any continuing social need for what the painter or sculptor did – a reflection not on painting and sculpture, but rather on our anaesthetic culture. Tragically, the institutions of art colluded with its destruction: the museums purchased as if only reductive 'innovations' were worth considering; the Arts Council doled out bursaries to the philistines within; and Sir William Coldstream, to his eternal shame, gave his name to a report on art education which argued that its purpose was no longer the pursuit of painting or sculpture, or indeed any particular art, but rather of an attitude of mind which could express itself in almost any way. (Try telling that to a student involved in any other art or craft, to a young ballet dancer, or clarinet player, or, until the likes of Brennand-Wood came on the scene, to an embroiderer).

This then has been the official, anti-aesthetic dogma for many years. There is nothing 'radical' or 'progressive' about it; it is a received wisdom which has failed. And all Brennand-Wood is doing is (with official backing, of course) applying it to a 'field' in which it has not hitherto been applied. Fortunately, however, in the 'fields' of painting and sculpture there is now a widespread and ever-growing revulsion against what has been going on this last quarter of a century. In the art schools, this revulsion is coming from staff and students alike. There is now growing recognition that achievement in any art (or craft) requires, as a *sine qua non*, acquisition of basic skills, and of real knowledges. Of course such things are not enough in themselves. Imagination and originality are certainly essential (though less so in the crafts than in the High Arts). If Brennand-Wood and his friends have

their way, the traditions of creative work in textiles will be in danger of being eroded, if not destroyed, by those whose duty it is to protect them: the Crafts Council, the British Council, and the various educational courses offering instruction in textile work.

Indeed, I believe it is the *duty* of the Crafts Council, and the other patronising agencies, to keep the traditions and skills of textile production alive; to patronise those who confine their innovations within the legitimate boundaries of those traditions; and to offer support, and encouragement, to craftsmen and women who are involved with the 'stock categories of weaving, tapestry, embroidery, knitting and so on', which Julian Andrews of the British Council's Fine Arts Department, sees fit to sneer at in his preface to the 'Fabric and Form' catalogue. To those who think otherwise, I would say this: go to the Victoria and Albert Museum, and look at the historic textile collections. Revisit 'Fabric and Form', and look again at such rubbish as Di Livey's *Hyde Park Corner, 1981*, and ask yourselves, has something not gone wrong? Are Brennand-Wood's policies and practices likely to make things better, or worse?

1983

34
Dressing Down: Fashion History

I have never known what I should wear, nor, come to that, how or when I should wear it, nor what I should wear with it. If it is true that '*le style est l'homme même*', then I am as yet unmade. I have just not been able to understand why it matters, nor in what way it matters, if, say, I wear flared trousers in 1984. But clearly it does matter, if only because other people are always telling me so.

In public, I tend to wear a pin-striped suit ('Made in Finland') with a pink shirt and a bold tie. Once, George Melly – who, despite a taste for the most chequered sartorial kitsch, manages to hold his own as an inveterately fashionable stylist – humiliated me at a *New Society* contributors' Christmas Party by homing in on the tie, with its striking, pseudo-William Morris design. He insisted that, as I did not know where it had come from, I should show him, and everyone else who was watching, the label. To my embarrassment, and their amusement, it turned out to be Austin Reed.

As a conspicuously inelegant art critic who is easily drawn on the subject of 'aestheticism', I attract a great deal of gratuitous advice about how I should appear. A fellow art critic once prescribed the 'Preppy' look. Alas, she never got me to the right shops before it was all over. (The style, I mean.) After I appeared on a platform with Marta Rogoyska, a distinguished tapestry-maker, she recommended a bevy of knitters, stitchers and weavers, floppy, brightly coloured bow-ties, and a close-cut hairstyle, befitting, or so she said, a prophet of the Craft Revival. The next time I saw her, she complained I was still wearing *that* suit. Indeed, I was.

As someone brought up in the Puritanism of English Non-Conformity, and confirmed in the Puritanism of the old New Left, I readily admit that fashion still confuses me, even though I presume it offers easy answers for some. But recently, fashion has

also come to intrigue me, because it poses the central questions about the nature of human aesthetic activity, the subject which concerns me most. And so, when the Dress Collection at the Victoria and Albert Museum went on display again last summer, five years after it was shut down for the roof to be rebuilt, I hurried over to South Kensington in the hope of enlightenment.

I soon discovered, however, that more had changed than superstructure. The clothes themselves have been beautifully restored to apparently pristine states by Mrs Sheila Landi and her team of textile conservators. But the old, theatrical tableaux which I dimly remembered, with all their incidental appurtenances and period touches, have gone.

I must admit to having had a sense of disappointment. I enjoyed those gloomy aquaria filled with the strange stuffed fish of fashion. In *Sartor Resartus*, Carlyle tells us of a luckless Elizabethan courtier, 'who having seated himself on a chair with some projecting nail on it, and therefrom rising, to pay his *devoir* on the entrance of Majesty, instantaneously emitted several pecks of dry wheat-dust: and stood there diminished to a spindle, his galoons and slashes dangling sorrowful and flabby round him.' The Dress Collection, as it was, had something of that comic feel. Now it is very brash and 'scientific' all at once: like a drug manufacturer's display material. And the emphasis has all been thrown, somewhat starkly, onto fabric, cut and style.

It should be said that the V. & A.'s Dress Collection has never tried to be comprehensive. It covers a period from the late sixteenth century to the present day, with an overwhelming emphasis on British fashion. Moreover, as Roy Strong, the Museum's Director, admits, the display is 'unashamedly elitist', in the sense that it chronicles only the costumes and *toilette* of the rich and privileged.

Pièces de résistance of the collection include a sumptuous suit in Italian plum-coloured velvet which is traditionally believed to have been worn by James I, but more probably graced the limbs of Lord Willoughby de Eresby, on the occasion of his King's Coronation; a dressing-gown and other fine items from the wardrobe of Thomas Coutts, an eighteenth-century banker, which was donated to the Museum in 1908, but, sadly, largely dispersed subse-

quently; and a galaxy of gowns worn by *glitterati* of the social scene in the thirties, forties and fifties, gathered together by, but of course, the late Sir Cecil Beaton.

As Strong puts it, 'in the pre-couture era' the collection is concerned only with the dress of the aristocracy and gentry, and, in the 'post-couture era', it is essentially a collection of designers' work, embellished with examples of the dress of those who, in their time, were regarded as 'stylish and fashionable'. The V. & A. collection inevitably ignores many specialised types of dress, e.g. ecclesiastical, military, naval, ceremonial robes, work clothes and children's clothes (except insofar as these can be used to illustrate, in miniature, developments in the history of adult dress).

In fact, this policy is less limiting than might be assumed. As Natalie Rothstein explains in *Four Hundred Years of Fashionable Dress*, a book which accompanies the revamped collection, England is possibly unique in Western Europe in having no regional or 'peasant' costume since the early sixteenth century. Since that time, the rich have worn fashionable dress, and the poor have worn 'second-hand clothes or rags'. But even these have followed the styles of the fashionable with remarkable fidelity. 'When a rare fragmentary garment is found which is undoubtedly from a poor household,' Rothstein writes, 'if enough survives, it can be almost instantly dated by its cut.' And so the V. & A. can, and does, legitimately claim to be collecting those styles and examples which have set, rather than followed, 'The Fashion'.

Now this new display, and its accompanying book, are indicative of what the Museum describes as 'a new seriousness of approach' to the history of fashion, which has only recently tried to shed its fanciful frills and fripperies, and to step out before the world in the sober grey serge of a fully-fledged academic discipline. Indeed, it is only in the last twenty years that we have begun to see the same sort of 'scholarly' analysis of clothes that has long been the vogue in the majority of branches of the decorative arts; the Department of Textiles *and Dress* at the V. & A. was not so renamed until 1979. And, after all, what could be more absurd than a collection of fashionable dress left 'to hang/Quite out of fashion, like a rusty mail/In monumental mockery.'

This new way of doing things will undoubtedly make it harder

to maintain the flagging spirits of footsore six-year-olds on week-
end visits. But, since they've reshuffled the Natural History
Collection across the road, I suppose nothing is sacred. Certainly,
all this detailed attention to materials, cut and style has already led
to an ever more convincingly accurate account of the historical
record, of what changes occurred, where, when and among
whom. This is a task of scholarly description for the well-doing of
which all of us who are preoccupied with the vagaries of taste will
be truly thankful. And yet I can only hope that no one will
presume that this is all there is to be said about the history of
fashion. To allude, once more, to across the road: Darwin had to
scrutinise the material evidence of variation provided for him by
the species on the Galapagos Islands; he had, similarly, to attend
to the minutiae of the fossil record. But it was not through the
mere accretion of such specimens and knowledge, but rather
through an imaginative response to them, that he breathed sense,
life and meaning into the evidence and arrived at his Natural
History, a theory of evolution through natural selection against a
background of struggle for survival. All good history is written
like that; even fashion history.

Let me give two small examples to illustrate what I am driving
at. Thanks to the new methods of fashion research, we now know
a good deal about the growth of the ruffle around the necks of
certain men and women in the later sixteenth century. Sound
scholarship, and the study of pictorial and literary sources like
Stubbs's *The Anatomie of Abuses*, can reveal how these great
starched wheels began to expand until they became what has been
described as 'vast cartwheels of starched and laced lawn propped
up with a support at the back of the neck called a supertasse'. We
can even establish something about who wore these creations in
their most extreme forms, who declined to wear them, and when
they started to disappear.

Similarly, we can now chronicle with considerable accuracy the
way in which in the nineteenth century the bustle popped up be-
hind to replace the disappearing crinoline, and how it went through
two distinct phases in the 1870s and 1880s: in the first of these it
was a hooped structure, leading to a graceful floating movement;
in the second, it was structureless and exaggerated, twisting

bosom, waist and bottom into an unnatural, constricted, and tilted 'S'.

Now all this is very interesting, but it leaves so many questions unanswered. For such research tells us nothing about why ruffles emerged in Elizabethan times, or why bustles burst out in late-nineteenth-century England. We want to know not just *that* such modes appeared, but what caused them to do so; we want, as it were, some explanation of the laws (if any) of *movement* of fashion. Similarly, even the most 'academic' of the fashion historians does not eschew an evaluative element entirely; we may, for example, be told that the largest ruffles or bustles became 'monstrous'. But what is this underlying constant which overrides the volatility of fashion, and enables us to make such judgments, regardless of when or where the object about which we are making them was made? The fashion historians may well be right to assume such judgments are possible, but they never spell out what they believe to be the basis on which they are made.

As soon as we begin to ask about such matters, however, we realise why historians are sticking so rigorously to fabric, cut and style. The sorts of theory available to explain the movement of fashion are legion: thus it can be interpreted as a reflection of social manners, or, in more sophisticated variants, as shifts in assumed 'signifying practices' and underlying semiotic systems; through changing emphases in the psychology and symbolism of the body; through an assumed immanent logic within the fashion tradition itself – what goes up must come down, what gets bigger will eventually shrink, and so on; through 'influence' from other fashion traditions, in other cultures; through parallel social, cultural, and even political developments – ranging from, say, the emergence of the motor car, to the rise of the Nazi Party; through the technology of fabric design and clothes manufacture, through economic factors . . .

And yet the trouble with all such explanations is that they have no *necessary* relation to the phenomena they attempt to account for. They are always 'after the event'; and regardless of the conviction with which they are asserted, they have no predictive value whatsoever.

For example, it is very often said that the emancipation of

women this century has been *the* determinative influence on the
evolution of women's clothing. Nonetheless, it seems to me that
almost *any* changes in women's fashion would have led to the
same assertion by those who need to believe that such things are
so. For 'emancipated' man, in the West, progressively condemned
himself to dark and relatively practical bifurcated clothes, in
which the aesthetic dimension shrank towards the tie and the
waist-coat. He adopted, in other words, the sort of attire associ-
ated with female purdah, and the complete subjection of women,
in Eastern Islamic countries. We can be sure that if matters had
been reversed, if the male had retained decorative display for
himself, and women in the West had worn dark and concealing
garments, then the eruption of something equivalent to, say,
eighteenth- and early nineteenth-century women's fashion would,
today, have been heralded as being symptomatic of 'the eman-
cipation of women'. *Intrinsic* relationships between emancipated
and unemancipated modes of dress are much harder to establish
than might at first appear.

Ought we then simply to accept that the movement of fashion is
arbitrary, or so over-determined that attempts to explain it, or to
isolate causative factors, are doomed to failure? Perhaps, but I
think we can at least get somewhere by recognising that fashion
itself is a relatively recent phenomenon. We can understand it
better by considering the case of non-fashionable dress.

The desire to ornament the human body, and the impetus to
protect and clothe it, are basic to human being, though the former
appears to be primary. In pre-fashionable societies, however, the
scope for individualised expression which adornment and clo-
thing provided was tailored by constraints of social and practical
function. Thus in some residual peasant societies today, such as in
parts of Brittany, one can still see the coexistence of highly
ornamental, ceremonial wear, embroidered with traditional floral
patterns; and related practical wear (clogs, smocks, etc.). Such
dress was, of course, never fashionable.

Fashion arises when members of a particular, privileged social
grouping find that the shared symbolic order has so disintegrated
that ornament is 'freed' to grow like a vine without a trellis; and
they, by reason of their status and wealth, have no need to restrict

dress to that which is practically functional. In this situation, the decorative element becomes of increasing importance in dress; it becomes an expressive arena in which the ability to innovate, and to exercise taste, are decisive.

It was just such a situation which gave rise to the glorious efflorescence of fashionable dress in Europe between the late sixteenth and nineteenth centuries, so beautifully chronicled in the V. & A. Dress Collection. In this period, dress acquired a 'relative autonomy' it had not previously possessed. For those in a position to engage with it, fashion became an endlessly inventive working, and reworking, of the possibilities clothing affords for individual aesthetic display, and the exploration of sexual symbolism.

The autonomy of even fashionable dress was, however, only *relative*; for the operation of fashion also depended on the existence of a hieratic (usually courtly) system which could 'set' taste at any given moment, by endorsing, or failing to endorse, a particular fashionable development. Clothing, too, even for the most fashionably attired of courtiers, was further restrained by a residue of practical considerations, and the human body's not-unlimited capacity for distortion and variation.

The grand era of fashion could not have achieved what it did without the existence of that sustaining and limiting hieratic structure, where each innovation can be imbued, however momentarily, with social force. The great fashion houses, and, more recently, the individual designers of the 'post-couture' era, were never entirely successful in replacing this lost authority; the emphasis shifted progressively towards increasingly unbridled individual expression. As the style writer David Hebdige puts it, 'narcissism and self-discovery' became the *only* area for experimentation: the exercise of taste, and of aesthetic innovation, depended on some affirmation of shared social values; in the new situation, fashion began to disintegrate. The prophecy cited in *Sartor Resartus* had come true: 'Clothes gave us individuality, distinctions, social polity; Clothes have made Men of us; they are threatening to make Clothes-screens of us.' Those screens stalk the cat-walks today.

Indeed, because it has lost all authority, High Fashion today is

compelled to feed off the sub-cultures. Fashion is thus now *follow-ing* rather than setting styles. This is bound to happen in a situation where Buckingham Palace and Sandringham are assumed to have no more cultural clout than, say, street punk. But public driving would be impossible unless everyone agreed to abide by the arbitrary decision to drive on the left (or, come to that, on the right). And fashion, too, becomes impossible when there is no enforced consensus about the limits within which taste is exercised: it ends up in the chaotic eclecticism of, say, Zandra Rhodes.

What then of those of us who lack the exhibitionism and physical grace to parade as narcissistic, self-concocted dandies – but who also feel we belong to none of the uniformed sub-cultures, not even that of fashion? It's tough. One can, of course, argue (as many did at the turn of the century) for a reform of dress on non-fashionable lines. Here, the crafts would come into their own. But it's not likely to happen; at least, not before Christmas. There is, I believe, nothing for it but bricolage . . . So I'll probably wear my pin-stripes, pink shirt and florid tie to the *New Society* Party again this year. But, if Mr Melly is there this time, having thought it all out, I'll feel rather less inhibited than before about stamping on his hideous turtleskin shoes, if he's still wearing them. Or even, come to that, if he's not.

1983

Modern Jewellery

I never thought I would live to see the day when it became necessary to say that diamonds are a better friend to a girl – or a boy, come to that – than used cinema tickets. Last year, however, the British Crafts Centre mounted an exhibition called 'Jewellery Redefined', billed as the first (one can only hope it will also be the last) 'International Exhibition of Multi-Media Non-Precious Jewellery'. Among the more laughable exhibits were Stirling Clark's 'necklace' and 'earrings' made from torn cinema tickets threaded on to leather thongs. Give me imitation pearls any day!

But if the materials used in this exhibition were not precious, the rhetoric surrounding it certainly was. Sarah Osborn, one of the selectors, wrote in the catalogue that a few young people were 'overturning the idea that jewellery has to make you look more pleasing'. She engaged in a lot of talk about 'courage', 'risk-taking', 'liberating forces in contemporary jewellery', and 'the relationship between working in non-precious materials and a poor economic climate', as if the qualities which make for good jewellery were identical to those needed in urban guerilla warfare.

Now 'Jewellery Redefined' has been followed by a heavier show of similar ephemera called 'The Jewellery Project', organised by the Crafts Council. All the items in it come from a collection made for New Yorkers Malcolm and Sue Knapp, who clearly possess more wealth than taste. They are the proud owners of such things as Otto Kunzli's outsized 'Stick', 'Cube' and 'Block' pins in polystyrene and plastic coated with wood-grain wallpaper; Pierre Degen's 'Pin Board', worn on the upper back to display a clumsy drawing in graphite on paper; Georg Dobler's box frame in steel rods, intended to be carried like some cubist parrot on the shoulder; Herman Hermson's 'Headpiece', a sort of personal lightning conductor or continuous spectacle frame without lenses encasing both sides of the head . . . And so on, and so forth.

Why is the Crafts Council giving gallery space to such sterile pretension? It is a tired old story, one I have told elsewhere in relation to both textiles and pots. The discredited ethic of a collapsed Late Modernist Fine Art tradition is now being transplanted into each of the several crafts with potentially debilitating results. New practitioners are denigrating established knowledges, traditions, skills, techniques, practices and above all values. In their place, they are putting the vacuous attitudes and materials of our synthetic, anti-aesthetic 'culture'. Predictably, this tragic vandalism is backed with public money, facilities and support structures. (What else would one expect from a Government which gave us Cruise, Cable Television, and a rundown of arts and crafts education?) Nonetheless, the 'discourse' which surrounds this destruction (*vide* Osborn) apes left-wing 'revolutionary' theory, with its rejection of 'conservative' taste and 'tradition', and its appeals to slogans of 'progress' and 'liberation'.

But just look at this new jewellery. It lacks intricacy, workmanship, sense of beauty or mystery, celebration of nature or affirmation of tradition. It is neither pretty, attractive, precious nor ornamental – all of which, Osborn notwithstanding, are appropriate qualities for jewels. Indeed, it is not really jewellery at all.

David Ward effectively admits this in his catalogue introduction to 'The Jewellery Project', which could easily be mistaken for an ironic parody, or, alternatively, serialised for many months to come in 'Pseuds' Corner'. 'Most of the objects in the Collection', Ward tells us, 'are conspicuous precisely because their formal, technical, material and even functional aspects do not derive primarily from other or earlier jewellery.' The word 'jewellery', he goes on to say, 'is inadequate to define these developments and cannot properly acknowledge or embrace the diverse nature of the hybrid objects being made today.' Predictably, he refers to the relevance to jewellery of 'a remarkable and rich vein in the wider visual arts' (i.e. the narrowest and most reductionist tributaries in the Modernist tradition). He goes on to imply that the 'progressive' modern jeweller has more to learn from Man Ray's photograph of Myrna Loy with a thermometer suspended from her ear

than from anything to do with amber, jade, jet, amethyst or precious metals and stones of any kind.

But if the jewellers reject almost everything which has previously been acknowledged as jewellery what do they put in its place? Well, first of all they seem to demand an ideological commitment to the qualities of non-precious materials. Sometimes this is presented, as in Osborn, as a sort of 'democratic' enjoyment of all substances, in and for themselves; hence she celebrates 'the rubberiness of rubber; the plasticity of plastic; the paperiness of paper'. (Why not, one wonders, the shittiness of shit?) All this comes with a polemic against the 'other sort of jewellery', which is described as 'a sub-station of the stock-exchange', etc. Alternatively, we are told that there is some sort of ecological virtue in using recycled or 'discarded' materials and objects.

But the aesthetic value of precious stones is *not* a mere by-product of market-price: rather, the reverse is the case. Market price is an incidental reflection of aesthetic (i.e. non-functional) value. And anyone who seriously believes that the 'plasticity of plastic' is even remotely comparable to the beauties of a fine gemstone, as revealed through its colour, brilliance, lustre and fire, is simply revealing the degree to which his, or her, aesthetic response has been (if you will forgive the expression) *jaded* and numbed by our mega-visual 'culture'.

Nor is this simply a matter of lack of refinement of a purely sensuous response (although that certainly comes into it). I believe that materials in the world, by reason of their inherent qualities, constitute a 'natural' symbolic order; and our perception of this seems bound up with our development of ethical and abstract concepts. To give a simple and self-evident example, the first substance we learn to reject is excrement: notions of evil and (by contrast) of good have much to do with this response. Similarly, the association between gold, wealth and power; granite, hardness and endurance; or mother-of-pearl and femininity is not arbitrary, nor is it economically or ideologically determined. Only someone who has become literally insensible could believe in the equality of materials.

But, of course, the new jewellers do not just prefer sensuously unattractive and symbolically negative substances. They believe

in redefining the *functions* of jewellery too. That is why the new work comes with all this talk about breaking the limits of traditional jewellery practices, and denigration of concepts like adornment and ornament. Much of the new jewellery seems to involve a repudiation of the notion of beauty itself. Instead, this work is concerned with a questioning of what jewellery is; with dissolving it into dance, or clothes design; or with arid proclamations about bodily functions and structures. It is this sort of 'pioneering' or 'experimental' work that picks up all the grants, publicly sponsored exhibition spaces and critical articles.

No doubt, in the near future, the Crafts Council or the British Crafts Centre will be supporting an exhibition called 'Confectionery Redefined' in which avant-garde sweet-maker persons present a wide range of objects for which the word 'sweet' will be inadequate, but all of which will question the limits of confectionery in a world of rising unemployment and a growing dental ecology problem. Many of these objects will be made out of polyurethane and vinyl chlorides; most, of course, will be inedible.

Meanwhile, however, the majority of sensible persons will continue to look to their confectioners and jewellers alike for something other than plastic humbug. The oil magnate's widow who wears a four-inch golden brooch, encrusted with diamonds and pearls, made up for her by Asprey's in the shape of Neptune's trident, in memory of her dear departed, may well be manifesting poor taste. Nonetheless her taste, and her insight into the true qualities of fine jewellery, seem to me better than those of the trendies who don Pierre Degen structures, or Julia Manheim wirewear to impress other trendies.

Of course, jewellery does not have to be expensive to be good; I have seen some fine necklaces whose beads were based on the shapes of fruit and flowers made out of brilliant coloured glass. Nonetheless, I believe that the roots of the jeweller's skills lie in a detailed knowledge of gemmology, precious metalwork and mounting techniques. There can be no evasion of tradition, nor yet of an intuitive grasp of the moral and aesthetic properties of material. In the absence of those symbolic orders once provided by religious ceremony, liturgy and heraldry, the jeweller who

wants to do anything worthwhile must turn to the symbolism of natural substances and forms. Similarly, I believe the Crafts Council should devote its resources for the sponsorship of jewellery to those who are engaged in such quests for jewels of great decorative and ornamental beauty. I hope we never see the like of 'Jewellery Redefined' or 'The Jewellery Project' again.

1983

VIII

WRITINGS

John Ruskin: a Radical Conservative

Ruskin was one of the most relentless critics of nineteenth-century industrial capitalism. When the Labour Party emerged as a political force, in 1906, six years after his death, he was regarded as a founding father of British socialism; more of the early Labour M Ps claimed to be indebted to *Unto This Last*, his critique of conventional political economy, than to any other book.

Indeed, it quickly became assumed that all Ruskin's essential ideas about 'good Government' and 'co-operation' had been incorporated into the development of the modern welfare state, or the reform programmes of the Labour movement. The rest of Ruskin, it was thought, constituted some sort of unfortunate husk, compounded of his psychologically determined authoritarianism, his Victorianism, and his doubtful sanity.

And so Ruskin began to disappear from the intellectual firmament. The olive-green bound volumes of his writings, with bizarre titles like *The Crown of Wild Olive*, *The Cestus of Aglaia* and *Fors Clavigera*, seemed destined to become no more than the bane of second-hand booksellers' 'one shilling' shelves.

When he edited an anthology of Ruskin's writings in 1964, Kenneth Clark wrote that, in the middle of the twentieth century, practically nothing was left of Ruskin's once towering reputation except a 'malicious interest in the story of his private life'.

Today, however, John Ruskin is back; nor is the interest in him any longer confined solely to his alleged responses to his wife's private parts on their wedding night. (The latest research suggests it was fear of menstrual blood rather than revulsion at the sight of pubic hair which prevented him from consummating his six-year marriage.) A major John Ruskin exhibition has been organised by Jeanne Clegg for the Arts Council (at the Mappin Art Gallery, Sheffield, and subsequently touring). This sets out to explain by means of a visual argument articulated through images, casts,

stones, coins and minerals, the range of Ruskin's interests and obsessions, the unity in diversity of his thought.

The fascinating exhibition is not a one-off shot, descending from out of the Ruskin blue vividly reproduced on the catalogue cover. For the last decade has seen an unprecedented resurgence of Ruskin studies, on which Dr Clegg has extensively drawn. And the man who is emerging from all this new work is less and less like the Socialist Sage those early MPs thought they revered; and yet, it seems, he may have more and more to say to the political and cultural crisis of the later twentieth century.

For all the recent shift away from biographical research towards Ruskin's ideas, however, it must be emphasised that in few other writers were the two levels so immediately intermingled. Even the interest in the events of his wedding night is not entirely unwarranted. Ruskin's way of handling (and failing to handle) his intimate feelings about separation from, and fusion with, the female body – the mother first, and potential adult sexual partners later – enthuses and informs his intense responses to the natural and social worlds.

Ruskin came from a closed, evangelical home. His father was a successful sherry merchant; his mother, he once explained, had, 'like Hannah', devoted her only child to God even before he was born. Mr and Mrs Ruskin lavished their son with loveless love, intended to deliver him eventually into the hands of the church as a perfected holy specimen. He, in turn, regarded them as 'visible powers of nature', whom, he said, he 'no more loved than the sun and the moon'.

Throughout his life, Ruskin was endowed with almost a superfluity of feeling – but he found it impossible to connect this with living people in appropriate and realistic ways. When he was thirty-three, he complained in a letter to his father that 'whatever feelings of attachment I have are to material things'.

Almost from the beginning, his responses to nature were intense. He describes, for example, how at the age of five he went rambling with his nurse at Friar's Crag overlooking Derwent Water (where a Ruskin memorial now stands) and felt a sensation of fusion with the mountains, twining roots and dark water.

But Ruskin also told his father, 'Pictures are my friends. I have

none other.' The first, and in some ways, the greatest cultural obsession of Ruskin's life was with Turner. Indeed, he set out to write his first major work, *Modern Painters*, as a defence of Turner against callous contemporary reviewers. The book swelled into five volumes. In the first of these Ruskin argued that Turner was more 'realist' than any landscape painter of the past, or the present, not just because he had more accurately observed the formation of leaves, branches and mountain structure than they but because he had also revealed nature as the literal handiwork of God.

Later, however, when in one of his phases of religious doubt, Ruskin wrote again to his father, 'About Turner you indeed never knew how much you thwarted me – for I thought it my duty to be thwarted – it was the religion that led me all wrong there.' But Ruskin's 'reading' of Turner makes sense if one sees the element in art which goes beyond verisimilitude not as revelation of God so much as the artist's own expression of imaginative transformation.

And this is what Ruskin's own drawings reveal. Dr Clegg's exhibition is replete with superb examples: for, if nothing else, Ruskin at his best was one of the finest draughtsmen of his age, perhaps of any age. And his strength lay in his capacity to see with devastating acuity and simultaneously to transmute what he saw.

For example, no man spent more time than Ruskin in 'anatomical work on mountains', as he liked to call it, in verbal and visual descriptions of every aspect of mountain structure and strata. But the way he speaks of the mountains – 'fiery peaks . . . with heaving bosoms and exulting limbs, with the clouds drifting like hair from their bright foreheads' – was anything but dispassionate. Similarly, his extraordinary drawings of mountain scenery, though as accurate as a drawing can be, are at their best enthused with tender imaginings of the human body, redolent with all the intimacy and energy of his displaced love.

And Ruskin's thinking about human society was similarly inflected. For, after Turner, the next great cultural symbol he chose was the history and fabric of Venice, which he idealised as a perfectly governed state whose moral and aesthetic health was still manifest in its surviving architectural and ornamental work.

Ruskin saw Venice as governed, under God, by the benign authority of an elected Doge; he conceived of it as a hieratic though cooperative community of men and women of varying talents, for each of whom the social space existed for the full expression of their creativity.

The reality of medieval Venice was, in fact, rather different; but it was this notion of an organic, though essentially static society (one whose model was natural growth rather than technological, historical or political development) which Ruskin repeatedly held up as an example to the working men of Britain.

Quentin Bell has described how he once talked to a 'veteran' of the British Labour movement who doubted whether any of those early Labour Party men who said they had read *Unto this Last* had in fact done so. Not only is the tenor of that book in fact quite incompatible with anything ever advocated by the Socialist movement; but some passages within it remain chilling. 'My continual aim', writes Ruskin, 'has been to show the eternal superiority of some men to others, sometimes even of one man to all others; and to show also the advisability of appointing such persons or person to guide, to lead, or on occasion even to compel and subdue, their inferiors, according to their own better knowledge and wiser will.'

Ruskin himself made no secret of his views. Indeed, he opened a Museum for working men in Sheffield and filled it with, among other things, casts from Venetian and other Gothic buildings, coins, minerals, etc., all of which were intended to be a visual and material argument for the sort of society he wanted to see. (Much of this is contained in Dr Clegg's exhibition. More still will go on show, next year, when the Ruskin Museum is scheduled to be reopened in Sheffield.) In *Fors Clavigera*, his eccentric monthly letter to working men, Ruskin asked the citizens of Sheffield, 'Why haven't you a Ducal Palace of your own, without need to have the beauties of one far away explained to you?' He went on to explain, 'How soon you may wish to build such an one at Sheffield depends on the perfection of the government you can develop there, and the dignity of the state you desire it should assume.' He had already suggested that his Sheffield supporters drew boundaries round the city and elected a Doge.

Like his vision of nature, Ruskin's view of human society had

10
Study of St George
John Ruskin

always been vulnerable to his violent convulsions of religious doubt. But it is one thing to put imagination in the place of religious revelation in art; quite another to sever the authority of the leader from obedience to divine authority, and to fail to root it thoroughly in democratic process.

Nonetheless, after the death of his mother in 1870, Ruskin, increasingly dogged by madness and a sense of 'The Failure of Nature' itself, began to live out the logic of his social vision too. He established the Guild of St George, a rural Utopian organisation, and had himself elected master. He engaged in exemplary acts, at once symbolic and practical, instigating roadbuilding and sweeping projects, spring cleaning, linen manufacture and so on, all of which seem to have a suspicious proximity to those maternal imaginings which underwrite so many of his activities.

And he started, increasingly, to rail against the evolutionary theories of Darwin. The idea of flux and development in Darwin was incompatible with Ruskin's belief that the physical world embodied permanent and discernible moral and spiritual values. Predictably, he began to draw up his own taxonomy, describing, illustrating and renaming rocks, birds, animals and flowers in a symbolic order whose roots were his own imaginative activity, and which was evaluative and ethical as well as being factual and empirical.

For Ruskin was well aware that his social thinking, as much as his aesthetics, depended on his view of nature as, if not God's, then at least his own, creation. As Dr Clegg points out, Ruskin took the striving of each branch and leaf to keep out of the way of the others so as not to deprive them of air, sun and rain as emblematic of fellowship. From this, he elaborated an organicist criticism of England, where competition was the rule: 'You find every one scrambling for his neighbour's place.'

To ask whether Ruskin's view of society, in his later years, was realistic or not is to miss the point. Gregory Bateson, the anthropologist, who was no believer, once pointed out how the erosion of the concept of divine immanence in nature led men to see the world around them as mindless, and therefore not entitled to moral, aesthetic or ethical consideration. This led them to see themselves as wholly set apart from nature; when this loss of a

sense of organic unity was combined with an advanced technology, Bateson argued, 'your likelihood of survival will be that of a snowball in hell.'

Ruskin believed the loss of the sense of God in nature, combined with rampant technological development and an economic system driven by competition, would lead to the eventual annihilation of civilisation and perhaps even of nature itself, to 'blanched sun, blighted grass, and blinded man'. Today it is apparent that, at the end of the nineteenth century, through his eccentric material symbols, Ruskin was presenting an argument which was not otherwise to be heard on either the left or the right (both of which were uncritically committed to secularism and increased production) for a very long time. Today, however, that argument is beginning to be heard again, in different forms, from many otherwise incompatible quarters. And even if we do not agree with Ruskin's idiosyncratic solutions, exhibitions like this may compel us to begin to acknowledge that this much misrepresented Victorian sage was the true prophet of the 'post-modern' and 'post-industrial' era.

1983

37
William Morris: a Conservationist Radical

William Morris's principal concern, in both theory and practice, was with the potentialities of human *work*. Morris believed men and women should derive pleasure from their labour and that, if they did so, those who used the things they made would themselves gain pleasure from them. The key to this 'joy in labour' was, he thought, sound ornament.

Morris celebrated 'joy in labour' almost to a fault; or, perhaps, it would be more accurate to say that of all aspects of human life, this was the one he understood best. Morris has surprisingly little to say, for example, about the joys of human relationships, in or out of productive work; and what he does have to say – about romantic relationships in the poems, or socialist marriage and comradeship in *News from Nowhere* – is often highly idealised, or even trite. But then Morris himself was always more successful in the making of beautiful things than in his sexual or political relationships with others.

Morris's views about art, society and politics were, in effect, derivatives, or consequences, of his central affirmation of the importance of 'joy in labour'. He thought an artist was simply 'a workman who is determined that, whatever else happens, his work shall be excellent': one of the most significant ways in which this excellence was made manifest was through 'the decoration of workmanship' which Morris described as 'the expression of man's pleasure in successful labour'.

For Morris, the decorative arts were 'part of a great system invented for the expression of a man's delight in beauty'. He described them as 'the sweetners of human labour, both to the handicraftsman whose life is spent in working them, and to people in general who are influenced by the sight of them at every turn of the day's work'. He thought that the decorative arts 'make our toil happy, our rest fruitful'.

11
Medway
William Morris

As Morris himself admitted, there was nothing very original in this view. 'Art', he writes, 'is man's expression of his joy in labour. If those are not Professor Ruskin's words they embody his teaching on this subject. Nor has any truth more important ever been stated; for if pleasure in labour be generally possible, what a strange folly it must be for men to consent to labour without pleasure; and what a hideous injustice it must be for society to compel most men to labour without pleasure.'

Like Ruskin, then, Morris believed human, productive work ought to involve an imaginative or ornamental dimension which went beyond the constraints of function and necessity. Both men belonged to a peculiarly English tradition of thinking about art, work and society which was at odds with the mainstreams of Western socialist and capitalist thought alike. Indeed, their objection to capitalism was not, in the first instance – and in Ruskin's case, not in the last instance either – to do with political or economic injustice. Their first criticism was rather *aesthetic*, though neither of them was particularly fond of that word. They were opposed to modern capitalism and the factory system because these things conspired to destroy the pleasurable, imaginative and joyous aspects of men and women's work.

Ruskin was the more profound and original thinker about these matters; but Morris differed from him in a number of significant respects. Unlike Ruskin, Morris was a practical craftsman of exceptional talent and resolve; he was perhaps the finest pattern designer to have emerged in the West since the decline of the medieval crafts. Ruskin, too, was tormented by religious questions; but, when he was twenty-one, Morris visited France with his friend, Edward Burne-Jones, and they both renounced the idea of entering the Church. From that moment on, religious issues played no further part in Morris's thought.

But this put Morris in a paradoxical position, which he never openly faced. For Morris had inherited from Ruskin an idealised image of 'The Gothic', which he saw as a sort of paradigm for human creative labour. His own practical work in the crafts – especially that for churches and colleges – immediately reflects this. Ruskin, however, assumed that the root of true 'Gothic' was Christian belief. The society of the future he proposed as an

alternative to modern capitalism was based on his conception of medieval Venice; it was democratic, yet hieratic, governed by an elected 'Doge' figure whose authority ultimately derived from God himself. Morris tended to imply that there was no real difficulty in severing 'The Gothic' paradigm of work from any association with Christianity; indeed, he believed that the midwife of the new era of joyous, creative labour would be revolutionary socialism.

Several writers (including Robin Page Arnot, Edward Thompson and Paul Meier) have recently shown that Morris became an unequivocal revolutionary in terms of his political ideas. There really can be no further argument about the fact that Morris embraced Marxism. Nonetheless, he differed from most Marxists of his day, and ours, in his belief that socialism was, first and foremost, the necessary means to the initiation of a new era of joyous labour; in this belief, of course, Morris was wrong.

In Soviet countries in the Eastern bloc, 'Five-Year Plan' policies came to dominate; no attention at all was given to Morris's principal concerns. The decorative arts tended to be destroyed along with the peasantry; factory labour was, if anything, more intensive and soul-destroying than in the West. But in the West, too, the major and minor currents of the labour movement ignored those arguments about the quality and potentialities of human work which were Morris's primary reason for espousing the Socialist cause. The Labour Party, Communist Party, 'Far Left' and Trade Unions alike have focused on economic or narrowly political issues, on, in effect, the issue of the ownership and control of existing means of production, rather than on their transformation. There is clearly no *necessary* relationship between the struggle for, or indeed the realisation of, socialism and Morris's principal concerns.

For example, the Russian, revolutionary avant garde espoused a *Modernist* aesthetic. Modernism was later to become the housestyle of Mussolini's Rome and Rockefeller's New York. Even so there were, and indeed there still are, many who argue that, despite its rabid anti-ornamentalism, celebration of mechanism, and technicist disregard for natural form, tradition, creative work and

'joy in labour', Modernism is the essential aesthetic, or rather anti-aesthetic, for the Socialist alternative in the West.

Indeed, one of the more bizarre distortions of recent cultural history is that first put forward by Nikolaus Pevsner, that Morris was himself a 'pioneer' of this modern design. Pevsner argued that what was essential in Morris's thought was his belief in 'art for all'; his affirmation of 'joy in labour' and his 'historicising' attitude towards work could be dispensed with as an obsolete husk. Pevsner thus managed to convince himself that Morris's dream could be realised by the mass-production of what he chose to call 'machine art'. Thus he saw the Bauhaus, and by extension, the whole modern movement, as a logical development from Morris's ideas.

Now it is true that Morris was not against the factory as such. He believed that in an ideal society, 'whatever is burdensome about the factory would be taken turn and turn about, and so distributed, would cease to be a burden – would be, in fact, a kind of rest from the more exciting or artistic work.' But he would have detested the idea that machines might *replace* that 'exciting or artistic work'. For him, a machine could make anything, *except a work of art*. He would have regarded the modern movement in architecture and design, with its celebration of mechanism in place of natural human and artistic values, as a case of art for no one, or of General Anaesthesia.

Even in his own time, Morris reacted strongly *against* incipient modernism in art and design. Peter Floud has demonstrated how Morris's textiles were, in part, a challenge to the Victorian 'progressives'. He advocated the rooting of pattern in the varieties of natural form, and the revival and development of traditional techniques, rather than mechanical abstractions, repetitions and processes. *Morris was an aesthetic conservative*, and today it is becoming easier and easier for us to see that it was precisely in this aesthetic conservatism (rather than his conventional 'revolutionary' political ideas) that his true radicalism lay.

Thus, though true, the excited discovery of recent years that, in political and economic terms, Morris became a revolutionary socialist is singularly unrewarding – except as a matter of biography. Morris got his politics and his economics wrong. The

working-class revolution he and other socialists expected did not come about – and it never will. Marx's inexorable laws of economic development are theoretical figments. More to the point, even if such a revolution had taken place in the West, there is little reason to suppose it would have brought about those things for which Morris yearned all his life.

And so it seems to me that the importance of William Morris today lies in his radical aesthetic conservatism, which proposes an alternative view of work to that advocated within contemporary Labourism and Thatcherism alike. Morris offers a vision of men and women engaged in creative and decorative labour, in union with nature, and at peace with each other and the world. Their satisfaction in work derives from the fact that they are able to derive pleasure from what they do.

History has discredited the political and economic means which, Morris believed, would bring about this 'Great Change'. As Raymond Williams and others are now arguing, the whole Socialist enterprise needs to be rethought from its very roots. And this rethinking must begin precisely where Morris himself began: by asking how can we create a society in which men and women derive pleasure, satisfaction and enjoyment from their work. The political and economic answers we come up with, however, will have to be different from his.

But perhaps, after all, not *that* different. For all his orthodox Marxism, William Morris – as E. P. Thompson has shown us – retained strong affiliations with that prior English tradition which had shaped and formed him. These he never abandoned. And many of his themes seem singularly in tune with the times. In a society which is at once 'post-Labourist' and 'post-industrial' Morris's radical suggestion of a two-tier economy, in which fully automated production develops *alongside* a true renaissance in the creative arts and crafts, acquires an unprecedented relevance. Similarly, his preoccupations with nature, conservation and peace have a new importance for 'The Left' in the era of ecology, Rudolph Bahro, and the campaigns against nuclear weapons. Indeed, perhaps, today we are in a better position than ever to resolve *the* great dilemma of Morris's thought: that is how 'spiritual', artistic and aesthetic work and values can flourish in a

secular society. Some of us on the Left, at least, are beginning to realise that aesthetics and ethics cannot be dismissed as 'class', or any other kind of relativistic values. They derive their authority not, as Ruskin believed, from divine absolutes, but rather from certain biologically given conditions of human being which must remain 'relatively constant' if we are to live happy and joyous lives. Modern capitalist and much modern socialist production, too, impinges upon, or suppresses, those conditions altogether, but Morris's practical work loudly affirms them. It is one of the many paradoxes of this paradoxical man that his most significant political tracts may well turn out to be his Willow wallpapers, or his Honeysuckle chintzes.

1983

38
Eric Gill: a Man of Many Parts

Eric Gill was a man of many parts; by this, I do not just intend to refer to the fact that he had a predilection for making drawings of his penis and those of his friends and associates, although he was singularly preoccupied with what he liked to call 'man's most precious ornament'.

When he died, Gill left these drawings to the Royal College of Surgeons because 'anatomy books are not well illustrated in respect of the male organ', but the bequest was declined because Gill had not illustrated any pathological conditions. He was also an incisive linear draughtsman; a talented sculptor, wood-engraver and architect; and a letter-cutter of genius.

An inveterate polemicist, Gill poured forth his decided views on everything from custard powder and spelling reform to nudism, liturgical practices and contraception. Although he was often contradictory, everything he said, wrote or did related to a coherent stance towards life and work, which he himself tried to live out to the full.

Gill was born in Brighton in 1882. His father was a Non-Conformist minister who converted to the Church of England when his son was fifteen years old; his mother was a professional singer. As a child, Eric showed a talent for drawing and decorative lettering, and when he was seventeen, he was apprenticed to the architect W. H. Caroë, one of the most innovative of the minor lights of the later Gothic Revival.

At this time, too, Gill went to the Central School of Arts and Crafts, headed by W. R. Lethaby, a founder figure of the Arts and Crafts movement; Gill was one of the first pupils in the lettering classes of the legendary Edward Johnston, with whom he formed a close and enduring working relationship. At the Central, Gill also studied masonry and stone-cutting, skills from which he earned his living when he ceased to be a student.

In 1904, he married the daughter of the head verger at Chichester Cathedral; but, soon after, he had a passionate affair with a young woman from the Fabian Society who introduced him to Nietzsche's *Thus Spake Zarathustra*. Despite his almost cloying devotion to his wife, Gill always had the greatest difficulty in managing his sexual drives and obsessions. As the diaries, lists and exotic collections he left behind reveal, he was compulsively fascinated by all things sexual – from the mating of farm animals, to the activities of lovers in Hyde Park, Indian sculpture, pornography, and prostitutes, whom he frequented.

At first, Gill moved in socialist and avant-garde circles. For example, he exhibited several sculptures in Roger Fry's Second Post-Impressionist Exhibition; but his own ideas took time to coalesce. By 1909, he had repudiated the Arts and Crafts movement, causing Lethaby to accuse him of 'crabbing his mother'. But, in 1913, he found the certainty for which he had been searching when he was received into the Roman Catholic Church. In his *Autobiography*, he says that everything that happened to him after that was just a series of postscripts: they were, however, busy postscripts.

At Ditchling in Sussex, Capel-y-ffin in Wales, and finally at Pigotts, near High Wycombe, Gill set up what were in effect religious-cum-artistic communities, which thrived on a mixture of self-sufficiency, catholic observance, creative work and his own relentless character. Characteristically, in 1921, he established the Craft Guild of St Joseph and St Dominic at Ditchling, attracting a trickle of highly talented followers.

Gill himself received many important public commissions: he made the Stations of the Cross for J. F. Bentley's Byzantine Catholic Cathedral in Westminster; and he managed to upset almost everyone with his war memorial for Leeds University, which, hardly appropriately, showed Jesus whipping from the Temple pawnbrokers, politicians, financiers and a woman of fashion in modern dress. There were more rows too about the figures he made for Broadcasting House, which included an Ariel so spectacularly well-endowed that the Board of Governors of the BBC felt moved to command Gill to cut the offending member down to size; this he reluctantly did.

The panel on the theme of the creation of Adam which he carved for the League of Nations building in Geneva was both less controversial and aesthetically more successful. When he made this work, Gill was inspired by anti-Fascist and Pacifist sentiments. But a lifetime of chain-smoking and stone-cutting had taken its toll. In 1940, Gill discovered he had lung cancer; he immediately wrote a lengthy *Autobiography*, and died later that year, aged fifty-eight.

Gill was nothing if not prolific. His brother Evan traced 762 stone inscriptions in 328 different towns which originated from his workshops. There were undoubtedly many more. Gill's letter-cutting and calligraphy are still well-enough known by those who care about such things; this aspect of his work lives on through that of his most talented apprentice, David Kindersley, the contemporary typographer and designer. His sculpture, and the outstanding church he built at Gorleston-on-Sea, in Norfolk, are also admired today. But Gill's writings are largely unread. His books were not reprinted after his death, and they are not easily available through second-hand booksellers. This new selection from all Gill's writings – *A Holy Tradition of Working: Passages from the Writings of Eric Gill*, edited by Brian Keeble for the Golgonooza Press – is to be welcomed.

In one sense, it is obvious why Gill's books have been forgotten. Whatever else he may have been, Gill was certainly bigoted and eccentric, a devout and heterosexual version of Edward Carpenter. His attitudes towards women, for example, were so idiosyncratic that they would shock even those who have little sympathy for the modern feminist movement. He thought women 'should dress in uniforms and be thoroughly covered up' – except, of course, on those frequent occasions when he wanted them to undress for *him*.

Gill's conversion to Roman Catholicism helped him to master, at least up to a point, his unruly sexual impulses, and to rationalise his innate bigotry. Predictably, he came to believe that many of his nuttier ideas were invested with the authority of absolute truth. He hated trousers, and preferred to wear a simple smock, beneath which he sported scarlet underpants, a crimson petticoat-bodice, or nothing at all. This form of dress was, he explained, 'the

Christian norm'. His writing was not only quirkish and dogmatic; it was also often contradictory and repetitious. He was as unworried by plagiarism as the medieval schoolmen he admired.

And yet, when all this has been said, Gill's writings do not deserve to be forgotten, nor even to be preserved simply as some sort of museum-piece of English oddity. His importance today resides in his views about the nature of human work; far from being archaic or Luddite throwbacks, these were, if anything, in advance of their time.

Brian Keeble's selection will disappoint those who pick it up hoping to read Gill's crankier utterances. Keeble refers to 'a growing body of opinion that would hold that if the industrialised world is to recover its balance it can only do so on the basis of a resacralisation of work such as Gill points to.' Through careful editing, he presents us with a cleaned-up version of the essential Gill which, though lacking the colourful underwear of the original, seems almost intellectually respectable.

As Keeble is at pains to point out, Gill's ideas did not spring up out of nothing. He belonged to a particular English tradition of thinking about work and anti-capitalism which can be traced through William Cobbett, Carlyle, Ruskin, Morris and Lethaby. But Gill diverged from this already divided stream.

He thought that both Ruskin and Morris paid too much attention to the artefacts of the medieval craftsmen, and not enough to the spiritual ideas which informed their work. Though Gill's sensual nature and his sculptural concerns ensured that he always, as he put it, gave 'due weight to the physical and material world which conditions our lives', he insisted upon 'the primacy of spirit'. This, of course, related to his vigorous Catholicism: his writings on art are liberally spiced with references, acknowledged and unacknowledged, to Jacques Maritain, a French Thomist who extracted an aesthetic theory from the schoolmen of Christendom.

If Gill's ultramontanism rendered him more philosophically idealist than his English heroes, it also meant that he was better able to appreciate the achievements of cultures other than those of medieval England. Under the influence of Ananda Coomaraswamy, Gill became increasingly aware that the 'spiritual' dimen-

sion he admired in work was apparent not only in the Gothic arts of Christendom, but in many oriental cultures too.

He briefly believed that replenishment of labour in the West would come about through the realisation of traditional Socialist goals; but he later explained, 'My socialism was from the beginning a revolt against the intellectual degradation of the factory hands and the damned ugliness of all that capitalist industrialism produced.' He said it was not so much the working *class* that concerned him as the working *man*, and 'not so much what he got *from* working as what he did *by* working.'

His criticisms of factory production and industrial capitalism were thus aesthetic and spiritual rather than economic. He often quoted Coomaraswamy's dictum, 'The artist is not a special kind of man, but every man is a special kind of artist.' Gill insisted the workman had as much right to make and to act upon aesthetic judgments in his work as he had to act upon a moral judgment in his life, or to make an intellectual judgment in his thought. He regarded the factory system as 'unchristian' (and therefore unacceptable) 'primarily because it deprives workmen of responsibility for their work'.

Again and again, Gill emphasised that 'the so-called "labour unrest" was not simply the result of a desire for higher wages; rather, Gill saw it as stemming from 'the workman's instinctive, if inarticulate, desire for freedom and responsibility'. He argued that if it chiefly took the form of demands for high wages and shorter hours, this was 'only a case of "the biter bit", for higher profits and longer holidays is the chief ambition of the masters.' 'The worship of money', he wrote, 'is a worship which the workman has learned from his superiors.'

Of course, there was a time when, within the Labour movement, such views would have been dismissed as hopelessly idealist. But today, though few may share Gill's religious convictions, many of the more radical thinkers on the Left would agree with him that the Labour movement took a wrong course through exclusive concentration upon economic issues. Many are coming to recognise that the demand should not so much be for a larger slice of the action as for a change in the nature of the action itself. The emphasis is shifting towards the qualitative rather than the

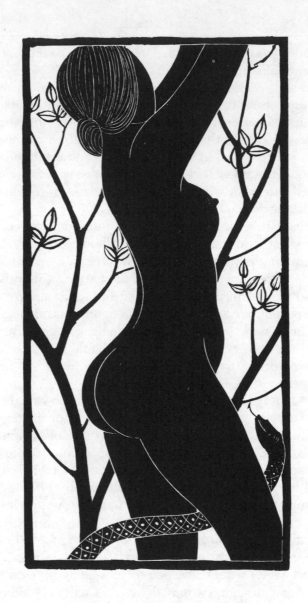

12
Eve 1926
Eric Gill

quantitative aspects of human work; and there is a parallel concern about the effects of unbridled industrial development, in whosoever's ownership, on the environment.

Indeed, barring his Roman Catholicism, it is easy to see Gill as prefiguring, say, the ideas of the later Herbert Marcuse, who rehabilitated 'the good, the true, and the beautiful' on the Left; or those of Raymond Williams, who is currently stressing, just like Gill, the degree to which the Labour movement has developed *in collusion* with capitalism, through its concentration on economic issues alone. Williams, too, is calling for a change of direction rooted in a revaluation of *work* itself.

Nor would I accept that Gill's religiosity immediately excludes him from today's debate. Rather, Gill felt impelled to focus upon themes and issues which today's secular commentators tend conveniently to evade or elide. In particular, he forces those of us who do not share his faith to face the problem of the apparent arbitrariness of aesthetics, and the purposelessness of work (except as a means of immediate subsistence) outside a shared symbolic order of the kind a religion provides.

It was said of Gill that he worked *as if* a tradition existed. But can work be reinvested with its spiritual-aesthetic dimension when tradition has in fact gone, and we have lost the illusions of faith? Gill may not provide us with the answer; but unlike currently more fashionable nineteenth-century secular thinkers, like William Morris, he at least compels us to ask the question.

1984

The Christs of Faith and
the Jesus of History

A joke has been going the rounds in theological circles for some time now. It goes like this. The Pope was told by the Cardinals that the remains of Jesus had been dug up in Palestine. There was no room for doubt; all the archaeologists, scholars and experts were agreed. Teaching about the resurrection, the linchpin of orthodox Christian faith, lay in ruins.

The Pope sat with his head in his hands pondering his position and that of the Church he headed. He decided it would be only decent – whether or not it would be Christian no longer seemed to matter – to let the separated Brethren know. So he called up Paul Tillich, the leading Protestant theologian, and told him the bad news. There was a long silence at the end of the phone. Finally, Tillich said, 'So you mean to say he existed after all . . .'

This joke exemplifies the wide range of 'christological' positions surrounding the figure of Jesus even within the mainstreams of contemporary Christian belief. (Christology is that part of theology concerned with the person and work of Jesus, 'The Christ'. In orthodox Christian confessions, the assertion that Jesus was 'Christ' implies belief that in him 'pre-existent' and eternal god became fully man, 'sharing truly and fully in the conditions of our empirical humanity' while yet remaining fully god.)

Christology is of significance even to those of us who are not Christian because as D. M. Baillie, a theologian, once put it, it 'stands for the Christian interpretation of history as against other interpretations'; and the Christian interpretation, of course, remains among the most prevalent in the world. But this joke also underlines one of the most significant differences between Christianity and the other world religions; and that is that Christianity makes claims about divine intervention in natural and human history which, on the surface at least, would appear to be poten-

tially vulnerable to advances in historical knowledge. If it became widely known that the body had been found in Palestine then belief would be, or perhaps I should say *ought to be*, affected.

Now, of course, nothing remotely as dramatic as the corpse of Jesus has turned up; but our historical knowledge and understanding has been growing steadily for two centuries or more. These advances, however, have not tended to favour 'the Christian interpretation of history'. Rather, as the theologian Walter Pannenberg has put it: 'Since the Enlightenment, the historical picture of Jesus has become farther and farther removed from dogmatic Christology in general.' He admits that for a long time now it has appeared impossible to unite the god-man of Christological dogma with the historical reality of Jesus; there is a sharp distinction between the Christ of Faith and the Jesus of History. For two centuries, he explains, theologians have concerned themselves with 'overcoming this growing cleft'.

Of course, as a historical materialist (of sorts), the overcoming of the cleft is not at the top of my agenda. Rather, I want to ask what, in fact, can we know about the Jesus of History, and what implications, if any, does this knowledge have both for 'the Christian interpretation of history', and for those of us who take a more secular view of historical process?

What, then, can we know about this 'Jesus of History'? The 'Old Quest' for the historical Jesus, as it is called these days, began in the eighteenth century and escalated during the nineteenth. For the most part it was conducted by German Protestant scholars, most of whom were believers, some of whom, however, were deists or sceptics. The 'Old Quest' was fired by the belief that a 'true' or 'authentic' picture of Jesus could be established by tearing through the 'monkish illusions' of Nicaea and Chalcedon and returning to the only sources about the life of Jesus – the gospels. The beginnings of serious, modern New Testament scholarship fuelled this 'Quest'; but one of the reasons why its results were so diverse and inconclusive was that the gospels still tended to be regarded as attempts to write 'biographies' of Jesus, drawn from various lost, written sources.

Between 1800 and 1900 no fewer than 60,000 lives of Jesus were published in Europe. Some were more 'scientific' than

others. But looking back over them today, they seem to have been written by writers for each of whom the gospels turned out to be a sort of mirror on which was painted a halo. Jesus was reflected back to the author in effect as an idealised and sanctified image of himself.

As Gunther Bornkamm (whose *Jesus* remains one of the first, and most impressive, results of this century's 'New Quest') once wrote about the 'Old Quest': 'The individual essays and pictures were determined by the typical dominant images of the Enlightenment, of German idealism, of incipient socialism, by the image of the rationalistic teacher of virtue, by the romantic concept of the religious genius, by the ideal of the champion of the abused proletariat and of a new, more just order of society, by the idea of Kantian ethics, and finally also by the bourgeois religiosity of the nineteenth and twentieth centuries.'

In other words, few of these representations of Jesus bore any relation to anyone (whether man or god!) who could conceivably have been born as a first-century Jew. But the commonest representation of Jesus after 1850 was undoubtedly that advanced by Liberal Protestants like Adolf Harnack, who believed that the essence of Jesus's teaching concerned the brotherhood of man and the fatherhood of God. Harnack believed Jesus was trying to initiate a progressive growth of 'The Kingdom of God' (which he conceived of as a kind of spiritual metaphor) in the hearts of men.

When Harnack's *What is Christianity?* was published in 1899, freight trains full of copies blocked the railway station at Leipzig and the book brought consolation to Empress Frederick, daughter of Queen Victoria, as she lay dying. As Father George Tyrell, a Catholic Modernist, once put it: 'The Christ that Harnack sees looking back through nineteen centuries of Catholic darkness is only the reflection of a Liberal Protestant face seen at the bottom of a deep well.'

In other words, the historical Jesuses of the nineteenth century were themselves historical phenomena: they belonged to *c.* 1800 AD. They were no closer to the authentic figure than the Christs of faith. The basic problem was that the nineteenth-century questers believed that the 'truth' about the life of Jesus was to be found in the gospels: but they did not understand the sort of material they

were dealing with. Early on it became recognised that 'Matthew', 'Mark', and 'Luke' were not independent eyewitness accounts (as had once been assumed) but rather three interrelated (or 'synoptic') texts; whereas John constituted a frankly contradictory account, based on a different theology, topography and chronology. But only very slowly did the investigative scrutiny of the scholars reveal just what a shaky kind of source the gospels were.

For a long time it was still hoped that 'Mark' would stand as a primary, eyewitness Christian document. But in 1901 William Wrede showed how Mark had been organised around a particular, theologically tendentious idea: 'The Messianic Secret', the theory that Jesus was trying to keep hidden the fact that he was 'The Messiah' from disciples too stupid to discern it. Wrede convincingly argued that this looked suspiciously like an attempt, in the light of developed Christian beliefs, to explain why Jesus had never declared himself as Messiah.

The 'Old Quest', however, was finally brought to an end in 1906 when Albert Schweitzer published his detailed critique of the nineteenth-century lives, *The Quest of The Historical Jesus*. Schweitzer argued that they all wrenched Jesus out of his time and ignored the fact that he was a reforming Jew who belonged to an apocalyptic and eschatological tradition of Late Judaism. Jesus had confidently expected the end of the world and the coming of 'The Kingdom of God' within the lifetime of those listening to him. Schweitzer, following Weiss before him, held that Jesus's chiliastic expectations were not intended as spiritual metaphors, but rather as literal beliefs. He called upon his fellow Jews to repent because he considered himself to be playing a part in that process which would bring the existing world order to an end. He thus had no intention of founding a new religion, let alone a Church. Schweitzer even claimed that his much vaunted moral teaching amounted to no more than an 'interim ethic', a description of how a good Jew should behave in the last days of the earthly world.

It has often been said that Schweitzer's *Quest* was, itself, the last contribution to that tradition which he effectively demolished. Certainly, aspects of his alternative 'Life' are easily challenged. For example, he believed Jesus thought of himself as 'The Mes-

siah': few modern scholars would agree. Furthermore, Schweitzer's thorough-going eschatological interpretation can easily be related to his own moment of history, when Europe stood in the gathering shadows of catastrophic conflict.

And yet no serious subsequent historical or theological research has ever eroded Schweitzer's basic insight: Jesus was a Jew who preached the literal coming of 'The Kingdom of God', and the restoration of 'The Chosen People', the Jews, to their rightful place in the world. And that Kingdom, of course, did not come. Since Schweitzer, if a critical scholar peers back through nineteen centuries of Catholic darkness, he perceives not the amiable physiognomy of a good fellow bourgeois, but the shadowy, semitic features of an alien, first-century Jew about whom one thing at least can be said with some certainty: his life's teaching was based on a profound historical misapprehension – an erroneous prophecy.

It was perhaps not surprising that, in the early twentieth century, the most able Christian scholars and theologians abruptly ended 'The Quest of the Historical Jesus'. The best scholarship was devoted to an ever-closer scrutiny of the biblical texts.

A consensus had emerged about the solution to the 'synoptic' problem. ('Mark', 'Matthew', and 'Luke' were usually dated c.70 AD, c.80 AD, and c.90 AD, respectively. Matthew and Luke were assumed to have had access both to Mark, and to a hypothetical text called 'Q', usually believed to have been written about 50 AD. John was thought to have been written about 100 AD, quite independently of the others.) But Form Criticism, initiated in Germany immediately after the First World War, gave rise to a better understanding of how the gospels had been written and the purposes for which they were intended.

The form critics stressed that the gospels were essentially compilations of material which had been handed down in the primitive church through oral traditions in specific and still identifiable forms. This material did not exist in a continuous narrative until the gospel writers tried to organise it as such – hence the considerable divergences between them. A later Redaction Criticism, too, emphasised that the gospels were, in effect, theological pamphlets written to meet the needs of particular

communities (needs related to preaching, teaching, polemic and ethical guidance) refracted through the highly specific visions and approaches of their individual authors.

Although the gospels apparently preserved certain material from the earlier oral tradition in stereotyped forms, they were extensively mediated by events which happened (e.g. the fall of Jerusalem in 70 AD) and by events which did not happen (e.g. the expected *parousia*, or coming of 'The Lord') long after the death of Jesus. Everything in them was mediated by hindsight; all that was said about Jesus was inflected by the assumption of his 'Resurrection'.

The conclusions of this critical work were highly negative concerning the possibility of knowing anything about the historical Jesus. 'We can now know almost nothing concerning the life and personality of Jesus', wrote Rudolph Bultmann, the greatest of the Form Critics and perhaps this century's finest New Testament scholar, 'since the early Christian sources show no interest in either, are moreover fragmentary and often legendary; and other sources about Jesus do not exist.' Or, as Paul Tillich put it, with the advance of historical criticism, the historical Jesus 'not only did not appear but receded farther and farther with every step.' Tillich, too, believed there was no picture behind the biblical one which could be made 'scientifically probable'.

Bultmann, however, did believe in a historical Jesus. What mattered about him was simply the *that* of his having come, and the *Kerygma* – or that proclamation of Jesus as Christ to be found in the New Testament, which, for Bultmann, still constituted a call to decision. But what kind of decision?

According to Bultmann, the gospels had built into their fabric an ancient cosmological world-view, involving a three-decker universe with heaven above and hell below. He argued that Jesus was construed in terms of a 'Redeemer Myth' compatible with this cosmology. (His particular emphasis on the importance of early Redeemer cults, and their influence on developing Christianity has, however, been subject to considerable recent criticism.) All that New Testament talk about demons, the descent into hell or the ascension only made any sort of sense within this framework.

But Bultmann himself did not believe the course of nature could be interrupted by supernatural powers. Thus he dismissed the miracles, the resurrection, and, of course, the incarnation, and called for a 'demythologising' of Christianity into anthropological and existential terms. For him, the vexed problem of Jesus's eschatology was easily resolvable: its deeper meaning was simply 'to be open to God's future which is really imminent for every one of us'.

Bultmann insisted he was still a Christian. But some of his 'left-wing' disciples went even further. Fritz Buri called for a 'dekerygmatisation' of the New Testament. And Herbert Braun argued that one of the mythological statements in the Bible was the assertion of the existence of God. The atheist, he said, had failed to grasp man. 'Indeed,' Braun wrote, 'we may ask whether there really is such a thing as an atheist.' Or, more pertinently perhaps, if such a view of Christianity were to prevail, such a thing as a believer . . . In such thought, Protestant theology had effectively evacuated itself of any specific content; it had arrived at what has been called a 'god-shaped hole', which, in Bultmann's case, was filled with the fashionable existential philosophy of his day.

Of course, the only way out of this impasse was a new appeal to the historical Jesus. The risk implicit in this was a confrontation with the strange eschatological figure who had begun to emerge at the end of the 'Old Quest'. Perhaps predictably, however, the 'New Quest' arose in the 1950s among the so-called 'right-wing' students of Bultmann, and was quickly taken up by scholars (both Christian and non-Christian) in America and Britain.

The 'New Quest' differed from the old firstly in that it could draw upon several decades of the new, sophisticated and productive methods of New Testament criticism and analysis. There was much greater understanding of what sort of texts the gospels were and of their limitations as potential sources about the 'Life': no one expected to extract from them, this time round, a complete biography. Nonetheless, a number of 'criteria' were developed which could reasonably be expected to indicate 'authentic' references to Jesus's life and teaching as opposed to later elaborations. For example, statements attributed to Jesus which were embarras-

sing to the early church – like his assertion that he came only to minister to the House of Israel – were deemed more likely to reflect his original teaching than statements compatible with the church's interests. Similarly, passages in the gospels which described Jesus's life as a literal fulfilment of ancient Hebrew prophecies – 'Matthew' is especially replete with examples of this – were to be regarded with particular scepticism.

Deployment of these textual methods went hand-in-hand with historical insights into first-century Roman history, and into the life and customs of the Jewish people at this time. Indeed, one distinctive feature of the 'New Quest' was an unprecedented collaboration and exchange between Christian and Jewish scholars. The gospels appear to go out of their way to denigrate the Jews and to exonerate Pilate, in particular, and the Romans, in general, for their part in the demise of Jesus. It is now widely accepted that this was a tactical position on the part of gospel compilers who wanted the Roman authorities to look favourably on the new faith. Moreover, in Jesus's time, the ruling Jewish party were the Sadducees, who accommodated with the Roman yoke. Surprisingly, Jesus is not attributed with many direct criticisms of them, though he is reported as railing incessantly against the Pharisees. Nonetheless, a closer reading of the ethical pronouncements in the gospels indicates that Jesus was profoundly influenced by liberal Pharisaic traditions. Again, this conundrum becomes explicable if we realise that the Pharisees were the ruling party of the Jews at the time the gospels were written, a period of violent struggles against Roman domination.

These textual and historical studies were fleshed out by a stream of archaeological finds, the most spectacular of which was of course the discovery and translation of the Dead Sea Scrolls. Though these yielded nothing which related *immediately* to Jesus, they gave considerable colour and detail to our picture of the world he inhabited, and the way in which he was likely to have lived and thought.

Now the findings of the 'New Quest' are diverse; there is no way in which they can be accepted as definitive. The whole field is one of the most contentious in scholarship, and the gaps in knowledge are (and probably always will be) great enough for

every kind of doubt and confusion to reign. Nonetheless, I think Don Cupitt is right when he says that our chances, today, of finding out about the real Jesus are better than they have been since the beginnings of Christianity. And the picture emerging from this recent scholarship seems as remote as ever from anything which an orthodox Christian has ever believed about Jesus.

We know that in Jesus's time, Roman tyranny had led to widespread belief among the Jews in the imminence of divine intervention in history, and the coming of a Messiah. Such beliefs took many different forms, and were associated with a range of different religious movements and responses. At one extreme, there was an armed resistance movement: the Zealots. But Zealotry interpenetrated with a variety of messianic and eschatological sects. There was also, however, a monastic movement of fanatical sectaries, the Essenes, who established communities in the deep ravines around the Dead Sea where they practised ritual bathing and property sharing, ate sacramental meals, studied the Law, and observed the Sabbath, effectively maintaining an uncorrupted 'provisional' temple. The Essenes were obsessed with a 'Teacher of Righteousness' and fused their religious and political ambitions into a recurrent fantasy about a victorious war against the 'Sons of Darkness'. Jesus has sometimes been associated with either the Zealots or the Essenes. Recent scholarship suggests he belonged to neither group. Jesus was, however, probably acquainted with the wandering prophetic teacher, John the Baptist, by whom he may have been baptised. Our knowledge of these movements and individuals is important for our understanding of Jesus because it enables us to attempt to situate his teaching in the context of the Jewish millennial tendencies of his day.

It is, however, no easy matter to recover exactly what Jesus taught. The New Testament writers refer to Jesus by many titles – 'Son of God', 'The Lord', 'Messiah', 'Logos', 'The Word', etc. These titles indicate a great deal about what the early Christians believed concerning Jesus. Scholars, however, are now agreed that with one possible exception, the titles were appended to Jesus by the so-called 'post-resurrection' Christian communities. For example, the use of the term 'Son of God' about Jesus in the gospels

has given rise to one of the most potent of all christological ideas, and the cornerstone of dogmatic Christianity: the belief that Jesus was divine. But 'son of God' was merely a conventional form of respectful address in Old Testament times; few scholars today believe that either Jesus, or those who heard him speak, thought he actually was divine. Nor does any reputable scholar today think that Jesus believed himself to be the expected Messiah of the Jews; though some say that there may have been those among Jesus's followers who saw him in this light. (The raising of Messianic expectations may have had something to do with his trouble with the Romans; and the disappointment of them, with his betrayal.) There is however strong evidence to suggest that Jesus may have used the curious term 'Son of Man' about himself. In Hebrew, the phrase had a colloquial usage, equivalent to 'man', 'chap', or 'somebody'; and Jesus may thus have simply been referring to himself in a conventionally self-deprecatory way. But the 'Son of Man' was also featured in the apocalyptic happenings described in texts like the books of Daniel and Enoch; this has suggested to some that Jesus may well have seen himself as playing some part in the eschatological process, beyond simply prophesying it.

Nonetheless, what is clear from all this work is that christology – any sort of thinking about Jesus as 'The Christ' in the sense Christians use the term – was a late accretion. As Julius Wellhausen once wrote, 'Jesus was not a Christian; he was a Jew.' Dennis Nineham, the distinguished Cambridge theologian, has described a consensus among 'the majority of competent New Testament scholars' concerning (as he puts it) 'what essentially made Jesus tick'. Nineham describes this as Jesus's conviction that with the emergence of John the Baptist and his own appearance as John's successor, the process of the arrival of the Kingdom of God had begun to occur. Nineham considered that Jesus would have expected that within his lifetime, or at latest that of some of his contemporaries, the course of history would be brought to a close and the Son of Man would appear in the glory of his father with his holy angels to judge and wind up the universe. 'There is no reason to think', Nineham adds, 'that the general way in which he envisaged the process differed significantly from the ways in

which it was conceived in some of the Jewish apocalyptic writings
which have survived from the period.'

But if Jesus did not conceive of himself as 'The Christ', or
god-man of the creeds, neither is it right for us to think of him as
giving the world a new ethic. Schweitzer's theory of an 'interim
ethic' is now regarded with some scepticism, but there is wide-
spread agreement that there was little original in Jesus's ethical
teaching. He was steeped in the liberal, Pharisaic rabbinical
tradition. Today, we can recognise how much of what he is
alleged to have said, which is believed to be unique and original to
Christian teaching, was anticipated in the writings of, say, Rabbi
Hillel, forty years earlier. As Edwyn Hoskyns and Francis Davey
wrote nearly half a century ago, the attempt to discover in the
teaching of Jesus some new teaching about ethics or morals has
completely broken down. They explained: 'Those modern Jewish
scholars who have busied themselves with a comparison between
the ethical teaching of Jesus and the ethical teaching of the rabbis
have given this judgment, that there is no single moral aphorism
recorded as spoken by Jesus which cannot be paralleled, and often
verbally paralleled, in rabbinic literature.' More and more Christ-
ian scholars, they claimed, were coming to agree with this conclu-
sion.

Nor (Christian humanists please note!) was Jesus particularly
concerned with telling men and women to love one another. As
C. H. Dodd, the conservative Cambridge theologian, once put it:
'Singular as it may appear, he seems to have said little . . . about
the duty of loving God, and not much more . . . about loving one's
neighbour, except where he was relating himself to the current
teaching with which his hearers would be familiar.' 'Jesus',
Wellhausen writes, 'did not preach a new faith, but taught man to
do the will of God; and in his opinion, as also in that of the Jews,
the will of God was to be found in the Law and in the other books
of scripture.'

In effect, the 'New Quest' had thus arrived at conclusions
comparable to those which had so summarily concluded the 'Old
Quest'. Admittedly, the 'picture' of Jesus the new questers offered
was much more residual, fragmented and incomplete. It was
universally agreed that the materials for a true 'life' or biography

simply did not exist. Similarly, there was extreme scepticism about claims, like Schweitzer's, that Jesus conceived of himself as the Messiah . . . And yet the centre of what the new questers said about Jesus was immediately comparable to what Schweitzer had said half a century before: Jesus was a reforming Jew who preached to his countrymen with a peculiar urgency because he erroneously believed the world was about to be culminated and transformed by divine intervention, and he conceived of himself as playing some part in that transformation. The essence of his message was, 'Repent! The Kingdom of Heaven is at hand.' The critical theologians, scholars – Jewish and Christian – and secular historians are agreed: Jesus did not conceive of himself as 'Son of God', in any sense remotely close to the meaning the title acquired in Christian confessions; he had nothing to say about his own nature as god-man, incarnation, resurrection from the dead, or the doctrines of salvation (soteriology) on which the Christian faith has been erected. The findings of the 'New Quest', then, would appear to deliver a decisive blow to 'the Christian interpretation of history'.

It is not within the scope of this paper to describe how the proclaimer became the proclaimed, how the shift occurred from the original, Galilean, eschatological teachings *of* Jesus, to Hellenistic, christological assertions *about* him. The emphasis of recent years has been to argue that this gap may not have been quite as wide as Schweitzer assumed. We now know much more about the complexity and diversity of first-century Jewish beliefs, for example about the charismatic Galilean cults which may have formatively influenced Jesus. Similarly, Hellenistic culture is now believed to have penetrated Judaism much more than had once been assumed. There are even those who, on the basis of the Qumran discoveries, are maintaining that the theology of 'John's' gospel may not be entirely a late, neo-platonic elaboration (as had once been assumed) but may draw upon the earliest Jewish tradition. Against the over-elaboration of such views, however, we must set the consistent development from a 'low' towards a 'high' christology in the Pauline letters. Paul, having taught the imminent coming of the Kingdom, had to explain away 'The Delay of the Parousia', or the failure of the divine event, so eagerly expected by

early believers, to occur. The expectation of the end of the world is
progressively replaced by the affirmation of Jesus as 'The Christ' –
and the content of the christological assertions about him was
undoubtedly derived from Christianity's ever-growing contact
with the wider Hellenistic world, and the syncretic religions which
proliferated throughout the Mediterranean basin.

As Frances Young has written, 'Christological confessions
about Jesus evolved from a vast range of expectations and con-
cepts, images and speculations that were present in the culture of
the age and society in which the church was born and matured.'
She continues, 'Scholarship has not yet found enough pieces of the
jigsaw to reconstruct a totally convincing picture of the sources
and development of christological belief, but it is certain the
jigsaw is there to be played with.'

There is, of course, a great deal I have left unsaid. I have
neglected to point out the overwhelming arguments against so
much that is assumed to be part of the traditional 'Jesus Story':
against the Virgin Birth; Bethlehem as birthplace; against the wise
men, and the Three Kings . . . Indeed against so many of those
iconographic props which support ordinary, everyday Christian
faith. I have tried to concentrate on what seems to me the central
discovery of Jesus research: that he was a latterday Jewish
prophet, and his teaching endlessly reiterated an event which did
not occur. (To be fair, I have also omitted to discuss the ingenious,
but to me quite unconvincing, ways in which certain, particularly
British, theologians – e.g. C. H. Dodd and Norman Perrin – have
tried to 'soften' the eschatological issue.) It has, I think, been
established beyond reasonable doubt that Christianity was an
entirely post-Jesus phenomenon, and one which would have
seemed alien and incomprehensible to him. Christianity was, in
effect, an attempt to explain away the failure of a prophecy. (And
this seems to me to be true however Jesus may, or may not, have
conceived of his relationship to God, whether or not he, uniquely,
addressed him as '*Abba*', or 'Daddy'.) As one Catholic Modernist
theologian so accurately put it: 'He foretold the Kingdom and it
was the Church that came.'

It would, of course, be easy for a historical materialist like
myself to be smug about the findings of this Jesus research. It may

well have been because they recognised that 'The Jesus of History' was hardly likely to be conducive to any kind of faith that Bultmann and Tillich's 'No Quest' generation insisted *so* loudly that no picture of Jesus was retrievable from behind the biblical texts. After all, Schweitzer himself had said, 'The historical knowledge of the personality and life of Jesus will not be a help, but perhaps even an offence to religion.' Nonetheless, a nucleus of historical knowledge has been established largely, though not entirely, through the assiduous energies of Christian scholars, historians and critical theologians. And that knowledge has indeed emerged as a scandal and a stumbling-block to Christian faith.

On the other hand, smugness would be far from being appropriate. For Christianity remains a scandal and a stumbling block to the 'historical materialist' interpretation of history. It is not just that historical materialist methodologies have so conspicuously failed to explain why it was Christianity, specifically, which rose to dominance; or how it managed to survive and develop in almost every known kind of social formation – sometimes as a 'State Religion', but often in opposition to official ideologies. The problem runs deeper still: the whole question of the historical Jesus, and the beliefs which accrued around him, should cause us historical materialists to consider just how far we are from understanding the *positive* role which such great and consoling illusions play in determining man's ethical, cultural, and indeed his spiritual life.

1983

Index

Peter Fuller

'The most original, most discussed and most controversial art critic in Britain today.'
 Edward Lucie-Smith

Peter Fuller, tragically killed in a car accident on April 28, 1990 as this book was going to press, was one of Britain's leading art critics. He was born in Damascus and educated at Epsom College and Peterhouse, Cambridge. A full-time writer and broadcaster since 1969, he was the founder editor and publisher of the quarterly journal, *Modern Painters*, and also contributed regularly to *New Society* and *Art Monthly*, and wrote for many other publications including the *Guardian*, the *Times*, the *Sunday Telegraph*, *The Times Literary Supplement*, *Design*, *Crafts* and the *New Left Review*.

Peter Fuller lectured widely throughout Britain, America and Australia and was involved in acclaimed television films on Robert Natkin, Ruskin and Morris: his programme, *Naturally Creative*, also examined the relationship between the arts and natural sciences. He was married with two children.

Peter Fuller wrote numerous books on art, including *Art and Psychoanalysis, Beyond the Crisis in Art* (1980); *The Australian Scapegoat* (1986); the autobiographical *Marches Past* (1986) and *Theoria: Art and the Absence of Grace* (1988).

The Hogarth Press will be publishing the paperback editions of *Theoria* and *Marches Past* in 1991.

Art and Psychoanalysis

In these penetrating essays Peter Fuller asks how psychoanalysis can illuminate art – both its creation and our enjoyment. He examines key works and central images, assessing Freud's critique of Michelangelo's *Moses*, undertaking fascinating detective work on the Venus de Milo, and makes surprising and stimulating connections: Marion Milner directs us to problems of Modernism and 'taste', Winnicott and Bion provide clues to abstract painters like Rothko and Natkin. Often controversial, always elating, *Art and Psychoanalysis* overturns accepted ideas, marking a turning point in contemporary art criticism.

The Hogarth Press

Marches Past

In this remarkable autobiographical memoir Peter Fuller takes two dates from his diaries – March 28th and March 29th – and interweaves his accounts of those two days over a four year period, juxtaposing the events, thoughts, feelings and pre-occupations of each of those days. He reveals his own childhood, his fascination with various glassed-in pet creatures, his struggles with his Baptist father and his own growing awareness; against these he counterpoints the struggles of the present – his work, his thoughts on art and politics, his marriage, fatherhood, and the psychoanalysis that changed his life. An irresistible and superbly evocative mixture of anecdote and intellect, of personal and global reflections, *Marches Past* is reminiscent of Edmund Gosse's *Father and Son*: it is beautifully written, intensely moving, and has all the haunting originality of outstanding auto-biographical writing.

Chatto & Windus

Theoria
Art and the Absence of Grace

Theoria explores a complex and fascinating web of connections between art, nature, science and faith. An uncompromising personal challenge to fashionable post-modernism – the reign of Gilbert and George – it points to the curious, bleak similarity in attitudes between Mrs Thatcher's government, Saatchi-type collectors and leading left-wing critics and administrators, 'give or take a difference of political rhetoric'. In contrast Peter Fuller looks back to an alternative tradition, Ruskin's 'Theoria', the moral response to beauty, rooted in awareness of nature. As he traces the circling arguments, from the Gothic revival to the 1980s, he shows how this hidden current of ideas, romantic and spiritual, runs through the finest of modern English and Australian painting. Scholarly, exhilarating and highly controversial, *Theoria* asks fundamental questions about values in art today.

Chatto & Windus